2000

ALEKSANDR

RODChENKO

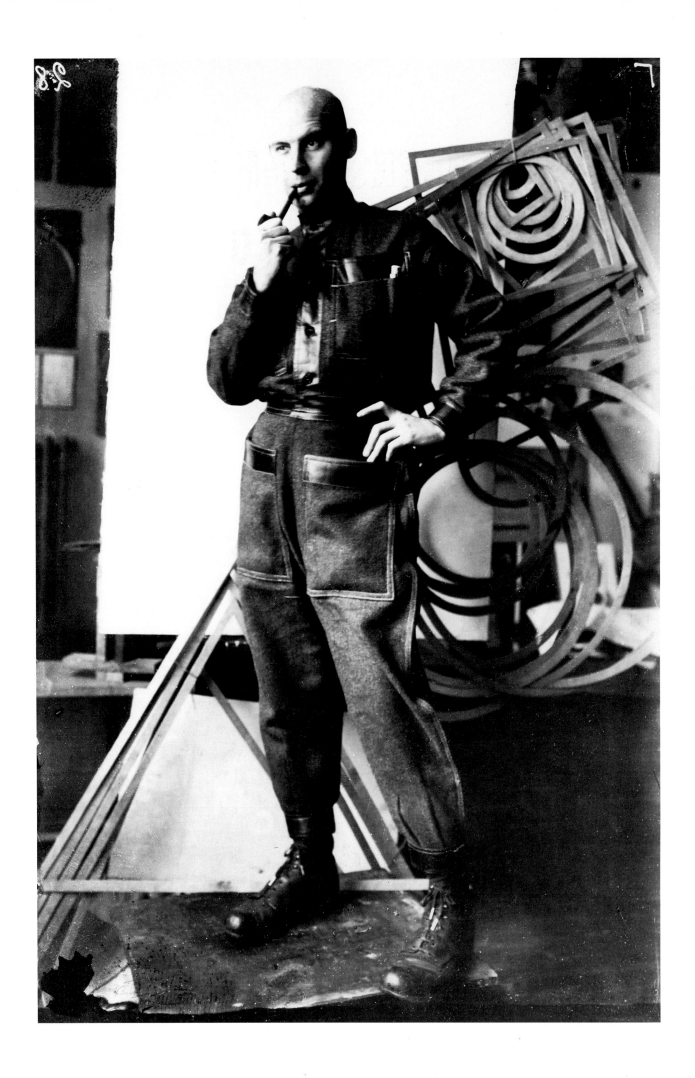

ALEKSANDR

RODChENKO

MAGDALENA DABROWSKI **LEAH DICKERMAN** **PETER GALASSI**

With essays by Aleksandr Lavrent'ev and Varvara Rodchenko

THE MUSEUM OF MODERN ART, NEW YORK

Distributed by Harry N. Abrams, Inc., New York

Published in conjunction with the exhibition *Aleksandr Rodchenko*, at The Museum of Modern Art, New York, June 25–October 6, 1998, organized by Magdalena Dabrowski, Senior Curator, Department of Drawings, The Museum of Modern Art; Leah Dickerman, Assistant Professor of Art History, Department of Art, Stanford University; and Peter Galassi, Chief Curator, Department of Photography, The Museum of Modern Art

The exhibition travels to the Kunsthalle Düsseldorf, October 1998–January 1999, and the Moderna Museet, Stockholm, March 6–May 24, 1999

This exhibition and accompanying publication are made possible by The International Council of The Museum of Modern Art and the William Randolph Hearst Endowment Fund.

Additional funding is provided by the Trust for Mutual Understanding, The New York Times Company Foundation, and the Howard Gilman Foundation.

The exhibition tour is organized under the auspices of The International Council of The Museum of Modern Art.

Produced by the Department of Publications
The Museum of Modern Art, New York

Edited by David Frankel
Designed by Bethany Johns
Production by Christopher Zichello
Duotone separations by Robert J. Hennessey,
 Middletown, Connecticut
Printed and bound by Stamperia Valdonega
 S.R.L., Verona

Published by The Museum of Modern Art
11 West 53 Street, New York, New York 10019
(www.moma.org)

Clothbound edition distributed in the United States and Canada by Harry N. Abrams, Inc., New York
(www.abramsbooks.com)
Clothbound edition distributed outside the U.S. and Canada by Thames and Hudson, Ltd., London

Library of Congress Catalogue Card Number: 98-065575
ISBN 0-87070-063-4 (clothbound, MoMA/
 Thames and Hudson)
ISBN 0-87070-064-2 (paperbound, MoMA)
ISBN 0-8109-6187-3 (clothbound, Abrams)

Printed in Italy

Cover, front: Back cover of the book *Conversation with the Finance Inspector about Poetry* (*Razgovor c fininspektorom o poesii*), by Vladimir Mayakovsky. 1926. Letterpress. 6⅞ ¥ 5" (17.4 ¥ 12.9 cm). See plate 135

Cover, back: Design for the USSR Workers' Club (*Rabochii klub SSSR*) at the *Exposition Internationale des Arts Décoratifs et Industriels Modernes*, Paris, 1925. Chess table. Black and red india ink and gouache on paper. 14⅜ ¥ 10" (36.5 ¥ 25.5 cm). See plate 167

Frontispiece: Rodchenko standing before dismantled hanging constructions. 1922. Photograph: M. Kaufman.

A note on the calendar
Until 1918, Russia adhered to the Julian or Old Style calendar, which lagged behind the Gregorian or New Style calendar followed in Western Europe. The discrepancy was removed by government decree on February 1, 1918 (Old Style), which became February 14, 1918 (New Style). Throughout this book, dates before February 1, 1918 (Old Style), follow the Old Style calendar.

A note on transliteration
Transliteration of the Russian alphabet throughout this book follows the Library of Congress system, except when the name of an individual or place is more easily identifiable by a familiar English spelling.

CONTENTS

Foreword

In the winter of 1927–28, nearly two years before he became the founding director of The Museum of Modern Art, Alfred H. Barr, Jr., traveled to Russia to study the new art that was flourishing there. One evening in Moscow he visited Aleksandr Rodchenko, whose relationship with the Museum thus began even before the Museum existed.

While in Moscow Barr also visited the Museum of Painterly Culture, which Rodchenko had directed in 1919–20, and whose systematic displays of advanced art anticipated a key aspect of the program Barr would establish in New York. Another important aspect of Barr's program was the wide range of mediums collected by The Museum of Modern Art—not only painting, sculpture, drawing, and printmaking, but also design, photography, and film. Barr recognized that the interrelationships among these diverse mediums are central to the vitality of modern art, and none of the great modernists was more versatile than Rodchenko, who made outstanding work in virtually every medium collected by the Museum. For all of these reasons it is gratifying and highly appropriate that this exhibition—the first major Rodchenko retrospective in the United States—should be organized by The Museum of Modern Art.

In their Acknowledgments, the curators express the Museum's gratitude to the many generous lenders to the exhibition. I would like to add a special note of thanks to our great friends and frequent partners in Russia: Irina Antonova, Director, Pushkin Museum of Fine Arts, Moscow; Valentin Alexeevich Rodionov, Director, State Tretyakov Gallery, Moscow; and Evgenia Nikolaevna Petrova, Deputy Director, State Russian Museum, Saint Petersburg. Our greatest debt is to the artist's daughter, Varvara Rodchenko, and her son, Aleksandr Lavrent'ev, who have not only lent generously but have tirelessly assisted the Museum in realizing the exhibition and this book.

I am also pleased to acknowledge generous support for the exhibition and this book from The International Council of The Museum of Modern Art and the William Randolph Hearst Endowment Fund. The Hearst endowment, for photography exhibitions, was established in 1997 with a generous grant from the William Randolph Hearst Foundation. I am thankful as well for the welcome support we have received from the Trust for Mutual Understanding, The New York Times Company Foundation, and the Howard Gilman Foundation.

The goal of this ambitious exhibition is to present a coherent view of Rodchenko's achievement in all of its prodigious variety. This has required the talent and expertise of three curators: the Museum's own Magdalena Dabrowski, Senior Curator, Department of Drawings, and Peter Galassi, Chief Curator, Department of Photography; and guest curator Leah Dickerman, Assistant Professor of Art History, Stanford University. Each has brought a profound understanding of Rodchenko, a keen sensibility, and a remarkable intelligence to this project. As a truly collaborative effort, their work together exemplifies a great strength of this museum.

—Glenn D. Lowry, Director, The Museum of Modern Art

We have received a great deal of help from a great many people in preparing this exhibition and book, and the multiplicity of our debts makes it difficult to acknowledge their depth. But the exhibition certainly could not exist without the generosity of the lenders, who are listed on page 335. In addition, nearly all of the lenders went to considerable trouble to make works in their collections available for study, to assist us in our research, and to accomplish the countless practical tasks that a project such as this involves.

We are deeply grateful to Natalia Dementieva, Minister of Culture of the Russian Federation, and her staff for enabling all of the Russian loans. It is a pleasure to add a special note of thanks to Pavel Khoroshilov, Deputy Minister of Culture, whose enthusiastic support has played a crucial role in the realization of the exhibition. We are grateful as well to a number of Russian museum professionals and the institutions they serve: Irina Antonova, Director, Alla Butrova, Head of the Foreign Department, Aleksei Savinov, Head of the Department of Private Collections, and Victoria Pavlova, Foreign Department, Pushkin State Museum of Fine Arts, Moscow; Valentin Alexeevich Rodionov, Director, Lydia Iovleva, Deputy Director, and Tatiana P. Gubanova, International Department, State Tretyakov Gallery, Moscow; Evgenia Nikolaevna Petrova, Deputy Director, State Russian Museum, Saint Petersburg; Svetlana Efimovna Strizhneva, Director, State Mayakovsky Museum, Moscow; Ljudmila Ivanovna Iljina, Director, Astrakhan State Picture Gallery; and Alla Anatolyevna Noskova, Director, Kirov Regional Art Museum. We are particularly thankful to the State Tretyakov Gallery for taking charge of the loans from the A. Rodchenko and V. Stepanova Archive, Moscow, and the regional museums.

A special debt of gratitude is owed to individuals who graciously arranged loans from the institutions or organizations they serve, or from their private collections: Svetlana Aronov; Hendrik Berinson, Galerie Berinson, Berlin; Janos Frecot and Ulrich Domröse, Berlinische Galerie, Berlin; Merrill C. Berman; Alain Sayag, Centre Georges Pompidou, Paris; Elaine Lustig Cohen; Bernard Danenberg; Barry Friedman, Barry Friedman Ltd., New York; Stephen and Jane Garmey; Therese Mulligan, George Eastman House, Rochester; Weston Naef, Gordon Baldwin, and Kate Ware, J. Paul Getty Museum, Los Angeles; Wim de Wit, Getty Research Institute, Los Angeles; Pierre Apraxine and Maria Umali, Gilman Paper Company Collection; Krystyna Gmurzynska and Mathias Rastorfer, Galerie Gmurzynska, Cologne; Manfred Heiting; Edwynn Houk, Edwynn Houk Gallery, New York; Rudolf Kicken, Galerie Rudolf Kicken, Cologne; Alex Lachmann and Brigitte Remmen, Galerie Alex Lachmann, Cologne; Maria Morris Hambourg, The Metropolitan Museum of Art, New York; Rheinhold Misselbeck, Museum Ludwig, Cologne; Joyce and Michael Axelrod and Arthur Ollman, Museum of Photographic Arts, San Diego; Peter MacGill, PaceWildensteinMacGill, New York; Patrice Haddad and Petros F. Petropoulos, Première Heure, Paris; Larry S. Zeman, Productive Arts, Brooklyn Heights, Ohio; Harvey S. Shipley Miller and Jared Ash, The Judith Rothschild Foundation, New York; Prentice and Paul Sack; Howard Schickler and Margaret Timmes, Howard Schickler

Fine Art, New York; Jack Banning, Ubu Gallery, New York; Thomas Walther; and Gary Wolkowitz.

For their generous assistance in a wide variety of matters we are grateful to Svetlana Artamonova, State Russian Library, Moscow; Ute Eskildsen, Museum Folkwang, Essen; Rosa Esman, Ubu Gallery, New York; Hubertus Gassner, Haus der Kunst, Munich; Graham Halstead, Museum of Modern Art, Oxford; Annely and David Juda, Annely Juda Fine Art, London; Nathalie Karg, New York; Garri Tatinsian, Berlin; and Evelyn Weiss, Museum Ludwig, Cologne. For assistance with linguistic translation we are indebted to Dr. Kostas Pouhtos and Michael Goldman Donally.

We are happy to acknowledge the generous cooperation of our partners in the exhibition tour, both of them distinguished scholars of Russian art: Jürgen Harten, Director, Kunsthalle, Düsseldorf; and David Elliott, Director, Moderna Museet, Stockholm. The Stockholm showing was graciously encouraged by Pontus and Kerstin Bonnier, members of The International Council of The Museum of Modern Art.

We warmly thank The International Council and its President, Jo Carole Lauder, for their generous support of the exhibition and book. In addition, this is the first exhibition to benefit from the William Randolph Hearst Endowment Fund for photography exhibitions, established in 1997 by a major grant from the William Randolph Hearst Foundation. The Museum is deeply grateful to Randolph and Veronica Hearst and to Robert M. Frehse, Vice President and Executive Director of the Foundation, for this far-sighted act of generosity.

Further support for the exhibition has been provided by The Trust for Mutual Understanding, and we thank Richard Lanier, Director of the Trust, for his thoughtful advice on many aspects of the project. Finally, the quality of the book has been greatly enhanced by grants from The New York Times Company Foundation and the Howard Gilman Foundation. For this support we are particularly grateful to Arthur Gelb, President of the Times Foundation, and the late Howard Gilman.

An exhibition of this scale and complexity requires the dedicated effort of scores of people at the Museum, and we are grateful to them all. We regret that their very numbers make it impossible to mention each by name, for it is through their work that the Museum is able to present Rodchenko's art at its best, so that a large audience may appreciate and understand it. We enthusiastically thank Director Glenn D. Lowry for his unwavering support. The exhibition and its tour have been ably supervised by Jennifer Russell, Deputy Director for Exhibitions and Collections Support. Linda Thomas and Kathy Bartlett in the Department of Exhibitions and Terry Tegarden and Jon Cordova in the Department of Registration have tirelessly and expertly handled the complex details of assembling the exhibition and executing its tour. Jay Levenson, Director, International Program, played a key role in arranging the tour. James Coddington, Karl Buchberg, Eugena Ordonez, Erika Mosier, and Victoria Bunting in the Department of Conservation scrupulously oversaw the care and restoration of key works. Jerome Neuner skillfully

designed the complex installation of the exhibition, and the exhibition production staff, led by Attilio Perino, Pedro Perez, Santos Garcia, and Peter Geraci, together with Mari Shinagawa, have expertly carried through its every detail. Giuseppe Maraia deserves a special note of thanks for his outstanding contribution to the recreation of Rodchenko's Workers Club of 1925. The exhibition's beautiful graphics are the work of John Calvelli and Santiago Piedrafita.

Mary Chan in the Department of Drawings assisted us in every dimension of the preparation of exhibition and book with exceptional professionalism and dedication, often working under the pressure of impossible deadlines. Petra Saldutti, also in the Department of Drawings, and Corey Keller, in the Department of Photography, made vital contributions. For further help of many kinds we are grateful to Pierre Adler, Josiana Bianchi, Michael Margitich, Monika Dillon, Steven Higgins, Christopher Mount, Pete Omlor, Mary Lou Strahlendorff, and Adrienne Williams.

The Museum's Department of Publications, under Michael Maegraith, Publisher, has done a superb job of producing a large and complex book made still more complex by the challenge of dealing with three curator-authors instead of one. We are especially grateful to editor David Frankel, for his patience as well as his thoughtfulness and skill; to Bethany Johns, for her spirited and elegant design; and to Chris Zichello, who expertly supervised production. The quality of the reproductions is due to the exceptional skill of Robert J. Hennessey, who made the negatives for the photographic duotones, and of Martino Mardersteig of Stamperia Valdonega, who made the four-color separations and printed the book. Over forty of the photographic duotones were made from direct digital scans executed at the Museum by Kate Keller and Erik Landsberg. These scans are the first fruit of an ambitious digital imaging project at the Museum, supervised by Linda Serenson Colet with the assistance of Sarah Hermanson, and made possible by a generous grant from CameraWorks, Inc.

Neither the exhibition nor the book could have been achieved without the exceptional efforts of two people. In Moscow, Zelfira Tregulova contributed her unsurpassed professional expertise, deft diplomacy, and inexhaustible energy to seeing the project through. In New York, Anne-Laure Oberson undertook countless tasks, including the compilation of the book's valuable chronology, and conquered them all with intelligence and good humor.

Rodchenko's daughter, Varvara Rodchenko, and her son, Aleksandr Lavrent'ev, maintain the A. Rodchenko and V. Stepanova Archive in Moscow. Tireless in their dedication, they have assisted many scholars and curators in countless practical ways and have shared their knowledge of Rodchenko's work and times. Over a period of some three years they have done all of this and more for us, and they have done it with great generosity and kindness. We are deeply grateful to them.

—Magdalena Dabrowski Leah Dickerman Peter Galassi

This book accompanies the first major exhibition in the United States of the work of Aleksandr Rodchenko, a founder and central protagonist of Constructivism—the vigorous artistic movement that arose in Russia after the Revolution of 1917. Like other leading modernists in Russia and the West, Rodchenko was a keen inventor of forms. In pursuit of Constructivist goals he also became a versatile innovator in a much broader sense: after producing bold work in painting and sculpture, he still more boldly abandoned these traditional mediums and reconceived his art in the service of the radically progressive, technologically advanced society envisioned after the Revolution. This ideal of social agency eventually involved him in virtually every branch of the visual arts, including projects of design and photography addressed to a mass audience. As a result, Rodchenko's work is perhaps the most diverse body of work created by any major twentieth-century artist, and the least susceptible to a narrow aesthetic interpretation. The primary goal of this exhibition and book is to present a coherent overview of his achievement in all of its diversity.

Rodchenko was born on November 23, 1891, just thirty years after Tsar Aleksandr II emancipated the serfs of Russia. His father, Mikhail Mikhaĭlovich Rodchenko, the son of a serf, had left his native province of Smolensk and made his way as a laborer to the capital, Saint Petersburg, learning to read and write along the route. After the turn of the century, the family moved to distant Kazan, where Rodchenko earned a certificate of elementary education and eventually entered the local art school. Thus Rodchenko's own family story seems to suggest that genuine social progress was underway in Russia. If so, it was too little too late.

The autocratic power of the Romanov dynasty had long been enforced through an alternating pattern of grudging reform and brutal repression, which intensified in the nineteenth century in the face of political turmoil and social transformations throughout Western Europe. In this climate there emerged a vibrant *intelligentsia* (a Russian word coined in this period) of dissidents inspired by Western ideals of freedom and social justice, who established a tradition of uncompromising moral commitment to radical political change. Although Russia remained largely an agricultural country populated by grievously burdened peasants, rapid industrialization at the end of the nineteenth century brought rising social tensions and helped to foster the growth of a fiercely dedicated political underground. Among the leading elements was the Russian Social Democratic Labor Party (Russkaia sotsial-demokraticheskaia rabochaia partiia), founded in 1898 and committed to the revolutionary program of Karl Marx. In 1903, the party split into Bolshevik ("majority") and Menshevik ("minority") factions. The former, led by Vladimir Il'ich Lenin, advocated immediate revolution and class war.

The first mass uprising against the tsarist regime occurred in 1905, and, although it failed, it strengthened the resolve of the radical parties. The onset of World War I in 1914 presented a renewed challenge to the weak Tsar Nicholas II, as military defeats abroad and food shortages at home created widespread discontent, provoking strikes in Petrograd (as Saint Petersburg had been rechristened, to rid the name of its Germanic connotation) and Moscow. Violent disturbances in late February 1917 forced Nicholas to abdicate, ending three centuries of Romanov rule. A democratic, bourgeois Provisional Government was formed, but proved no match for the single-minded Bolsheviks, who seized power in Petrograd on October 25.[1] They immediately set out to dismantle the embryonic apparatus of democracy that had grown up after February and to dominate or eliminate rivals, including the soviets, or councils, of workers in whose name they had assumed power. Although the coup itself was relatively bloodless, it took three years of very bloody civil war for the Bolsheviks to secure control over the vast country.

Marx had taught that all dimensions of social life were expressions of class interest, and Lenin believed that society therefore had to be thoroughly remade in the interests of the victorious proletariat. The sole agent of this "dictatorship of the proletariat" was to be the Communist Party, as the Bolsheviks renamed their organization in March 1918. This was the first of the twentieth century's totalitarian regimes, and for many in Russia and abroad the idealism of its stated social goals at first masked its terrible novelty.

Magdalena Dabrowski's essay on pages 18–49, which traces Rodchenko's career through 1921, includes an account of his youth and artistic education. (See also the Chronology on pages 300–312.) The key development was his move in late 1915 or early 1916 from provincial Kazan to Moscow, where he instantly brought his art up-to-date with the current experiments of the avant-garde. There he rejoined the artist Varvara Stepanova, whom he had met in Kazan and who became his lifelong companion and frequent collaborator.

Beginning in the last decade of the nineteenth century and with increasing vigor in the decade before the Revolution, advanced Russian artists had pursued an unprecedented exchange with their counterparts in Europe. Russian painters, notably Vasily Kandinsky, played significant roles in developments abroad, while connoisseurs such as Ivan Morosov and Sergei Shchukin in Moscow were forming outstanding collections of advanced European painting, including superb examples of work by Georges Braque, Henri Matisse, and Pablo Picasso. Most important, Russian artists at home responded with enthusiasm to innovations in the West, often inflecting them with lessons drawn from native traditions such as icon painting and folk art. The key innovators were Kasimir Malevich and Vladimir Tatlin, each of whom by 1915 had elaborated the vocabulary of Cubism into a distinctive style of abstract art. Among the equally experimental poets was the flamboyant Vladimir Mayakovsky, later to become Rodchenko's close friend and collaborator.

The outbreak of World War I cut short the exchange, occasioning the return of the expatriates and helping to cultivate the specifically Russian dimension of the new art. Over the next few years Petrograd and Moscow enjoyed a period of thrilling and competitive creative ferment, marked by a series of landmark exhibitions. This was the heady artistic environment that Rodchenko entered when he arrived in Moscow, and he soon made his mark by presenting a group of austere drawings at the *Store* (*Magazin*) exhibition organized by Tatlin in March 1916. Shortly thereafter, however, he began military service as operations manager of a hospital train, and made very little new work until after his discharge in December 1917.

After the October Revolution, the Bolsheviks moved swiftly to suppress dissent—in 1918, for example, they liquidated the independent press, closing more than 150 daily newspapers in Moscow alone. Many members of the liberal intelligentsia soon emigrated, creating a relative vacuum of authority in academic and artistic fields. At least since the failed revolution of 1905, an experimental attitude in art had been associated with progressive politics in Russia, and in artists' circles "leftist" was a common shorthand for "avant-garde." Indeed the avant-garde was the only artistic group to side unambiguously with the Bolsheviks, who in the precarious aftermath of the October Revolution welcomed any support. Thus it was that a tiny, gifted, obstreperous group, whose highly sophisticated art was unknown or incomprehensible to the vast majority of the Russian people, identified its own artistic ideals as the vanguard expression of the unfolding Communist society—and in the process created a unique and lasting body of art and theory.

At first the avant-garde enjoyed considerable institutional authority. Among the agencies of the new state bureaucracy (whose alphabet soup of abbreviations surpasses even the one spawned slightly later in America by the bureaucracy of the New Deal) was the Narodnyi komissariat prosveshcheniia, or Narkompros—the People's Commissariat of Enlightenment. Headed by the cosmopolitan Anatoly Lunacharsky, Narkompros administered all branches of education and culture and, by policy, encouraged artists of all tendencies. Alone among Bolsheviks in high places, Lunacharsky had a temperamental weakness for the leftists, whose work he studied and appreciated. They soon occupied prominent positions in Izo (Otdel izobrazitel'nykh iskusstv, the Section of Visual Arts of Narkompros). Tatlin's *Monument to the Third International* (*Pamiatnik III Internationala*) of 1919–20—a grand, highly imaginative, and wholly impractical design for a government building some 1,300 feet tall—arose from Lenin's Plan for Monumental Propaganda, which Tatlin administered as the head of the Moscow branch of Izo in 1918–19.

Rodchenko's rise to prominence in the years immediately following the Revolution was rapid and comprehensive. From 1918 onward he held several positions within Izo, notably as head of the Museum Bureau (Muzeinoe biuro) and its Moscow centerpiece, the Museum of Painterly Culture (Muzei zhivopisnoi kul'tury), both founded in 1919. In

late 1920 he was appointed to an important teaching post at Vкhuтемаs (Vysshie gosudarstvennye khudozhestvenno-tekhnischeskie masterskie—the Higher State Artistic-Technical Workshops), the principal state art school, across the courtyard from the apartment building into which Rodchenko and Stepanova moved in 1922.

In a period when few if any Western museums took note of recent avant-garde art, the Museum Bureau, charged with establishing a network of provincial museums of contemporary art, was a farsighted institution. And under Rodchenko the Museum of Painterly Culture was perhaps the first not only to assemble outstanding examples of advanced art but to chart its formal evolution systematically—an aim that apparently made a lasting impression on Alfred H. Barr, Jr., when he visited the museum in 1928, the year before he became the founding director of The Museum of Modern Art in New York. The systematic character of the museum's scheme reflected Rodchenko's quasi-scientific conception of artistic progress, which is the subject of the essay by Aleksandr Lavrent'ev on pages 50–61.

As the present exhibition demonstrates (despite the absence of a number of key works of sculpture long known only through photographs), the years from 1918 to 1921 were a period of intense creativity in Rodchenko's art. Although fueled by competition with other artists including Malevich and Tatlin, this achievement was deeply rooted in Rodchenko's conviction that the creation of a new, Communist art must be a collective enterprise. He derived much of the impetus for his own innovations from his vigorous participation in group projects, meetings, and associations. The most important of these was Inкhuк (Institut khudozhestvennoi kul'tury—the Institute of Artistic Culture), founded under the auspices of Izo in March 1920.

Inкhuк may be unique in the history of state-sponsored institutions, for its sole mission was to establish objective, universal principles of art. Rodchenko played a decisive administrative role at the institute, and was outspoken in articulating key positions in its heated theoretical debates. In February 1921 he helped to lead the group that drove Kandinsky from his position as head of one of the institute's committees, and the following month, with Stepanova and others, he formed the First Working Group of Constructivists (*Pervaia rabochaia gruppa konstruktivistov*).

In the course of 1921, the Constructivists decided that what they called their "laboratory period" of theoretical investigation and pursuit of a rigorously abstract art had reached its logical conclusion. They resolved henceforth to devote their talents and energies to the design and production of useful objects and products. Five years after arriving in Moscow, Rodchenko had assumed a leading role as artist, theorist, teacher, and administrator in the new culture. He now took decisive action in charting its future by embarking on a new career that would involve him in virtually every domain of the applied arts, as well as photography and film. That remarkable career—unique for a modern artist who had first established his or her prominence in the traditional mediums of painting and sculpture—is extensively surveyed in the present exhibition. The

sole notable exception is Rodchenko's work in costume and set design for theater and film, much of which was ephemeral by nature, so that its surviving elements do not adequately represent his achievement.

One of the defining motives of modern art has been a mandate to pursue the internal logic of formal invention, however strange its outcomes might seem with respect to prior conventions. A second key motive has been to escape from the hermetic sophistication often perceived as arising from the first—to break down the barriers between high art and ordinary life, and to redefine art as an instrument of social and political change. Rodchenko's work drew upon both motives, yielding extremes of rarefied abstraction on the one hand and, on the other, practical applications ranging from advertising and product design to propaganda photojournalism. What is particularly challenging is that both poles of his art were deeply rooted in both motives. The guiding aim of the present exhibition has been to grasp Rodchenko's best work, in all of its varieties, as a whole.

At the end of the civil war, in 1921, the Bolsheviks found themselves in control of a thoroughly devastated country. Lenin's prediction that the Revolution would unleash an international class war, with Russia in the vanguard, had failed. The economy had collapsed, industrial production had fallen 80 percent below the levels of 1913, hundreds of thousands were dying of famine, and the incipient proletariat in whose name the Revolution was won had all but ceased to exist. Lenin responded by relaxing the draconian policies of the civil war, under which virtually every resource had been commandeered for the state and the army, and by reintroducing a limited form of capitalist competition, which gradually revived the economy. The New Economic Policy, or NEP, persisted until 1928, when Joseph Stalin launched his First Five-Year Plan of forced industrialization and collectivization of agriculture.

Lenin's decline into illness in 1922, followed by his death in January 1924, provoked a struggle for succession among Leon Trotsky, Nikolai Bukharin, and Stalin, whose ascendancy was not secure until at least 1927. Thus politically as well as socially and culturally, the early and mid-1920s in Russia, although filled with tension and uncertainty, were a period of relative openness, opportunity, and flux. The advent of NEP, however, diminished the relative institutional autonomy of the leftist avant-garde. Thereafter the vociferous but tiny group was obliged to compete more actively for attention and funds. Among its most formidable opponents was AKhRR (*Assotsiatsiia khudozhnikov revoliutsionnoi Rossii*—the Association of Artists of Revolutionary Russia), which was founded in 1922 by conservative adherents of nineteenth-century realist painting, who ultimately triumphed by establishing the style of Party-sponsored Socialist Realism in the 1930s.

In this contentious climate, several extraordinarily talented leftist artists formed Lef (*Levyi front iskusstv*, the Left Front of the Arts), whose voice was the magazine *Lef* (Left, 1923–25), followed by *Novyi Lef* (New left, 1927–28), both financed by Narkompros.

In addition to its nominal leader, Mayakovsky, Lef included or was associated with (among others) writers Nikolai Aseev, Osip Brik, Boris Kushner, and Sergei Tret'iakov; filmmakers Sergei Eisenstein and Dziga Vertov; stage director Vsevolod Meyerhold; and Viktor Shklovsky (who, with Roman Jakobson, on the eve of the Revolution, had founded the Russian Formalist school of literary theory and criticism). Rodchenko, the house artist, designed all of the covers of *Lef* and *Novyi Lef*, and contributed to their contents as well.

Lef strove to realize Marx's social ideals, aiming at "the production of a new human being through art," in Tret'iakov's words.[2] This collective project yielded an original and probing body of writing, which sought to synthesize Marxist materialism with advanced artistic experiment and Russian Formalist theory. Leah Dickerman's essay on pages 62–99 analyzes Rodchenko's sustained effort, from 1923 through the early 1930s, to put Lef principles into concrete practice. Among his most original achievements in this vein was his advertising work, often in collaboration with Mayakovsky, for Dobrolet (the state airline), Mossel'prom (the state grocery concern), and GUM (the state department store), which under NEP were obliged to compete for investors (in the case of Dobrolet) or customers.

Stalin's rise to power in the late 1920s ended the relative tolerance and diversity of the NEP era. Directly and indirectly, the Party revived the divisive rhetoric of class war, fomenting a climate of vituperative accusation in which the accuser shored up his standing as an ally of the "proletariat" by denouncing the "bourgeois" tendencies of the accused. The resulting cultural revolution, most intense from 1928 to 1931, discredited many adherents of the Revolution, including Mayakovsky, Rodchenko, and eventually the entire Lef circle, along with other remnants of the free-thinking intelligentsia. In 1932, when the First Five-Year Plan met its goals a year ahead of schedule, Stalin judged that the cultural revolution had done its work of replacing unreliable elements with loyal Party cadres. All artistic organizations were dissolved, eventually to be replaced by a single union of artists under Party control.

In 1929, Rodchenko joined the October group (*Oktiabr'*), which united a wide range of leftist artists in the aim of closing the gap between advanced art and the everyday life of the proletariat. In the latter part of the 1920s, photography was becoming Rodchenko's principal occupation, and, as Peter Galassi shows in his essay on pages 100–137, he played a key role in establishing the lively vocabulary of European photographic modernism. When his photographs were first attacked as "bourgeois formalism" in April 1928, he defended himself vigorously. Over the next several years, however, he attempted to adapt to the changing circumstances, principally by devoting more and more of his efforts to propaganda photojournalism and graphic design. Doubtless Rodchenko and many other members of October were sincere in serving its goals, but it is difficult to believe that his expulsion from the group in 1932—again for "bourgeois formalism"— was anything but a desperate (and ultimately futile) attempt at self-preservation on the part of the group's leadership.

Rodchenko was an original theorist of art, but he was not a political thinker. He remained steadfastly committed to the ideals of the Revolution, and his diaries suggest that he never understood the forces that drove him from the prominence he had enjoyed in the decade after 1917, and eventually rendered him, as he put it, "an invisible man."[3] In the mid-1930s the artist who had boldly renounced painting in 1921 again began to paint—not abstract works but imaginary circus scenes. These paintings signal his alienation from the thrilling collective enterprise to which he had dedicated his life and from which he had drawn much of his unflagging inventiveness. In the 1940s he also painted abstract works of somewhat greater interest, but these too are omitted from the present exhibition. For as his diaries express, they are not products of a sustained creativity but of a painful and bewildering isolation, suffered by an artist whose work had been deeply rooted in collective goals. By the late 1930s Rodchenko and Stepanova were largely excluded from official culture, despite the design commissions they continued to receive from time to time. Like most Russians they suffered miserably during World War II, from which Rodchenko never fully recovered. He died in 1956, the year in which Nikita Khrushchev denounced Stalin's crimes.

Rodchenko's and Stepanova's daughter Varvara Rodchenko begins her reminiscences of her father (pages 138–43) with an excerpt from her mother's diary recording a visit from Alfred Barr in January 1928. The evolution of Barr's view of Rodchenko's work is suggestive of its critical fortune generally. Later in 1928, Barr published an essay on the Lef group, stressing the political dimension of its art and theory.[4] In the ambitious *Cubism and Abstract Art* exhibition at The Museum of Modern Art in 1936, however, he presented Russian Constructivism as an episode of inspired formal innovation, largely dissociated from its revolutionary context. By then avant-garde art and artists had been suppressed in the Soviet Union, and the continuing international influence of Constructivism increasingly dissolved its historical and political identity within a broad and vaguely defined stream of geometric abstraction. It was not until the 1960s that a growing concern among scholars for the historical context and ideological implications of all works of art brought a new outlook to bear on Constructivism—of all artistic movements perhaps the most thoroughly embroiled in politics. At the same time, both Russian and Western scholars began the work of reconstructing and making sense of the very complex historical record—a process greatly accelerated by the collapse of the Soviet Union and the consequent opening or easing of many paths of inquiry. This exhibition and book are inconceivable without that work, and aim to further it, for it is still very much underway.

Notes

1. In March 1918 the seat of government was moved to Moscow, which was considered safer because more distant from the Western border.

2. Sergei Tret'iakov, "Otkuda i kuda? (Perspektivy futurizma)," *Lef* no. 1 of 1923, p. 195. Published in English as "From Where to Where," in Anna Lawton and Herbert Eagle, eds. and trans., *Russian Formalism through Its Manifestoes, 1912–1928* (Ithaca: Cornell University Press, 1988), p. 208.

3. Diary entry of May 28, 1945, in Aleksandr Rodchenko, *Opyty dlia budush-chego: dnevniki, stat'i, pis'ma, zapiski*, ed. O. V. Mel'nikov and V. I. Shchennikov, compiled by A. N. Lavrent'ev and V. Rodchenko (Moscow: Grant', 1996), p. 382. Trans. James West, in a manuscript commissioned by The Museum of Modern Art.

4. Alfred H. Barr, Jr., "The LEF and Soviet Art," reprinted from *Transition* (Fall 1928) in *Defining Modern Art: Selected Writings of Alfred H. Barr, Jr.*, ed. Irving Sandler and Amy Newman (New York: Harry N. Abrams, Inc., 1986), pp. 138–41.

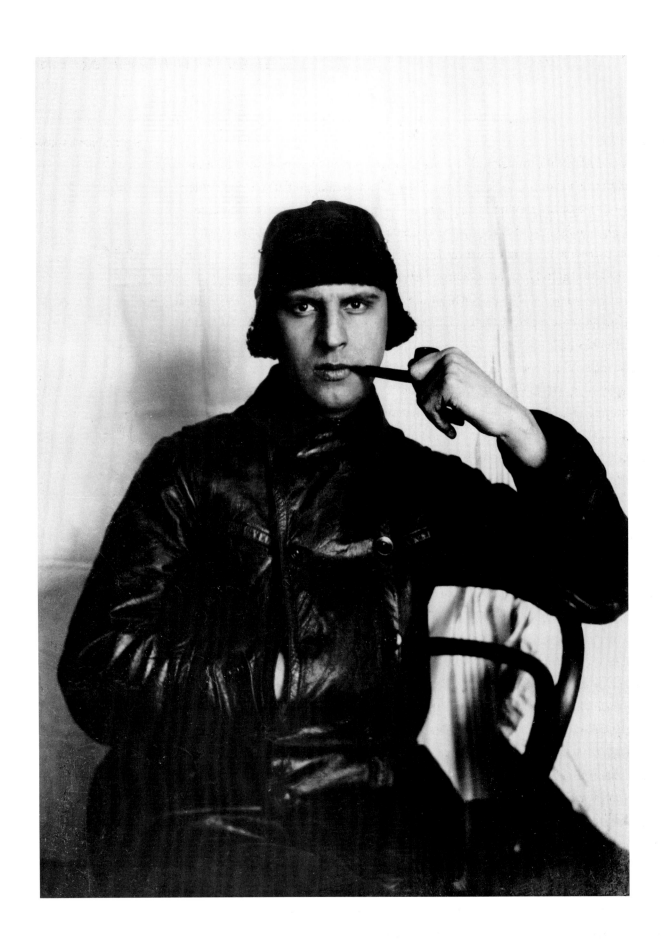

ALEKSANDR RODCHENKO:
INNOVATION AND EXPERIMENT

Introduction

Magdalena Dabrowski

The work of Aleksandr Rodchenko represents a high point in the evolution of Russian Constructivism, its innovative, experimental spirit, its versatility, and its incomparable creativity distinguishing it from that of other constituents of the Russian avant-garde movements that flourished during the first two decades of this century. Rodchenko's oeuvre encompasses a remarkable diversity of mediums and fields of endeavor: painting, sculpture, drawing, collage, photomontage, graphics (in book and magazine covers, posters, and advertising), designs for furniture and other utilitarian objects, architectural projects, and photography. The broad range of his artistic expression is only matched by its exceptionally high quality.

The great achievements in Rodchenko's artistic development fall within the Constructivist period, running from the end of the 1910s through the 1920s. Not only did he contribute to the development of Constructivism on a formal, creative level but his theoretical ideas helped shape the movement's discourse and the practices of its younger generation. In this artistic philosophy's early stages, Rodchenko was a driving force behind the formulation of its principal concepts and its search for novel solutions. The formal and ideological transmutations at the different stages of his own work reflected radical changes in the make-up and understanding of the Constructivist doctrine.

Rodchenko's evolution from an aspiring artist in the provincial city of Kazan, where his knowledge of new art came mainly from the art magazines available at the house of a local collector, to one of the most important members of the avant-garde was the result of his remarkable multifaceted talent and his desire always to reach higher, to experiment, to reach out to the future and to create the new world, the new man, the new art. In his determination to achieve this he first developed new modes of expression in easel painting, then abandoned painting to create novel three-dimensional constructions, then finally turned to a range of artistic activities of much broader social appeal and accessibility. He was an innovator in book design and a pioneer in photomontage, combining newsprint and photographic reproduction in seamless composite wholes. The posters and advertising materials that he designed are exceptional in their expressive power and their simple but unusual compositions. In search of a medium compatible with modern times, Rodchenko turned to photography, producing spectacular images. His designs for utilitarian objects, furniture, and architecture all expressed his vision of the modern society. All of these inventions evolved against the background of his strong idealistic involvement with the cultural, social, and political goals of the new Soviet state.

In 1935, after that state had curtailed artists' freedom of expression, relegating even the most talented of the avant-garde to the social and economic margins, Rodchenko

Rodchenko in Moscow in 1916.

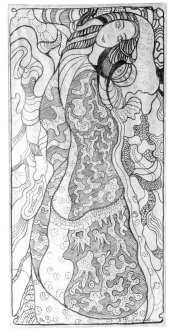

1.

2.

1. Aleksandr Rodchenko. *Figure in a Kimono (Figura v kimono)*. 1912–13. Ink on paper, 8⁹/₁₆ × 4⁵/₁₆" (21.7 × 11 cm). Whereabouts unknown.

2. Aubrey Beardsley. *The Peacock Skirt*, illustration for *Salomé: A Tragedy in One Act*, by Oscar Wilde (London: Elkin Mathews and John Lane, and Boston: Copeland and Day, 1894). Ink and graphite on paper, 9¹/₁₆ × 6⁵/₈" (23 × 16.8 cm). The Fogg Art Museum, Harvard University Art Museums, Bequest of Grenville Winthrop.

took up painting again. Attempting to stay in the mainstream, he not only created abstract works but even returned to figuration, the dominant, officially sanctioned mode of artistic expression supported by the state. And until his death, in 1956, he continued to produce excellent advertising and book designs as well as films and photographs, the latter in particular becoming his favored means of expression. The legacy of his innovations in all of these domains remained alive among younger generations of artists.

The Early Years

When Rodchenko decided to become an artist, he had had virtually no exposure to or background in art. Born in 1891 in Saint Petersburg, his father a landless peasant who had become a caretaker at a theater, his mother a washerwoman, in terms of culture he was exposed primarily to the world of the stage. (The family's apartment was in the building where his father worked.) He also developed a fondness for the circus, a popular and inexpensive mass entertainment. Rodchenko loved Saint Petersburg's canals and ships, an important feature of the city's scenery. Museum visits were not a part of his education. It was in the early 1900s, after his family moved to Kazan, the old Tartar city on the Volga some fifteen hundred miles east of Saint Petersburg, that he determined to study art.

In the autumn of 1910, having completed his elementary education by 1905 and after working in the interim as a dental technician, Rodchenko entered the Kazan School of Fine Arts (the Kazanskaia khudozhestvennaia shkola). He would graduate in the summer of 1914. His diaries and his letters to Varvara Stepanova, his future companion and wife, provide an illuminating account of his interests and activities during this period.[1] According to notes from 1912, the young Rodchenko was fascinated by Japanese prints, and by the art of Matisse, Gauguin, and, in Russia, Mikhail Vrubel and the World of Art (*Mir iskusstva*) artists. Reading—both poetry and prose, by writers such as Fyodor Dostoevsky, Paul Geraldi, and Oscar Wilde—and visits to the public library were among his favorite pastimes. He also loved going to concerts, particularly to hear the music of Tchaikovsky, Wagner, Mozart, and Beethoven.

To this period also dates Rodchenko's acquaintance with the local collector whose art magazines he read, a lawyer named Nikolai N. Andreev, who in 1913 purchased a small oil of his on the theme of the carnival. Through the magazines he found at Andreev's house and at the library, as well as through Andreev's collection, which included works by Georgii Yakulov and other contemporaneous Russian artists such as Nikolai Sapunov and Nikolai Krymov, Rodchenko acquired a broader knowledge of artistic trends in Russia and in the West. Among the Western artists who caught his interest was the English Symbolist Aubrey Beardsley, whose influence soon became apparent in his work.[2] With its sinuous line, profusion of pattern, and bold use of large, flat areas of color, *Figure in a Kimono* (*Figura v kimono*, 1912–13; fig. 1) clearly recalls Beardsley's stylizations (fig. 2). The paintings of these early years, such as *Portrait of*

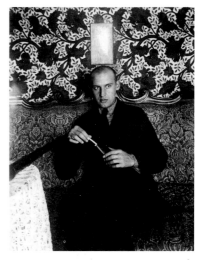

Rusakov (*Portret Rusakova*, 1912), showing a fellow student of Rodchenko's at the Kazan School of Fine Arts, are competent but undistinguished, emphasizing heavy impasto and stark color contrasts.

Photographs of Rodchenko from these years, it has been pointed out, suggest that before his move to Moscow he was more of an aesthete than an anarchist or a revolutionary (fig. 3).[3] Quite removed from the flourishing new art movements in Moscow and Saint Petersburg, which dramatically changed the Russian art scene at the beginning of the century (particularly after the abortive revolution of 1905), he nevertheless seems to have had a fair knowledge of them. Groups such as the Symbolist-oriented Blue Rose (*Golubaia rosa*), the Cézanne-ist Jack of Diamonds (*Bubnovyi valet*), and the more avant-garde Donkey's Tail (*Oslinnyi khvost*) all actively exhibited new art, creating an atmosphere of ferment and of revolt against the established canons.[4] Beginning in 1912, Cubism and its relation to Russian art were hotly debated by progressive artists such as Natalia Gontcharova, Mikhail Larionov, David Burliuk, and others. The independence of Russian art from Western influences and its relationship to the Eastern (Byzantine) tradition were strongly emphasized, and Russian Futurism was firmly established.[5]

When a series of debates on these topics held in Moscow (in February 1912) and Saint Petersburg (the following November) proved extremely popular, their organizers—Burliuk and the writers Vasilii Kamenskii and Vladimir Mayakovsky—decided to tour seventeen southeastern Russian provinces in order to disseminate the tenets of Russian Futurism.[6] Rodchenko attended a lecture and performance of theirs in Kazan, on February 20, 1914; affected by the three men's behavior as much as by the content of their presentations, he was completely converted to Futurism.[7] (Rodchenko was especially impressed by Mayakovsky, who read some of his own Futurist poetry.) As a result, the artist's painting took a new course, away from the stylizations of Symbolism, Beardsley's English Aestheticism, and the World of Art artists. The costume designs he executed for Oscar Wilde's play *The Duchess of Padua* in 1914 show simplified forms, with an emphasis on linear and semicircular shapes; seemingly combining formal elements present in the work of Umberto Boccioni, Giacomo Balla, and Fernand Léger, they indicate the artist's knowledge of both Cubism and Futurism (fig. 4). In *Two Figures* (*Dve figury*, plate 1), an oil of c. 1916, the influences of these two schools are integrated with that of Rayonism, as exemplified in Larionov's *Woman Walking on the Boulevard* (*Promenade. Vénus de boulevard*, 1912; fig. 5). The flat semicircular forms are highlighted in bright, mostly unmodulated color, creating a counterpoint to figuration and introducing a still partially illusionistic Cubo-Futurist space. A slightly earlier painting, probably from late 1915, entitled *The Dancer* (*Tanets*, fig. 6), elaborates the issues of fragmented dynamic forms in semi-illusionistic space; probably Rodchenko's most Futurist painting, it bears affinities to works by Boccioni and Gino Severini, whose paintings—*Dynamic Hieroglyphic of the Bal Tabarin* (1912, fig. 7), for example—he might have known through

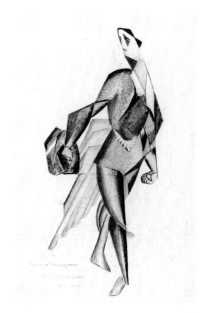

3. Rodchenko in a Kazan art collector's apartment, 1915.

4. Aleksandr Rodchenko. Costume design for the play *The Duchess of Padua*, by Oscar Wilde. 1914. Tempera and varnish on paper, 12⅝ × 7⅞" (32 × 20 cm). A. Rodchenko and V. Stepanova Archive, Moscow.

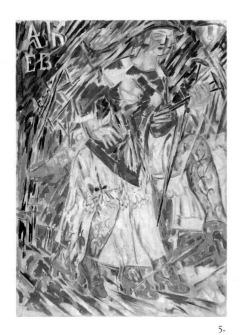

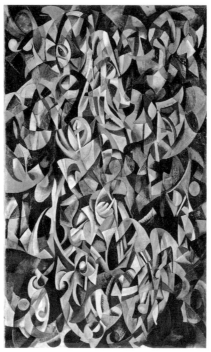

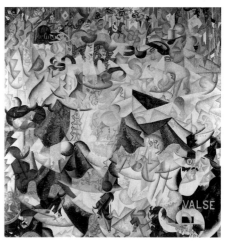

5.

6.

7.

art magazines or from information provided by Stepanova, then already living in Moscow.[8]

Rodchenko's interest in figuration would soon be displaced by his experiments with purely pictorial elements such as surface qualities and the interaction of line and color. These come to the fore in a series of twelve non-objective compass-and-ruler drawings from 1915, which emphasize the expressive possibilities of mechanically created line and its relationship to flat areas of color or of "noncolors" such as black. The series might be considered a "next step" growing out of the fragmented forms in *The Dancer*, discarding that painting's semi-illusionistic space. The progression is clearly evident in a compass-and-ruler drawing (plate 3) in which circular lines create white and black shapes reminiscent of those in *The Dancer*, even while the interplay of the white and black areas creates a dynamic effect, an ambivalent interchange of positive and negative forms and spaces. It was a selection from this compass-and-ruler series that marked Rodchenko's entrance into the Moscow art world at the exhibition *The Store* (*Magazin*), organized by Vladimir Tatlin in March 1916.[9] By that time Rodchenko had moved to Moscow (judging from his correspondence with Stepanova, he did so sometime in the fall of 1915[10]), and his meeting with Tatlin and participation in *The Store* put him at the very heart of the avant-garde.

Tatlin was already well-known as the creator of a new expressive idiom: his three-dimensional painterly reliefs and counter-reliefs,[11] innovative assemblages of randomly found, everyday industrial materials, the inherent qualities of which dictated the works' forms (fig. 8). Begun sometime during the winter of 1913–14, these works were planar structures assembled initially within the pictorial plane and then on the wall—or, rather, in front of it, since their multiple surface planes actually sat a little out from it, incorporating the space of the viewer as an active component of their form and a crucial

element of the perceptual process that they required. The ideas for these works came both from Cubism and from native Russian sources (icons, for example). After exhibiting them in his studio in a four-day private showing in May of 1914,[12] Tatlin had presented them to the general public in the exhibition *The Last Futurist Exhibition of Paintings: 0:10* (*Posledniaia futuristicheskaia vystavka kartin: 0, 10 [nol'-desiat']*), held in December 1915 at the Dobychina gallery in Petrograd (as Saint Petersburg was called at the time).[13] This show had clearly marked the beginning of a new direction in art.

Tatlin's contribution to *0:10* had been countered by that of Kasimir Malevich, who showed work in his new, non-objective, geometric idiom, Suprematism, for the first time in this exhibition.[14] Whether or not Rodchenko saw that work on this occasion is unclear, but it would seem that he did not; he was not living in Petrograd at the time, and neither he nor Stepanova discuss visiting *0:10* in their writings. Rodchenko does mention meeting Malevich on the occasion of *The Store*, which included no Suprematist art.[15] The influences of both Tatlin and Malevich, however, would later appear in Rodchenko's work, albeit in a personal, assimilated form.

Rodchenko's own innovative spirit came significantly to the fore for the first time in a commission he executed with Tatlin, Yakulov, Nadezhda Udal'tsova, and Ivan Bruni for the Café Pittoresque, Moscow, in 1917, shortly before the outbreak of the October Revolution (plates 5–8). The commission was actually awarded to Yakulov, by the café's founder, Nikolai Filipov (the owner of most of the city's bakeries); Rodchenko, by his own account, prepared working drawings of ideas and details that Yakulov had drawn in sketch form, and he was also assigned some of his own design projects.[16] Rodchenko's drawings for lamps for the café are based on interplaying geometric shapes, and indicate that his inspirations of the moment were both Tatlin and Malevich: designs such as that in plate 6 clearly attest to his familiarity with Tatlin's reliefs and counter-reliefs, while concepts apparent in plate 7 bring to mind the free-floating planes of Malevich's Suprematism. At the same time, however, Rodchenko's compositions are distinctly individual, and certainly without precedent in interior decoration. This can be considered his first involvement with utilitarian design, a field that would begin to become increasingly important to him at the end of 1921.

From his early years as an artist, Rodchenko was interested in more than merely formal artistic explorations; he was preoccupied with the idea of an art for the future. This became particularly important after his move to Moscow and his entry into the circle of the avant-garde. As he writes in his memoirs, he felt far less close to the aesthetes of the World of Art group, with their bourgeois tastes, than to artists who were neglected by the collectors and attacked in the newspapers, artists such as Malevich, Tatlin, Mayakovsky, and Velimir Khlebnikov, artists whose work subverted the established aesthetic canons, tastes, and values—artists like him.[17] "We were for the new world," he wrote, "the world of industry, technology and science. We were for the new man; we felt him but did not imagine him clearly. . . . We created a new understanding

8.

8. Vladimir Tatlin. *Corner Counter-Relief* (*Uglovoi kontr-rel'ef*; detail). 1914–15. Iron, copper, wood, and rope, $27^{15}/_{16} \times 46^{7}/_{16}$" ($71 \times 118$ cm). State Russian Museum, Saint Petersburg.

of beauty, and enlarged the concept of art. And at that time such battle—I believe—was not a mistake."[18] This battle had barely begun by October of 1917, when the artists' "leftist" ideas were joined to the ideals of the Revolution.

The October Revolution and Its Aftermath

The year of 1917 was the most important year in Russian history in the first half of this century, bringing fundamental changes that had a permanent effect on Russian society and government. It witnessed first the February Revolution—which was based in the bourgeoisie, established a democratic provisional government, and forced the abdication of the tsar—and then the Revolution of October 25, which was based in the proletariat and brought Lenin and the Bolsheviks to power. As Rodchenko points out in his memoirs, "leftist" artists were the first to join forces with the Bolsheviks. After long debate, they came to see in this alliance the greatest opportunity they would have for involvement in the creation of the new world, the new man, and the new art.[19]

Rodchenko had considered himself a leftist artist since his early years in Kazan—although, as he points out in his writings, his leftist tendencies were at that point embodied in his admiration for such nonacademic artists as Vrubel and Gauguin.[20] Later, after his move to Moscow and his encounter with the avant-garde, his leftist tendencies broadened beyond the subversion of aesthetic traditions and became more politicized. At the beginning of the summer in that same year of 1917, in fact, together with Tatlin and others in the avant-garde, he had organized a professional union of artists, Profsoiuz.[21] This was composed of three federations: "Young," "Center," and "Senior," or, as they were also often called, "left," "center," and "right." The Young, or left, federation included Futurists, Cubists, Suprematists, and non-objectivists; the Center organized the artists of groups such as the World of Art, much of the Union of Russian Artists (*Soiuz russkikh khudozhnikov*), the Jack of Diamonds, and the Donkey's Tail; and the right embraced more conservative artists from the Union of Russian Artists as well as the Wanderers (*Peredvizhniki*), a group of realist painters. These different federations professed radically varying goals, and only the artists of the Young or leftist one saw themselves as prophets of the future.

Also in 1917 (probably in March or May), Rodchenko had a one-man show at the Young Federation's club in Moscow, summing up his achievements since 1910. It accordingly included work from his years as a student in Kazan through a time when, as a result of the October Revolution, his artistic production diminished and his political involvement increased. The exhibition was advertised by a poster that he himself designed (plate 9); using different typefaces and an irregular compositional structure, this poster foreshadowed his future activities as a graphic designer during the 1920s and '30s.

The period immediately following the October Revolution was turbulent yet exciting for the avant-garde, and particularly for Nathan Altman, Malevich, Mayakovsky,

Rodchenko, Stepanova, and Tatlin. These artists vacillated between their desire for creative independence of government intervention and their determination to create for the masses, influence popular taste, and formulate an art that would effectively allow them an active participation in formulating the aesthetic policies of the new state. During these tumultuous months, the official organ established by the state to steer cultural policy was Narkompros, or the People's Commissariat for Enlightenment, headed by Anatoly Lunacharsky. Within Narkompros was Izo (Otdel izobrazitel'nykh iskusstv), the Section of Visual Arts, over which the most dedicated and politically engaged artists were given de facto control, making them the leading voices in the establishment of new art institutions such as Inкhuк (the Institute of Artistic Culture, founded in 1920); the organization of an art program, state exhibitions, and art schools; and the creation of a network of museums to collect and display progressive art and disseminate a radical modernist program. The latter task, in fact, was the primary goal of Izo and Inкhuк.[22] For this brief moment, the avant-garde effectively had the power to impose its precepts and artistic vision. Initiatives such as Lenin's Plan for Monumental Propaganda, begun in 1918, also attracted progressive artists such as Tatlin and Rodchenko, allowing them to implement their creative ideas.

Rodchenko's personal, formal researches were momentarily overshadowed by his political preoccupations during this period, but subsequently reemerged and remained the stronger concern for several years to come. In his diaries for 1918, he wrote, "I have begun to paint again. I am painting on a black matte background—and white and shiny black. I also started a small long board with four circles."[23] The entry could describe several works and groups of works that he would paint in the forthcoming years. His activities at this point were moving in several directions: painting, drawing, and sculpture, or, more accurately, the design of three-dimensional constructions.

Some of these pictures, be they drawings or paintings, still show a stylistic dependence on the influences of Tatlin and Malevich, apparent, for instance, in *Composition* (*Kompozitsiia*, 1918; plate 10). Here free-floating color planes, akin to those in Malevich's Suprematist works, are assembled into a configuration of overlapping elements structured according to the principles of Tatlin's reliefs. (Semicircular linear sections also recall Rodchenko's own compass-and-ruler works of 1915.) This dependence on Tatlin and Malevich would soon give way, however, to compositions that investigated the new pictorial syntax by separating color from form, assigning to each its independent existence, and by introducing light as a component of form. Earlier on, multiple planes had interacted within one composition; now they are both separated and limited in number, so that the compositions become more minimal, more sober. They often consist of two interlocking, almost identical forms, such as the triangles in *Non-Objective Composition no. 53* (*Bespredmetnaia kompozitsiia n. 53*, 1918; plate 14) and *Non-Objective Composition* (*Bespredmetnaia kompozitsiia*, 1918; plate 15). Executed on small narrow boards, these works, with their economical use of form and color against neutral white

backgrounds, nevertheless project a considerable sense of monumentality. Yet even as the forms seem solidly anchored, their overlaps and the way they are modeled give them a sense of dynamic interaction. This latter quality is enhanced by the slight irregularities of the triangular forms, and by their mottled colors and variegated textures.

Besides focusing on pictorial syntax in these works, Rodchenko was also exploring such attributes of painting as "surface-plane" (*ploskost'*), a term relating to the primary characteristics of the pictorial support, such as its height and breadth.[24] The surface-plane concept, a quintessential preoccupation of the Russian avant-garde in their attempt to create a new pictorial language, affirmed the existence of the picture as a two-dimensional object devoid of any illusion of depth. Artists as diverse as Larionov, in his Rayonist style, Burliuk, in his Cubo-Futurist work, and Malevich, in his Cubo-Futurist and especially his Suprematist paintings, were addressing this innate attribute of painting. Malevich in particular emphasized the importance of the plane as the fundamental element of non-objective creation—a universal means of expression. In his painting from 1918 on, Rodchenko too would make the investigation of this concept a crucial task, a project that would culminate in 1921 in his paintings of three pure colors: red, yellow, and blue (plate 54).

Integrally connected to the concept of surface-plane was a second idea that had preoccupied the Russian avant-garde since 1912: that of *faktura*, or the treatment of the painting's surface.[25] As the critic and theoretician Nikolai Tarabukin pointed out in his essay "For the Theory of Painting" (*Opyt teorii zhivopisi*), written in 1916 (although not published until 1923), *faktura* plays a paramount role in conveying meaning in non-objective painting;[26] the character of the pictorial surface—that is, its texture—generates an expressive power, and as such contains within itself a potential for the transmutation of form. As the Russian avant-garde explored the expressive possibilities of paint, in which they were interested as a "real" material—a "*matière*," material and physical, rather than a medium of illusion—*faktura* became a crucial principle in both creating and appreciating painting. Decisions as to whether the paint was to be thick, glossy, smooth, or matte could help to determine the picture's expressive quality and affect the viewer's perception of it. The combination of color with different textures could also play a role. The significance of *faktura* as a perceptual agent increased with Tatlin's introduction, in 1914, of a parallel concept in three-dimensional work, namely that of a "culture of materials," a theory, building on Cubist inventions, that assigned to each material its own form-creating ability. According to this principle, the inherent qualities of any material generated an optimal form for it: wood, for instance, was to be used as flat shapes; iron could be applied in flat sheets or formed into conical or cylindrical elements; glass too could produce both flat shapes and conical, cylindrical, or semicircular forms. Every material also revealed itself as the paradigm of a specific texture inherent in its nature, and presenting different options of *faktura* depending on the surface treatment.

In the West, meanwhile, the Cubists' recent invention of collage had opened up new possibilities of altering the pictorial surface through the unconventional addition of nonpainterly materials. This development only further focused Russian artists' attention on the condition and expressiveness of the pictorial surface. For Rodchenko, a conflation of these concepts offered new avenues of experiment. He developed them in different series of paintings, such as the works with white forms against black backgrounds (plates 17 and 18), the famous "Black on Black" series of 1918 (plates 19 and 20), and the "Concentration of Color" series of 1918–20 (plates 30 and 31), as well as subsequently in his innovative photomontages of the 1920s.

The Serial Principle

From this point on a practice of serial experiment with different aspects and nuances of the same fundamental premise, altering relationships between given components from work to work in order to discover the essence of a specific pictorial concept, began to dominate Rodchenko's creative path. As if returning to the idea that had informed his compass-and-ruler drawings of 1915, he applied the principle of seriality to both his two-dimensional and his three-dimensional work, arriving at new solutions both visually and conceptually.

The works in which Rodchenko explored the separation of color from form are also explorations of movement and space. In *Composition no. 71 (Flying Form)* (*Kompozitsiia n. 71 [Letiashchaia forma]*, 1918; plate 17), a white form, a luminescence moving through space, evokes an illusory pictorial depth. As this slightly convex shape slides across the black background, there is a clear indication of sequential movement and the suggestion of a deep spatial recession. The strangely defined form moves from lower left to upper right, as a stream of light would travel through cosmic space. This investigation is taken a step farther in a work of 1919, *Composition no. 86 (66) (Density and Weight)* (*Kompozitsiia n. 86 [66] [Plotnost' i ves]*, plate 18), which examines the effects of a circular motion of forms within an illusory pictorial depth. Controlling this sense of movement, and of the movement's speed, are the density and weight of the colors and forms, which create a whirlpool sensation within the dark center of a semi-circular white shape that seems to orbit the central part of the painting. They also indicate another trajectory of light, from the center toward the upper right. Works like this one indicate Rodchenko's awareness of the theories of the fourth dimension that were circulating during these years; broadly discussed among avant-garde artists, they were extensively incorporated into the work of Malevich. It is known that Rodchenko owned a copy of S. H. Hinton's work on the subject, *The Fourth Dimension and the New Era of Thought*, a text that was at the core of Malevich's interest in it also, through the medium of Pavel D. Uspensky's *Tertium Organum*.[27]

The density and weight of color were considered vital elements affecting the viewer's sense of the movement of pictorial masses: they gave these masses their physi-

cality, and defined their location within an unstructured compositional space. Further research into such physical attributes of painting, and into the dynamic relationships among those attributes, appears in Rodchenko's "Black on Black" series (plates 19–21), in all of which the artist investigates mutations of the same structural problem: how to organize interlocking circular and parabolic or elliptical elements, colored in a close range of blacks, in the most economical way, yet at the same time in the most expressive one. He also explores the inherent potentials of *faktura* in this series. The differing textures of individual elements; the interplay of these textures, and of the forms to which they are applied; the play of light on them—all these result in transformations of the surfaces and expressive qualities of Rodchenko's paintings. Differences in texture, for example, set some forms in greater relief, while others seem to act as the stronger forms' "shadows," or even to dissolve into the background. The content of the paintings becomes the dynamic interaction of basic geometric forms in closely valued hues against a uniformly colored pictorial surface. The works bear no relation to any traditional mimetic or narrative values, and their highly reductive pictorial vocabulary manifests the ultimate radicalism of Rodchenko's innovations.

These experiments further show Rodchenko's interest in discovering new pictorial options through both technical transformations of the painting's surface and the creation of dynamic spatial effects by solely pictorial means. In the process he examines the properties of color, in its absolute as well as its relative values—that is, both the fundamental characteristics of a color and those of its different shades. Aleksandr Lavrent'ev has suggested that Rodchenko's "Black on Black" paintings represent his response to Malevich's famous *Black Square* (*Chernyi kvadrat*), which had been prominently displayed in the *0:10* exhibition back in 1915 (fig. 9) and had been much discussed since then by the avant-garde.[28] As Malevich began the non-objective phase in painting, so Rodchenko responded to the dialectic of non-objectivity.[29] In fact, however, Rodchenko was responding not only to the iconic image and meaning of *Black Square* but also to Malevich's quintessential statement on the absolute in art, which he attempted to achieve in his most reductivist work, *White on White* (*Beloe na belom*) of 1918 (fig. 10). The "Black on Black" works counter Malevich's icon of spirituality with symbols of nothingness.

When this group of eight paintings was first shown, in the *10th State Exhibition: Non-Objective Creation and Suprematism* (*10aia gosudarstvennaia vystavka: Bespredmetnoe tvorchestvo i Suprematizm*) in Moscow in April 1919, they hung alongside five white paintings by Malevich. Stepanova comments on this in her diary entry for April 10:

> Finally our exhibition of "non-objectivists and Suprematists" is almost ready. . . .
> Malevich exhibited 5 white paintings, Anti [i.e., Rodchenko]—black ones. Of
> course, Malevich did not discover anything. He painted a white square on a
> white background, it is not even painted, it is simply colored. Obviously Anti

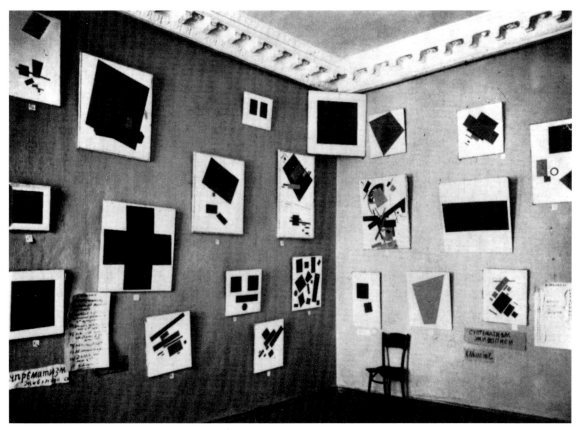

9.

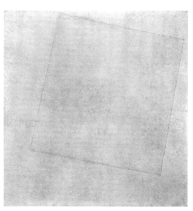

10.

beats him in painting and in faktura *and even if he as yet did not outdistance*
Malevich he became a figure of importance with whom one has to count.[30]

She also clarifies further why Rodchenko's black paintings have to be considered so
exceptional an achievement:

> *Where his black works are winning is in the fact that they have no color, they are*
> *strong through painting, they are not clouded by any extraneous elements, not*
> *even color. It is obvious that his black paintings are actually the rage of the*
> *season. With them he has shown what* faktura *is . . . what the next step in paint-*
> *ing after Suprematism is . . . what a professional achievement is . . . a model for*
> *a new type of easel painting.*[31]

Stepanova, probably like Rodchenko himself, saw the black paintings as the way
out of the colors of Suprematism—as the destruction of Malevich's *Black Square* and
also of his "white" conception of the absolute. She also saw these works as a new form of
painting that would make that art form as such more profound, more self-absorbed. The
main emphasis here is on painting as "a new interesting *faktura*, and exclusively painting,
i.e. no 'coloring' but use of the most unyielding color, black."[32] Clearly the impact of the
faktura is recognized as resulting from the absence of color. Rodchenko had realized that
the same *faktura* used in the black works would have had a diametrically different effect
in color, which would have distracted from its power. Color was a purely decorative ele-
ment. "In the 'black' works," Stepanova writes,

> *nothing besides painting exists. That is why their* faktura *is so immensely*
> *enhanced. . . . Those shining, matte, muddy, uneven, and smooth parts of the*

9. View of *0:10* exhibition, Moscow,
1915, with, in the corner, Kasimir
Malevich's *Black Square* (*Chernyi*
kvadrat), 1915.

10. Kasimir Malevich. *White on White*
(*Beloe na belom*). 1918. Oil on canvas,
31¼ × 31¼" (79.4 × 79.4 cm). The
Museum of Modern Art, New York.

surface result in an extraordinarily powerful composition. They are so effectively painted that they are in no way inferior to color.[33]

In the black paintings, then, black is divested of its function as color and becomes subsumed into the element that engenders new meaning—the *faktura* or surface treatment, the material substance identified with the parameters of the picture plane.

In addition, a crucial new aspect comes to the fore, namely the concept of professionalism of execution. Objective elements displace subjective judgment as criteria of the work's artistic value; in fact they become vital components in the viewer's process of evaluation. The physicality of the painting as an object, and the physicality of the execution, become the new criteria in the appreciation of the work of art. Material itself—in this case paint—and the method of its application influence the perception of the object. This unprecedented approach to the painting as an object in itself marks a major development in Rodchenko's art, and indeed a crucial innovation in the history of the avant-garde. It also represented their utopian conception of the aesthetic needs of the new mass viewer.

The black paintings, as Stepanova notes in that same diary entry of April 10, 1919, were received with great enthusiasm, and gained Rodchenko a place among the leaders of the avant-garde. To be sure, his experiments were situated within a more general context of interest in *faktura*, not only in painting but also in the linguistic studies of the Formalist school, led by Roman Jakobson and Viktor Shklovsky. These writers believed in the importance of *faktura* as the fundamental feature of all the arts. As Hubertus Gassner points out, Shklovsky argued in his article "On Faktura and Counter-Reliefs" (*O fakture i kontr-rel'efakh*), of 1920 (published in *Zhizn' Iskusstva*, on September 20, 1923), that "*faktura* is the main distinguishing feature of the particular world, especially constructed things, which in their entirety we call art. . . . The work of the artist-poet and the artist-painter ultimately aims at creating a permanent object that is tangible in all its details, a *faktura* object."[34]

This emphasis on the tangible and material object grew up as a consequence of, and in opposition to, the spiritual values of Suprematism and the earlier ideals of Symbolism. When Malevich had painted his *Black Square*, in 1915, it had been seen as a harbinger of the new art and society that the Russian avant-garde so ardently sought to create in the years after the unsuccessful revolution of 1905. By 1918, however, when Rodchenko created his black paintings, the Malevich work appeared irrelevant and idealistic. Its aspirations and metaphysical symbolism seemed distinctly removed from the reality that was emerging in the wake of the revolution of February 1917, not to speak of that of the following October. The ideals of what the new society and new man would become had changed radically from those of the early years of the avant-garde. Now art negated the individual's creative impulse, emphasizing instead an objective, nonphilosophical, nonidealistic stance. The important task for artists became their contribution to the collective effort of building a society in which the individual was to be subsumed

for the collective good, advancing the condition of the masses and working quite prag-
matically, perhaps in concert with government-appointed cultural institutions.[35]

The negative quality of Rodchenko's radical rejection of color has also been viewed
as related to his anarchist sympathies.[36] Anarchist tendencies—represented, for instance,
by Mayakovsky and Tatlin, and by the members of the Freedom for Art Federation
(*Federatsia khudozhnikov "Svoboda iskusstvu"*) and the Moscow Association of Anarchist
Groups (*Moskovskaia assotsiatsiia anarkhistov*)—were quite popular in Russia after the
February Revolution, until they began to be suppressed by the Cheka (the state security
apparatus) in April 1918.[37] The anarchist press reviewed exhibitions by both Tatlin and
Rodchenko, and on April 2, 1918, it was an anarchist journal, *Anarkhiia*, that published
Rodchenko's article "The Dynamism of the Plane" (*Dinamizm ploskosti*), which elabo-
rated his theories on the relationships of shapes and colors.[38] Rodchenko was attracted
by the writings of the anarchist writer Max Stirner, whom he quoted in his text for the
catalogue of the *10th State Exhibition*,[39] and he is known to have been involved in the
Moscow Association of Anarchist Groups. Furthermore, since the color black was a
symbol of anarchism (analogously to the way red symbolized communism), and had
been used as such by Russian artists to express anarchist views since the middle of the
nineteenth century, Rodchenko's black paintings can be seen not only as a challenge to
the pictorial tradition that preceded him but also, in a certain way, as a continuation of
an anarchist tradition.[40]

In this sense, and in view of the period's heated debates over the appropriate form
and function of art and artists in post-Revolutionary society, and over the role of the
state in the organization of art and art institutions, Rodchenko's defiant gesture can also
be interpreted as a political statement. The sympathies of the leftist artists—Tatlin,
Mayakovsky, Burliuk, Kamenskii, Aleksei Morgunov, and Rodchenko himself—were
close to the anarchist position that art should be separated from state control. The black
paintings, then, can be considered expressions of Rodchenko's anarchist attitude in the
politics of art, staking out a nihilistic position in opposition to official art policies and
the state's involvement in art. Avant-garde artists like Rodchenko only gradually became
involved with state art institutions such as Izo Narkompros. Once they had, though,
they placed their talent unstintingly at the service of the administration, creating art
intended both to appeal to the masses and to propagate the objectives and goals of the
new system.

The catalogue for the *10th State Exhibition* includes a statement, "Rodchenko's
System" (*Sistema Rodchenko*), that explains the artist's views. It opens with a series of
quotations from Stirner, Aleksei Kruchenykh, the turn-of-the-century Viennese writer
Otto Weininger, and Walt Whitman, of which those by Stirner and Kruchenykh in
particular seem to touch directly on Rodchenko's understanding of the significance of
the black paintings; Stirner's "At the basis of my cause I have placed nothing" and
Kruchenykh's "Colors disappear—everything merges into black" sound like succinct

apologias for the principles that Rodchenko put into practice in these works.[41] The black paintings were his conscious attempts at creating a new world of form and meaning compatible with the new reality. His awareness of this historical necessity is expressed in the final paragraphs of "Rodchenko's System":

> The motive power is not synthesis but invention (analysis). Painting is the body,
> creativity the spirit. My business is to create something new from painting. . . .
> I am the inventor of new discoveries in painting.[42]

In Rodchenko's view his black paintings marked the end of all previous "isms" in art. (He was particularly addressing himself to Suprematism, the anathema for the new type of painting.) They opened up a new road for artistic creation, and a fresh—conscious, rational—attitude for the artist to maintain toward the artwork. The serial principle that Rodchenko employed in the black paintings validated his conviction that it lay within the artist's powers to discover, within the greatest economy of pictorial means, alternative ways of painting.

The First Spatial Constructions

Rodchenko's first forays into abstract sculpture also came in 1918, when he created a series of six "spatial constructions," or, as he often referred to them, "white sculptures." Although the works themselves are no longer extant, sketches for them survive in one of his notebooks (plate 51, top row).[43] These sketches are inscribed with various numbers, presumably indicating the sculptures' sizes, and with words describing the material to be used: plywood. Two of the sculptures (numbers five and six, figs. 11 and 12) were included in the *10th State Exhibition*, and are listed in the catalogue under the heading "Works of the second half of 1918."[44] In their structural principles they recall the artist's lamp designs for the Café Pittoresque in 1917: fundamentally unlike any modeled sculptural form, they are composed of flat, two-dimensional elements that use a series of pivots to relate circular, semicircular, and linear components to one another, creating coherent spatial forms.

Despite this use of planar components, the sculptures are also distinct from Tatlin's reliefs and counter-reliefs (fig. 13)—essentially planar spatial structures assembling various elements in different materials, and hence in different shapes, on the wall. Although projecting into the spectator's space, and incorporating space as an active agent in their form, Tatlin's constructions were still to be viewed frontally, from a single viewpoint. Rodchenko's constructions, on the other hand, were unquestionably to be experienced in the round; they encompassed real space and interacted with it. Rodchenko himself pointed this out in notes written in 1922:

> In the first place they signified the abandonment of painting for the move
> toward real space. Tatlin had not yet made up his mind to take this step and
> had constructed counter-reliefs which were still attached to the walls and like
> paintings could not be looked at from all sides.[45]

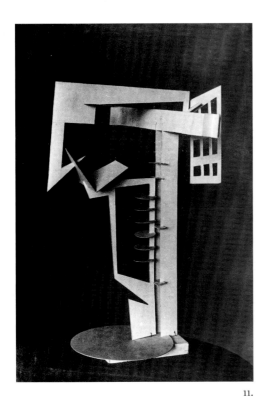

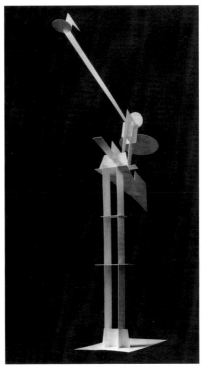

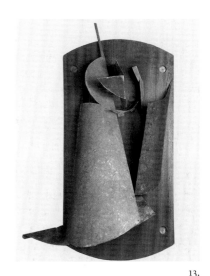

11. 12. 13.

Tatlin would in fact take that step only a year later, in his famous project for the *Monument to the Third International*—the so-called Tatlin's Tower, essentially a monumental spatial construction à la Rodchenko.[46]

Like the black paintings before them, Rodchenko's new inventions not only signified a formal innovation, this time in three dimensions, but marked a new beginning, a new idiom that he believed uniquely suited to and compatible with modern times. As black symbolized the abandonment of painting, the "noncolor" marking its change of status from image into an object, so the white sculptures signaled the starting point for a new, "real" kind of three-dimensional object—an object made of mundane materials, not modeled, not representational or mimetic, but to be understood instead through its structure and through the skill of the artist's execution. Founded on a systematic pursuit of solutions to problems arising from the manipulation of geometric forms in space, these works illustrate Rodchenko's researches into a new grammar, a new philosophy, of art, and also a beginning of his "leap into space." He focused on two aspects, amplified in his statement for the catalogue of the *10th State Exhibition*: the "motion of projected planes" and the "isolation of color from form." Even while the structural perfection of the white sculptures gave them a certain static equilibrium, they cut dynamically through space, as various geometric shapes cantilevered out from each construction's vertical axis, creating a multitude of unexpected spatial relationships. The serial principle applied here attests to Rodchenko's systematic probing of the problems of dynamic forms in space. Meanwhile the "isolation of color from form" involved the use of white, another "noncolor," as the only hue, inexpressive and neutral.

The structural principles of the white sculptures reappear in Rodchenko's designs of 1918 and shortly after for actual utilitarian constructions, including his projects for

11. Aleksandr Rodchenko. *Spatial Construction no. 5 (Prostranstvennaia konstruktsiia n. 5)*. 1918. Cardboard, 13⅜ × 14¾ × 18⅛" (34 × 37.5 × 46 cm). No longer extant.

12. Aleksandr Rodchenko. *Spatial Construction no. 6 (Prostranstvennaia konstruktsiia n. 6)*. 1918. Cardboard, 27⁹⁄₁₆ × 19¹¹⁄₁₆ × 5⁵⁄₁₆" (70 × 50 × 13.5 cm). No longer extant.

13. Vladimir Tatlin. *Selection of Materials (Counter-Relief) (Podbor materialov [Kontr-rel'ef])*. 1917. Varnished mahogany, rosewood, pine, and galvanized roofing tin, 39⅜ × 25³⁄₁₆ × 9⁷⁄₁₆" (100 × 64 × 24 cm). State Tretyakov Gallery, Moscow.

newspaper kiosks (plates 11 and 12) and architectural proposals such as his plan for Sovdep (the Soviet of Deputies building, plate 28). And at the same time that he was producing these objects, in the second half of 1918, he was also beginning the "Concentration of Color" (*Kontsentratsiia tsveta*) series, including works such as *Composition no. 60* (*Kompozitsiia n. 60*, plate 30), mentioned in the catalogue of the *10th State Exhibition*. These works explore the pictorial options that result from creating form and visual impact through the expressive effects of deeply saturated color. Malevich had moved from *Black Square*—the herald of Suprematism—to colored Suprematism and then to the absolute of white Suprematism; Rodchenko made a similar transition, in an almost analogous yet distinctly personal way. The issue of concentrated color, which had preoccupied him since the beginning of 1918, culminated that year in two series of works at the opposite ends of the artistic spectrum: the black paintings and the white sculptures, both of them embodiments of his original, innovative spirit, his interest in serialism, interrelations of form and space, and the transition from surface to space marking the beginning of the inventions to come.

The Line

One of the quintessential attributes of pictorial expression has always been the line. Probably the most primal and the most direct of the visual artist's means of expression, line is the basis of all drawing, and can act as a stand-in for a brushstroke or for the edge of a plane. In the art of Rodchenko's time, whether it be Cubism or Futurism, it is line that provides the armature for the pictorial structure, and for the relationships among such other agents as color and space. Rodchenko, in his researches into the dissociation of color from form, arrived at an isolation of line as an independent feature of the work of art. That process led him to evolve a new system, "Linearism" (*Liniizm*), the basic premises of which are illustrated in a small drawing of the same title from 1920 (plate 33) and explicated in a text that he prepared for presentation at Инхук.[47] Lavrent'ev points out that as early as the end of 1919, Rodchenko wrote,

> LINEARISM *is a new tendency in non-objective creation. The surface plane is, logically, being discarded, and in order to express a stronger constructive and architectural quality in compositions—since there appears to be no further need for it—that old favorite of painting,* faktura, *is being discarded too.*[48]

It was only between the *10th State Exhibition*, in April 1919, and the *19th State Exhibition* (*19aia gosudarstvennaia vystavka*), in October 1920, however, that Rodchenko evolved his linear works, fifty-seven of which were included in the latter show.

In this new phase, Rodchenko replaced the interest in *faktura* so manifest in the black paintings, and also the interest in surface-plane, with an emphasis on line as an autonomous means of expression. His interest in line as a principal structural agent of two-dimensional composition can be traced back to his compass-and-ruler drawings of 1915 (plates 2–4), but there he still used color, albeit monochrome, as a complementary

compositional device to help convey spatial illusion. Now, in 1919–20, he grew interested in line as the essence of painting. It has been noted that Rodchenko's interest in line may have been inspired by Vasily Kandinsky's investigations of the subject, as expressed, for example in his article "On the Line" (*O linii*), published in the magazine *Iskusstvo* on February 22, 1919.[49] Rodchenko was in close contact with Kandinsky (for over a year in 1919–20, he even lived in Kandinsky's apartment during the older artist's absence), and is likely to have been familiar with this essay; moreover, although there are differences between his and Kandinsky's conceptions of the meaning and role of line, one also notices certain affinities in their views. Many other avant-garde artists of the time, however, were also engaged by this subject; in 1920–21, for instance, Lyubov Popova would create powerful, innovative compositions by exploring the use of line (fig. 14).[50]

Notes in Rodchenko's workbook of 1919 indicate that his investigations of line came into focus between March and October of that year. His theoretical essay on the subject[51]—actually his first text intended for publication—is dated 1921; clearly related to discussions on the subject of "composition versus construction" then taking place among the members of Inkhuk, it represents a pivotal point in the development of Russian Constructivism.[52] But Rodchenko's experiments with line as the fundamental element of non-objective art preceded his theoretical statement and provided the basis for it. The practical investigation of this pictorial component conditioned the artist's theoretical position on the subject.

Discarding form and color as nonessential aspects of painting, Rodchenko emphasized the importance of real materials in the creation of nonrepresentational art, ascribing the primary function to the surface. The liberation of the surface from the nonessentials of form and color affected the picture's structure, producing new organizing principles and resulting in the creation of an artwork that was an autonomous entity. Another effect of this process was the emergence of line as a vital pictorial element. Rodchenko underlines this very strongly:

> *Continuing to work in this field, the absolute value of line emerged, as a primary element in the construction of anything whatsoever. The functionality of line depended on the different phases of construction. On the one hand, line is the entire construction taken as a whole. . . . it defines its characteristic system— in this case line is the carcass, the skeleton, the relationship between different planes. On the other, it fixes the kinetic moments of the construction of an organism used as a unitary whole made up of individual parts, and in this case line is the path ahead, movement, collision, conjunction, break and continuation.*[53]

As one analyzes this statement it becomes evident that Rodchenko considers line a universal pictorial factor that can engender various meanings within the structure of the work of art. An objective tool in the artist's hand, line has an infinite potential for creating structure. Used objectively, it can eliminate the subjective aspect of creation,

14.

14. Lyubov Popova. *Space-Force Construction (Prostranstvenno-silovoe postroenie)*. 1921. Oil with marble dust on plywood, 27⅞ × 25⅛" (71 × 63.9 cm). Art Co. Ltd. (The George Costakis Collection).

especially when devices such as rulers or compasses are employed to produce it. Line has an unlimited ability to convey dynamic quality and to "enter" into the environment, extending the form it produces into space. Attitudes like these demonstrate Rodchenko's focus on the materiality of the picture's structural components, and on the material construction itself—two of the essential tenets of Constructivism.

In notes from 1921, Rodchenko clearly states that he executed his first linear works in 1919 and showed them in 1920 (at the *19th State Exhibition*). None of the artists who saw them there considered the works to be paintings at the time, and yet, he feels, many of these artists soon began imitating him.[54] Executed within ten months of the "Black on Black" paintings, these works—exemplified by *Construction no. 92 (on Green)* (*Konstruktsiia n. 92 [na zelenom]*, plate 32), *Construction no. 89 (on Light Yellow)* (*Konstruktsiia n. 89 [na svetlo-zheltom]*, plate 34), and *Construction no. 90 (on White)* (*Konstruktsiia n. 90 [na belom]*, plate 35)—are composed of dynamically interacting lines, generally in simple, rigorous configurations. At this point Rodchenko was primarily investigating the compositional options offered by the straight line (curving lines would follow later). In *Construction no. 89 (on Light Yellow)*, multiple short straight lines of differing length fan out across the pictorial surface, their starting points spaced from upper right to lower right. They are intersected by a sharp diagonal, which cuts through them from the lower left corner to the upper right. The spectator is faced with a dynamic configuration of elemental forms that seem to rotate in space along the diagonal axis. On the other hand, these forms leave no doubt that they are firmly grounded in the pictorial surface. This dichotomy creates a perceptual tension, and foreshadows Rodchenko's future leap from surface to space, from two to three dimensions, with line as the catalyst.

Construction no. 90 (on White) explores this dichotomy in a remarkably economical way, deploying parallel straight lines of the same thickness in two groupings positioned at a sharp angle to each other and creating a grid at the center right of the picture plane. The tension of this dynamic interaction is heightened by the interplay of the deep blue lines against the smooth white background. One feels as if this linear structure were sliding through space, or were suspended in it. A greater spatial complexity emanates from *Construction no. 92 (on Green)*, in which groups of white and black lines in parallel configurations are disposed throughout the surface in different directions and intersect at multiple points, again creating the effect of a linear construction suspended in space. Rodchenko reaffirms these goals in his essay of 1921, placing an extraordinary emphasis on line's autonomy and expressive capabilities:

> *Only the line, then, tells us what has happened, since without making use of material and excluding physical phenomena, it is the element that defines us, in the form that we see. It gives us the image of what is growing out from the construction as a whole, or at different stages in this construction, and of any other type of movement. Conceived in this way, the line has stripped away the importance of spots of color and shade, an atavism of the nonfigurative painting that is*

concerned with naturalistic themes. Line has brought about an alteration in our way of seeing the surface of the picture, changing the concept of shape represented solely by an area of color. It has altered our perception of area by defining its precise qualities.[55]

The shift from the works highlighting *faktura* or color and form to those based uniquely on line can be equated with a transition from the sensuous to the cerebral. A restrained, cerebral quality is also apparent in another group of canvases from 1920, including *Construction no. 127 (Two Circles)* (*Konstruktsiia n. 127 [Dva kruga]*, plate 36), *Construction no. 126 (Line)* (*Konstruktsiia n. 126 [Liniia]*, plate 38), and *Construction no. 128 (Line)* (*Konstruktsiia n. 128 [Liniia]*, plate 37). All of these place the utmost emphasis on reduction. Exercising the greatest restraint in the use of line, Rodchenko creates powerful iconic images that forcibly engage the spectator in intellectual discourse. Economy of line is paralleled by economy of color: white line stands against black background as a hallmark of constructive function and rationalism. Personal or gestural marks are completely eliminated, stressing the absence of conventional style. Line becomes a universal, almost mathematical symbol, totally objective and scientific.

As the "Black on Black" paintings were intended to defy Malevich, so these works seem to defy Kandinsky, with his theories about line's expressive possibilities. In the political arena Rodchenko was later to displace Kandinsky in the structure of Inкhuк, enabling him to substitute his own objective and rational principles for the older artist's "subjective" program. Within three years of Rodchenko's first public presentation of his own stylistically independent works, then, he had introduced pictorial and conceptual innovations that faced down the challenges posed by the work of the two stalwarts of non-objective art. The oeuvres of Malevich and Kandinsky, each from opposite ends of the spectrum of non-objective art, had subverted existing pictorial traditions; by rejecting the premises of non-objective painting and moving toward a greater reductivism, Rodchenko thwarted those traditions even farther. In doing so he set the stage for his next transitions—first into real space and subsequently into utilitarian art.

The World of "Constructions"

Rodchenko's investigations into line as a structural "material" coincided with his membership in a group known by the acronym Zhivskul'ptarkh, or "Collective of painterly, sculptural, and architectural synthesis." This association, founded in November 1919, included artists working in all three of the aesthetic domains listed in its name,[56] and it stimulated Rodchenko's interest in architecture and architectural design. The first projects he executed for the group were the designs for newspaper kiosks (plates 11 and 12), their structures looking back to the drawings and paintings of 1918 that were built up of numerous overlapping planes (plate 10). They also paralleled Gustav Klucis's projects for "Radio-Announcers" (fig. 15), structures of movable platforms held together by cables and incorporating loudspeakers for broadcasting political speeches and information, to

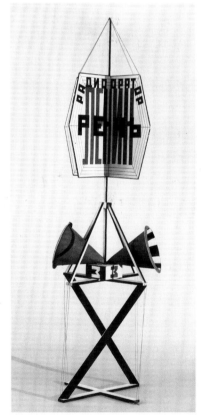

15.

15. Gustav Klucis. Maquette for *Radio-Announcer* (*Radio-orator*). 1922. Construction of painted cardboard, paper, wood, thread, and metal brads, 41¾ × 14½ × 14½" (106.1 × 36.8 × 36.8 cm). The Museum of Modern Art, New York. Sidney and Harriet Janis Collection Fund.

be set in the streets as tools for communicating the Communist credo to the proletariat.[57] Like Klucis and other members of the avant-garde, Rodchenko became actively involved in the task of organizing a new, modern, Communist future for the masses. By its nature and purpose, architecture constitutes a direct tool for exercising such influence and forming public taste.

As architecture, the structures Rodchenko imagines in these drawings are "futuristic" and inventive. At the same time, as demonstrated by a striking architectural drawing of 1919 (plate 26) and another of 1920 (plate 27), both for the "City with Observatory" series, they have a linear quality that acted as a catalyst for the emergence of the artist's "Linearism" system and for his interest in three-dimensional structures in real space. These works would find their three-dimensional counterparts in Rodchenko's experimental freestanding structures of 1921, built of identically sized wooden parts assembled into complex geometric forms (figs. 16 and 17). The structures were based on a systemic principle not dissimilar from that applied in the "Black on Black" *faktura* paintings: a basic element (the wooden part), of a given length and size, served as a recombinant module in generating diverse geometric configurations and acting in space as line acts on the picture surface.

The use of straight lines, or, in the freestanding works, of repetitions of the same, basic, linear three-dimensional element, however, did not fully address the issue of the dynamics of form. For that, Rodchenko eventually began to experiment with combinations of straight and circular lines, creating in 1920 a series of drawings and paintings based on this principle. To make these linear constructions (plates 43–45), and the painting *Construction no. 106 (on Black)* (*Konstruktsiia n. 106 [na chernom]*, plate 46), he used mechanical devices (a compass and ruler), deploying objective, reductivist means to produce a series of studies of the spatial relationships among forms based on the line and the circle. As in earlier linear works on black grounds (plate 36), the organization of the elements derives from the manipulation of mechanical devices. This essentially eliminates the notion of style. Although decisions as to the placement and number of the mechanically drawn forms still remain with the artist to make, all other subjective elements are absent.

The works become stereometric studies. Interacting tensely and dynamically, lines and circles intersect to produce composite forms that seem to imply volume and defy the laws of gravity, hanging suspended in unstructured abstract spaces. The logical conclusion of these works, then, was the extension of such forms into real space. This Rodchenko achieved in a new series of geometric, kinetic spatial constructions suspended from the ceiling, which he first exhibited in the *Second Spring* exhibition of the Обмоkhu (the Society of Young Artists) (*Vtoraia vesenniaia vystavka Обмоkhu [Obshchestvo molodykh khudozhnikov]*) in Moscow in May 1921 (fig. 18).

Conceptually simple but visually and structurally complex, these constructions, of which only one survives—*Spatial Construction no. 12* (*Prostranstvennaia konstruktsiia*

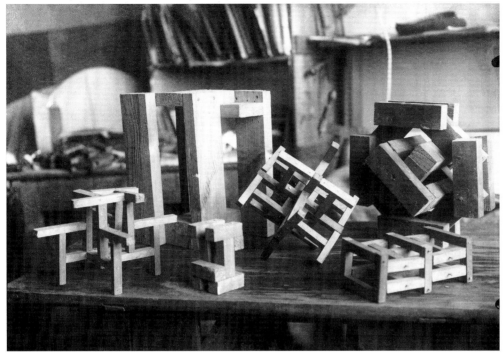

16.

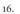

17.

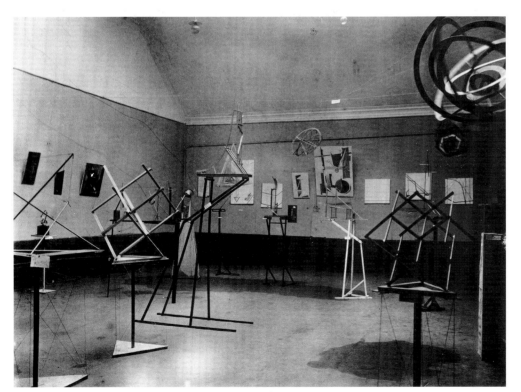

18.

16. Rodchenko's wooden standing constructions, c. 1921. Photograph: Rodchenko, 1924.

17. Aleksandr Rodchenko. *Spatial Construction no. 15 (Prostranstvennaia konstruktsiia n. 15)*. 1921. Wood, 14⁹/₁₆ × 12³/₈ × 9¹/₁₆" (37 × 31.5 × 23 cm). No longer extant.

18. View of the *Second Spring Exhibition of the Обмоκhu [Society of Young Artists]* (*Vtoraia vesenniaia vystavka Обмоκhu [Obshchestvo molodykh khudozhnikov]*), Moscow, 1921.

19.

19. Rodchenko standing before dis-
mantled hanging constructions, 1922.
Photograph: M. Kaufman.

n. 12, c. 1920; plate 53)—transposed Rodchenko's two-dimensional linear drawings into
the third dimension. A drawing from the artist's notebook (plate 51) shows sketches for
all of the works in the series. All six were geometric shapes: an oval, a circle, a triangle, a
square, a hexagon, and an octagon. Rodchenko executed them in thin sheets of plywood,
composing each of them as a series of forms inscribed one within the other, identical in
shape but graduating downward in size, and cut out at intervals of about half an inch.
Their surfaces were thinly painted silver, to reflect light. When flat, each of them made a
two-dimensional form, and they are clearly visible as such in a famous photograph of
Rodchenko in his studio, wearing a Constructivist outfit made by Stepanova (fig. 19).
They could, however, be opened up into space by fanning the layers apart. (The geo-
metric shapes within each geometric shape all rotated along the same axis.) Thus real
space became an integral part of the constructed form.

Other elements also played roles in these works: they didn't always hang still, simple gravity giving them a twist of kinetic movement. Their shadows on wall or ceiling similarly complemented the viewer's perceptual experience. Rodchenko's hanging constructions were unique in their conception. They literally embodied the artist's intention of producing three-dimensional forms by manipulating two-dimensional ones, overcoming the limitations of the flat format. They also proved that innovative solutions could be arrived at through skillful treatment of a single geometric form; and they demonstrated a new option for the creation of autonomous three-dimensional art, attesting to the possibility of defining concrete physical spaces without resorting to the traditional format of a volumetric modeled sculpture. In the bold creative thought that they reflect, these works stand as the ultimate achievement of the early stage—the so-called "laboratory period"—of Constructivism.

The End of Painting

Rodchenko's three-dimensional constructions emerged from the context of his activities and theoretical discussions at Inкhuк. The institute's main goal was the development of theoretical principles to support art's innovative modernist tendencies, and the establishment of an objective, scientific basis for art's creation. One of Inкhuк's founding members, Rodchenko was also among its most active practitioners and theoreticians. (The institute had in fact evolved out of Profsoiuz, the artists' union in whose creation he had been involved back in 1917.) He, Kandinsky, Viktor A. Shestakov, and Stepanova played active roles in formulating the organization's premises, and he was first its secretary, later one of its directors, contributing his ideas on the canons of the new art and on its most appropriate forms of expression and working methods.[58]

In his opinions on these subjects Rodchenko differed markedly from a number of Inкhuк's other members, including Kandinsky, head of its Section of Monumental Art and the originator of its initial program, which was eventually rejected, in part through Rodchenko's agency, as too subjective and conservative. In November of 1920 these disagreements within Inкhuк led to the formation of a study group, the General Working Group of Objective Analysis (*Obshchaia rabochaia gruppa ob'ektivnogo analiza*), which aimed to develop a materials-based approach, focused on the object and on technical experiments. This program would dominate Inкhuк thinking until the spring of 1921. The following March, further schism led to the formation of a second group, the First Working Group of Constructivists (*Pervaia rabochaia gruppa konstruktivistov*), which argued for a program emphasizing an objective method of artistic expression, devoid of the marks of the creator's individuality. It emphasized two directions: theoretical analysis of the basic components of a work of art—color, texture, material, and construction; and "laboratory work" on the practical applications of theoretical discoveries. The results of this research were the subject of general discussions, the most significant being those on the meaning of the terms "composition" and "construction." While numerous discor-

dant theories were presented, it was finally established that "composition" represented a more conventional, static method of creating a work of art, while "construction" was recognized as a dynamic way of creating a three-dimensional structure. Furthermore, the term "construction" was understood on two levels: as a descriptive process of creating a work of art, and as a three-dimensional work of art itself, devoid of volume and modeling and incorporating space as an active component of form. A crucial element in these discussions was the focus on "line"—the fundamental element of both composition and construction, and the catalyst in the transition from surface to space.

This program shaped the philosophy of Russian Constructivism, the language of which had begun to evolve as early as 1918. The movement finally emerged in 1921. Focusing on the two fundamental concepts of composition and construction, the First Working Group tried to find the most objective definition of construction and the most rational and systematic way of evaluating artistic creation. Its discussions guided the practices not only of Rodchenko, Stepanova, Popova, and the sculptor Aleksei Babichev but also of the younger generation represented by Обмокhu, which included such figures as Konstantin Medunetskii, Karel Ioganson, and the brothers Georgii and Vladimir Stenberg.[59] As the participants in these discussions presented their views, they illustrated them with corresponding drawings. Continuing through the spring of 1921, these debates provided the context for the transition from composition to construction as the most progressive and "leftist" means of artistic creation.

In September and October of 1921, Rodchenko, Alexandra Exter, Popova, Stepanova (working under the name "Varst"), and Aleksandr Vesnin co-organized a two-part Moscow exhibition, *5x5=25*, to mark a final gesture in the ethos of painting. As implied by the title, the five participants contributed five works each to each part. The exhibition was accompanied by a number of small handmade catalogues in which the participating artists announced their views on easel painting and outlined their artistic goals.[60]

To the first part, which focused on painting, Rodchenko contributed two linear compositions, one entitled *Line* (*Liniia*), the other *Grid* (*Kletka*), from 1920 and 1921 respectively. Bringing the total of his works to five were three monochromatic canvases dating from 1921: *Pure Red Color* (*Chistyi krasnyi tsvet*), *Pure Yellow Color* (*Chistyi zheltyi tsvet*), and *Pure Blue Color* (*Chistyi sinii tsvet*) (plate 54). The selection, then, reflected the two aspects of Rodchenko's investigations within the preceding three years, namely line and color. His statement in the catalogue highlighted what he felt were his most significant achievements:

> *1918*
>
> *At the exhibition of non-objective art and Suprematism in Moscow I for the first time announced spatial constructions; and in painting [I showed]* Black on Black.[61]

1920

At the 19th State Exhibition *I for the first time announced "line" as an element of construction.*

1921

In the present exhibition I for the first time announced three basic colors in art.[62]

In presenting these canvases, each reductive in its limitation to one color, Rodchenko established what he understood as the logical next step in the development of pictorial art. The works marked the final stage in the investigation of the traditional pictorial components of color and surface-plane: uniformly covered in a single flat color, devoid of texture, surface-plane became an end in itself. The message resembled an idea expressed almost four decades later by the American artist Frank Stella: "What you see is what you see."[63] The viewer was to focus on the physical parameters of the surface, admiring this styleless artistic object for the straightforward beauty of its shape and color.

Tarabukin clearly understood the radicalism of this move. In "The Last Painting Has Been Painted," a lecture he presented at Inкhuк on August 20, 1921, a few days before *5x5=25* opened,[64] he concluded that the "little canvas, almost square, entirely covered with solely red color" represented a significant, and final, step in the evolution of artistic forms that had taken place over the preceding ten years. Its monumental importance was its eloquent demonstration that painting had arrived at a dead end—had lost its content and its raison d'être, in fact had become *devoid* of content. Within the historical development of artistic form, however, these works were an epochal invention, both as a value in themselves and as a crucial step in the evolution of artistic expression. Tarabukin wrote,

> *This work is extremely significant for the evolution of artistic forms in the course of the last ten years. This is no longer a stage that can be followed by the new ones, but the last step, the final step taken at the end of a long path, the last word, following which the painting has to remain silent; the last "picture" executed by a painter. This painting demonstrates eloquently that painting as an art of representation—which it has been always until now—has arrived at the end of the road.*[65]

Rodchenko, himself, in his manuscript "Working with Mayakovsky," written in 1939, affirmed the gravity of his iconoclastic gesture in the three monochromes, stating,

> *I reduced painting to its logical conclusion and exhibited three canvases: red, blue and yellow. I affirmed: it's all over.*
>
> *Basic colors.*
>
> *Every plane is a plane and there is to be no representation.*[66]

This radical step, then, signaled the end of viable options for further innovation in painting.

The only remaining path for progressive leftist artists to follow was the extension into the utilitarian third dimension, into an art that would simultaneously reflect and shape contemporary life rather than being confined to the gallery or museum. As a result of ideological changes within Inкhuк in November 1921,[67] these artists came to subscribe to a more functional view of art and of the artist, who came to be seen as a worker in the service of the Revolution and the post-Revolutionary society. The Marxist leaning introduced by such ideologues as Aleksei Gan, Osip Brik, and Mayakovsky became a dominant direction, and the Productivist imperative of "art into life" gained increasing currency. The emphasis on Constructivist art's appeal to the mass consumer became a serious motivating force behind the innovations of Rodchenko and his peers. He responded to it in his teachings at the Metfak (Metalicheskii fakul'tet, the metal-working faculty) of the Vкhuтeмas school (Vysshie gosudarstvennye khudozhestvenno-tekhnicheskie masterskie, or Higher State Artistic-Technical Workshops), where his central preoccupation was to teach the younger generation of Constructivists the technical skills and methods of handling material and organizing visual data that would make the viewer aware of the environment. As such, Rodchenko's constructions defied their status as individual art objects and acquired an identity as communal property, serving the mass consumer. His design for a workers' club at the 1925 *Exposition Internationale des Arts Décoratifs et Industriels Modernes*, in Paris (plates 160–67), became a paradigm for his aspiration to influence the life of the masses and to contribute to a better, Communist future.

The goal of reconstructing everyday life prevailed among these artists throughout the 1920s, and was fostered by Narkompros, which for much of this period was headed by Lunacharsky, an enlightened commissar. After Lunacharsky left Narkompros, in 1929, the agenda continued into the early 1930s, until Stalin curtailed it in 1934. Rodchenko was an active participant in the attempts to change Soviet reality. Besides creating propagandistic and advertising art, graphic design of many kinds, documentary photography, and work in film and architecture, he actively participated in reorganizing the state's educational programs, pushing them toward more practical content and closer ties to technology. This he did through his work at Vкhuтeмas, the pedagogical institution that was to implement Inкhuк's ideas through its teaching program, its goal being to produce the new generation of artist engineers. Most of the Constructivist artists— Rodchenko, Tatlin, Popova, Stepanova, Vesnin—taught there, developing theoretical ideas and practical applications for them.

The Constructivist principles that Rodchenko developed during the early, "laboratory" period of his work continued to permeate his art, even as he tried to give his production a more clearly practical and visible social function. Formal devices such as the use of a diagonal to convey dynamism reappear in his photomontages, graphic design, and advertising, as well as in the dramatic oblique angles of his photographs. The early explorations of pictorial *faktura* are revived in his photomontages, in which diverse

materials are applied so as to create a texture that energizes the surface, for instance in his photocollages for the Mayakovsky book *About This* (*Pro eto*, 1923; plates 63–71). The principle of serialism, explored in the "Black on Black" paintings, the "white sculptures," the hanging constructions, and the freestanding constructions, returns in the photomontages, in the book designs, and especially in the photography. Although the mediums of expression changed in Rodchenko's later years, the fundamental concepts dominant in his early painting and constructions seem to have persisted and evolved.

In 1935, when Russian art strongly returned to the traditions of late-nineteenth-century realism (in part because forced or urged to by the state, and in part because figurative art was better suited to directly conveying an ideological message), Rodchenko took up painting again. His focus, however, was no longer non-objective art, rejected and dismissed as irrelevant in the new reality; although he still occasionally painted abstract paintings, he more often chose such subjects as the circus, clowns, and athletes, which reintroduced narrative content and a figurative idiom, and also must have brought back childhood memories.

In evaluating Rodchenko's legacy, both for the Russian avant-garde and for Western art more generally, we find the uniqueness, the incredible diversity, and the versatility of his talent coming to the fore with an overwhelming strength. He was the pivotal force behind the formation not only of the Constructivist doctrine but also of the school's practical artistic achievements. The richness of his artistic inventions, their experimental nature, and their impact on the work of younger generations in many areas of creativity, certainly including advertising, book design, and photography, continue to surprise us to this day. His art belongs among the most innovative and compelling chapters not only in the history of Russia's idealistic utopian experiment but in the evolution of the most progressive art of the twentieth century. Indeed his pursuit of an art that could equally satisfy political, social, and artistic ideals, while in the process helping to create a new society, remains a challenging model for many of the artists of today.

Notes

1. Rodchenko describes these in detail in his diaries; see Aleksandr Rodchenko, *Opyty dlia budushchego: dnevniki, stat'i, pis'ma, zapiski* (Experiments for the future: diaries, articles, letters, notes), ed. O. V. Mel'nikov and V. I. Shchennikov, compiled by A. N. Lavrent'ev and V. Rodchenko (Moscow: Grant', 1996), pp. 19–32, and *A. M. Rodchenko: Stat'i, vospominaniia, avtobiograficheskie zapiski, pis'ma*, ed. V. A. Rodchenko, E. Iu. Dutlova, and Lavrent'ev (Moscow: Sovetskii Khudozhnik, 1982), pp. 47–48. (An English translation of the former of these books has been commissioned by The Museum of Modern Art, from James West.)

2. There was a monograph on Aubrey Beardsley among the books in Rodchenko's library. These and other details illuminating Rodchenko's tastes and interests referred to in this section are described in Rodchenko, *A. M. Rodchenko: Stat'i*, pp. 47–78.

3. See David Elliott, "An Account Rendered," in *Alexander Rodchenko: Works on Paper 1914–1920* (London: Sotheby's, 1991), p. 9.

4. An in-depth description of the Russian artists' groups founded between the turn of the century and the beginning of World War I, in 1914, appears in V. M. Lobanov, *Khudozhestvennye gruppirovki za poslednie 25 let* (Moscow: Obshchestvo AKhR, 1930). See also John E. Bowlt, "Russian Exhibitions 1904–1922," *Form* no. 8 (September 1968): 4–13.

5. For a discussion of the artistic climate and debates of the time, see Vladimir Markov, *Russian Futurism: A History* (Berkeley: University of California Press, 1968), chapters 2, pp. 29–60, and 4, pp. 117–63. See also Benedikt Livschits, *L'Archer à un oeil et demi* (Lausanne: L'Age d'Homme, 1971), p. 88 ff. Published in English as *The One-and-a-Half-Eyed Archer*, ed. and trans. Bowlt (Newtonville, Mass.: Oriental Research Partners, 1977), pp. 72–92. On the influence of the Byzantine tradition on Russian avant-garde art see Margaret Betz, "The Icon and Russian Modernism," *Artforum* 15 no. 10 (Summer 1977): 38–45, and James H. Billington, *The Icon and the Axe: An Interpretive History of Russian Culture* (New York: Knopf, and London: Weidenfeld and Nicolson, 1966).

6. In Russia in the early years of the century, the term "Futurism" did not necessarily connote Italian Futurism or a style influenced by or resembling it. Instead the word applied generally to all avant-garde movements in art and literature. See Markov, *Russian Futurism*, and Lobanov, *Khudozhestvennye gruppirovki*.

7. Rodchenko describes that evening and his response to it in "Rabota s Maiakovskim," in Rodchenko, *Opyty dlia budushchego*, pp. 205–8. See also his "Is rukopisi 'Rabota s Maiakovskim'" in *A. M. Rodchenko: Stat'i*, pp. 53–54. A discussion of the evening can also be found in Elliott, "An Account Rendered," pp. 10–11.

8. Rodchenko's knowledge of Italian Futurism and other contemporary avant-garde movements can be inferred from his correspondence with Stepanova at the time. See Rodchenko, *Opyty dlia budushchego*, pp. 41–51, and Elliott, "An Account Rendered," p. 11.

9. The exhibition was named after its location, in an empty store at 17 Petrovka Street, Moscow, rented by the artists specifically for the purpose. The circumstances of Rodchenko's participation in the exhibition are described in Rodchenko, "O Tatline. 1915–17," in *A. M. Rodchenko: Stat'i*, pp. 83–84.

10. Rodchenko, "Rabota s Maiakovskim," pp. 204–6. Rodchenko also describes his meeting with Vladimir Tatlin in *A. M. Rodchenko: Stat'i*, pp. 83–87.

11. These compilations of materials, initially executed in a pictorial format—that is, their three-dimensional elements were set on a flat rectangular plane evoking the conventional support of painting—were called "assemblages of materials" or "painterly reliefs." Their structure suggests the influence of French collage—and, particularly, the open-form constructions of Pablo Picasso (the *Guitar* of 1913, for example, in the collection of The Museum of Modern Art)—as well as the indigenous influence of Russian icons. Tatlin saw reproductions of Picasso's collages and constructions in the November 15, 1913, issue of the French magazine *Soirées de Paris*, easily available in Russian avant-garde and collector circles. Visiting Paris in the spring of 1914, he saw actual three-

dimensional constructions by Picasso in the artist's studio. He also knew the Russian practice, popular since the sixteenth century, of applying gems and gold or silver incrustations to the gold or silver mounts in which an icon's painted image was set, creating a distinctly three-dimensional object. (He had himself painted icons as a young man.) He put these combined principles into practice in his relief constructions.

Tatlin's "painterly reliefs" were followed by "counter-reliefs" (so called because in entering the third dimension by adding elements rather than by subtracting unnecessary material, their construction process was the opposite of the method for creating a traditional relief). The later "corner counter-reliefs" were hung in a corner, fixed to the two walls to either side of them by tensile cables. Discussions of Tatlin's reliefs can be found in Sergei K. Isakov, "K Kontr-rel'efam Tatlina," *Novyi Zhurnal dlia Vsekh* no. 12 of 1915, pp. 46–50; Larissa A. Zhadova, ed., *Tatlin* (New York: Rizzoli International Publications, Inc., 1984); Margit Rowell, "Vladimir Tatlin: Form/Faktura," *October* no. 7 (Winter 1978): 83–108; Magdalena Dabrowski, *The Russian Contribution to Modernism: Construction as Realization of Innovative Aesthetic Concepts of the Russian Avant-Garde* (Ann Arbor: UMI Press, 1990), chapter 2, pp. 44–74; and Jürgen Harten, ed., *Vladimir Tatlin: Leben, Werk, Wirkung* (Cologne: DuMont Buchverlag, 1993), pp. 28–32, 117–125.

12. The exhibition, *Personal Exhibition of Synthetic-Static Compositions (First Exhibition of Painterly Reliefs)* (*Personalnaia vystavka sintezo-statichnykh compozitsii [Pervaia vystavka zhivopisnykh rel'efov]*), took place in Tatlin's studio at Ostozhenka 37 (apartment 3), Petrograd, from May 10 to 14, 1914, and was seen primarily by the artist's friends in the avant-garde.

13. To accompany his contribution to *0:10* Tatlin published a small brochure, *Vladimir Evgrafovich Tatlin* (Petrograd, 1915), describing his development and illustrating his new works: painterly reliefs and counter-reliefs. The brochure can be found in RGALI (Russkii Gosudarstvennyi Arkhiv Literatury i Iskusstva, the Russian State Archive for Literature and Art), Moscow, f. 2089; it is

reproduced in Troels Andersen, *Vladimir Tatlin*, exh. cat. (Stockholm: Moderna Museet, 1968), pp. 36–38. See also Zhadova, *Tatlin*, pp. 124–26.

14. For an in-depth discussion of the genesis and development of Suprematism, see Anna Leporskaia, Miroslav Lamac, Jiri Padrta, et al., *Kasimir Malewitsch zum 100. Geburtstag*, exh. cat. (Cologne: Galerie Gmurzynska, 1978), especially pp. 65–69, 134–231; Dmitri V. Sarabianov, "Kazimir Malevich and His Art, 1900–1930," in *Kazimir Malevich 1878–1935*, exh. cat. (Los Angeles: The Armand Hammer Museum of Art and Cultural Center, 1990), pp. 164–68; E. Kovtun, "The Beginning of Suprematism," *From Surface to Space*, exh. cat. (Cologne: Galerie Gmurzynska, 1974), pp. 32–47; and Sherwin W. Simmons, *Kasimir Malevich's "Black Square" and the Genesis of Suprematism 1907–1915* (New York and London: Garland Publications, 1989).

15. Rodchenko describes this meeting and the relationship between Tatlin and Kasimir Malevich in his diary, "O Tatline. 1915–17," pp. 84–85.

16. Rodchenko describes the circumstances surrounding this commission in "Is rukopisi 'Rabota s Maiakovskim.'" In the entry headed "1917," he writes, "Just before the outbreak of the October Revolution we were hired— with Tatlin—to work at the Café Pittoresque on Kuznetskii Most. The owner of this 'Pittoresque' was capitalist [Nikolai] Filipov. Filipov—that meant almost all the bakeries in Moscow. He evidently decided to design an original café and entrusted the task to Yakulov. Essentially, I don't know how it happened but Yakulov engaged me and Tatlin to work. We worked in this manner: I was working out sketches for the artists and large working details according to quick rough pencil sketches by Yakulov. Tatlin, [Nadezhda] Udal'tsova, and [Ivan] Bruni executed those sketches already in the café. I was given a room and began working." *A. M. Rodchenko: Stat'i*, p. 58. Trans. Dabrowski.

17. Ibid., p. 62.

18. Ibid.

19. Rodchenko describes the state of mind among the avant-garde artists in "Is rukopisi 'Rabota s Maiakovskim,'" pp. 53–82,

and "Rabota s Maiakovskim," *Opyty dlia budushchego*, pp. 211–24. See also Hubertus Gassner, "The Constructivists: Modernism on the Way to Modernization," in *The Great Utopia: The Russian and Soviet Avant-Garde 1915–1932*, exh. cat. (New York: Solomon R. Guggenheim Museum, 1992), pp. 298–319; Paul Wood, "The Politics of the Avant-Garde," in ibid., pp. 1–26; and Timothy E. O'Connor, *The Politics of Soviet Culture: Anatolii Lunacharskii* (Ann Arbor: UMI Press, 1983).

20. Rodchenko, *Opyty dlia budushchego*, p. 51. See also Gassner, "The Constructivists," p. 302.

21. The details of the creation of Profsoiuz are described in Rodchenko, *Opyty dlia budushchego*, p. 51, and Gassner, "The Constructivists," p. 302. Rodchenko's description of the federations also appears in "Is rukopisi 'Rabota s Maiakovskim,'" pp. 57–58.

22. The activities and policies of Narkompros, Izo, and Inкhuк receive a thorough analysis in Christina Lodder, *Russian Constructivism* (New York: Yale University Press, 1983), chapter 2, pp. 47–53, and chapter 3, pp. 73–108. See also Selim O. Khan-Magomedov, *Rodchenko: The Complete Work*, ed. Vieri Quilici, trans. Huw Evans (Cambridge, Mass.: The MIT Press, 1987), chapter 3, pp. 55–82, and chapter 4, pp. 83–115.

23. Rodchenko, "Avtobiograficheskie zapiski," in *A. M. Rodchenko: Stat'i*, p. 49. The specific work referred to is probably *Non-Objective Composition* (*Bespredmetnaia kompozitsiia*, 1918), in the collection of the State Russian Museum, Saint Petersburg (plate 13).

24. A primary source of the idea of "surface-plane" was an article by David Burliuk in the Futurist anthology *Poshchechina obshchestvennomu vkusu* (Moscow: Kuzmin and Dolinsky, 1912), pp. 95–101. Published in English in Bowlt, ed. and trans., *Russian Art of the Avant-Garde: Theory and Criticism, 1902–1934* (New York: The Viking Press, 1976), pp. 69–77. The article was signed "Nikolai Burliuk" (David's younger brother), but its argument was clearly David Burliuk's, since he expressed analogous opinions in his lecture "On Cubism," presented on February 12, 1912, at a debate organized by the Jack of Diamonds group in Moscow and subse-

quently at a second debate on November 12, 1912, organized by the Union of the Youth in Saint Petersburg. See Livschits, *L'Archer à un oeil et demi*, p. 88 (Eng. trans. pp. 78–87). Discussion of the "surface-plane" concept can also be found in Dabrowski, *The Russian Contribution to Modernism*, pp. 22–27.

25. The concept of *faktura*, like that of "surface-plane," first came into focus in an essay by David Burliuk: "Faktura," in *Poshchechina obshchestvennomu vkusu*, pp. 102–10. It was further developed by Vladimir Markov (Matvieys) in his pamphlet *Printsipy tvorchestva v plasticheskikh iskusstvakh, Faktura* (Saint Petersburg: Soiuz Molodezhi, 1914). A few years later the critic Nikolai Tarabukin emphasized the importance of the concept in his text *Opyt teorii zhivopisi*, written in 1916 and published in 1923. Published in French in A. B. Nakov, ed., *Nikolai Taraboukine: Le Dernier Tableau* (Paris: Éditions Champ Libre, 1972), pp. 117–24. See also Dabrowski, *The Russian Contribution to Modernism*, pp. 27–34.

26. See Tarabukin, *Opyt teorii zhivopisi*.

27. The theories of the fourth dimension are discussed in depth in Linda Dalrymple Henderson, *The Fourth Dimension and Non-Euclidean Geometry in Modern Art* (Princeton: at the University Press, 1983), chapter 5, pp. 238–94.

28. See Aleksandr Lavrent'ev, "On Priorities and Patents," in the present volume.

29. Malevich's presentation of *Black Square* and thirty-eight other non-objective Suprematist paintings in December 1915 in Petrograd was accompanied by a pamphlet, *From Cubism and Futurism to Suprematism. The New Realism in Painting*—an apologia for his newly evolved style and for the philosophy of Suprematism. Here Malevich delineates the fundamental premises of Suprematism. The pamphlet, distributed at the exhibition, was illustrated with two Suprematist paintings, *Black Square* and *Black Circle*. Published in English in Andersen, ed., *K. S. Malevich: Essays on Art 1915–1928*, vol. 1 (Copenhagen: Borgen, 1968), pp. 19–41.

30. Varvara Stepanova, *Chelovek ne mozhet zhit' bez chuda: Pis'ma, poeticheskie opyty, zapiski khudozhnitsy*, ed. O. V. Mel'nikov, compiled by V. Rodchenko and Lavrent'ev

(Moscow: lzd. "Sfera," 1994), p. 88.

31. Ibid.

32. Ibid. Quoted as translated in Gassner, "The Constructivists," p. 309.

33. Ibid.

34. See Gassner, "The Constructivists," p. 310.

35. A detailed discussion of various aspects of the ideology and political situation of this period appears in ibid., pp. 299–308.

36. See ibid. and Elliott, "An Account Rendered," p. 11.

37. Created in the winter of 1917–18 by Feliks Dzierzhinski, often referred to as a "terror merchant," the Cheka began to carry out raids on "undesirable elements" in April 1918, raiding several anarchist clubs, for example, on April 12. See Gassner, "The Constructivists," p. 303.

38. Many other artists published in *Anarkhiia*. Malevich, for instance, was a contributor between March and July of 1918.

39. See Rodchenko's preface to his catalogue statement in *10aia gosudarstvennaia vystavka: Bespredmetnoe tvorchestvo i Suprematizm*, exh. cat. (Moscow, 1919). Reprinted in I. Matsa, ed., *Sovetskoe iskusstvo za 15 let: Materialy i dokumentatsiia* (Moscow and Leningrad: Ogiz-Izogiz, 1933), p. 114.

40. See Gassner's discussion of anarchism in "The Constructivists," pp. 302–5, and Elliott, "An Account Rendered," pp. 13–14.

41. Quoted from Matsa, ed., *Sovetskoe iskusstvo*, p. 114.

42. Rodchenko, "Sistema Rodchenko," *10aia gosudarstvennaia vystavka*. Quoted here as translated in Bowlt, ed. and trans., *Russian Art of the Avant-Garde*, p. 150.

43. The notebooks are preserved in the A. Rodchenko and V. Stepanova Archive, Moscow. The pages with sketches of constructions are reproduced in Khan-Magomedov, *Rodchenko. The Complete Work*, pp. 36–37.

44. *10aia gosudarstvennaia vystavka*. See also a list of Rodchenko's exhibitions compiled by the artist's daughter, Varvara A. Rodchenko, in 1982, in the A. Rodchenko and V. Stepanova Archive.

45. See Khan-Magomedov, *Rodchenko: The Complete Work*, p. 38, note 2. Original manuscript in the A. Rodchenko and V. Stepanova Archive.

46. Tatlin was commissioned to create the *Monument to the Third International* in 1919, by Izo Narkompros. He completed his first model in 1920. The Third International was an international association of the Communist parties of different countries, and Tatlin's design, based on two upwardly rising spirals, embraces the utopian ideal of linking aesthetic form with functionality. The spiral forms (made of wood in the model, but intended to be metal) served as the supporting structure. They surrounded four stacked geometric shapes—from bottom to top, a cube, a pyramid, a cylinder, and a hemisphere—which, again in the model, were paper, but in the finished work were to be glass. Rotating rooms, these shapes were to symbolize different functions of the Soviet government and to house legislative assemblies, executive committees, and, at the top, an information center, complete with radio masts. Tatlin's tower immediately came to symbolize the Constructivist movement and its hope for a new revolutionary society. See Andersen, *Vladimir Tatlin*, pp. 7–8, 23–27, and 56–66; Lodder, *Russian Constructivism*, chapter 2, pp. 55–67; and N. Punin, *Pamiatnik Tretego Internatsionala* (Petrograd: Izo Narkompros, 1920).

47. The essay was to be published as a pamphlet by Inkhuk in 1922, but never appeared. See Khan-Magomedov, *Rodchenko: The Complete Work*, pp. 292–94.

48. See *A. M. Rodchenko: Stat'i*, p. 49. Quoted in Lavrent'ev, "What is Linearism?," *The Great Utopia*, p. 295. The original manuscript is in the A. Rodchenko and V. Stepanova Archive. The text appears in *Opyty dlia budushchego*, p. 78, from which the present author translated it.

49. Vasily Kandinsky, "On the Line," in Kenneth C. Lindsay and Peter Vergo, eds., *Kandinsky: Complete Writings on Art* (New York: Da Capo Press, 1994). German Karginov notes that Rodchenko must have read Kandinsky's article; see his *Rodchenko*, trans. Elisabeth Hoch (London: Thames and Hudson, 1979), p. 62.

50. See Dabrowski, *Liubov Popova*, exh. cat. (New York: The Museum of Modern Art, 1991), pp. 21–24, and Sarabianov and Natalia Adaskina, *Liubov Popova*, trans. Marian

Schwartz (New York: Harry N. Abrams, Inc., 1990), pp. 137–44.

51. See announcement in *Vestnik Iskusstva* no. 5 of 1922; also Khan-Magomedov, *Rodchenko: The Complete Work*, pp. 106, 110.

52. For detailed discussion of these debates see Khan-Magomedov, *Rodchenko: The Complete Work*, pp. 83–89; Lodder, *Russian Constructivism*, chapter 3, pp. 83–93; Khan-Magomedov, "Early Constructivism: From Representation to Construction," in *Art into Life: Russian Constructivism, 1914–1932*, exh. cat. for the Henry Art Gallery, University of Washington, Seattle, with an introduction by Richard Andrews and Milena Kalinovska (New York: Rizzoli International Publications, Inc., 1990), chapter 2, pp. 49–96; Lodder, "Constructivism and Productivism in the 1920s," in *Art into Life*, chapter 3, pp. 99–167; Angelica Rudenstine, *Russian Avant-Garde Art: The George Costakis Collection* (New York: Harry N. Abrams, Inc., 1981), pp. 110–27; and Dabrowski, *The Russian Contribution to Modernism*, chapter 3, pp. 75–92.

53. Rodchenko, in Khan-Magomedov, *Rodchenko: The Complete Work*, pp. 293–94.

54. *A. M. Rodchenko: Stat'i*, p. 51.

55. Rodchenko, in Khan-Magomedov, *Rodchenko: The Complete Work*, p. 294.

56. For information on Zhivskul'ptarkh, its activities, and Rodchenko's involvement in it, see Khan-Magomedov, *Rodchenko: The Complete Work*, pp. 45–54, and Lodder, *Russian Constructivism*, p. 60.

57. Gustav Klucis's "Radio-Announcer" constructions are discussed in depth in *Art into Life*, p. 104, and in L. Oginskaya, "Das Phantastische und die Realität in den Konstruktionen von Gustav Klucis," in Gassner and R. Nachtigäller, eds., *Gustav Klucis. Retrospektive* (Stuttgart: Verlag Gerd Hatje, 1991), pp. 99–130.

58. For details of Rodchenko's involvement with Inkhuk, see Lodder, *Russian Constructivism*, chapter 3, pp. 83–93; Khan-Magomedov, *Rodchenko: The Complete Work*, pp. 55–71; and Gassner, "The Constructivists," p. 312.

59. For discussion of Obmokhu see Lodder, *Russian Constructivism*, chapter 2, pp. 67–72; Khan-Magomedov, "Early Constructivism: From Representation to

Construction," pp. 49–96; and Nakov, *2 Stenberg 2: The Laboratory Period of Russian Constructivism*, exh. cat. (London: Annely Juda Fine Art, 1975), pp. 57–60.

60. Several copies of the catalogues survive, for example in the A. Rodchenko and V. Stepanova Archive; the Drawings Department of The Museum of Modern Art, New York; and the Getty Research Institute, Los Angeles. See plates 55–57.

61. The exhibition Rodchenko is referring to actually opened in January 1919. He probably chose to list it under "1918" since the works he mentions were executed in the second half of that year, as we know from other statements by him.

62. See *5x5=25: Vystavka zhivopisi*, exh. cat. (Moscow: Klub V.S.P., 1921), n.p. In the collection of The Museum of Modern Art, New York.

63. Frank Stella, quoted in Bruce Glaser, "Questions to Stella and Judd," ed. Lucy R. Lippard, *Art News* 65 no. 5 (September 1966): 59.

64. Tarabukin later included this lecture as a subchapter in his text *From the Easel to the Machine*, compiled in Moscow in March 1922 and published in 1923. See Nakov, ed., *Nikolai Taraboukine: Le Dernier Tableau*, pp. 40–41.

65. Tarabukin, "The Last Painting Has Been Painted," lecture presented at Инхук on August 20, 1921. In ibid., p. 64.

66. Manuscript in the A. Rodchenko and V. Stepanova Archive. For excerpts see *A. M. Rodchenko: Stat'i*, p. 61.

67. Lodder discusses the ideological changes in Инхук in her *Russian Constructivism* and her "Constructivism and Productivism in the 1920s," pp. 99–167.

Color is the fundamental element that gives power to the picture.
The line is the fundamental element of pictorial form.
Composition and texture are what reveals the picture itself.
—Aleksandr Rodchenko, 1920

Aleksandr Lavrent'ev

Avant-garde art of the early twentieth century comprised a number of distinct aesthetic conceptions—"isms"—that generally came with detailed textual underpinnings, often in the form of manifestoes. These texts could play important roles, advertising new movements, describing conceptual frameworks, and serving as statements of purpose. It was through their writings that Russian avant-gardists such as Kasimir Malevich, Vasily Kandinsky, and El Lissitzky created evaluative standards by which to judge new artistic movements. And textual apparatus was an especially important tool for Aleksandr Rodchenko, whose paintings, drawings, and constructions demand an understanding of the development of nineteenth- and twentieth-century pictorial culture if they are to be understood.

At the *19th State Exhibition* (*19aia gosudarstvennaia vystavka*) in Moscow in 1920, in fact, alongside his linear-themed paintings and graphic works, Rodchenko displayed an essay on the wall (opposite): "In each of my works," he wrote, "I do a new experiment, with a different valence from the one that came before it."[1] The scientific attitude invoked by the word "experiment" reappears in the manifesto's title: "Everything Is Experiment" (*Vse-opyty*). Indeed Rodchenko divided his work into separate elements, components, and tasks, which make sense to us only in reference to an overall plan: the application of the scientific method to art.

When we refer to principles in physics—the properties of electromagnetism, for example—we implicitly recall the series of experiments that revealed them. Every era has its tenets of accepted scientific wisdom, and also its experiments undermining those tenets. Every experiment represents a step in the history of knowledge. In the early twentieth century, the scientific idea of gradual progress in knowledge began to move over into art. It was especially influential for the "leftists" in the Russian avant-garde—the "non-objective" artists, of whom Rodchenko considered himself one.

Not all discoveries are alike. Artists' study of anatomy in the Renaissance, the invention of photography in the early nineteenth century—these are finds of a different order from the Impressionists' discovery of optical methods of blending color, or from the Cubists' discovery of geometry and of methods of representing objects and events from multiple viewpoints simultaneously. The latter are inventions of a formal and aesthetic kind—inventions of formal principles. Such innovations give birth not only to

Rodchenko's work installed with the text of his essay "Everything Is Experiment" (*Vse-opyty*) at the *19th State Exhibition* (*19aia gosudarstvennaia vystavka*), 1920.

51

their own, unrepeatable artistic worlds but to entire artistic movements. Rodchenko's experiments belong to this second order.

How did Rodchenko himself view the progress of nineteenth- and twentieth-century art? In June of 1920, when the Russian avant-garde's period of artistic experiment was at its height, he composed a system of classifications, a table listing different painting movements in the left-hand column, their achievements on the right. The basis of this table is the following formula: "The foundations of painting are line and color. The composition of the one and the texture of the other constitute painting's value."[2] For each of the movements he names, Rodchenko poses three basic questions: what that movement accomplished in terms of color, form, and texture. In the entries under color, for example, he characterizes Impressionism as "the superimposition of pure colors, but for the sake of creating a false impression of nature." Post-Impressionism is marked by "pure coloring," Cubism by "tone arising from the object's material conditions, contrasts, mass." In Suprematism, Rodchenko notes "purity of color independent of form," and in abstract art a "dissociation of color from form; free tone."

The comments on form are more detailed. Impressionism and Neo-Impressionism involve the "atomization of objective form." Post-Impressionism and Expressionism create "a grainlike resolution of form, planar resolution." Cubism is marked by "the intersection of objective forms and the construction from them of compositions not found in nature," Futurism by "displaced nature, the movement of objects," abstraction by "forms that are abstracted but indefinite in their formal composition (Kandinsky)." Orphism produces "forms that are non-objective yet piled up without composition ([Francis] Picabia, [Alexandra] Exter)." Suprematism shows "non-objective forms flying in space; canvases spread out for the sake of flatness; composition for the sake of filling the entire canvas (Malevich, [Olga] Rozanova, [Lyubov] Popova)."

For Rodchenko, the problem of form has been most thoroughly worked out in abstract art. Such art contains

> *non-objective forms laid down in keeping with content. Composition for the*
> *sake of composition. Constructions in space. Motion of the entire construction.*
> *Motion of the construction in its individual parts along a definite path. Precision*
> *of construction. Stasis within the composition itself and motion within it as a*
> *whole. Stasis in the whole and motion within. A new mode of being for form:*
> *unreal beings.*[3]

Constructivist art is the next stage in abstract art's development, and is distinguished by a predominance of linear forms. "The non-objective foundation of all forms," Rodchenko concludes, "is the line."[4] In this part of his inquiry, it is clear that he is exploring where he himself fits into the scheme—working out his own location, and the connections and differences between that location and the art preceding it. In describing

the formal accomplishments of abstract art, Rodchenko is speaking mostly of his own experiments.

The table's final section addresses the evolution of texture, which Rodchenko considers no less important than composition as a field of innovation. He calls Realism "the modeling of nature with paint"; Impressionism is "dabbing"; Neo-Impressionism is "pointillism, dots"; and Expressionism involves "a wide-brush technique." On Cubism Rodchenko writes, "Texture of different materials, conveyed by brush and by other painter's instruments (imitating wood, stone, cork, glass, iron), imitation through imitation of materials. The introduction and affixing of the materials themselves in order to attain depth, contrast, mass. Work with the material itself and its color value ([Georges] Braque, [Pablo] Picasso, [Nadezhda] Udal'tsova, [Vladimir] Tatlin)." He characterizes Suprematism as "simple coloring of surfaces. The absence of any texture and painterliness. Poverty of expression (Malevich, [Ivan] Kliun, Rozanova)." Once again, as in the section on color, Rodchenko reserves his most detailed description for abstract art, which entails "the precise working over of surfaces, the hammering-in of pigment, rubbing in, smoothing out. Careful application of tones. The introduction of mechanical instruments (compass, ruler, stencil, roller, needle, press). Whence: density, sharpness, precision. The introduction of fluidity, the use of combinations, different techniques of priming."[5]

Few artists before Rodchenko had created such a detailed classification of the various types of painted surface, and of the methods associated with them. But Russia's non-objective artists, and Rodchenko in particular, paid careful attention to execution; Rodchenko left no room for accidental meanderings of paint, or for any sort of incompletion in any part of the canvas. Every section of every form has not only a certain formal or compositional import but also a characteristic texture. This gives the work a tactile quality, widening its effect on the viewer.

The textures of Rodchenko's work attracted the notice of his fellow painters. At one exhibition, Marc Chagall told him, "You should show us your kitchen."[6] At the *10th State Exhibition* (*10aia gosudarstvennaia vystavka*) in 1919, Udal'tsova asked if she could take one of his "Black on Black" paintings, featuring a variety of differently worked surfaces, down from the wall and feel its texture with her fingers. Rodchenko in turn paid attention to his contemporaries and colleagues, mentioning a number of them in his table alongside well-known French painters of the nineteenth and twentieth centuries. He believed that new artistic discoveries should be recognized at the moment of their appearance, rather than having to wait for the slow train of history. In 1918 he had published an article, "Luminaries, Patrons, Innovators" (*Svetila, metsenaty, novatory*), proclaiming in bold terms the need to support living artists:

> Live in the present, bow down to the living idols, creators, geniuses, inventors!
> Give the living the chance to create calmly—support them!
> Give life to the living and death to the dead.

Old coins, beer-bottle labels, stamps, and powder compacts clutter up your single-family homes, while we, the bearers of new ideas, will still be stockpiling our seditious artistic inventions under creaky beds to be speculated upon by the aesthete-collectors of the future.[7]

This was the era of the creation of the Young Federation within Profsoiuz (the artists' union), a time when the upcoming generation of leftist artists, of which Rodchenko was a member, was banding together to organize itself democratically as a labor force. Rodchenko believed that the October Revolution of 1917 would touch even the world of contemporary art, and that leftist art would be in demand. Seeing interest in work like his as objectively inevitable, he at this point gave little thought to his audience. Following the motto "Create and do what is new, through and through,"[8] he had little concern for what others would think or say. At the same time, he knew that later scholars would study the art of his time, classifying, systematizing, and evaluating it, and, certainly, finding links between even its boldest gambits and earlier art history. Rodchenko understood the interdependence of past and present, that each is manifest within the other, and he taunted the artists who resisted his innovations:

Let those who have already been recognized and canonized curse us!

Let them excommunicate us from the Church of Tried-and-True Painting. Let them call us Barbarians and "non-painters." Because afterward—I wish to comfort the timid—art historians will explain everything. They will propound their justifying theories, their systems, their psychological explanations. They will recognize and acknowledge [our] commonality with ancient culture. (Seek, after all, and ye shall find.)[9]

Rodchenko similarly, like many other avant-gardists, related to the art critics of his time with decided reserve. As a rule, these writers did not take abstract art seriously; they lacked not only the criteria to evaluate it but the conceptual foundation that would allow such criteria to be articulated. (This kind of critical language, or professionalized set of standards, did not predate the work but arose concurrently with it, and was therefore as unfamiliar and disorienting as the work itself.) It was not uncommon at the time to believe that non-objective art was limited in its repertoire, that its essence was an all-too-exhaustible set of geometric compositional conventions and processes of texture and tone. This may help to explain the aggressiveness and combativeness of Rodchenko's texts. It may also explain why he tried to record the steps and stages of his work in writing, as a scientist would. Without the text, the conceptual field necessary to evaluate the work would not emerge, particularly since Rodchenko's circles and squares are intended to be taken less as circles and squares than as "constructive possibilities," to borrow a phrase from Lissitzky.

Rodchenko's 1920 text "Everything Is Experiment" initially contained a fragment explaining why he felt compelled to comment on his work in such detail:

I used to think that it was not so important—perhaps not necessary at all—to explain any of my work. But now it seems that three years have passed since I exhibited my "Dynamism of Surface" series, in which I decomposed real space, showing the independence of color and form, the breaking of forms by means of line, the breaking of form by color and mass. And still no one understands; still befuddled by these works, people think that the mere fact of their existence is all that can be said about them, and don't see how they progress down a certain evolutionary path. You have to stick your nose into them to figure out what they mean. I am not saying that no one understands them. It's just that vanguard artists don't understand them.[10]

The fact was that each of the artists producing non-objective art had his or her own set of ideas and motives—for Malevich the Suprematist vision of the universe, for Kandinsky the inexhaustibility of a spiritual and emotional outlook on the world, for Lissitzky the realm of mathematics. Rodchenko, in his most intensive period of experiment with abstract geometric forms, was trying to determine the laws of construction governing the physical world. The categories of space and time interested him less as philosophical concepts than as attributes of various astronomic, geometric, and psychological models of the world. It is no coincidence that his library of 1917–20 included such works as S. H. Hinton's *The Fourth Dimension and the New Era of Thought*, Moritz Willkomm's *Die Wunder des Mikroskops* (The miracle of the microscope), Camille Flammarion's *L'Atmosphère* (The atmosphere), C. A. Young's *The Sun*, and the speeches and papers of the German physiology professor Max Verworn. Completely in the spirit of Rodchenko's concept of analytic research was the title of a book by the German physicist Arthur Zart: *Bausteine des Weltalls* (The building blocks of world creation).[11] All of these books contained information on the physical, biological, and conceptual building blocks of the world, the *prima materia* of its construction.

One of Rodchenko's notebooks contains a hand-copied quotation from a book by A. Solonovich:

Cantor's famous theorem asserts that the number of points within a square, cube, etc. is equal to the number of points on a line, and is also equal to the number of points upon any segment thereof. *And this means that our entire universe, with all its endless planets, suns, and Milky Ways, is composed of the same number of points as any old line segment.* One would be able to construct the entire universe from a single piece of a line, *providing that one were able to arrange the points in a different order [emphases Rodchenko's].*[12]

Here we see Rodchenko finding confirmation of his belief in the universality of linear form. He was excited by the idea that the infinitude of the world and universe might be commensurable with the small canvases on which he worked, allowing him to hope that his own constructions might allow him to gaze into the depths of space and time.

"I am so interested in the future," Rodchenko wrote in 1920, "that I want to be able to see several years ahead right away. . . . It will be interesting to see what will move people in the paintings themselves."[13] He was preparing at the time for the *19th State Exhibition*, at which he would present a kind of summation of his path thus far, beginning with his first non-objective compositions, of 1917, and continuing through his series of 1919 and 1920, a cycle of paintings and drawings on the principle of "Linearism" (*Liniizm*). These line works, and the ideas on which they are based, are among the artist's most remarkable "inventions," both physically and conceptually. Rodchenko opened up an entire world of line; the line was for him at once border or frame and core. The viewer ignorant of the series' intellectual foundation might think it strange to want to draw nothing but sticks, stripes, and hatch-marks, but Rodchenko, commenting on these works, revealed the multiplicity of meanings line had for him: "The line is the alpha and the omega, both in painting and in construction in general. The line is path, passage, movement, collision, facet, edge, joining, transection."[14] He formulated this multiplicity as both a conceptual framework and a broadly applicable formal or compositional element. In the works of 1919–20 and their accompanying commentaries, in fact, he effectively "patented" the line, not as a geometric form but as a product of his creative laboratory, an element of his visual thought.

The next major public display of Rodchenko's art after the *19th State Exhibition* was his contribution to the *5x5=25* show, a two-part exhibition of which the first part opened in Moscow on September 18, 1921. Here five artists—Exter, Popova, Rodchenko, "Varst" (Varvara Stepanova), and Aleksandr Vesnin—displayed five works each, with each group of works serving to declare a new formal device or mode of artmaking. Taken as a whole, *5x5=25* marked a "closing" of abstract art: each participant used it to bring a series of experiments in abstraction, and in color, form, and space, to a conclusion. (Its short numerical title recalled Malevich's celebrated show *The Last Futurist Exhibition of Paintings: 0:10* [*Posledniaia futuristicheskaia vystavka kartin: 0, 10 (nol'-desiat')*], in Moscow in 1915, which both introduced Suprematism and, in a way, marked the end of Russian Futurism.) But the show was intended to end the group's non-objective experiments not merely with a period but with a boldface exclamation point. Rodchenko's work, then, appeared at its newly, most radically minimal, with the triptych constituted by *Pure Red Color* (*Chistyi krasnyi tsvet*), *Pure Yellow Color* (*Chistyi zheltyi tsvet*), and *Pure Blue Color* (*Chistyi sinii tsvet*, all 1921; plate 54). Less works of art than objectlike colored surfaces, these canvases announced the death of pictorial art and served as the finale to Rodchenko's work as an easel painter.

Twenty-five handmade, typewritten catalogues were prepared for the exhibition; each artist contributed five covers, each of which had a small drawing glued inside (plates 55–57). Rodchenko's pages are particularly interesting. First of all, he omits his first name, supplying only his last: RODCHENKO, written proudly along the top, in bold, widely spaced letters. As documentation below, he prints his telephone number—a

sequence of numerals.[15] Beneath this appear the titles of the works in the show: one called *Line* (*Liniia*, 1920), a second called *Grid* (*Kletka*, 1921), and *Pure Red Color, Pure Yellow Color*, and *Pure Blue Color*. (The first two works on this list have not survived; one can surmise, however, that *Line* was a smallish canvas painted black, and transected by a narrow white line on a diagonal from the upper right to the lower left.) Inside, in lieu of some sort of artistic credo, Rodchenko presents a list of formal artistic systems that he has worked out and displayed in earlier exhibitions:

> ***1918***
>
> *At the exhibition of non-objective art and Suprematism in Moscow I for the first time announced spatial constructions; and in painting [I showed]* Black on Black.
>
> ***1920***
>
> *At the* 19th State Exhibition *I for the first time announced "line" as an element of construction.*
>
> ***1921***
>
> *In the present exhibition I for the first time announced three basic colors in art.*[16]

Reading this list of formal systems, we can see Rodchenko moving toward an ever greater minimalism of expression. In the "Black on Black" painting he erases both light and color. He then introduces the conceptual and plastic category of line, an autonomous element not only of painting but of prints, architecture, graphic design, photography, politics, literature, cinema, and so on. Finally he announces the ascendance of the three primary colors. It turns out, in fact, that he conceived the *5x5=25* exhibition specifically to show these three canvases—that he made the paintings, then thought up a pretext for showing them. It is possible that in doing so he was competing with Malevich, trying to produce something still more global and fundamental than Malevich had claimed to do through the creation of his *Black Square* (*Chernyi kvadrat*) of 1915. Both of these artists, however, had their own projects to fulfill: if Malevich can be credited with having opened up non-objective art, Rodchenko to some degree can be said to have closed it down.

We see this effect in action not only in the three canvases themselves, which are simply colored surfaces, but also in one of Rodchenko's commentaries on them:

> *Smooth color. (Pure color, not ornament).*
>
> *My last laboratory experiment in the realm of color and form consisted of a series of panels shown at the exhibition* 5x5=25 . . . *on which a single canvas was covered with a single color—that is, each board was painted completely and evenly with one and only one color.*
>
> *[My aim was to] completely cover a real surface with only one color without adding any representational forms, [to show that] surface by itself is form.*

No surface could bear the burden of carrying some other sort of representa-
tional form. Yet each surface could take on some other real surface or form—just
not a representational one.

If a room is first painted, then covered in a wallpaper with birds and flowers,
it is ugly. Then on top of this wallpaper someone hangs a frame with a picture,
and in the picture is, again, a room, etc. . . .

You have a wooden table, and on the table is a tablecloth printed with snakes.
On the tablecloth are plates with landscapes on them, etc.

With these canvases I assert [the right] to impart a new color or method of
treatment to the border of a new surface.

I am against any kind of representation whatsoever on any surface or volume.

There is nothing we need to represent; instead we should only make, process,
and construct. . . .

If a tablecloth is cut from only one piece of fabric, then it should be of only
one color.

The same goes for walls.

A cube, for example, may be painted in six colors, one color per surface. But
on a solitary surface one should put neither [another] color nor a representa-
tional form, because to do so is a deliberate act of deception, an act of violence
upon surface and volume.

This is the final achievement in the battle with representation, illusion in art,
and the fantastic.

The battle with cheap imitations of reality.[17]

The response to the *5x5=25* exhibition was for the most part negative or ironic. The
main targets, of course, were Rodchenko's three canvases, with a review in a feuilleton
published by the newspaper *Teatral'naia Moskva*, for example, suggesting that the artist
had only forgotten to include an advertisement offering his services as a sign- and fence-
painter. On November 4, 1921, Rodchenko wrote to the journal *Ekran* asking them to
publish a rebuttal, in which he explained, first, that the three canvases should be seen not
as instances of "artistic inspiration," a notion he absolutely denied, but as "laboratory
experiments on the subject of the three primary colors—red, yellow, and blue." Second,
he wrote, their making served as the culmination of a "complete renunciation in the field
of accomplishment in painterly form." Third, he asserted that the laboratory practice
"worked just as precisely in the world of art as it did in industry, both analytically and
synthetically."[18]

The second part of *5x5=25*, also containing twenty-five works, opened on Octo-
ber 6, in the same space in the Klub vserossiskogo soiuza poetov (the All-Russian Union
of Poets) that had housed part one. This show concentrated on graphic works and works
in three dimensions. Exter, Popova, and Vesnin showed drawings similar to those they
had glued into the catalogue; Stepanova hung quickly executed figural drawings done in

ink on the backs of panels used in architects' presentations. Rodchenko showed drawings of constructions—freestanding tensile structures, a new stage in the artist's minimalism. For each structure consisted of the minimum number of wire pivots, and the minimum amount of gauze connecting them, that would allow it to stand. Each work looked like a cluster of sticks or tubes, or a bundle of wires, of sizable dimensions, along the line of Buckminster Fuller's constructions.

This second part of the *5x5=25* exhibition was intended to show that by negating art in the conventional sense, artists could move toward a positive and useful redefinition of art's content. All of the works shown, in fact, had practical applications: Vesnin's and Exter's were stage designs, Popova's were signboards, Rodchenko's were maquettes for lamps. Yet if the first part of *5x5=25*, which had announced the artists' divorce from art, had been a bold *succès de scandale*, the second part proved less effective. Who could have predicted that the public would take Rodchenko's strange, prickly constructions as ordinary lamps and chandeliers? General appreciation for such things always comes much after the fact.

In that Rodchenko's work as an artist eventually moved into the realm of practical tasks and themes, and in that even as an easel painter he had been absorbed in mathematical formulae and analytical research, architecture was a logical extension of his practice. In fact he made innovative contributions to twentieth-century architectural thought. Rodchenko and his colleagues advanced a dynamic image of architecture— many of his designs for Zhivskul'ptarkh (Collective of Painterly, Sculptural, and Architectural Synthesis), an association of which he was a member, conform less to architecture's usual rectilinear grid than to a diagonal one, with the building's different parts joining in sharp angles. Formally, too, these sketches usually concentrate on the building's skeleton, so that instead of showing walls, Rodchenko draws lines indicating beams, girders, and stanchions. In this he shares the impulse in twentieth-century architecture to reveal the spatial framework of the building through its exterior appearance. Predictably enough, Rodchenko's history as a non-objective artist also fed his architectural ideas, suggesting possibilities for chromatic transitions, shifts of texture and painted surface, and the use of colored light.

Architecture, however, was only a point of departure for Rodchenko—he was interested not just in the design of individual buildings but in the city plan. Architecture offered him a set of ideas and concepts guiding the construction of entire cities, including systems of communication, vertical growth, and eventually the modeling of the skyline, which he imagined as a progress to ever higher vantage points. He also saw architecture as a medium of information, and constantly peppered his projects and maquettes with screens for announcements and advertisements, posters and colored tableaux. Underscoring the new informational and chromatic roles of urban architecture, he would cram even a small architectural project such as a commercial kiosk with functional additions. One of these kiosks (plate 12) has a mast like a ship's, with a

three-sided clock at its top. Below the clock, where the sails might be, are flat billboards for propaganda posters; below them is a crow's-nest-like balcony for public addresses; and on the ground level is the kiosk itself.

Rodchenko's three monochrome canvases of 1921 only temporarily brought his non-objective project to a close; he returned to abstraction in the years around World War II. His "automatic" paintings are cousins to the work of Jackson Pollock, and the sketches for his series of "Streamlined Ornament" (*Obtekaemyi ornament*) paintings in many ways anticipated the art, architecture, and design styles of the 1950's. Rodchenko never stopped experimenting, then, but where, in his early "laboratory" period, he had to some extent left it to the public to catch up with him, in his later years he tried to explain himself more. Here textual commentary again played a role. In Rodchenko's photographs, for example, buildings may be photographed at peculiar angles, or an automobile may be seen as a fragment, a geometric composition; space is condensed, concentrated, tightened; the picture frame's usual coordinates of top and bottom lose meaning. And when collections of these photographs began to appear, in the late 1920s, Rodchenko found it necessary to explain these effects.

If the point of the writing, however, was to demonstrate how or from where this or that shot was taken, the point of the photographs was to broaden people's vision, to alter their sense of their orientation in space, to demonstrate the conventionality of accepted behavioral norms. In the final analysis, Rodchenko was trying to create the visual spaces for an elusive, almost mystical kind of consciousness, a heightened state of awareness. The formalist theorist Viktor Shklovsky—like Rodchenko, a member of the Lef group of artists and writers—understood this clearly: discussing Rodchenko's photographs, he wrote of "seeing the world through new eyes."[19]

Translated from the Russian by Michael Goldman Donally.

Notes

1. Aleksandr Rodchenko, "Vse-opyty," 1920, in *Opyty dlia budushchego: dnevniki, stati', pis'ma, zapiski* (Experiments for the future: diaries, articles, letters, notes), ed. O. V. Mel'nikov and V. I. Shchennikov, compiled by A. Lavrent'ev and V. Rodchenko (Moscow: Grant', 1996), p. 92. Published in English in Peter Noever, ed., *The Future Is Our Only Goal: Aleksandr M. Rodchenko, Varvara F. Stepanova*, exh. cat. for the Österreichisches Museum für Angewandte Kunst, Vienna, and the A. S. Pushkin State Museum of Fine Arts, Moscow (Munich: Prestel-Verlag, 1991), p. 131.

2. Rodchenko, "The Comparative Table of the Developments in Painting," 1920. Drafts and manuscripts, the A. Rodchenko and V. Stepanova Archive, Moscow.

3. Ibid.

4. Ibid.

5. Ibid.

6. Marc Chagall, quoted in Varvara Stepanova, *Chelovek ne mozhet zhit' bez chuda*, ed. Lavrent'ev and V. Rodchenko (Moscow: Izd. "Sfera," 1994), p. 146.

7. Rodchenko, "Svetila, metsenaty, novatory," *Anarkhiia*, April 23, 1918.

8. Rodchenko, drafts and manuscripts, the A. Rodchenko and V. Stepanova Archive, Moscow.

9. Rodchenko, drafts and manuscripts, the A. Rodchenko and V. Stepanova Archive, Moscow.

10. Rodchenko, draft for the article "Vse-opyty" (omitted from the final manuscript), drafts and manuscripts, the A. Rodchenko and V. Stepanova Archive, Moscow. The "Dynamism of Surface" series is a group of abstract compositions comprising planes of varying colors and textures situated one behind the other in space.

11. These books remain in Rodchenko's library today.

12. Rodchenko, drafts and manuscripts, the A. Rodchenko and V. Stepanova Archive, Moscow. In *Opyty dlia budushchego*, p. 86.

13. Ibid.

14. Rodchenko, "Liniia," in *Opyty dlia budushchego*, p. 96.

15. It was not uncommon in the teens and '20s for Russian artists to provide addresses and telephone numbers in their catalogues, allowing gallery-goers to contact them to find out about later exhibitions, or perhaps to make purchases.

16. Rodchenko, *5x5=25: Vystavka zhivopisi*, exh. cat. (Moscow: Klub V.S.P., 1921), no. 1.

17. These texts, written in Stepanova's hand in 1921–22, have not yet been published. The manuscripts are in the A. Rodchenko and V. Stepanova Archive, Moscow.

18. Rodchenko, letter to the editors of *Ekran*, 1921, in the A. Rodchenko and V. Stepanova Archive, Moscow.

19. Viktor Shklovsky, in a note in the guest book in the A. Rodchenko and V. Stepanova Archive, Moscow, May 25, 1966.

In 1921, at the *5x5=25* exhibition in Moscow, Aleksandr Rodchenko hung three canvases, each painted a single color, and labeled them "Pure Red. Pure Yellow. Pure Blue" (plate 54). With this act of radical distillation Rodchenko presented painting as an inventory of the three primary colors from which all others could be made, and also as a worked surface, its materiality emphasized by traces of the brush. He later asserted, in a now famous statement: "I reduced painting to its logical conclusion and exhibited three canvases: red, blue, yellow. I affirmed: it's all over. Basic colors. Every plane is a plane and there is to be no more representation."[1] For Rodchenko this tautological gesture spelled the end of painting as a viable artistic activity.[2]

It was not just Rodchenko who saw this triptych as defining a point of no return; in notes for a lecture, the theorist Nikolai Tarabukin, a colleague of the artist's, presented the gesture as an act of violence:

7) Painting is dead. Rodchenko the murderer and suicide.

8) But if painting is dead, is art dead as well?

9) Current social circumstances dictate new forms of art.[3]

If Rodchenko killed off both the traditional artist and his work, it was in order to reconfigure art as a modern, politically aware practice that would be part of and responsible to the new Soviet society. For if the triptych seemed to carry painting's progressive definition of its own materials and qualities as far as that process could go, it also displayed the limitations of the idea that artistic development could be purely formal—the limitations, that is, of the idea of the autonomous work of art. To Rodchenko and those around him, the death of painting clearly signaled a paradigm shift: artmaking could no longer be regarded as a self-sufficient activity. The artist, by extension, had also lost his or her autonomy, expelled, as it were, from the confines of the studio and into society.

The loss of painting, however, left an absence in its wake, an absence that became a crucial problematic. Perhaps *the* key issue for Rodchenko and his Constructivist colleagues was the question of how to be an artist in the new Soviet Union—how to redefine the artist's role as a social agent.[4] How could artists reconcile, on the one hand, an interest in baring the devices of representation, and on the other, a newly politicized mandate? How could they create a practice both political and modernist? Given the consensus that painting and sculpture were no longer viable artistic activities, this question was formulated in terms of the ways in which the role of the artist might be defined in relationship to new media.

Rodchenko was not alone in addressing these issues. His work and writing were developed in the context of his association with the Lef group, a loose network of writers, artists, theoreticians, and filmmakers (including the Futurist poet Vladimir

Leah Dickerman

Rodchenko working at the White Sea Canal, Karelia, 1933. Photograph: Anatolii Skurikhin.

63

Mayakovsky, the poet and playwright Sergei Tret'iakov, the critic Osip Brik, the Formalist theorist Viktor Shklovsky, the Marxist theorist Boris Arvatov, and the filmmaker Dziga Vertov), which coalesced around the journals *Lef* (1923–25) and *Novyi Lef* (1927–28). Perceiving a post-Revolutionary subject still alienated by the persistent structures of bourgeois culture, Lef called for an art that would transform consciousness. The group self-consciously synthesized the semiotic model of Russian Formalism with Marxism to produce a theory of artmaking both overtly political and modernist, in which two key, consistent principles can be discerned: 1) that form and technique were themselves to be understood as ideological, so that a transformative art had to be grounded in new systems of representation; and 2) that a subject's self-definition took place within praxis, so that such an art would require labor in both its making and its interpretation. Lef, in turn, consistently held up Rodchenko as an example of the revolutionary artist.

In his work after 1921, Rodchenko approached the problem of reconceptualizing the role of the artist in multiple ways, defining at least three distinct conceptions of a social artistic practice.

First was the design of useful objects for production. Rodchenko created designs for fabric (plates 76–78), a tea set (plates 74 and 75), a workers' costume (plate 72), and furniture (plates 166 and 167), but he did so in a limited way. Like other artists, he may have been dissuaded from doing more work of this type by the period's material shortages, and the resistance of factory managers to new design protocols.[5] It would seem unfair, in any case, to say that this work was marginal to his concerns, since much of Rodchenko's teaching was directed toward educating young designers in the production of new objects for a new society.

Rodchenko's second mode of social practice was the creation of an art that, while not overtly exhortative, aimed at the transformation of the beholder into the new Soviet citizen, often through strategies of estrangement intended to shock him or her out of ossified states of consciousness. The artist's oblique-angle photographs, for example, can be seen as attempts to emancipate the camera from the human body, and to establish a specifically technological mode of vision capable of bringing about a new subjectivity— attempts to reorient the viewer's perspective as much as the camera's point of view.[6] Rodchenko's third category of artistic practice, and perhaps the one in which he was most prolific, was his activity as an advertising designer and propagandist on behalf of the Soviet state and state enterprises.[7]

Despite the distinctions among them, these various engagements shared a general embrace of the mediums of mechanical reproduction, and in particular of graphic design and photography, as vehicles for defining a social practice. For this reason Rodchenko's work is important to consider as a case study of a significant type of artistic endeavor in the 1920s: he was an artist consistently rethinking his relationship to mass media, in this way attempting to develop the possibilities of a *political modernism*.

This essay will explore the third of these strands of Rodchenko's practice—his activity as a propagandist. It is important to emphasize that this is only one aspect of his creative production, that these strands are not easily divisible, and that the borders between them are permeable; yet because of a general art-historical discomfort with politically explicit work, this part of Rodchenko's practice has often been overlooked, or its political commitment minimized. As a result, Rodchenko has often been positioned as an artist concerned primarily with formal issues until late in his career. Even ignoring the political aims of his practice in general, however, Rodchenko worked as a propagandist—making politically explicit art in support of the Soviet state—throughout his production after 1921. A focus on his propaganda work highlights one powerful model for reimagining the artist as a social agent—as a mass communicator, capable of employing new technologies to reach a broad audience.

To the extent that Rodchenko's propaganda work encouraged allegiance to the undeniably coercive Bolshevik regime, its goals were problematic at best. But however misguided it was, we see in it, and in the work of many of his contemporaries including Gustav Klucis, El Lissitzky, Tatlin, and Vertov, a utopian belief in the possibility that the Soviet state would bring about a new type of society. Rodchenko was not merely conveying a message; his propaganda work was not a break from but a continuation of a sophisticated, nuanced attempt to define a new artistic practice, and through this practice to construct a new political subject.

The 1920s, the period in which Rodchenko jettisoned painting, saw the dawn of the era of mass communication. Radio was just coming into use in the early part of the decade, and while cinema had existed for twenty-odd years, its potential political uses first crystallized in public consciousness in the wake of World War I. Especially in the Soviet Union, this was a moment of unabashed media optimism. The Bolsheviks understood better than their political rivals—and perhaps better than any previous government in history—that mass politics required mass communication. Although they had successfully consolidated their political power, they (and sympathetic intellectuals) diagnosed a gap between the fact of revolution and a population still largely conditioned by a pre-Revolutionary mind-set, which, they believed, was inhibiting the development of a truly revolutionary society. The creation of a new, ideologically conscious Soviet citizen became a political imperative. Raising propaganda to the level of a policy issue, then, the government dedicated several agencies to political education, and paid unprecedented attention to the possibilities of media of mass communication— particularly film, radio, and posters—for binding and influencing their audience.[8] The means by which the new political entity was to be brought into being were seen as lying largely in the realm of technology. For Rodchenko and many of his contemporaries, the problem of revolutionizing the artist's social role demanded immediate engagement with this new media culture.

Advertising

Rodchenko's work in the field of advertising, and that of colleagues such as Anton Lavinskii and Varvara Stepanova, stands as one of these artists' first developed responses to the problem of redefining the role of the artist as a social agent after declaring the end of painting as a viable artistic activity. Between 1923 and 1925, advertising for state economic enterprises became an important sphere of activity for Rodchenko; by his own estimation, he produced some 150 advertising and packaging designs, many of them in collaboration with Mayakovsky, who wrote the slogans and jingles.[9]

The embrace of advertising as a form of revolutionary artistic practice is of course paradoxical at its heart. But the ideological tensions embedded in Rodchenko's project are shaped to a large degree by those of the historical circumstances that gave rise to it. At the close of the civil war, the victorious Bolsheviks turned to the immediate task of rebuilding the war-devastated economy. Their industrial working-class political base— the proletariat—had been reduced to roughly half its size, through factory shutdowns, mass flight to the countryside (spurred by food shortages), military conscription, and promotions into the administration of the new government.[10] The government responded pragmatically, backing away from the radically centralizing policies of the civil-war period and instituting a combination of measures together known as the New Economic Policy (*Novaia ekonomicheskaia politika*, or NEP).[11] To appease the peasantry, the government ended the requisitioning of agricultural produce that it had found necessary during the war. It allowed private trade in domestic markets, and offered foreign investors concessions in a variety of Russian enterprises and natural resources. Recognizing its urgent need for technical advice, it also dampened the rhetoric of class struggle and encouraged "bourgeois experts"—people with professional training and experience in fields such as engineering—to cooperate with the new regime.

Along with many intellectuals who identified with the revolutionary regime, the Constructivists had an ambivalent relationship toward NEP. On the one hand, as they were bourgeois by class origin, NEP gave them a framework within which to define themselves. In fact they developed an elaborate analogy between the artist and the engineer, implicitly categorizing themselves as "experts." On the other, the Constructivists recognized the inherent tensions in the new policies: how was the Soviet Union different from market economies? And they feared the threat of *embourgeoisement* (*meshchanstvo*) within NEP—the possibility that nothing but the symbols had changed. In the context of NEP, it became especially important (and difficult) to distinguish Soviet labor from the alienated labor of capitalism, the revolutionary commodity from the commodity fetish, and Soviet technology from the oppressive machines of the industrial revolution. Again and again in their various forms of artistic work, the Constructivists attempted to redefine these primary sites of modern conflict, to rid them of their pernicious aspect, and to develop their potential to produce a new Soviet citizen.

In his writing on advertising, Mayakovsky asserted that revolutionary forces had to mobilize the instruments of capitalism against capitalism itself. (The idea that bourgeois activities, in the hands of different masters, can serve revolutionary purposes is a consistent motif within NEP.[12]) Instead of scorning advertising as a "bourgeois trick," the poet believed that "under NEP, it is necessary to employ all the weapons used by [our] enemies, including the advertisement, for the popularization of state and proletarian organizations, offices, and products."[13] In a letter to the head of the state publishing house Mospoligraf, Mayakovsky further argued that while state political agencies must promote support of government industries with publicity of general "agitational significance," Mospoligraf and similar agencies must produce "pure advertising" for those enterprises most threatened by the competition allowed under NEP.[14] Through an elegant rhetorical inversion, he linked advertising to propaganda (the legitimate revolutionary activity par excellence), calling propaganda the "advertisement of ideas" and advertising "the propagandizing of things."[15] Thus the advertising designer became a committed soldier in economic battle. At the same time, the phrase "propagandizing of things" points to the Lef group's belief in the ideological character of consumption, and to these artists' and writers' commitment to the creation of objects configured differently from bourgeois ones—objects that would be potentially transformative.[16] (Rodchenko's design for a model workers' club, which I will discuss later, was just such a project.)

Socialist advertising, of course, already existed, as Mayakovsky pointed out. But he repeatedly stressed that state agencies had so far advertised *badly*. His letter to Mospoligraf condemned contemporary Soviet advertising as disjointed, boring, one-sided (in that it used only print ads), and expensive. In an article of 1923 he mocked the monotonous, bureaucratic tone of announcements such as "The Moscow Communal Farm reports . . . ," commented "Here we are still puppies," and stressed the need to learn—invoking, as one model, contemporary German advertising.[17] He also proposed a new form of publicity that he called "universal advertising," which would present full-scale multimedia assaults: coordinated campaigns using posters, newspapers, magazines, the covers of notebooks and notepads, labels for bottles of ink and glue, and even slide projections in the cinemas and theaters. Using standardized images and slogans, these campaigns would be made engaging (and humorous) in order to command the consumer's attention and recognition.[18] The concepts of coordinated advertising campaigns and corporate identity had already been developed in Europe by 1920, especially in the work of Peter Behrens at Allgemeine Elektrizitäts Gesellschaft (AEG) in Germany, and of Lucian Bernhard for various clients in France. Mayakovsky's articulation of the concept, however, is nonetheless quite early, and distinct in its imperative to define both a "revolutionary" commodity and a new, proletarian consumer.

In 1923, Rodchenko and Mayakovsky began collaborating on advertising work, using the joint name—which Rodchenko called their trademark—"Mayakovsky-Rodchenko Advertising-Constructor." Mayakovsky took charge of client relations,

soliciting new work and delivering completed projects during the day; he and Rod-chenko seem to have worked on the actual production of the campaigns largely at night. The operation moved between the apartment of Osip and Lili Brik, where Mayakovsky wrote jingles while beating out the time on Lili's piano, and that of Rodchenko, who designed advertisements with the help of two students from the Vкhuteмas art school.[19] Along with the copy, Mayakovsky often provided sketches, which Rodchenko sometimes used as a starting point in designing an advertisement's visual look.

The pair's presentation of themselves as art experts for hire—a move underscored by their creation of a portfolio of work to show potential clients, along with a list of set prices[20]—marks a radical step away from the romantic conception of the artist as an inspired genius, alienated from the external world, and toward a professionalized, collaborative, and instrumental practice. (The shift was accompanied by a certain amount of self-justifying rhetoric, such as Mayakovsky's claim that his jingle "Nowhere else as at Mossel'prom"—Mossel'prom being the state enterprise for the sale of agricul-tural products—stood as "poetry of the highest order."[21]) Rodchenko and Mayakovsky seem to have recognized that the NEP paradigm of the "expert" created a social category allowing members of the bourgeoisie to serve the new regime. And while the concept implied an individual with a body of specialized technical knowledge, it also worked to define the artist as a worker like all others—one who produced material things with real social value.

Rodchenko's and Mayakovsky's advertising work attempted to answer both a pragmatic and an ideological imperative (these two ends, of course, are often conjoined, in Russia as elsewhere): on the one hand, to sell state-manufactured products, which would help to strengthen the Bolshevik regime financially; and on the other, to sell the regime itself, which would help to produce new, ideologically transformed subjects (and, presumably, better customers). A striking example of this "advertising of ideas/propagandizing of things" approach can be found on a series of candy-wrappers designed by Rodchenko and Mayakovsky (plates 93–99). The leading slogan "*Karamel' nasha industriia*" (which, if translated directly, would read "Caramel our industry") can in Russian be interpreted three ways: as identifying the brand of caramel (Nasha Industriia); as asserting the collective ownership of the means of production ("The caramel is *our* industry"); or as emphasizing the candy's status as the result of human labor, a foregrounding of the production relations obscured under capitalism ("The caramel is the product of our industry"). The wrappers show pictures of industrial structures—tram cars, steam engines, bridges, grain elevators—that further develop the analogy between candy manufacture and Soviet industrialization. (Other series of caramel wrappers bore portraits of political leaders, Moscow revolutionary monu-ments and institutions, and units of the new system of weights and measures.) Finally Mayakovsky's slogans, in rhyming couplets such as "Don't stand there on the bank of the river / until old age, / it's better to throw a bridge / over the river" (plate 94), exhort the

consumer to work toward collective and collectivizing goals. Packaging is here recon-
ceived as a space for propaganda and enlightenment.

This dual marketing of product and ideology runs through much of Rodchenko's
advertising work, even predating his collaboration with Mayakovsky. Earlier in 1923, for
example, before he and the poet joined forces, he had produced designs for Dobrolet, a
shareholding company for the development of a Soviet civilian air-fleet. In these he
began to define a new, socialist mode of advertising practice distinguished by its address
of a collective, proletarian audience, its bold graphic idiom, the way its message and its
design mutually reinforce each other, and the coordination of component elements in
various formats within a broad campaign. Recognizing the importance of public support
for its task, Dobrolet established an independent printing house, and its advertising was
coordinated with publicity events such as demonstration flights at fairs and attempts to
break long-distance flying records.[22]

Rodchenko conceived a broad multimedia campaign for Dobrolet, not only pro-
ducing posters in different sizes but designing trademarks, logos, stock-prospectus
covers, letterhead, decorative designs for the airplanes themselves, and lapel pins and
cufflinks (plates 79–92). All were linked by bold colors, sans serif lettering, and the
recurring form of a Junkers airplane, the converted military plane that made up most
of the Dobrolet fleet.

The exhortation to invest was of course the main purpose of the campaign. The
task was a tricky one, fraught with the ambiguities constant within NEP. The selling of
stocks seems paradigmatically capitalist; the campaign's slogans, however—one of them
reads "Everyone . . . Everyone . . . Everyone. . . . He who is not a stockholder in Dobrolet
is not a citizen of the USSR"—performed an ideological task. Now that the proletariat
had come into power, the poster implied, it should *behave* like owners of the means
of production, and invest. The visual presentation reinforced this call to collective
participation, using a graphic device to perform a function on the order of the cry "Hey,
you!": a bold exclamation point stretching from top to bottom of the poster's left side,
grabbing attention. (Think of it in comparison to the dry "The Moscow Collective Farm
reports . . . ," which makes no direct address, visual or verbal, of the reader.) An arrow
begins at the exclamation point's punctuating dot, then wraps around three sides of the
poster, demanding that the viewer read along its length, passing first the airline's name in
bold, then the location for stock sales, then a message both embracing and exhortative—
"Everyone . . . Everyone . . . Everyone . . . "—and finally moving directly into the pro-
peller of the schematically drawn plane. Surprising us today, but reflecting the intensity
of Russia's aspiration to unite its population through technology, is the urgency of this
particular goal: few countries even had national airlines in the mid-1920s.

In 1923, Mossel'prom commissioned Rodchenko and Mayakovsky to produce a
broad multifaceted campaign including posters, newspaper ads, leaflets, and packaging
(plates 101–10). Mayakovsky's ditty "Nowhere else as at Mossel'prom" (in Russian, it

rhymes) appears on much of this work, linking a broad variety of products under the Mossel'prom umbrella. Rodchenko, too, uses repeating visual frames and formats. In all of his advertisements for Mossel'prom's various cigarettes (plates 101–5 and 109), for example, Mayakovsky's slogan appears at the bottom of a broad colored band, flanked by two exclamation points that extend the full height of the ad; inside the space defined by this border, the cigarettes' brand name and pictures of their box appear along with product-specific rhyming couplets by Mayakovsky. The frame works to establish a relationship between the various Mossel'prom cigarette brands, while at the same time allowing brand differentiation within the frame; and as in the Dobrolet poster, the exclamation points establish a code, a kind of shorthand address, that intervenes in public space.

Rodchenko's design also served an ideological purpose: contrasting with the old-fashioned packaging designs (and often the pre-Revolutionary brand names) of the cigarettes, the modernity of the bold graphic frame repositioned these familiar commodities within the contemporary moment of NEP, negotiating between past and present.[23] An ad with the slogan "Only Ira cigarettes remain with us from the old world" recognized the power of nostalgia over consumers shaken by the unfamiliarity of the world around them. (Perhaps, also, it mocked the post-Revolutionary passion for renaming.) The ads often referred specifically to the context of NEP, working to assuage or make fun of the anxieties of the time. In a period of rampant inflation, the advertising team promoted Chervonets cigarettes (named for the Soviet bank note, itself named for a pre-Revolutionary gold coin convertible to hard currency) with the refrain "Strong, as strong as pure gold currency," thus playfully linking them to an image of stability (fig. 1).

While the cigarette ads often worked to package (and repackage) old commodities, an ad for cooking oil attempted to redefine the commodity itself, reconstructing it as something specifically revolutionary (plate 107). At the top of the ad, playing on the analogy between the poster and other, more technologically advanced systems of mass communication, text in a black field announces, in the manner of a public address system, "Cooking oil / Attention working masses." Text in a flanking white field trumpets, "Three times cheaper than butter! More nutritious than other oils!" Not only did

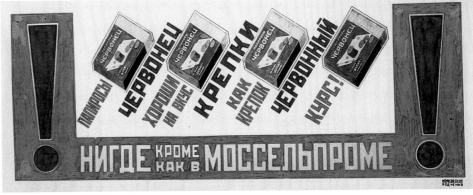

1. Aleksandr Rodchenko. Maquette for an advertisement for Chervonets cigarettes, produced for the state grocery concern Mossel'prom. 1923. Gouache on paper. 4⅜ × 10¹³⁄₁₆" (11.1 × 27.5 cm). Collection Merrill C. Berman.
Text by Vladimir Mayakovsky:
"Chervonets cigarettes are good to the taste / strong as strong gold currency! / Nowhere else as at Mossel'prom."

1.

Rodchenko and Mayakovsky target a proletarian audience (defining a specific consumer group was relatively unusual at the time), they also appealed to rational consumption considerations (the product's competitive price, and its value as a source of nutrition) rather than to tangential factors such as its sex appeal or social status. (The quantification of these claims in the refrain "Three times cheaper . . . More nutritious . . . " reinforces the implication of rationality.) They tried to sell, in other words, by referring specifically to *use-value*—defined by Karl Marx as an object's functional worth to human beings, an attribute often obscured in capitalism by the object's *exchange-value*, or worth on the market. The emphasis on use emerged as a strategy for circumventing the disengagement of things from basic human needs, a disengagement that many leftist thinkers saw in capitalism, and also in the market economy of NEP.

The bold stripes of the cooking-oil ad, and its central circle (framing a bottle of oil), relate to a number of ads for other Mossel'prom products, all featuring a striped background and the use of a basic geometric form as a frame—a girl eating Einem cookies, for example, appears within a hexagon (plate 106), loaves of bread within a diamond (fig. 2). Rodchenko was carrying the principle of a geometric series over from his hanging constructions of 1919–20 (plate 53), but now he transformed this visual device into a framing system of meaning with a specific ideological function. All of the ads are for basic staples offered by Mossel'prom, which are presented as providing a buffer between the consumer and the vagaries of the NEP marketplace. In fact some ads explicitly contrast their offerings with the shoddy products, and extortionate prices, of that marketplace, as when Rodchenko transforms Mossel'prom's Trekhgornoe (Three peaks) beer into a kind of alcoholic superhero: a slogan in rhythmic verse claims that: "Trekhgornoe beer drives out hypocrisy and moonshine," while zigzag arrows extending from a bottle of this state-supplied beer shatter two bottles of home brew (plate 110). Visual and verbal humor plays an important role, both fixing the product in consumers' memories and allowing them a sense of control over their environment in an often confusing time.

In the paradigmatically modernist device of the *mise-en-abîme*, the cooking-oil ad uses a smaller image of itself as the label on its central bottle of oil to set up a seemingly infinition regression. Here, repetition conjures a mythic socialist plenitude, and at the same time works to develop a coordinated system of identity between the advertising graphic and the product itself: even as it sells oil, Rodchenko's design sells the concept of "universal" advertising. No matter what the product or how explicit the message, however, Rodchenko's and Mayakovsky's ads never quite escape the ideological ambiguity of their enterprise. Constructivist advertising almost always vacillates between the revolutionary imperative to circumvent the fetishizing of the commodity, on the one hand, and the construction of desire necessary to sell the product, on the other. The wrappers for Nasha Industriia caramels point to this tension, for their use of a series of related images—tram car, steam engine, airplane—encourages collection, a consumption

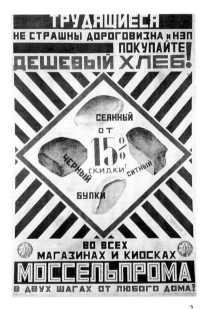

2.

2. Aleksandr Rodchenko. Advertisement for bread, produced for the state grocery concern Mossel'prom. 1923. Lithography. 29⅛ × 19¼" (74 × 49 cm). A. Rodchenko and V. Stepanova Archive, Moscow.
Text by Vladimir Mayakovsky:
"Workers / Don't fear high prices and NEP / Buy! Cheap bread! / From 15% less / In all Mossel'prom stores and kiosks / two steps away from any house!"

mode grounded in acquisitive desire rather than in human use. Though I suppose their reconceptualization as agitational units or units of knowledge ameliorates the structure of acquisition implied by collection, the distance between image and what is inside remains great.

The Workers' Club

In 1925, Rodchenko moved beyond two-dimensional work to design a three-dimensional structure, a model workers' club (plates 160–67), as one of the Soviet contributions to the *Exposition Internationale des Arts Décoratifs et Industriels Modernes*, in Paris. The workers' club was a new, post-Revolutionary entity, a communal site intended to offer both political enlightenment and rest and renewal at the end of the working day. Slogans in the many campaigns for the creation of such clubs proclaimed the virtues of the "healthy relaxation" they offered, and Soviet journals ran endless debates about their role in the creation of a *novyi byt*, a new everyday life.[24] In the Paris club, Rodchenko conceived an ideologically infused public space for proletarian relaxation, which would stand in opposition to the private, hidden realm of bourgeois leisure. The club, however, was aimed at a Western audience as much as a Soviet one, and at the close of the exhibition, the Soviet delegation presented it to the French Communist Party.

The exposition itself carried with it certain shaping political agendas. The event was hosted by the French government, in large part to prove to the world that France had recovered from World War I; the Soviet Union, similarly, hoped to prove that it had developed a vital, and civilized, socialist culture in the wake of the Revolution—to shake its reputation as a nation of red barbarians. France's invitation to the Soviet Union to participate was one of the first acts of cultural exchange between the two countries after their reestablishment of diplomatic relations, in 1924. From the Soviet point of view, an appearance in the exposition furthered a general NEP agenda of accommodation with ideological enemies in pursuit of market opportunities. At the same time, the Soviet exhibition committee concurred that its entries should represent the country's *novyi byt*—should present the Soviet Union as ideologically distinct from its coparticipants.

The political resonance of situating the spare wooden forms of Rodchenko's club (and also of Konstantin Mel'nikov's Soviet pavilion at the exposition) amidst the other exhibition buildings—many of them showcases for department stores—was not lost on the artist, or on other observers. The correspondent of the Soviet magazine *Rabochii Klub* (Workers' club), a journal that took up the contemporary discussion of club culture in considerable detail, wrote to his Russian readership,

> On show were an infinite quantity of dressing tables with space for innumerable
> scent-bottles, ottomans for corpulent idlers, very delicate and complicated pieces
> of furniture on which one can sit only sideways, and an infinite number of

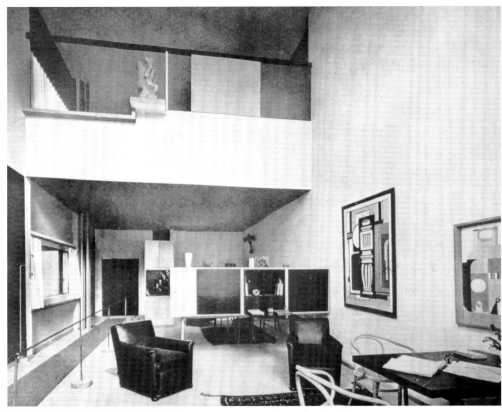

3.

screens and drapes. . . . But what did the representatives of the USSR do with
their two rooms? They showed consistency: to everyone's horror, they were not at
all interested in bourgeois coziness, which only serves to mask the space that
remains unused.[25]

"Coziness" had already found its way into Constructivist (and Lef) texts as a pejorative term, an example of *meshchanstvo*. By their very understatement, both Rodchenko's club and Mel'nikov's pavilion stood as antimonumental critiques of the rest of the exposition. The reading table, expanding media center, bulletin boards, and photographs of Lenin in the workers' club also made it a space for collective relaxation quite unlike the ornate parlors of the department-store displays. Next to it, in fact, even Le Corbusier's Pavillon de L'Esprit Nouveau, a famous pavilion at the exposition (fig. 3), seems less a radical reconceptualization of living space than a technologized revamping of a traditional upper-crust living room, full of paintings (though paintings by Fernand Léger and Amédée Ozenfant) and overstuffed armchairs (though made of leather and steel).

The Paris workers' club implied that Soviet workers, unlike those in capitalist countries, belonged to a leisure class. At the same time, it differentiated their relaxation from contemplative, private bourgeois leisure: rather than an individual occupation, proletarian leisure was imagined as communal, a complement to collective labor. On the other hand, with its focus on reading, chess, and shared social space, the workers' club in some ways related closely to the Parisian café, if a café rationalized and redone for the socialist worker (with alcohol noticeably absent).

3. Le Corbusier. Pavillon de L'Esprit Nouveau, at the *Exposition Internationale des Arts Décoratifs et Industriels Modernes*, Paris, 1925.

Rather than masking space—a masking that the *Rabochii Klub* correspondent had seen as characteristic of "bourgeois coziness"—Rodchenko's objects unmasked it. The un-upholstered furniture displaying its joints, the chairs with their open-frame arms, the expanding latticework of the rostrum-cum-cinema-screen (plate 161), the sides of the bookcases revealing the shelves within as a play of planes (plate 162)—all these opened the making and functioning of the objects to the viewer's sight. For Rodchenko and many of his contemporaries, the light, uncovered, and unadorned structures of this furniture invoked a rhetoric of hygiene. He wrote proudly of his club's cleanliness and light, and of the way that it held the dirt of the French commodity world at bay: "It really is so simple and clean and light that you instinctively don't want to track dirt into it."[26]

Not only was the workers' club functional, in the ideologically loaded context of the *Exposition Internationale* it served as an exemplar of functionality to the outside world. A description of it by Stepanova, in an article based closely on Rodchenko's own notes, insists on the economy, standardization, and multifunctionalism of Rodchenko's club equipment:

> THE FUNDAMENTAL REQUIREMENTS *to be met in each object for the*
> WORKERS' CLUB:
>
> *1) Economy in the use of the floor-area of the clubroom and of the space occupied*
> *by an object with maximum utility.*
>
> *2) Simplicity of use and standardization of the object; it must be possible to*
> *increase the size or the number of its component parts.*[27]

Within the club, standardization was expressed in geometric regularity and in repetition of form—in the dozen identical chairs, for example, that lined both sides of the reading table. Emphatically mobile, the club's objects were to be adjustable by the user, both for convenience and for different functional requirements. The reading table had leaves that could be moved from an inclined position, for supporting reading matter, to a flat one, creating an expanded work surface; cylinders holding photographs allowed for a rotating display of many images in a small space; and the gaming surface of the chess table spun to the vertical to allow the players access to the built-in seats (plate 167). Color too, Stepanova asserted, underlined the objects' functions and structures: the four-color scheme of gray, red, black, and white had "organizational significance—it distinguishes and underlines the methods of use, the parts and the nature of the object."[28] Red also tied together functional components of the club's equipment—the rotating cylinders, the tabletop and bookshelves, and the chair backs—and the "Lenin Corner," a section of the space devoted to the recently deceased leader (plate 160).

Insistently reiterating the grid, and compartmentalizing the activities it staged, this rationalized space pointed to an industrial model, one "based on total efficiency in every respect."[29] The functionalism of the club's furniture can be seen as a way of reinvesting the object with use-value, inscribing it with its relation to human needs and activities. The applications of Rodchenko's objects, in fact, had an almost hyperbolic quality—

as in the complex of struts and planes against one wall that unfolded into the rostrum-cum-movie-screen (also with built-in bench; fig. 4). This particular object managed to be not only impressively multifunctional but obscurely so; it is hard to read the structure's purpose in its collapsed state, and only in its full extension does the logic of the system become visible.[30]

This hyperfunctionalism did not necessarily exclude an implicit human presence. As Christina Kiaer notes, there was a certain fragility in many of the pieces—in the delicate vertical beams of the chairs, the openwork sides of the bookcases, the latticework of the folding screen. And the precarious mobility of the rostrum in particular invokes for her a certain human quality: "expanding and collapsing, encircling and extensive, folded in and disappearing, . . . like the human body in its vulnerability."[31] All this, she suggests, brought the new forms of industrial modernity down to human scale.

But while objects like the rostrum can be seen in some ways as having served as analogues for the human body, their movements also charted a path between two rationalized poles—between space efficiency and hyperfunctionality. Much of the club's design in fact aimed at bodily control. Aligned along the central table, the straight-back chairs with their high encircling arms would have held readers in neat rows, insisting on their collective concentration. And when the game board of the chess table was flipped down, it would seem to have locked the players in place, committing them to enlightening play. Contemporary commentators noted the furniture's discomfort; even the Soviet organizing committee, reviewing an earlier model, suggested Rodchenko "find a more comfortable form of furniture."[32] His reluctance to do so might reflect a sense on his part that discomfort served an ideological purpose, distinguishing the "equipment" of the workers' club from the "cozy" bourgeois armchair, and implicitly defining proletarian relaxation as active and alert, rather than soporifically disengaged from the world.

In all its transformable potential, the club's equipment was designed largely to deliver information to the working-class visitors imagined for it back in the Soviet Union. In Stepanova's article, based on Rodchenko's only partially realized plans for the club, she listed the following objects:

> *The furnishings of the reading room, a table, chairs, a display stand for books and magazines with a cupboard for storing current issues of reading material, movable wall-cases for posters, maps, and newspapers. . . . A model set of equipment was devised for a corner devoted to Lenin, a movable wall-case for storing and displaying materials, documents, and photographs with room for headlines and theses, a movable display case for posters and slogans, a movable display-case for exhibiting the latest photographic material. . . . An installation for meetings, rallies, and performances of the "live newspaper"; it consists of the following components: a platform for the speaker, a place for the chairman or newspaper editor, a pull-out wall-screen for the display of illustrative material, a moving roll-screen for slogans and slides.*[33]

4.

4. Aleksandr Rodchenko. Design for a collapsible rostrum for the USSR Workers' Club (*Rabochii klub SSSR*) at the *Exposition Internationale des Arts Décoratifs et Industriels Modernes*, Paris, 1925. Black and red india ink on paper. 14¼ × 10" (36.2 × 25.5 cm). A. Rodchenko and V. Stepanova Archive, Moscow.

The function of most of these elements makes it clear that the club was intended above all as a media space, employing multiple and simultaneous information technologies. Its patron was conceived as a consumer of information; the idea was implicit that the working class had a right to political knowledge. The sheer quantity of elements also suggests a kind of media saturation, an excess of information coming from all sides. The workers who used the club, however, were not to be passive spectators and consumers. An active engagement with information was at least as important as information itself, and the games and activities within the club were to promote consciousness, putting ideology into practice.

Not only did Rodchenko's design function as a critique of passive bourgeois structures, it could also be seen as a response to certain trends within the Soviet Union in the wake of Lenin's death, in 1924. In a period of political transition during which various factions attempted to claim the nation's leadership, Lenin's image—in the form of countless busts, paintings, photo albums, postcards, etc.—served a legitimating purpose.[34] Kitschy as these objects might seem in hindsight, their proliferation reveals a profound anxiety, a kind of political *horror vacui*. One of the most common manifestations of the phenomenon was the spread of the Lenin Corner—most typically a painted portrait or a bust in a niche in a public site. The very name is significant, as it echoes that of the "Red Corner," the place in the peasant home where, in Russian tradition, icons and religious objects were displayed. Further reinforcing this religious undertone, the government placed a great deal of importance on the preservation of Lenin's physical body, as an original conferring authenticity on all its iconic copies (over which, significantly, the authorities tried to impose controls).

Not surprisingly, Rodchenko and Lef attacked this kind of passive veneration in all its manifestations, positing an alternate representation of the leader. The workers' club in Paris was one such alternative: it was saturated with references to Lenin, but the design privileged constructive activity over veneration. Within the club, electricity (in the geometrical lamp construction, plate 164), reading (in the slanted table and bookshelves), and chess (in the chess table with swiveling gameboard) all appeared under the aegis of the word Lenin, and of the leader's photograph. Neither electricity, nor chess, nor reading was politically neutral in early Soviet culture: literacy and electrification had been among Lenin's first major policy initiatives, and chess had emerged as a political concern slightly later, in 1924–25, when a Soviet victory over France in the game's first-ever state-sponsored international tournament catalyzed a drive to convert chess from bourgeois pastime to mass activity.[35] Although this campaign was launched after Lenin's death, chess, like reading and electricity, was rhetorically associated with him—his own playing was frequently invoked—and all were promoted as ways to produce a conscious worker capable of participating actively in the new society.[36] The Paris workers' club, then, in its entirety, can be seen as a kind of extended portrait of the leader, but one dedicated to putting aspects of his political legacy to work. In contrast to the site of con-

templative veneration offered by most Lenin Corners, Rodchenko's club was constructed as a site of practice. One might even say that it gave Lenin himself use-value, relating his political legacy to activities of work and play, and transforming the Lenin Corner into usable space.

Stepanova's description of the display originally planned for the club's Lenin Corner—"A movable wall-case for storing and displaying materials, documents, and photographs with room for headlines and theses, a movable display case for posters and slogans, a movable display case for exhibiting the latest photographic material"—brings out the archival abundance, even excess, which was to accompany the image of the dead leader. (It seems that Rodchenko also planned an electrified map of important sites in Lenin's life, a portal with mobile slogans, and a stand with a scroll of Lenin posters that could be turned with a crank.[37]) And, at the same time, it also underscores the manipulability of Rodchenko's Lenin Corner display, and points to the openness and contingency of its structures and of the relationships they establish. The club that was actually built in Paris did not achieve such archival density—Stepanova noted that not everything could be completed in time[38]—but the principle of documentary representation remained. Alongside the image of Lenin hung a glass display box labeled "Stengaz"—a shortened form of *stennaia gazeta*, or "wall newspaper." The information it contained could be updated easily and often. A stand supporting three rotating hexagonal cylinders offered a large quantity of photographs for perusal, and provided a great variety of possibilities for their juxtaposition. A bookshelf supplied reading material, while the collapsible rostrum-cum-movie-screen held out the possibility of simultaneous speeches, posters and slogans, and film images. The image of Lenin, then, was to be accompanied by a profusion of texts—written and oral, visual and verbal.

The prominence granted Lenin in the club's design affirms how important the visual commemoration of the leader was to Rodchenko. But the fact that the image the artist chose for the Lenin Corner was photographic holds particular significance in the context of his practice. In his first theoretical article about photography, a 1928 text called "Against the Synthetic Portrait, for the Snapshot," Rodchenko posed the question,

> *Tell me frankly, what ought to remain of Lenin:*
>
> *An art bronze,*
>
> *Oil portraits,*
>
> *Etchings,*
>
> *Watercolors,*
>
> *His secretary's diary, his friends' memoirs—*
>
> *Or*
>
> *A file of photographs taken of him at work and rest,*
>
> *Archives of his books, writing pads, notebooks, shorthand reports, films,*
>
> *photograph records?*[39]

In this division into two groups, Rodchenko refuses the established hierarchy of mediums that would privilege the traditional art object as the most appropriate form for memorializing a leader. But there is something more. Implicit in this distinction lies a temporal difference: the first group could be called objects of retrospection, of imaginative reconstruction, while those of the second are relatively immediate or synchronic in nature. Primary documents, they belong to files and archives rather than to collections and museums. With his carefully weighted question, Rodchenko is proposing an archival mode of representation.

This issue of time gets to the heart of the matter, for, in Rodchenko's words, "The first big collision between art and photography, a battle between eternity and the moment," took place over the image of Lenin.[40] Rodchenko saw painting as attempting a distillation of the individual's essence over time, presenting what the painter has deemed characteristic. Photography, in contrast, captured "a precise moment documentarily,"[41] and he thought it was this difference in temporal structure that made photography the privileged mode for modern signification—since the possibility of stable, essential knowledge assumed by painting and its allied genres, he argued, was no longer historically available. In the rapidly unfolding present, "People do not live by encyclopedias, but by newspapers, magazines, card catalogues, prospectuses, and directories."[42] And this change in the structure of knowledge he linked to the death of the integral subject. Dismissing the pursuit of "the real V. I. Lenin," Rodchenko wrote, "It should be stated firmly that with the appearance of photographs, there can be no question of a single immutable portrait. . . . A man is not just one sum total; he is many, and sometimes they are quite opposed."[43]

For Rodchenko, the mass of photographs (and other documents) representing Lenin in all of his contradictory manifestations did important political as well as aesthetic work by challenging the false wholeness of any synthetic representation. He wrote, "There is a file of photographs and this file of snapshots allows no one to idealize or falsify Lenin."[44] The existence of photography in all its multiplicity, then, undermined the concept of the true copy or icon. And the photographic archive worked against the presentation of any one image as an exemplar of the universal, constructing instead a discontinuous collection of artifacts, of which the individual could construct his or her own active interpretation. Rodchenko's publication and display of photographs of Lenin might be seen as an effort to force open this "file of photographs," and thus to challenge essentializing images of the leader.

History Posters

Rodchenko further pursued this concept of archival abundance in a series of twenty-five posters he executed in 1925 (the same year he designed the workers' club) for the Museum of the Revolution (Muzei revolutsii) and Komakademiia (the Communist academy), both in Moscow.[45] Called "The History of the VKP(b) [All-Russian Communist Party

(Bolshevik)] in Posters" (*Istoria VKP(b) v plakatakh*), this series was a propaganda effort on the part of the party, but also the model for a specific way of conceptualizing history. Within each poster, a variety of photomechanically reproduced documents—photographs, pamphlets, organizational guidelines, and pages from newspapers and journals—are splayed across blocks of color, at times overlapping to suggest links or subsets. Quotations from speeches are occasionally interspersed. Rodchenko's boast in the pages of the journal *Novyi Lef* that the work was "done with photographic means and constructed from genuine documents"[46] points to his own understanding of the project's distinguishing features.

This poster series also participates in the period's discussion on the presentation of revolutionary history. As Soviet historian Sheila Fitzpatrick notes, in the aftermath of the Revolution, history was dropped for a time from the new nation's educational curriculum because of its perceived irrelevance to contemporary life, and in repudiation of its traditional use in inculcating patriotism and the ideology of the ruling class.[47] (Differently cloaked, this latter function was to return with a vengeance in the official—and ever evolving—Party histories of Stalin's later rule.)

One of the posters from the series is dedicated to the 1905 Revolution (plate 183). In January of that year, in an event subsequently named "Bloody Sunday," demonstrators who had marched to the Winter Palace in Saint Petersburg, to bring economic grievances to Tsar Nicholas II, were fired on by troops. The action catalyzed a series of demonstrations, strikes, and mutinies that eventually led Nicholas to concede to the principle of a constitution and parliament (commitments on which he later largely reneged). The documents displayed in Rodchenko's poster include photographs of the demonstrating masses and of the corpses of the victims; an illicit poster, distributed in the wake of Bloody Sunday, emblazoned with a bloody handprint; and headlines published in the newspapers and journals of workers and revolutionary organizations. In the second poster (plate 184), dedicated to the revolutionary parties during World War I, photographs of soldiers dug into trenches and fighting in the farmland of Europe are overlaid with photographs of the Bolshevik leaders on one side, the Menshevik leaders and the German Communists Rosa Luxemburg and Karl Liebknecht on the other.

Certain overall themes can be discerned in these posters: the lack of concern for human (and in particular working-class) life exhibited by the tsarist government, and the increasing strength of the revolutionary parties and their internal divisions. What is perhaps surprising, however, is the *relative* absence (I stress "relative") of ideological guidance offered to the viewer beyond the selection of documents itself. The texts include captions identifying people, events, and places; quotations from named speakers; and sometimes the list of a basic sequence of events. Together these provide a limited framework for interpretation, and headlines, too, inflect understanding. Yet there is little attempt to mold the facts into an overarching narrative. Furthermore, despite a tendency to privilege images of historical victors, such as Lenin and Stalin, Rodchenko often pre-

sents the documents in dialogical oppositions: a photograph not only of the Bolshevik leader Lenin but of the Menshevik leader Iulii Martov, not only of Stalin but of Lev Trotsky, the failed heir. Such juxtapositions allow the viewer to negotiate between various positions. Even if the field is tilted to favor the leaders of Rodchenko's time, the strategy differs distinctly from that of later, Stalinist histories, which erase historical rivals altogether. Implicit, too, is the knowledge that today's leaders may not be tomorrow's, as is suggested by figures who play a role in earlier posters, then disappear.

Perhaps most important, the posters configure history in a nonlinear way. The representation of events through the display of primary documents—discrete texts and images from specific moments—and within a loose interpretive framework presents an aggregate model—an accumulation of fragments rather than a seamless organic whole. The poster series' division into twenty-five temporal segments reinforces this; it presents history not as a narrative of progress—a teleological advance toward a culminating moment—but as a series of narrowly defined chronological cross-sections. Unlike an organic narrative, with its well-defined trajectory from beginning to middle to end, this set of temporal core-samples is potentially infinite in its extension. The photomechanical reproduction of documents in the series also allows for the possibility of different understandings of them in the future. The posters cast these documents as mobile units within the archive of history, implying that they can always be reordered, the past can be reconfigured, and new meanings can come to supplant old ones. As the theorist Boris Eikhenbaum wrote in the late 1920s, in an article on literary history that suggests the potency of the archive model for Formalist thinkers, "We do not apprehend all the facts at once; it isn't always the same facts we take in, and not always the same correlations of facts we need to bring out."[48]

This is a move of tremendous ideological significance, for it presupposes that the present is no more stable than the past, and that revolution is an ongoing process rather than an achieved state. The meaning of the document fluctuates according to the social and theoretical preoccupations of those who see it. The presentation of historical documents within an open structure—their presentation as *mobile*—offers a counterpoint to concepts (and institutions) elsewhere presented as eternal.

Perhaps the boldest move in this project is its use of the poster medium to make access to the archive *public*. Historical documents become a kind of collective social memory, which each viewer can sift for meaningful associations. The relative absence of interpretive guidance allows the individual to perform the work of the historian. (This might also be seen as a subtle strategy encouraging political identification by asking the viewer to work through the documents selected, and in the process to recognize the Bolsheviks' revolutionary claims.) Recent critical writing has focused on the archive as an instrument of social control;[49] Rodchenko, by contrast, seems to be attempting to tap into its emancipatory potential through the public display of its (edited) contents.

Photo-Stories

Between 1929 and 1933, Rodchenko began to focus on photographing social phenomena, and on designing photo-stories for illustrated magazines. His self-reinvention as photo-journalist and magazine designer was part of a worldwide tendency, a change in the press across Europe and America: the emergence of what Mikhail Kaufman, Vertov's brother and cameraman, called an "image-oriented journalism,"[50] marked by the increasing transmission of information by images rather than text. Encouraging a proliferation of photo magazines, technological advances created new potentials for photographs in ink, allowing them to be printed in greater quantity and at lower cost, and creating the opportunity of integrating them with other pictorial and graphic systems to produce a newly flexible relationship between text and image. Photographers in the Soviet Union in particular seized on the possibilities of these new reproduction technologies to transform photography into a mass medium. With typical assurance, Tret'iakov declared his belief in the political significance of such images: "Soviet reality, fixed by the lenses of the Soviet camera . . . and finding itself in the pages of the illustrated magazine, is as interesting and necessary as daily bread."[51]

Rodchenko's re-creation of his work, however, also coincided with the inauguration of Stalin's first major industrialization drives, the First Five-Year Plan, of 1928–32, and the Second Five-Year Plan, of 1933–37. The former of these set high production targets in key industries in order to achieve manufacturing equality with the West within five years, and was underwritten by the forced collectivization of agriculture. From the state's point of view, it thus created an urgent need to communicate with the laboring population, so as to unite them in communal effort—a service Rodchenko sought to provide. Meanwhile the plan's accompanying reassertion of proletarian hegemony in the new Soviet state fueled an aggressive rejection of social privilege, and "experts"—artists among them—found themselves in a precarious social position. The Second Five-Year Plan introduced more moderate production goals, and has been seen as a period of normalization—of a retreat from class militancy and radical egalitarianism, and of the reinstitution of more traditional social values.[52] Often, though, as in Rodchenko's case, these values were recovered on changed terms.

Rodchenko's work of these years reveals certain shifts. First, labor becomes the primary subject. A photo-essay of 1929 in the magazine *Daesh'* (Give your all), for example, on the AMO automobile factory in Moscow, explicitly represents processes of production and construction. So does the famous 1933 issue of the journal *SSSR na Stroike* (*USSR in Construction*) devoted to the building of the Belomorsk, or White Sea, Canal. A second shift in Rodchenko's work (and in that of his colleagues) is a new intensity in the commitment to address a mass audience, a goal that served as a catalyst for significant institutional changes.

AMO

The rhetoric of class militancy that provided the social underpinning for the stepped-up tempo of industrialization under the First Five-Year Plan had profound repercussions for Rodchenko and his colleagues. The NEP policy of accommodation with bourgeois intellectuals and with capitalism had effectively ended in 1928, with the announcement of the Plan. The emergence of the term "cultural revolution" signaled a strident confrontation between the proletariat and its perceived enemies. Literary historian Katerina Clark has found in this period an "extraordinary depreciation of intellectual expertise of all kinds," and the nurturing of a kind of radical egalitarianism to take its place.[53]

In 1928, October (*Oktiabr'*), a group Rodchenko would join the following year, issued a call to the cultural barricades, demanding a new level of partisanship and ideological responsiveness from artists. A broad organization, October included practitioners of various media and embraced a range of stylistic tendencies. It was united, however, by its opposition to the cultural domination of artistic groups that advocated a didactic realism grounded in nineteenth-century traditions. Although the membership of these groups was not for the most part proletarian in origin, the groups were called "proletarian" because they advocated these programs in the name of the working class. In distinct contrast to them, October's manifesto, in careful language, asserted its members' commitment to the principle that revolutionary practice demanded (broadly construed) modernist forms of representation.[54] Reflecting a sensitivity to the changed political circumstances of the First Five-Year Plan, the group's declaration introduced an elaborate class hierarchy. The industrial proletariat was at its apex; the artist was positioned below the proletariat, but was to strive to stand "at the same high ideological level."[55] Throughout, the document reveals a new sense of accountability to the proletariat—in the demand that artists subordinate themselves to "the task of serving the concrete needs of the proletariat,"[56] in the humility of a general call for self-critique, and in the imperative to build a mass aesthetic culture.

This mandate was to be achieved both by addressing the needs of a large audience—designing buildings for mass use, objects for mass consumption, and mass festivals—and by nurturing the worker-artist through art education and factory-based art circles. Underpinning this program was a demand that the artist move physically closer to the proletariat—move, that is, to the site of production. Projects such as Rodchenko's AMO series (plates 263–66 and 268–69), which documents a specific production practice, were a means of doing this. Only by integrating themselves into the proletariat could artists become functioning members of the collective. October's self-conscious attempt to construct a new institutional frame for artistic production implies a mutual exchange: while artists would be present at sites of industrial production, and would participate in it, workers would finally come into the self-determining creative labor that had been denied them under capitalism.

For all its efforts, October faced a paradoxical problem: how could artists be avant-garde in any sense of the term at a time when they were explicitly defined as backward on class and ideological grounds? The contradiction inherent in their role as defined in the manifesto—"technical experts," they are at the same time ideological pupils of the proletariat—points to their precarious social position.

Rodchenko's AMO photo-story in *Daesh'* provides an example of the delicate balance between the October group's documentary and its exhortative imperatives, and also of its commitment to linking new systems of representation with revolutionary politics. The group's photography section had stressed the development of a mass audience for the medium, unambiguously demanding that the photographer work with the mass media, and with the means of mass distribution—"with printing or . . . with newspapers and magazines."[57] Rodchenko himself began to fulfill this imperative in 1929–30 by publishing work in illustrated magazines such as *Tridtsat' Dnei* (Thirty days), *Za Rubezhom* (Abroad), and *Daesh'*. To judge by the masthead (which includes Rodchenko), *Daesh'* can in fact be considered an October institution, and it stood as a concerted effort on the group's part to address a mass proletarian audience. Not only was the magazine inexpensive and its print run high, but its editors held open hours at their offices, and solicited and published the creative production of workers alongside that of professional artists. In all of these policies *Daesh'* stands in contrast to the journals *Lef* and *Novyi Lef*, which had relatively limited circulations and aimed primarily at an intellectual audience, rather than a proletarian one. (*Lef* cost fifty kopeks, as opposed to the ten-kopek cover price of *Daesh'*.) *Daesh'* ran cartoons and drawings, but *photographs* were the privileged mode—perhaps in recognition that as the results of a mechanical means of reproduction, they were congruent with the journal's commitment to rapid industrialization, and as a skill that could be mastered (via the factory-based art circles) by a large population, they were consistent with the editors' commitment to the deprofessionalization of artistic practice.

Photographing at the AMO factory, Rodchenko produced a montage chronicle of a specific production process, a format he was to follow in most of his other work for *Daesh'*. The series groups images of machine components—both automobile parts and devices for their manufacture (figs. 5–7). These are shown in sharp focus, and in close, narrow detail. Though not entirely excluded, human presence is minimized, and the body, when it is shown, is truncated into parts.

Such a representation of social relations through an image of technical rationality can appear problematic in its obscuring of human labor, needs, and costs. In a 1929 essay, however, Tret'iakov offers a possible justification for this kind of approach in proposing a new literary genre (or method), "the biography of the thing."[58] More than just a shift in subject matter, such a practice would privilege "the world of things and processes" over the "world of emotion," offering an antidote to the heroic mode of the bourgeois novel, with its focus on individual experience.[59] The "biography of the thing"

would not lack human interest; it would provide a social cross-section, in fact, in order to present human characters as they participated in the production process. Tret'iakov writes of the production narrative, "Individually specific moments of people in the biography of things pass away, [as] personal bumps and imperceptible epilepsies, while on the other hand professional sicknesses of a given group and social neuroses become especially prominent."[60] In a radically deindividualized and situated way, the "biography of the thing" represents the human as both a producer and a collective, class-determined subject.

Like Tret'iakov's "biography of the thing," Rodchenko's AMO photo-story offers a production narrative in which process serves as a structural axis for the work as a whole. The story presents machine parts not as commodities but as products of collective, class-based, technologically advanced labor, products that themselves produce. It also represents a dramatic effort to redefine the human being as a producer, both collective and class-defined. Its arrangements of photographs reveal a certain logic, theoretical as much as graphic: in the first spread, three photographs of work stations appear on the left (human presence at them being marked by the back of a head and a pair of hands), while products of the factory's labor appear on the right, in groups, emphasizing their replication and standardization. Captions serve the same function: "Steering wheels," "Gear wheels before cutting teeth," "Clutches," and "Gear shafts" (fig. 5). The second and third spreads have similar layouts, with workers in fragmented or obscured views appearing on the left and the products of their labor on the right. These juxtapositions strongly suggest various kinds of progress—from labor to product, from conception to actualization. And since neither a completed vehicle nor any worker's face appears until the final spread, the photo-story as a whole emphasizes the process of production rather than the result—although it does so relatively loosely, since the specific, ordered stages of production are not defined. In fact the photo-story resists a linear sense of narrative. Instead, repeated forms throughout the story suggest infinite repetition—a refusal of closure that can be seen as very much of a piece with the ever expanding goals of the First Five-Year Plan.

The fragmentation and antinarrative quality of the AMO photo-story is more than a modernist aesthetic choice, then. The articulation of the manufacturing process—the particularization of both gestures and tools—conveys a sense of respect for the collective endeavor. Meanwhile, other formal strategies particularly associated with photography (crop, sharp focus, fragmentation) stress the pictures' status as *photographic* images, products of mechanical reproduction. Since reproducibility is also proper to the machinery that the photographs show, a symbiotic, self-reinforcing relationship is suggested between photography as a medium and technology as a photographic subject. Meanwhile the fragmentary human traces work synecdochically: the part (rather than the whole body) stands for the human presence in production. This kind of synecdochic substitution—allowing the human part to stand for a collective subject, and the

„АМО" —

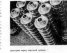

5.

6.

7.

5–7. "AMO—The First State Automotive Factory." Page spreads in *Daesh'* (Give your all) no. 14 of 1929, with layout and photographs by Aleksandr Rodchenko. The Museum of Modern Art, New York. Gift of Philip Johnson, Jan Tschichold Collection.

machine fragment to stand for a rational industrial social order—manages to lend signs new meaning without leaving the literal plane. Allowing the empirical to function symbolically, synecdoche, I think, is Rodchenko's chosen tool in his effort to produce a photographic practice that would fulfill both exhortative and documentary functions—while also remaining true to the Lef imperative of interpretive labor on the part of the reader, who must make the ideologically significant connections between the represented part and the socioeconomic whole.

Even though the AMO photo-story can be seen as Rodchenko's most concerted effort to represent a collective subject, its focus on things conveys a certain ideological ambivalence. In one spread, four photographs of machine components, taken in sharp focus and from close up, fill each quadrant of one page (fig. 6, plate 264). By conveying minute detail, and limiting one's understanding of the object's three-dimensional shape, the extreme proximity of these views directs attention to the physical surface. The result is a lingering, almost sensual perception of the machine. And in combination with the photo-story's relative lack of human presence, this intimacy with the mechanical raises the specter of fetishism.

As Rodchenko represents the machine, its rationality has a seductiveness that operates as a kind of subterfuge, threatening to obscure the human cost of industrialization—implying that the Plan's demands for increased productivity would be met not by pushing workers harder but by the mobilization of new technology. Perhaps it can be argued that Rodchenko's work participates in a kind of fetishism that was endemic to the Five-Year Plan: the demand for hyperbolic productivity as an end in itself, rather than for its value on the market, obscures the workers' role in the process, conflating the social purpose with its material shapes. Rather than standing for the whole, the part threatens to take its place entirely.

Vakhtan Lumber

Beginning in 1931, an ideological shift in the sphere of Soviet political rhetoric toward a more humanistic conception of labor made the insistently technological image of production conveyed in the AMO story increasingly less viable. A Rodchenko photo-series of 1930 would seem to have anticipated this shift. That May, the October photographers' section mounted an exhibition of their work at Moscow's Press-House (Dom pechati). The images that Rodchenko showed here—of workers at a lumberyard in Vakhtan—focused on people rather than machinery (fig. 8, plates 280–85). The series follows Rodchenko's previous practice of examining labor at specific sites, but here the sequence is even more insistently nonlinear, abandoning the sense of a process that culminates in a finished product. While the location of labor's energy in the human body rather than in machinery is new, the skewed perspectives of Rodchenko's camera are familiar: sticking close to working bodies as they move lumber, he almost always shoots from behind, and usually at oblique angles (plates 280–82 and 284). Combined with the

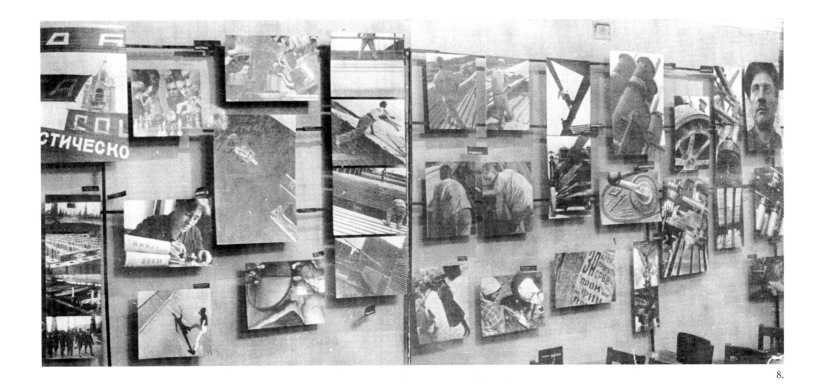

workers' own twisting movements, this rotation of the picture plane produces more-extreme effects of torsion and foreshortening in the human figure than seen previously in Rodchenko's work. And in several works the figure is cropped, or is twisted or folded onto itself, to present only a fragmentary body: the broad expanse of a back, a pair of legs squatting to lift.

The view from behind is significant in that it refuses access to the face, denying the individuation of character. At the same time, it establishes a certain congruence between the body of the viewer (or of the artist) and that of the laboring figure—a structure of identification that Michael Fried has discussed in his work on Gustave Courbet.[61] Like Courbet, Rodchenko aligns the position of the viewer's own body with that of the figure within the picture. In this way he can be seen as working to undo the distance between himself (or the viewer) and the laboring body. The Vakhtan images thus open a space for viewer identification lacking in the AMO series, with its close-up emphasis on machine parts. In the intensity of what one imagines is Rodchenko's longing to occupy the proletarian position—to merge with the laboring body—he constructs what might be called an erotics of class desire.

The ideological shift that would seem to have been anticipated by Rodchenko's newly embodied vision of labor was first announced the month after the photo-section exhibition, in a speech that Stalin delivered at an economic conference in June of 1931.[62] A new Communist Party slogan, "The reality of our program is active people—is you and us," signaled the waning of the technological determinism and militant collectivism of the early years of the First Five-Year Plan, and the emergence of a new conception of labor oriented toward the figure of the individual worker. This new platform repudiated collective class hegemony in favor of individual responsibility. The Second Five-Year Plan

8. Exhibition of the October photo-section, at the Press-House (Dom pechati), Moscow, May 1931. Installation view showing Aleksandr Rodchenko's series on the Vakhtan lumber yard (center). Also shown: photographs by Eleazar Langman (left) and Boris Ignatovich (right).

itself, initiated in 1933, for the most part set more moderate goals than the First had, and its rhetoric stressed quality of production and the acquisition of skills.[63]

Despite the human focus of both Rodchenko's new photography and the new political rhetoric, however, Stalin's speech only lent authority to October's critics, who attacked the group for their mechanistic imaging of the world and their focus on photography's technological foundation. Although Rodchenko's Vakhtan pictures were far less mechanistic than his AMO photo-story had been, their exhibition that May provoked a series of attacks in the journals of a number of groups that advocated, in the name of the working class, a photographic practice grounded in the traditions of nineteenth-century realism. Writers in, for example, *Proletarskoe Foto* (Proletarian photography) were more articulate about what they were against than about what they were for, but certain concepts come through in their program: the demand for unification (as opposed to fragmentation) of the artwork, for visual hierarchy and exemplary figures, for an artistic expressivity understood as dramatic and readable, and for the divination (and iteration) of historical laws behind appearances.

A strongly antivisual position emerges in this writing. In October's focus on "not that which is shot, but how it is shot," and in the group's Formalist conception of art as a "system of devices,"[64] critics saw a departure from the proper balance between form and content; *Proletarskoe Foto* scorned October's "mechanical gliding over surfaces."[65] The very appeal (and sensuality) of form, it was implied, distracted attention from the serious business at hand—a masking of politics that any good Marxist could recognize as characteristically bourgeois.

In keeping with the political rhetoric of the time, the fatal blow to the October photo-section was struck when, in February 1932, *Proletarskoe Foto* published "The Voice of the Workers, Collective Farmers, and Photo-Reporters," a collection of letters from workers expressing opinions on a group of October photographs that had been published in the magazine.[66] Now the proletariat was offered as ultimate critic and authority. Singled out for particular derision was a Rodchenko series on Pioneers—the Soviet version of the Boy Scouts. Roughly contemporary with the Vakhtan pictures, the Pioneer photographs are marked by similarly dramatic foreshortenings of the human figure— or in this case the human face, repeatedly photographed from oblique perspectives (plates 277–79). The steep low viewpoint in the photograph of a trumpet-playing boy (plate 279), for example, abstracts the young face into a group of foreshortened masses, lending the figure a certain monumentality.

In fact the Pioneer photos represent a departure from Rodchenko's previous practice of portraiture, which had been aggregate in nature, documenting multiple manifestations of an individual and refusing a definitive view or synthesis. The Pioneer series offers itself as an investigation of a particular social category or type. Its subjects, however, found little in it to identify with, and their letters to *Proletarskoe Foto* display an almost personal sense of insult. Members of a photography circle at a state farm, for

example, wrote, "We are surprised that comrade Rodchenko wanted to so disfigure the young, healthy face of the pioneer. As a result of this 'experiment,' the face of a normal person has been transformed into the face of a freak, and for what?"[67]

Under increasingly insistent demands that the October group "reconstruct" itself, its members seem to have felt largely defeated, and willing to recognize their guilt. An open letter published in the same issue of *Proletarskoe Foto*, and signed by eighteen members of October, including Rodchenko, announced that the group had been "deeply mistaken and politically dangerous, inasmuch as its basis lies in the leftist principle of abstract documentariness."[68] Soon after writing the letter, the October group expelled Rodchenko, in an attempt to save itself.[69] The artist would later write, "I plunged into photo-reportage and sports photography in order to cure myself from *stankovizm* ["easelism," or an art-for-art's-sake stance], aesthetics, and abstraction."[70] Using the language of disease within a healthy body, Rodchenko seems ultimately to have internalized the criticisms ranged against him.

White Sea Canal

Distraught by the criticisms of him and facing increasing difficulty in finding jobs, Rodchenko made several decisions to salvage his professional career—decisions that brought about a fundamental change in the nature of his work. The first of them brought him to the northern region of Karelia to document the construction of a canal from the Baltic to the White Sea. The trip—there were actually three, beginning in February of 1933—was perhaps partly a self-imposed exile: "One could quit photography and work in other fields," Rodchenko would later write, "but simply to surrender is impossible. So I left."[71] Paradoxically, though, he may also have wanted to redeem himself by aiming straight at the political thick of things. The White Sea Canal was one of the giant projects of the two five-year plans. The rhetoric of construction notwithstanding, however, the canal was in fact an ideological and carceral project more than an engineering one: it was administered by the OPGU, the predecessor to the KGB, using penal labor (even the engineers were prisoners), held for the most part as class enemies rather than as criminals. In celebrating the canal, Rodchenko lent his artistic authority to one of the most coercive and irrational projects in the Stalinist period, one that, for those willing to see, exposed the Communist dream of unalienated labor as myth.

Rodchenko took over 3,000 photographs of the construction—a quantity dwarfing all of his previous photographic projects.[72] Later that year, a selection of them appeared in a special issue of *SSSR na Stroike*, a luxurious oversized magazine published in Russian, English, German, and French (plates 286–94). Rodchenko was also responsible for the layout and design of this issue, so that it bears his imprint in its entirety. The look and the structure of the White Sea Canal photo-story can be regarded as the result of another decision by Rodchenko, whether conscious or unconscious: to abandon many of the principles that had guided his earlier work. Though certain familiar devices remain

(oblique camera angles, for example, and the medium of photomontage itself), a sense of overarching narrative has replaced his earlier aggregate structures, which had allowed the reader to negotiate between component parts and potentially multiple meanings. Indeed the structure of the White Sea Canal photo-story, and the relations it establishes between images and text, work to a new degree to reinforce *particular* readings. Furthermore, Rodchenko's earlier insistence on baring the constructed nature of his artwork— its status as representation—is jettisoned for a technique that mutes the seams of photomontage, making its juxtapositions appear as natural ones.

Even more disturbing, perhaps, than the blatantly celebratory quality of the White Sea Canal issue are the obvious skill and craftsmanship that went into it. Rodchenko's personal investment in the project is perhaps one explanation of why this fundamentally coercive narrative retains a strange power: through his images of collective effort—the collective effort of forced penal labor—the artist was attempting to secure his own redemption. In its very discontinuity with the rest of Rodchenko's work, the White Sea Canal photo-story casts a significant retrospective light on his career. At the heart of his decision to do the project was his struggle to retain the professional status that was such an integral part of his self-definition as an artist. The photo-story was created in the context of perhaps the most radical institutional shift of his career: his expulsion from October, as the group fell under increasing pressure to reform itself ideologically. For the first time in his post-Revolutionary career, Rodchenko was deprived of an institutional base—a loss not only of financial security and status but, more profoundly, of the kind of intellectual milieu and dialogue that had been the crucible for much of his artistic and political development.

October, however, along with all other artistic groups (including the "proletarian" ones), was itself soon disbanded, as part of the shift in cultural policy that immediately preceded the Second Five-Year Plan (1933–37). Much of the overt hostility toward bourgeois intellectuals was tempered as Stalin pragmatically encouraged renewed respect for expertise. But the price for welcoming back the "expert" was a new social and cultural conservatism.[73] The artists' groups were consolidated within broad umbrella organizations—the writers' or the artists' union, and the state-run publishing houses. As they moderated factionalism,[74] these unified associations reasserted the authority of tradition, the primacy of traditional genres such as painting and sculpture, and the professionalism of art (for they validated practices of which only trained artists were capable). These were the developing conditions when Rodchenko, on April 15, 1932, signed a contract with the state publishing house Izogiz to work as a photo-correspondent, at the same rate as any other photographer. Izogiz also claimed the unlimited right to reuse the photographer's negatives without paying again.[75]

As historian Loren Graham has argued, the White Sea Canal was in its very conception a supremely irrational project. Party officials insisted on a route with an inadequate water supply, generally forbade the use of mechanized equipment or concrete (which

would have required the expenditure of currency abroad), and required that the whole project be completed in twenty months. Construction conditions were unbelievably harsh: Graham estimates that 200,000 people died in less than two years of construction (roughly 10,000 a month), many from hypothermia and starvation.[76] Rodchenko could not have failed to notice this; in fact the workers' status as prisoners is confirmed in his photo-story, both in the text and by images of armed guards. The text, however, mis-identifies the prisoners as criminals, effacing any sense of them as victims. Political violence was thus recuperated or, as Walter Benjamin might say, aestheticized, and made to seem crucial to economic achievement and the creation of a collective society.

Rodchenko's actions in this instance were neither wholly voluntary nor wholly coerced. On the one hand, he was making choices in radically changed and narrowed circumstances; on the other, unlike the other "experts" working on the canal (the engineers, for example, who had to plan the waterway against all practical sense, because its route had been decreed by Party officials), he did have the option of *not* going. As he himself remarked, he could have chosen to "quit photography and work in other fields."[77] In choosing to go to the White Sea Canal, Rodchenko did what he felt he had to do to continue working as a professional artist at the service of the Soviet state. On the most immediate level, his work for *SSSR na Stroike* can (and should) be seen as a largely sincere response to the criticism of 1931–32—to meet the demand for essence, the revelation of historical laws, and the function of exemplification. And to a great degree, the White Sea Canal story worked successfully to this end, garnering praise from former "proletarian" critics of Rodchenko's, including one who said the photographer had now "voted for realism"[78]—the realism implied being, of course, that of Socialist Realism. (It should be noted, however, that the same critic admonished Rodchenko for his continued "sarcastic" attitude to dramatization.[79]) Nevertheless, by 1935 Rodchenko was rehabilitated enough to be included in the *Exhibition of the Work of the Masters of Soviet Photography* (*Vystavka rabot masterov sovetskogo fotoiskusstva*) in Moscow.

One gets a telling (and tellingly oblique) view of the conditions underlying Rodchenko's White Sea Canal project in Stepanova's letters to him, which describe a landscape of poorly marked political hazards, of restrictions intuited but not to be spoken of directly. Writing from Moscow, she explains, "While in general nothing is prohibited, they even relate to landscape suspiciously."[80] In couched language, she warns Rodchenko to avoid both the photographic detail and a focus on the production process—the very things that had characterized his photo-stories to date. And where those earlier projects had also been discontinuous in sequence, the White Sea Canal issue offers a strong narrative, charting two parallel transformations: "wild nature" is conquered through the wills of the leader and of the collective, and "the dregs" of society are redeemed to become "honest workers." Finally these threads intermingle and collapse into a single plot: if man transforms himself, it is not through his labor; rather, like nature, he is wild, and must be tamed by the will of the leader.

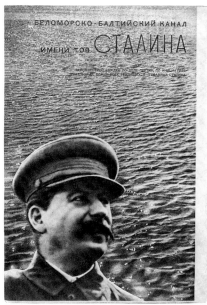

9.

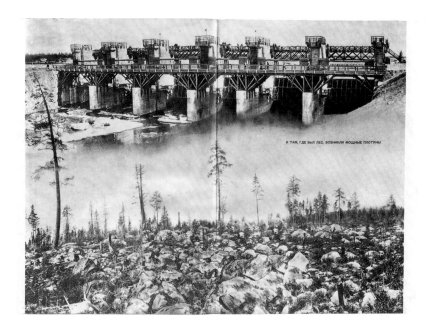

10.

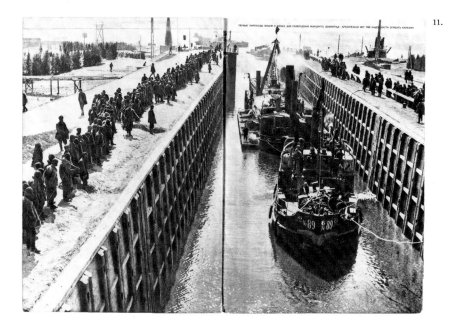

11.

9. Frontispiece for the magazine *SSSR na Stroike* (*USSR in Construction*) no. 12 of 1933. Collection Stephen and Jane Garmey.

 Text: **"White Sea–Baltic Sea Canal named after Comrade Stalin."**

10. Spread from the magazine *SSSR na Stroike* (*USSR in Construction*) no. 12 of 1933. Collection Stephen and Jane Garmey.

 Text: **"Mighty dams spring up where there had once been forest."**

11. Spread from the magazine *SSSR na Stroike* (*USSR in Construction*) no. 12 of 1933. Collection Stephen and Jane Garmey.

12. Spread from the magazine *SSSR na Stroike* (*USSR in Construction*) no. 12 of 1933. Left: workers and party officials attend the opening ceremony for the White Sea Canal; right: "the great pro-letarian writer" Maksim Gorky gives a speech. Collection Stephen and Jane Garmey.

13. Page from the magazine *SSSR na Stroike* (*USSR in Construction*) no. 12 of 1933. Collection Stephen and Jane Garmey.

 Text: **"Comrades Stalin, Voroshilov, and Kirov on the White Sea Canal."**

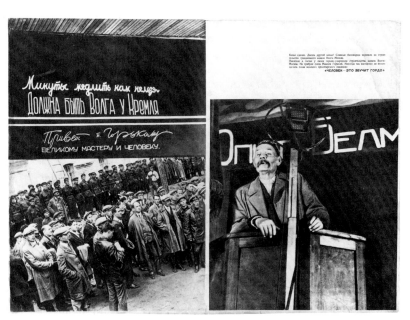

12.

Rodchenko sets up these narrative lines in a simple, readable manner. The photostory commences with (and emerges from) a statement of Stalin's will, printed over a forward-looking portrait image of the leader and placed in contrast to the "wild nature" of Karelia (fig. 9). Next, work begins: both land and people are transformed through the "romance of labor" (figs. 10–12, plates 287–94). Finally, in the four-page spread on the canal's inauguration, the transformed workers and the completed canal receive a benediction of sorts from Party officials (plate 294). As executors of Stalin's will, they are rewarded with the approbation of, first, the state, through prizes and early release; then Maksim Gorky, who, in the role of official Soviet writer, testifies to their humanity (fig. 12); and finally Stalin himself, who graces them with his presence (fig. 13).

13.

As this brief overview suggests, the White Sea Canal issue of *SSSR na Stroike* represents, on a number of related levels, a shift to a more panoramic imaging of the world than that seen in Rodchenko's earlier work, and renounces his earlier insistence on partial perspectives. The shift lies at the core of the transformation in his practice. In many images he constructs this panoramic sense through the scope of the gaze, tending to establish a high, centralized point of view that spreads the landscape out before the beholder. At once removing the beholder from the action (in contrast, for example, to the close-ups of the AMO and Vakhtan series) and granting him or her privileged visual access, this viewpoint is, as Benjamin H. D. Buchloh and others have suggested, one of governance.[81] Further, where earlier photomontages by Rodchenko had called attention to the disparateness of their different elements, the disjunctures between the component parts in the White Sea Canal photo-story are muted through retouching, and through a staggering of scale relationships to follow roughly the rules of perspectival recession. The figures loom large in relationship to the landscape, yet their scale is not so extreme as to break the illusion of spatial integrity, and they progressively diminish in scale as we move up the picture plane. Rodchenko thus provides a coherent, unified stage for the activity he documents. Through montage, he overrides the positional specificity of individual fragments to build a centralized space that offers itself to the beholder as an authoritative view.

Some spreads do display characteristically modernist effects—an oblique perspective within an image, say, or an overlap of several images in a montage. The obliquity is more moderate than before, however, especially in representations of the human body; and the montages are more easily readable, a human figure usually being positioned against one or two photographs that establish background (fig. 13). This two-tiered layering—human in front, construction site behind—presents an ordered structure rather than an atomistic one; it makes social hierarchy visible ("The reality of our program is active people").

In its reiteration of a dominant paradigm, and in the way it forestalls one's awareness of the constructedness of the image by allowing for a suturing identification between the beholder and the center of perspectival projection, the movement toward a

centered point of view establishes a generalized, rather than a specific, viewing position. In this way it serves as the analogue of the third-person, omniscient voice in written narrative, of which the linguist Emile Benveniste writes, "The events seem to tell themselves."[82] In fact the photo-story's captions *are* written in the third person, so that the writer never identifies himself. There is also a tendency toward the passive voice, which grants events a certain quality of self-manifestation: "Mighty dams spring up where there had once been forest." "Cargoes began to move: minerals, lumber, fish, grain, coal." The third-person voice functions not simply to *name* (as the captions in the AMO series do, for example) but to *interpret*, and to present this interpretation as an absolute truth rather than a specific, perspectival one. It acts, as Michel Beaujour has said, as "an authority in the text," limiting and delimiting meaning.[83] The implication of authoritative interpretation runs across the entire White Sea Canal photo-story, and often within the images themselves. Where, in the AMO series, the juxtaposition of images and adjacent texts allows both to claim a certain equivalence and self-sufficient authority, here the text is often literally written over the image. All other voices within the text—the signs placed by photomontage in workers' hands, for example, reading "Bring forth the water"—reiterate and thus reinforce the voice of the omniscient narrator, who establishes a complete congruence between the will of the masses and that of the leader. The inclusion of reprinted newspaper pages telling individual narratives of salvation through labor, and of an official memorandum to Stalin attesting to the canal's completion, claim authenticity while abetting total coherence.

This panoramic quality extends to the temporal scope of the work as well: Rodchenko moves away from his earlier works' accumulation of moments—each marking a "now"—toward a historical spectrum in which the past is posited and the future foreseen. In a kind of before-and-after anticipation of the human narrative, one of the early spreads in the White Sea Canal story introduces the dregs of society carousing unproductively on one side and the canal-building workers on the other. The prisoners' "crimes," then, establish a past, and their redemption through labor—a redemption destined from the beginning by the will of the leader—becomes a reclamation of an earlier innocence. Rodchenko's photo-story makes the canal's completion fully intersect with the prisoners' transformation into socially productive citizens. This merging allows a narrative conclusion, a passage from one moral order to another, as opposed to the kind of mere breaking-off imposed in a set of reorderable fragments.[84] The positional and temporal specificity of Rodchenko's earlier work—its implicit but crucial acknowledgment that truth is always partial, embedded in time and point of view—is evacuated, then. Instead, images are presented as reality in an unqualified way—as objective rather than perspectival truth.

The manipulations of and within Rodchenko's White Sea Canal photographs strip away their temporal contingency and specificity—the very qualities that constituted

photography's claim as an avant-garde medium. As a work that purports to image reality (hence the centrality of photography) but that at the same time exemplifies a larger social order, this photo-story has a pseudo-documentary character—one that appears again and again in Socialist Realist work, and is in fact integral to it. Socialist Realism is an inherently contradictory mode. Presenting itself as the reflection of a world held to be not empirically but ideologically true, it is suspended between the opposing discourses of realism and didacticism. A comparison between one of Rodchenko's photographs at the canal and its eventual appearance in *SSSR na Stroike* is telling (plates 288 and 289): in the published version the now seamless magic of photomontage enlarges the size of the crowd of workers (the same figures appear several times); makes the rocky wall higher and more dramatic, so that it dwarfs the figures below; and places a wooden building on an improbable perch, with a hand-painted sign on its side admonishing those who are not participating fully enough in the construction. The carefully interworked fragments, muted disjunctures, and rough adherence to perspectival laws enforce the scene's presentation as actuality.

The totalizing effect of the photo-story's mainly centralized perspectives and non-specific narrator is matched by a newly corporeal representation of both labor and the state. Social structures are made to appear as the relations between a few individuals; the state's authority is embodied in the figure of Stalin. Such an operation—coercive in the way it masks the inequality of the negotiation and the institutionalization of authority—might be understood as a totalitarian inversion of commodity fetishism, in which human relations appear as the relations between things. The photographs transform the individual workers into exemplary figures: their faces are retouched into anonymity, granting them a certain generality—neither so specific as to let them be seen as distinct individuals, nor so amorphous as to offer no guidance in providing a model of the ideal. Viewer identification is both encouraged and controlled.

The Vakhtan photo-story had also focused on the human form, and had encouraged a form of viewer identification, but the effect was fundamentally different. There, the fragmented, dynamically twisted bodies of the lumbermen, their backs turned to the camera, made for a kind of suturing of the viewer not only into the photographic space but into the work being done. In the White Sea Canal series, on the other hand, the monumentality and the foregrounding of the workers serve to separate them—and us—from the construction behind them. This positioning signals a fundamental shift in not only the representation but the conception of labor. A productive process (whether creative, interpretive, or physical) is elided. Losing its rational, productive dimension, it is instead aestheticized and monumentalized. (The photo-story's epigraph, "The poetry of labor, the romance of construction work," is a suggestive phrase in this context.) Finally it is recuperated as an agent of moral transformation. In the photo-story, the canal seems to take care of itself; the real product of work is redemption.

While we have seen that Rodchenko's options and opinions were more restricted in 1933 than previously, this alone does not account for the care, craftsmanship, and conviction that seem to inform every page of the White Sea Canal issue of *SSSR na Stroike*. The photo-story, in fact, can be read as a kind of transference, with the artist, by then in disfavor, identifying with the official narrative of penal labor as redemptive. His journey from the AMO factory and the Vakhtan lumber-mill to the White Sea Canal—from center to periphery—is an almost paradigmatic one for the career of a Soviet bourgeois intellectual. As Katerina Clark notes, the best chance of redemption for such "experts" was now felt to lie in traveling to some provincial construction site, factory, or kolkhoz.[85]

In Rodchenko's case, the quest for redemption permeates the work as unspoken text. "I left for the White Sea Canal in a very bad mood," he would write in an article of 1935, significantly titled "*Perestroika khudozhnika*" (Reconstruction of the artist):

> *This was salvation, this was a start in life. . . . Man arrives downcast, punished, and embittered, and leaves with a proudly held head, with a decoration on his breast and a start in life. And it reveals to him all the beauty of real, heroic, creative labor.*
>
> *I was staggered by the sensitivity and the wisdom with which the reeducation of the people was fulfilled. There they managed to find an individual approach to everyone. Even now, we still don't have this sensitive approach to the creative worker. We had such: Renounce formalism and go to work as you know how. There on the canal it was not done this way. . . . My pictures were placed in all the press. . . . Only in* Sovetskoe Foto *was I not published, and not a word was said about how I conducted this work. But now it was not painful to me. I knew I was right.*[86]

In its passive voice and rhetoric, Rodchenko's expression in this passage echoes the language of the narrator in the White Sea Canal story, but adds another layer: the artist's identification with the prisoners, expressed in the correspondence between the worker's path from embittered arrival to proud departure, and in Rodchenko's own journey from "a very bad mood" to the confident "I knew I was right." For Rodchenko, the canal photo-story seems to stand as an allegory for his own punishment and transformation. The terrible irony is that the coercive nature of the White Sea Canal project did not hinder Rodchenko's work—it became his main inspiration.

Notes

I am grateful to my co-curators, Magdalena Dabrowski and Peter Galassi; to this book's editor, David Frankel; and to Jean-Christophe Castelli, Maria Gough, Corey Keller, Janet Kraynak, Richard Meyer, and Molly Nesbit for reading a draft of this essay and for their many insightful comments. In many of the views in this essay I have particularly benefited from my discussions with Gough.

Unless footnoted to an English-language source, translations from the Russian in this essay are generally by myself.

1. Rodchenko, "Is rukopisi 'Rabota s Maiakovskim,'" *A. M. Rodchenko: Stat'i, vospominaniia, avtobiograficheskie zapiski, pis'ma,* ed. V. A. Rodchenko, E. Iu. Dutlova, and A. N. Lavrent'ev (Moscow: Sovetskii Khudozhnik, 1982), p. 61. Under the title "Rabota s Maiakovskim," this essay also appears in Rodchenko, *Opyty dlia budushchego: dnevniki, stati', pis'ma, zapiski,* ed. O. V. Mel'nikov and V. I. Shchennikov, compiled by Lavrent'ev and V. Rodchenko (Moscow: Grant', 1996).

2. On Rodchenko's triptych, the monochrome in the twentieth century, and the death of painting, see Yve-Alain Bois, "Painting the Task of Mourning," *Painting as Model* (Cambridge, Mass.: The MIT Press, 1990), pp. 229–57; Benjamin H. D. Buchloh, "The Primary Colors for the Second Time," *October* no. 37 (Summer 1986): 41–52; and Thierry de Duve, "Who's Afraid of Red, Yellow, and Blue," *Artforum* 22 no. 1 (September 1983): 30–37.

3. Nikolai Tarabukin, "Communication to the Inкhuк Praesidium," October 6, 1921. Quoted in Selim Khan-Magomedov, *Rodchenko: The Complete Work,* ed. Vieri Quilici, trans. Huw Evans (Cambridge, Mass.: The MIT Press, 1987), p. 292.

4. Hubertus Gassner sees this question as driving Constructivist production. Gassner, "The Constructivists: Modernism on the Way to Modernization," *The Great Utopia: The Russian and Soviet Avant-Garde, 1915–1932,* exh. cat. (New York: Solomon R. Guggenheim Museum, 1992), p. 298. In "the collective (as) threat," a paper presented at Columbia University on March 22, 1996, Maria Gough has discussed some of the contradictions that

arose in attempting to define this mandate in practice. My dissertation—"Aleksandr Rodchenko's Camera-Eye: Lef Vision and the Production of Revolutionary Consciousness" (Ph.D. dissertation, Columbia University, 1997)—looks at Rodchenko's photographic and photomontage work as a series of responses to this question.

5. Christina Lodder describes the Constructivists' limited success in developing a direct engagement with industry in her *Russian Constructivism* (New Haven: Yale University Press, 1983).

6. See Dickerman, "The Radical Oblique," in "Aleksandr Rodchenko's Camera-Eye," pp. 136–75.

7. In her seminal study, Lodder views the Constructivist artists as striving toward the ideal of productivism—toward a position, established at the end of the Inкhuк debates, that artists should engage directly in industry, producing real objects for mass production— and then as subsequently compromising in the wake of their inability fully to achieve this goal. An effect of this reading is to devalorize a major arena of Constructivist practice: graphic design and photography. Graphic design, for example, becomes the consequence of the artist "lowering his sights" (Lodder, *Russian Constructivism,* p. 181). In his important "From Faktura to Factography," *October* no. 30 (Fall 1984): 83–118, Buchloh develops a model of Constructivism as a continually shifting body of theory and practice responsive to historical exigencies. Taking such a model as a starting point, I would like to claim that among the most significant of Rodchenko's reconceptualizations of his artistic role is that of the creative producer engaged in a fundamental way with the mass media.

8. See Peter Kenez, *The Birth of the Propaganda State: Soviet Methods of Mass Mobilization, 1917–1929* (Cambridge: at the University Press, 1985).

9. Rodchenko, "Iz rukopisi 'Rabota s Maiakovskim,'" p. 67.

10. Sheila Fitzpatrick, *The Russian Revolution,* 2nd. ed. (Oxford: at the University Press, 1994), p. 94.

11. See description in ibid., pp. 93–96. See also Lewis Siegelbaum, *Soviet State and Society*

between Revolutions, 1918–1929 (Cambridge, Mass.: Harvard University Press, 1992), and Fitzpatrick, Alexander Rabinowitch, and Richard Stites, eds., *Russia in the Era of NEP: Explorations in Soviet Society and Culture* (Bloomington: Indiana University Press, 1991).

12. Another example of this is the Soviet embrace of Taylorism, the system of industrial efficiency named after the American engineer Frederick Winslow Taylor.

13. Vladimir Mayakovsky, "Agitatsiia i reklama," 1923, *V. V. Maiakovskii: Polnoe sobranie sochinenii* (Moscow: Khudozhestvennaia Literatura, 1959), 12:57.

14. Mayakovsky, "Zaveduiushchemu 'Mospoligrafom' N. T. Poliakovu. Zapiska ob 'Universal'noi reklame,'" not later than the second half of November 1923, ibid., vol. 13 (1961), p. 63.

15. Mayakovsky, "V izdatel'stvo 'Mospoligraf,'" December 29, 1923, ibid., 13:64.

16. See Christina Kiaer, "Rodchenko in Paris," *October* no. 75 (Winter 1996): 3–35, and "Boris Arvatov's Socialist Objects," *October* no. 81 (Summer 1997): 105–18.

17. Mayakovsky, "Agitatsiia i reklama," pp. 57–58.

18. Mayakovsky, "Zaveduiushchemu 'Mospoligrafom' N. T. Poliakovu," pp. 63–64.

19. Rodchenko, "Iz rukopisi 'Rabota s Maiakovskim,'" pp. 66–67.

20. Ibid., p. 66. See also Mayakovsky's, Anton Lavinskii's, and Rodchenko's joint letter to the tariff bureau of the Moscow Regional Union of Art-Workers, May 15, 1924, in *V. V. Maiakovskii,* 13:209.

21. Mayakovsky, "Ia sam," *V. V. Maiakovskii,* vol. 1 (1955), p. 27.

22. See Lennart Anderseen, *Soviet Aircraft and Aviation, 1917–1941* (London: Putnam, 1994), pp. 38–40.

23. Kiaer addressed this point in her paper "Constructivist Advertising and the Collective Wish Image," presented at the Harvard University Art Museums on March 14, 1997.

24. In the years around 1924, an enormous literature on the workers' club had developed in magazines like *Rabochii Klub,* and in a series of publications issued by Proletkul't, including *Iskusstvo v rabochem klube* (Moscow: Vserossiiskii Proletkul't, 1924) and Valerii Pletnev, *Rabochii klub: Printsipy i*

metody raboty (Moscow: Vserossiiskii Proletkul't, 1923). The workers' club was also the subject of some discussion within Lef: see Osip Brik, "Ne v teatre, a v klube," *Lef* no. 5 of 1924, p. 22; V. Zhemchuzhnyi, "Lef i klub," *Novyi Lef* no. 2 of 1927, pp. 38–39; and Sergei Tret'iakov, "Klubkombinat," *Novyi Lef* no. 2 of 1927, pp. 39–41.

25. N. Neznamov, "Na parizhskoi vystavke," *Rabochii Klub* no. 8–9 of 1925, p. 82.

26. Rodchenko, letter of June 1, 1925, *A. M. Rodchenko: Stat'i*, p. 97.

27. Varvara Stepanova, "Rabochii klub. Konstruktivist A. M. Rodchenko," *Sovremennaia Arkhitektura* no. 1 of 1926, p. 36. Published in English as "The Workers' Club: Constructivist A. M. Rodchenko" in Peter Noever, ed., *The Future Is Our Only Goal: Aleksandr M. Rodchenko, Varvara F. Stepanova*, exh. cat. for the Österreiches Museum für Angewandte Kunst, Vienna, and the A. S. Pushkin State Museum of Fine Arts, Moscow (Munich: Prestel-Verlag, 1991), p. 180.

28. Ibid.

29. Lavinskii, "Engineerism," document 23 in *Art into Life: Russian Constructivism, 1914–1932*, exh. cat. for the Henry Art Gallery, University of Washington, Seattle, with an introduction by Richard Andrews and Milena Kalinovska (New York: Rizzoli International Publications, Inc., 1990), p. 81.

30. See Kiaer's description of the rostrum in her "Rodchenko in Paris," p. 31.

31. Ibid.

32. RGALI (Russian State Archive for Literature and Art), f. 841, op. 15, d. 15, l. 18. February 2, 1925, meeting of the organizing committee.

33. Stepanova, "Rabochii klub," p. 36, and "The Workers' Club," p. 181.

34. See Nina Tumarkin, *Lenin Lives!: The Lenin Cult in Soviet Russia* (Cambridge, Mass.: Harvard University Press, 1983). See also Dickerman, "Lenin in the Age of Mechanical Reproduction," in "Aleksandr Rodchenko's Camera-Eye," pp. 69–135.

35. On literacy, electrification, and chess, see respectively Peter Kenez, *The Birth of the Propaganda State: Soviet Methods of Mass Mobilization, 1917–1929* (Cambridge: at the University Press, 1985); Jonathan Coopersmith, *The Electrification of Russia, 1880–1926*

(Ithaca: Cornell University Press, 1992); and D. J. Richards, *Soviet Chess* (Oxford: Clarendon Press, 1965).

36. Mark von Hagen notes the role of both workers' clubs and chess in the project of transforming Red Army soldiers into model Soviet citizens. See his *Soldiers in the Proletarian Dictatorship: The Red Army and the Soviet Socialist State* (Ithaca: Cornell University Press, 1990).

37. RGALI, f. 841, op. 15, d. 15, l. 1. February 11, 1925, meeting of the organizing committee for the Soviet section of the Paris exhibition.

38. Stepanova, "Rabochii klub," p. 36, and "The Workers' Club," p. 181.

39. Rodchenko, "Protiv summirovannogo portreta za momental'nyi snimok," *Novyi Lef* no. 4 of 1928, p. 16. Published in English, trans. John E. Bowlt, as "Against the Synthetic Portrait, for the Snapshot," in Christopher Phillips, ed., *Photography in the Modern Era: European Documents and Critical Writings, 1913–1940* (New York: The Metropolitan Museum of Art and Aperture, 1989), p. 241.

40. Rodchenko, "Against the Synthetic Portrait," p. 240.

41. Ibid., p. 239.

42. Ibid.

43. Ibid., p. 241.

44. Ibid.

45. The history posters are only one of several archival projects taken on by Rodchenko in these years. In various issues of *Novyi Lef*, for example, he published a curious group of found photographs all with the caption "From the *revarkhiv* [rev(olutionary) archive] of A. R." See Dickerman, "The Fact and the Photograph," in "Aleksandr Rodchenko's Camera-Eye," pp. 176–215, for discussion of this project, and of the significance of the archival model in general.

46. "Tekushchie dela," *Novyi Lef* no. 2 of 1927, p. 47.

47. Fitzpatrick, *The Russian Revolution*, p. 159.

48. Boris Eikhenbaum, "Literaturnyi byt," *Moi vremennik* (Leningrad, 1929), pp. 49–58. Published in English as "Literary Environment," in Ladislav Matejka and Krystyna Pomorska, eds., *Readings in Russian Poetics: Formalist and Structuralist Views* (Ann Arbor: University of Michigan, 1978), p. 56.

49. See, for example, Allan Sekula, "The Body and the Archive," *October* no. 39 (Winter 1986): 3–64. See also Sandra S. Phillips, Mark Haworth-Booth, and Carol Squiers, *Police Pictures: The Photograph as Evidence*, exh. cat. (San Francisco: San Francisco Museum of Modern Art and Chronicle Books, 1997).

50. Mikhail Kaufman, "An Interview," *October* no. 11 (Winter 1979): 63.

51. Tret'iakov, "B'em trevogu," *Novyi Lef* no. 2 of 1927, p. 3.

52. See Fitzpatrick, *The Russian Revolution*, chapters 5 and 6, pp. 120–72; Fitzpatrick, "Cultural Revolution as Class War," in Fitzpatrick, ed., *Cultural Revolution in Russia, 1928–31* (Bloomington: Indiana University Press, 1978), pp. 8–40; and Katerina Clark, "Little Heroes and Big Deeds: Literature Responds to the First Five-Year Plan," in ibid., pp. 189–206.

53. Clark, "Engineers of Human Souls in an Age of Industrialization: Changing Models, 1929–1941," in Siegelbaum and William Rosenberg, eds., *Social Dimensions of Soviet Industrialization* (Bloomington: Indiana University Press, 1993), p. 252.

54. "Ob"edinenie Oktiabr'," in I. Matsa, ed., *Sovetskoe iskusstvo za 15 let: Materialy i dokumentatsiia* (Moscow and Leningrad: Ogiz-Izogiz, 1933), pp. 608–11. Published in English as "October—Association of Artistic Labor: Declaration," in Bowlt, ed. and trans., *Russian Art of the Avant-Garde: Theory and Criticism, 1902–1934*, 2nd. ed. (New York: Thames and Hudson, 1988), pp. 274–79.

55. "October—Association of Artistic Labor: Declaration," p. 276.

56. Ibid., pp. 274–75.

57. "Programma fotosektsii," in Matsa, ed., *Sovetskoe iskusstvo za 15 let*, p. 616. Published in English, trans. Bowlt, as "Program of October Photo Section," in Phillips, ed., *Photography in the Modern Era*, p. 285. Margarita Tupitsyn offers an extensive analysis of the October photographic platforms and of the debates that ensued. See her *The Soviet Photograph 1924–1937* (New Haven: Yale University Press, 1996).

58. Tret'iakov, "Biografiia veshchi," in Nikolai Chuzhak, ed., *Literatura fakta* (Moscow: Federatsiia, 1929), pp. 66–70.

Facsimile reprint ed. (Munich: Wilhelm Fink, 1972). Gassner notes the relevance of this essay to Rodchenko's work for *Daesh'* in his *Rodčenko Fotografien* (Munich: Schirmer/Mosel, 1982).

59. Ibid., p. 66.

60. Ibid., p. 69.

61. Michael Fried, "The Structure of Beholding in Courbet's *Burial at Ornans,*" *Critical Inquiry* no. 9 (June 1983): 635–82; "Painter in Painting: On Courbet's *After Dinner at Ornans* and *Stonebreakers,*" *Critical Inquiry* no. 8 (Summer 1982): 619–49; and "On the Central Group in Courbet's Studio," in Stephen J. Greenblatt, ed., *Allegory and Representation: Selected Papers from the English Institute, 1979–80* (Baltimore: Johns Hopkins University Press, 1981), pp. 94–127.

62. Gassner discusses this shift in relation to the reception of John Heartfield's work in Russia. See Gassner, "Heartfield's Moscow Apprenticeship," in Peter Pachnicke and Klaus Honnef, eds., *John Heartfield* (New York: Harry N. Abrams, Inc., 1992), pp. 256–89.

63. Fitzpatrick, *The Russian Revolution,* chapter 6, pp. 148–72.

64. S. Fridliand, "Za proletarskuiu fotografiiu," *Proletarskoe Foto* no. 1 of 1931, p. 14.

65. ROPF (Rossiiskoe ob"edinenie proletarskikh fotoreporterov) declaration, *Proletarskoe Foto* no. 2 of 1931, p. 15.

66. "Golosa rabochikh, kolkhoznikov, fotoreporterov na tvorcheskoi diskussii," *Proletarskoe Foto* no. 2 of 1932, pp. 13–17.

67. Ibid., p. 16.

68. Open letter from October, *Proletarskoe Foto* no. 2 of 1932, p. 3.

69. Lavrent'ev has quoted the resolution expelling Rodchenko, which claimed that his signature on the group's open letter had not been sincere: "With regard to the systematic refusal to participate in the practical reconstruction of the group, and repeated declarations of resistance to this reconstruction, it is concluded that Comrade Rodchenko is excluded from the group, considering that the open letter of the group signed by him is objectively a tactical maneuver to hide his resistance to practical reconstruction." Lavrent'ev, *Rakursy Rodchenko* (Moscow: Iskusstvo, 1992), p. 167.

70. Rodchenko, "Perestroika khudozhnika," *Sovetskoe Foto* nos. 5–6 of 1935, p. 20.

71. Ibid.

72. Lavrent'ev, "Rodchenko v *SSSR na Stroike,*" *Sovetskoe Foto* no. 1 of 1981, p. 40.

73. Clark discusses this shift in literature in "Engineers of Human Souls."

74. See Clark, "Little Heroes and Big Deeds," pp. 204–5.

75. Lavrent'ev, *Rakursy Rodchenko,* p. 169.

76. Loren Graham, *The Ghost of the Executed Engineer: Technology and the Fall of the Soviet Union* (Cambridge, Mass.: Harvard University Press, 1993), pp. 61–65.

77. Rodchenko, "Perestroika khudozhnika," p. 20.

78. S. Morozov, "Na putiakh k realizmu, k narodnosti," *Sovetskoe Foto* nos. 5–6 of 1936, pp. 3–4.

79. Ibid.

80. Stepanova, letter of May 25, 1933, in Stepanova, *Chelovek ne mozhet zhit' bez chuda. Pis'ma, poeticheskie opyty, zapiski khudozhnitsy,* ed. O. V. Mel'nikov, compiled by V. Rodchenko and Lavrent'ev (Moscow: Izd. "Sfera," 1994), pp. 267–77.

81. Buchloh, "From Faktura to Factography," p. 114. In chapter 5 of *The Soviet Photograph* (pp. 127–74), Tupitsyn offers an important reading of the White Sea Canal issue, though a somewhat different one from Buchloh's and from mine.

82. Emile Benveniste, *Problems of General Linguistics,* trans. Mary Elizabeth Meeks (Coral Gables: University of Miami Press, 1971), p. 208.

83. Michel Beaujour, "Exemplary Pornography: Barres, Loyola, and the Novel," in Susan Suleiman and Inge Crossman, eds., *The Reader in the Text: Essays on Audience and Interpretation* (Princeton: at the University Press, 1980), p. 344.

84. On the nature of narrative conclusions, see Hayden White, "The Value of Narrativity," in W. J. T. Mitchell, *On Narrative* (Chicago and London: The University of Chicago Press, 1980), p. 22.

85. Clark, "Engineers of Human Souls," p. 253.

86. Rodchenko, "Perestroika khudozhnika," p. 20.

Peter Galassi

In the course of the 1920s photography came to play an important and eventually a dominant role in Rodchenko's work. This development was shaped, sometimes decisively, by the highly charged cultural politics of early Soviet Russia, and by Rodchenko's participation in the militant Lef group of artists and intellectuals. Since the institutions, associations, decrees, debates, and manifestos of the period left behind a rich paper trail, and since members of Lef voluminously explained their work and ideas, it is possible to map Rodchenko's immediate cultural environment in considerable detail. Without such a map it is easy to get lost.[1]

Nevertheless, as Rodchenko himself insisted, it can be enlightening to look at things from more than one point of view, and his photography invites a mobile outlook, for it has many links, parallels, and echoes beyond the borders of Russia. Rodchenko was a central protagonist of art in Russia in the aftermath of the Revolution. He was also a key participant in photography's obstreperous European revolution of the 1920s. This essay approaches his work from the latter perspective, with special attention to Germany, which served as Rodchenko's principal window on the West. After an introductory section, the essay will trace the evolution of Rodchenko's photographic work, periodically considering related issues before again taking up the chronological thread.

The invention of photography, made public in 1839, was a product of the Industrial Revolution, and its fortunes were intimately tied to the great social changes that accompanied the progress of industrialization. The rise of photographic modernism in Europe in the 1920s was an important new chapter in this story, and it involved both the coming to maturity of photographic technologies and the new political and cultural landscape of Europe in the wake of World War I. This vast background can hardly be summarized here, but it is nonetheless essential to keep it in mind. Among other things, the political background helps to explain the differences between advanced photography in Europe, with its eager, untidy engagements with the world outside the studio, and the parallel movement in America, where photographers found artistic solace in a principled withdrawal from the upheavals of modernity.[2]

Except for the United States, isolated geographically and psychologically in the New World, the combatant nations of the Great War emerged from it in a state of turmoil. Throughout Europe, in perception if not also in concrete and immediate fact, the continuities of the past had been broken, radically altering the prospects of the future. Different sensibilities reacted differently, of course, but revolutionaries and reactionaries alike confronted a deeply altered state of affairs. In this sense the longing of many in France to recover the certainties of the classical past was not unrelated to the longing of

Aleksandr Rodchenko. Self-portrait. 1924. Gelatin-silver print (printed 1990s). 6$\frac{7}{16}$ × 4$\frac{5}{8}$" (16.4 × 11.8 cm). The Museum of Modern Art, New York. Gift of the Rodchenko family.

many in Russia to dispense with them once and for all. Nevertheless, the effects of the war were felt most deeply in countries that experienced defeat or revolution.

The circumstance was most extreme in Russia, where the war had precipitated the abrupt collapse of centuries of repressive tsarist rule, preparing the way for the Bolshevik seizure of power in October 1917 and the civil war that ensued. But the demise of Kaiser Wilhelm in November 1918 left a defeated Germany in a barely less precarious state. Ilya Ehrenburg, the peripatetic Russian writer and political chameleon, wrote of the early 1920s, "In Dresden, the Communists are organizing a workers' government and in Munich the Fascists are preparing a revolt. Reading about this, Berliners think that Dresden and Munich are fortunate cities. They have genuine timetables. In Berlin no one knows when and where the next train will be leaving."[3] Within little more than a decade the confusion would be resolved by the brutal regimes of Joseph Stalin and Adolf Hitler. Our familiarity with the outcome may require of us a special effort to imagine the brief time when it was not yet certain.

Just before World War I, the venerable art of painting had spawned a revolution of its own. The innovation extended well beyond Cubism, but Cubism in itself created a watershed from which fruitful experiment would spread along many paths for decades to come. Although it had been created in France, its influence rapidly widened and diversified in many countries, including Russia, where Kasimir Malevich, Vladimir Tatlin, and others created distinctive offshoots on the eve of the Revolution. Even those artists who dissented from the influence of Cubism, such as the proponents of New Objectivity (*Neue Sachlichkeit*) in Germany, did so in the context of a wholly trans-formed artistic landscape. The upheavals of the war further enriched and complicated that landscape by giving rise to a new sense of anxiety and urgency in the arts, often explicitly associated with the turmoil of social and political life. In the eyes of the Hungarian leftist Ludwig Kassák, co-author, with László Moholy-Nagy, of the fascinating *Buch neuer Künstler* (Book of new artists, 1922), "There has never been an epoch compa-rable to ours in which legions of awakened men set out in so many different directions in search of new form—in which so many men burn with a fanatical flame from which bursts the cry of a new birth: an epoch which creates simultaneously the fury of despair and the flaming pillar of positive flight."[4]

At the core of the new outlook, or constellation of outlooks, was a widely felt (and variously interpreted) imperative to reassess not only the materials and styles of art but also its functions and audiences. For many, the search for new forms of art was no longer enough; it was necessary to change the very *idea* of art, in order to describe, or even to create, new forms of life. Bursting upon a tradition already in the full flower of reinven-tion, this imperative bore profound and lasting consequences. Among these was a new understanding of photography.

The notion that photography might serve as a medium of high art had flickered at the margins of European culture since 1839, and from time to time it had produced some

fine pictures. But photography's prospects as an art had invariably been identified with the emulation of painting, thus foreclosing in advance the possibility that photography might tread an untrodden path. In consequence, the notion of photography as art had produced not an evolving tradition but a sequence of dead ends, of which the most recent—the turn-of-the-century "artistic photography" movement—was the most vacuous.

In the meantime, applied or vernacular photography, propelled by resourceful inventors and entrepreneurs and unfettered by pretensions to the lofty status of fine art, had evolved considerably. Indeed this evolution was so great, and its effects so massive, that by 1919 photography hardly resembled the medium that France had announced as its gift to the world eighty years before.[5] There were three main paths of development, all significant in themselves but especially powerful in concert. The first involved the way photographs were made: earlier constrained by a tripod and a slow and messy process, the photographer had been set free. The invention of the dry plate in the 1880s had unleashed a gathering momentum of ease and mobility, which culminated in the 1920s with the introduction of such versatile hand-held cameras as the Ermanox and the Leica. Many have called photography the democratic medium, but it became truly accessible to everyone only with the advent of the dry plate. When everyone *did* become a photographer—when there emerged not only a great mass of amateurs but a diverse array of specialized professionals as well—the proliferation of new subjects and new ways of picturing them was exponential.

The second key dimension of photography's maturity concerned the ways in which photographs reached their audiences. Toward the end of the nineteenth century, persistent tinkering had at last made it possible to translate a photograph mechanically into ink on paper. This innovation did a great deal more than introduce a cheaper and more efficient way of multiplying the photographic image, for it created a new medium in which text, photograph, and other graphic elements were combined in an amalgam of unprecedented fluidity. Moreover, the photomechanical revolution coincided with other advances in printing technology, which soon enabled the press run of a daily newspaper to reach into the millions.

Finally, industrial technology at the turn of the century had created motion pictures. In its first two decades, just as the photographically illustrated press was achieving modern mass-market proportions, film too captured a great popular audience. In the meantime the most alert practitioners of the new medium were learning how to exploit its unique vocabulary of montage, which would have an enormous and liberating influence on still photography.

These three developments in applied photography—its extreme ease, mobility, and availability; its prominent and polymorphous presence in the mass media; and its extension into film—were just achieving maturity at the close of World War I. Consequently,

although photography was much older than the skyscraper and the airplane, it was rightly regarded along with them as an exemplar of modernity.

That this modern medium owed none of its potent new capabilities to high-art traditions made it all the more appealing to the advanced European artists who took it up with such a vengeance in the 1920s. Up-to-date, mechanical, perceived as impersonal and objective, saturated in the reality of the world outside the studio, capable of reaching a mass audience, photography was also taken to be blessedly free of the cultivated pieties of the past. It offered a welcome alternative to artistic business as usual, a path of escape from bourgeois convention and pretension, which many progressive artists blamed for the devastating war. The adventurous avant-gardes of Europe pursued this opportunity with quasi-anarchic enthusiasm, contributing to a sea change in photography for which "revolution" is not too strong a word.

The emancipation of the medium from the moribund aesthetic of "artistic photography" was the least of it. For by adopting the fecund, chaotic vernacular as a model, forward-looking artists embraced not one photography but many. They borrowed its energy and repaid in the coin of discipline, opening a dialogue—a love affair, an argument, a full-blown, open-ended exchange—between photography's artistic and its practical functions. Photography has been at once an art and not an art ever since, and in this impure, unstable identity has rested its vitality.

Rodchenko's involvement with photography was an integral aspect of the adventure he began in 1921. Concluding that painting was hopelessly compromised by the bourgeois arrangements in which it had flourished, he not only abandoned it but enacted its death, committing himself henceforth—in principle, at least—to applied art in the service of the nascent Communist society. Identifying the avant-garde mythology of artistic progress with the Marxist mythology of the Revolution, Rodchenko projected the momentum of his work into a future both ideal and unknown—ideal *because* it was unknown. For while Bolshevik ideologues had a hard enough time squaring their intractable economic and social problems with Marx's airy predictions, Rodchenko and other artists who threw in their lot with the Communist dream had still less to go on.

The absence of a clear path was part of what convinced them that they were going in the right direction. In 1919, *Azbuka Kommunizma* (The ABC of Communism), a vastly popular primer issued by the Party, had proclaimed that in Russia, "Within a few decades there will be quite a new world, with new people and new customs."[6] In 1923, in the first issue of *Lef*, the journal of Rodchenko's Lef group, his friend Sergei Tret'iakov asserted that "since its infancy, Russian Futurism has oriented itself not toward the creation of new paintings, poetry, and prose, but toward the making of the new man, using art as one of the means of this creation."[7] This alloy of naïveté and hubris was a hallmark of modernist zeal, throughout the West as well as in Russia. (In France in the 1920s, for example, Le Corbusier proposed to raze the center of Paris so as to rebuild it

to a sweeping design of his own.) In Russia, however, which lurched into modernity with unusual abruptness, the thirst for a new beginning took a particularly virulent form, in art as well as in politics. Rodchenko's work embodies an extreme of a specifically modern creativity, in which the artistic concept no longer defined an endpoint toward which the work aspired but provided a starting point from which to embark on an uncharted future. The extraordinary energy and inventiveness of his art cannot be fully understood apart from the intensity of the political illusion that fueled it.

The contrast between Rodchenko's work before and after 1921 is stark, marking as radical a break as occurred in the work of any twentieth-century artist. Before: a rarefied art of abstraction, cloistered from the world outside the studio, unfolding according to a fierce internal logic unintelligible to the man in the street. After: what Alfred H. Barr, Jr., described as "an appalling variety of things,"[8] called into being as much by successive professional assignments or commissions as by any artistic imperative, and often addressed to the broadest possible audience. Before: work in the traditional mediums of easel painting, sculpture, drawing, and printmaking, charting a teleology of stylistic progress whose roots Rodchenko traced into the distant past.[9] After: work in virtually every medium except those he had mastered earlier, ranging broadly in the applied arts, including designs for fabric, costumes, jewelry, and furniture, and sets and costumes for theater and film. Here continuities of style were obliged to make giant leaps across diversities of function. Instead of creating self-sufficient objects that articulated a unified aesthetic principle, the artist adapted his creativity to the varying demands of the practical function at hand, often in collaboration with others.

In the midst of this adventure Rodchenko engaged photography not as a distinct medium, and certainly not as a pure art, but as part of an open-ended array of available tools. Nor did he first engage photography as a photographer. The technique of collage was part of the Cubist vocabulary he had received from Malevich, Tatlin, and others, and as he turned away from painting his collages began to incorporate a wide variety of vernacular graphic material, including photographic imagery. Soon, if not from the beginning, this sort of collage was associated in Rodchenko's circle with the abrupt juxtapositions of cinematic montage.[10] His most lasting achievement in the new medium consisted of the cover and eight illustrations that he made in March and April 1923 for an edition of Mayakovsky's poem *Pro eto* ("About this," "About it," or simply "It"; plates 63–71).[11] Expressing Mayakovsky's troubled state of mind as he endured a separation from his lover Lili Brik, the poem, written between December 1922 and early February 1923, is aimed at redeeming the intensity of "It"—their love—from the depredations of comfort and habit. But the poet's passion is granted a political dimension too, for habit also threatens the spirit of the Revolution: "Featherbeds will squash / both willpower and stone, / the Commune will turn / into comfy bunkum. / . . . / October's storm of judgment is behind."[12]

We who must read the poem in translation can guess only dimly at its wit and idiomatic verve, but even in English Mayakovsky's vaults from colloquial realism to delirious fantasy are invigorating. The poem's vivid imagery and the visual analogies that spark its poetic leaps—a pillow becomes an ice floe, a cigarette smoldering in the fireplace is confused with a distant bonfire seen through the window—are well suited to the capacities of photocollage. With the diversity of their imagery and their jumps in scale, Rodchenko's illustrations capture the poem's boisterous energy.

Several of the collages contain geometric elements that recall the organizing grids of Constructivism. But their freedom of composition and effect brings to mind the anarchic energy of collages made a few years earlier by the Berlin Dadaists Raoul Hausmann, John Heartfield, Hannah Höch, and George Grosz.[13] Shortly before holing up to write the poem, in fact, Mayakovsky had returned to Moscow from Paris and Berlin, bringing with him quantities of printed material including not only avant-garde periodicals such as *Der Dada* (fig. 1) but samples of the illustrated press from which the Dadaists—and Rodchenko—clipped their raw material.

Rodchenko's turn toward the applied arts in 1921 had coincided with the end of Russia's devastating civil war, which had largely isolated the country from the rest of the world. The relaxation of extreme wartime measures and the relative openness of the New Economic Policy (NEP) era allowed a tentative rebuilding of ties to the West, and in particular to Germany. A variety of forces, including Russia's desperate need for industrial technology and the hostility of the victorious Allies toward both Russia and Germany, encouraged the growth of this special relationship, formally ratified in the Rapallo accord of 1922. As Germany recovered from economic depression and unchecked inflation, and as Russia emerged from the ashes of the civil war, their budding relationship fostered a lively cultural exchange.[14] From 1922 onward, this link was enhanced within the Lef circle by the frequent excursions of Mayakovsky, Osip Brik, and others to Germany, especially to Berlin. From each journey the traveler returned with the latest foreign publications for deposit at the Brik apartment and eventual distribution to other members of the group.[15]

Progressive artists in Germany and Eastern Europe, disgusted with the corruptions of the past and eager for a bold new start, were for their part thirsty for news of the new Russian art, which appealed both for its bold formal experiments and as a talisman of social progress. Even before they had seen Tatlin's work, the Dadaists opened their Berlin fair of 1920 under the slogan "*Die Kunst ist tot. Es lebe die neue Maschinenkunst Tatlins*" (Art is dead. Long live the machine art of Tatlin). Moholy-Nagy, emigrating that year from Hungary to Berlin, soon embraced Russian Constructivism (and the work of Rodchenko in particular) as an escape from the dead end of Expressionism. The Bauhaus (where Moholy taught), in Weimar and later Dessau, evolved in uncanny parallel to Vкнuтемаs (where Rodchenko taught), in Moscow, both schools being dedicated to propagating new forms of art for a new form of life.[16]

1. Cover of *Der Dada* no. 3 (1920), reproducing a collage by John Heartfield. Collection Merrill C. Berman.

The overheated imagery and antics of Dada and the disciplined forms and programs of Constructivism were equally inspired by revolutionary fervor, and the encounter between them produced sparks of experiment that epitomize the turbulent creativity of the period.[17] Unlike his contemporary El Lissitzky, who was often in Germany and played a leading role in the alliances, arguments, exhibitions, and publications that marked this heady exchange, Rodchenko was dependent on his Lef colleagues for news from the Western front. But from 1923 onward he remained keenly alert to it. Thus the *Pro eto* collages simultaneously mark the beginning not only of his sustained involvement with photography but of his participation in the rapidly evolving course of European, and especially German, photographic modernism. The two sides make a single coin. Whatever the specific commission or occasion of a given work, however its meaning might be inflected by its Soviet theme and audience, Rodchenko's photographic activity drew from and contributed to a lively artistic field that stretched beyond the geographical and ideological borders of the Soviet Union.

Throughout the 1920s and early '30s, the medium of photocollage was a prominent feature of that field, and it developed a broad range of expression, from the witty anatomies of Höch through the Freudian puzzles of Moholy to the hectoring propaganda of Heartfield and the alluring concoctions of advertising. These varied applications embodied diverse and sometimes mutually antagonistic ideologies of progress, but underlying them all was the universal perception that the medium of photocollage was distinctly modern and therefore progressive.

Hausmann attributed the rise of photocollage to a postwar climate in which "not only painting, but all the arts and their techniques, required a revolutionary transformation in order to remain relevant to the life of their times."[18] In an essay of 1926, Lissitzky set current artistic experiment in the context of mass communication:

> *In America there was a new optimistic mentality. . . . It was there that they first started to shift the emphasis and make the word be the illustration of the picture rather than the other way around, as in Europe. Moreover, the highly-developed technique of [half-tone reproduction] made a particular contribution; and so the photomontage was invented.*
>
> *. . . The invention of easel-pictures produced great works of art, but their effectiveness has been lost. The cinema and the illustrated magazine have triumphed. We rejoice at the new media which technology has placed at our disposal.*[19]

Lissitzky's key perception is that the medium of photocollage was not the invention of an artistic elite but the outgrowth of a technological revolution. Although he granted priority to American experiments (fig. 2), European magazines and newspapers were also quick to exploit the opportunity of photomechanical reproduction (figs 3–5). By the 1920s the liveliest illustrated periodicals were German, especially those published by the Berlin firm of Ullstein, such as *Berliner Illustrirte Zeitung, Die Dame, Koralle,* and *Uhu.*[20]

2.

2. Advertisement for Westinghouse in *Collier's,* July 1, 1916, p. 35.

3. 4. 5.

3. *Berliner Illustrirte Zeitung*, May 13,
1917, p. 264. General Research Division,
The New York Public Library, Astor,
Lenox, and Tilden Foundations.

4. *Berliner Illustrirte Zeitung*, June 3,
1917, p. 308. General Research Division,
The New York Public Library, Astor,
Lenox, and Tilden Foundations.

5. *Berliner Illustrirte Zeitung*, July 3,
1921, pp. 402 and 403. General Research
Division, The New York Public Library,
Astor, Lenox, and Tilden Foundations.

To practitioners of the avant-garde photocollage, these publications and others provided a rich store of raw material, and a great deal else as well. The eagerness to appeal to advanced taste; the wide range of subject matter, offering vicarious experience of far-flung places; the abrupt juxtapositions and shifts of scale; the rich bouillabaisse in which disparate elements of image, text, and graphic material exchanged flavors without losing their distinct identities; the familiar tone of address to the viewer, by turns seductive, hortatory, and comic; the spirit of effortless recycling, recombination, and reproduction; the disappearance of the artist's hand behind the anonymous tools of the graphic designer and the art director—all of these qualities of avant-garde photocollage were already present in its raw material.[21]

One persistent motif suggests the way in which the character and associations of that material survived its transformation in the photocollages of the avant-garde. It is the automobile tire, invariably presented in three-quarter perspective: an ellipse ready to roll (plate 69).[22] The ubiquity of tire ads in the illustrated press only begins to explain the popularity of this motif, which carries with it, unaltered, an implication of modern energy and mobility. Nor does it seem incidental that among Rodchenko's most vibrant *Pro eto* collages are two that take aim at the overstuffed comforts and indulgent entertainments of bourgeois decadence (plates 67 and 68). These spirited lampoons distill in the vocabulary of art the cacophony of a crowd of advertisements on a single page, each raising its voice to draw attention from the others. Rodchenko saw the shift from painting to photocollage as full of revolutionary significance, but this did not prevent him from capitalizing on the liveliness of bourgeois advertising.

It would be absurd to suggest that Rodchenko and other early practitioners of photocollage passively adopted the aesthetic of the anonymous layout artists who churned out the pages of the illustrated press. That would ignore the inventive, self-conscious sophistication of the photocollage artists, and their often bitterly critical attitude toward their raw material. But it was more than raw material—it was a vocabulary, a whole language of modernity, that enabled the artists to make their work urgently modern precisely because it so deeply implicated that work in the modern world. Thus the art

6.

7.

of photocollage exemplified photography's new force in the realm of the arts, a force arising from the permeability of the shifting barrier between the medium's artistic and vernacular roles.

Rodchenko the photocollagist was not a photographer; when he needed photographs of Mayakovsky and Lili Brik for his *Pro eto* collages, he commissioned them from portraitist Abram Shterenberg. To the collagist, photography was not a medium for fixing visual perceptions but an archive of ready-made pictures evoking a far wider range of experiences than any individual could encounter. (Typically of the genre, the *Pro eto* collages include scenes from places Rodchenko never visited—a skyscraper in New York [plate 69] and a tribal gathering, presumably in Africa [plate 67].) So Rodchenko became a collector of photographs—not only those he clipped from the illustrated press but also what he called the *revarkhiv*, the revolutionary archive of scenes from the Revolution and its aftermath (figs. 6 and 7, for example).[23]

This approach to photography led directly to another, which introduced Rodchenko to the nuts and bolts of the medium. Referring to the period of 1923 or 1924, he later recalled that "in connection with my photomontage work, I began studying photography as well—now and then I had to copy, enlarge or reduce something. . . . I bought myself two cameras."[24] In other words, Rodchenko's engagement with photography as a bottomless resource of preexisting imagery soon involved him with photography as a fluid process of replication and recombination. These two functions, central to photography's identity as a modern medium, were linked to each other in a circular way. The photomechanical revolution had added a powerful range of imagery to the arsenal of the printed press. It had also transformed the whole practice of the graphic arts by radically enhancing the ease of copying, enlarging, reducing, and thus combining graphic elements of all kinds, including photographs. This created both a fluid, polymorphous field of imagery and a new profession—what we now call the

6. Unknown photographer. View of the Sukharevskii market, Moscow. 1925 or earlier. Gelatin-silver print. A. Rodchenko and V. Stepanova Archive, Moscow.
 From Rodchenko's revarkhiv, *or archive of documentary photographs of the Revolution and its aftermath.*

7. Unknown photographer. Destruction of the monument to Alexander III, Moscow. 1917. Gelatin-silver print, $3\,13/16 \times 2\,3/8$" (9.7 × 6.1 cm). The Museum of Modern Art, New York. Gift of the Rodchenko family.
 There is another print of this photograph in Rodchenko's revarkhiv, *in the A. Rodchenko and V. Stepanova Archive, Moscow.*

art director, who shapes and manages the process. From the new field of imagery Rodchenko and others drew both the material and the modernity of their collages, and from the role of the art director they modeled a new artistic identity.

Rodchenko's first work as a photographer in the usual sense grew directly from his photocollage work. In 1924, anticipating further collaborations with Mayakovsky, he made a group of posed studio portraits of the poet (plates 133–34, 137–38, and 140–41). These in turn led to an open-ended series of portraits of family and friends, through which Rodchenko began to explore photography as a descriptive medium. This exploration included the brilliant concision of the portrait of his mother, tightly cropped from the more generous framing of the negative (plate 146), and a handful of multiple exposures (plate 148, for example). Both the cropping and the double exposures signal the graphic designer's approach to the photograph as an invitation to alteration.

Except for Shterenberg's portrait of Lili Brik, commissioned and presumably stage-managed by Rodchenko and Mayakovsky for the cover of Pro eto (plate 63), the unadorned directness of Rodchenko's Mayakovsky portraits (heightened by the poet's muscular good looks and piercing stare) was virtually without precedent in photographic art. In Russia as in the West, the artistically ambitious photographer was expected to emulate the dignified cuisine of traditional painted portraiture. But there did exist a precedent in vernacular photography: the identity picture (what we would now call the passport photo), which had begun to achieve currency in the late nineteenth century, and whose simple recording function discouraged artistic posturing.[25] This does not mean that Rodchenko intended to evoke the vernacular model, or even that he was explicitly aware of it as such.[26] But it does mean that here as in other instances yet to come, Rodchenko's photographic work effected a short circuit between the high ambitions of the avant-garde and the basest vernacular forms. For Rodchenko as for many of his most adventurous contemporaries, much of the force of early modernist photography derived from the unrepeatable first thrill of applying to artistic ends the most elementary operations of the medium.

We encounter the same short circuit as we consider the implications of the multiplicity of the Mayakovsky portraits. (There are six of them.) Four years later, in an essay titled "Against the Synthetic Portrait, for the Snapshot," Rodchenko would denounce as false the traditional aim of capturing a whole personality in a single painted portrait, and would advocate instead the accumulation of photographic portraits, each evoking a specific aspect of the subject. The essay contributed to a body of sophisticated Lef theory that prized the contingency of perception in literary and pictorial description, and it illuminates Rodchenko's persistent practice of photographing in series.[27] Yet it is also true that serial portraiture had been a commonplace since the 1850s, when André-Adolphe-Eugène Disdéri, the resourceful Parisian purveyor of cheap portraits, multiplied his revenues by dividing his plate into eight frames exposed in succession (fig. 8).

8.

9.

Rodchenko did have occasion to use his portraits of Mayakovsky for their intended purpose, on the front and back covers of the poet's *Razgovor c fininspektorom o poesii* (Conversation with the finance inspector about poetry, 1926; plates 135 and 136). But this use was soon overshadowed by another. After Mayakovsky's death, in 1930, and especially after Stalin proclaimed the poet a hero of the Revolution in 1935 (adding, ominously, that "indifference to his memory and to his work is a crime"), Rodchenko's photographs took on a new life as icons of an orchestrated cult of personality—what Boris Pasternak called Mayakovsky's "second death."[28] Blown up to large, sometimes enormous proportions, and printed softly in warm, romantic tones (plates 142–45), the portraits were marshaled in the creation of mythic propaganda.

By the spring of 1925, when Rodchenko visited Paris (where he would play a central role in projecting a forward-looking image for the Soviet regime at the *Exposition Internationale des Arts Décoratifs et Industriels Modernes*), he had mastered photography as the potent process at the heart of the graphic arts, and had made a small number of remarkable photographs. But he did not yet consider himself a photographer. The trip to Paris was his first and only encounter with a Western metropolis and its burgeoning technology. In his almost daily letters to Varvara Stepanova he frequently remarked on the novelty of fast-moving motor traffic, and still more often on his plans to purchase cameras that were hard or impossible to obtain in Russia. He brought back two: a 4-by-6.5-cm. Ica and a 35-mm. Sept, a hand-held movie camera that could hold five meters (or about ten seconds) of film and that could also take still frames.[29] Rodchenko later used the Sept to make short film clips, individual photographs, and works composed of two or three frames, as if excerpted from a film sequence (plates 222–24)—a form halfway between film and still photography, similar in spirit to roughly contemporaneous composite works by Josef Albers (fig. 9).

A basic grasp of the capabilities and limitations of Rodchenko's various cameras is crucial to an understanding of his work, and since the matter may be puzzling to non-

8. André-Adolphe-Eugène Disdéri. *Chevalier Hidalgo.* 1860. Uncut sheet of carte-de-visite portraits. Albumen-silver print from a glass negative, 7⅞ × 9⅛" (19.9 × 23.1 cm). The Museum of Modern Art, New York. Purchase.

9. Josef Albers. *Marli Heimann. All during an Hour* (*Marli Heimann. Alle während 1 Stunde*). 1931. Collage of gelatin-silver prints, 11¹¹/₁₆ × 16⅞" (29.7 × 41.8 cm). The Museum of Modern Art, New York. Gift of the Josef Albers Foundation, Inc.

specialists a brief explanation is perhaps in order here. A camera is typically classified (as I have just classified the Ica and the Sept) by the dimensions of the negative it produces or, if it is a roll-film or motion-picture camera, by the width of the film. A key issue for Rodchenko and his contemporaries was that a large negative requires a large camera, mounted on a tripod, which severely limits the photographer's mobility. Rodchenko regularly used two tripod-bound cameras: one, 13 by 18 cm. (or roughly five by seven inches) in format, which he acquired for copy work for his photocollages; the other, 9 by 12 cm. (or roughly four by five inches) in format—the one with which he made the portraits of Mayakovsky. The significance of the 4-by-6.5-cm. (or roughly 1½-by-2½-inch) Ica (and of a Kodak Vest Pocket of the same format that he had acquired in 1923 or 1924) was that it was small enough to be held in the hand, thus granting the photographer the ability to move freely, and to quickly revise the picture he or she was about to make. This capacity to respond to changing circumstances was further enhanced if, instead of using individual plates or sheets of film (as the Ica did), the camera used roll film (as the Kodak did), enabling the photographer to make a series of exposures in rapid succession.

Upon his return from Paris Rodchenko possessed a full arsenal of camera equipment. He had used the Kodak sparingly before the trip,[30] but it and the Ica henceforth served as his principal cameras for outdoor work until November 1928, when he acquired a Leica. Introduced in 1925 and designed to make still pictures with 35-mm. motion-picture stock, the Leica was not only smaller and easier to handle than the Ica and the Kodak but boasted thirty-six pictures to a roll.[31] For Rodchenko and his contemporaries throughout Europe, it soon became the favored agent and lasting symbol of photography's newfound mobility.

Rodchenko photographed Konstantin Mel'nikov's Soviet Pavilion at the Paris exposition,[32] but his first extended experiment with photographing outdoors was a series of oblique views, from above and (mostly) below, of his apartment building on Miasnitskaia Street in Moscow (plates 168–73). These striking pictures, made in the fall of 1925 within a few months of his return from Paris, already contain the germ of his mature photographic aesthetic. But Rodchenko was still a novice photographer, and it would take him some time to find his footing. Most of his outdoor pictures of the following year are rather tame cityscapes and landscapes in the style of Pictorialism, a diluted survival of the art-photography movements of the turn of the century (fig. 10).[33]

Rodchenko made some of the cityscapes in his capacity as artistic advisor for *Moscow in October* (*Moskva v Oktiabre*), a film directed by Boris Barnet in 1927 to celebrate the tenth anniversary of the Revolution. Yet the film itself bears the stamp of Rodchenko's bold modernist vision (figs. 11 and 12), which also emerged decisively in his still photographs of 1927 (plates 192, 193, 195, and 196). One picture (fig. 13) appears almost as if it were a frame enlargement from the film (fig. 11), for which Rodchenko chose not only the locations but the camera viewpoints and angles.[34] Despite the brief Pictorialist interlude, his signature photographic style had developed very quickly.

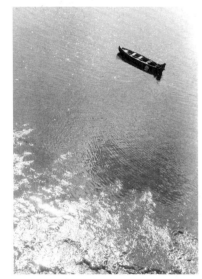

10.

10. Aleksandr Rodchenko. *The Boat* (*Lodka*). 1926. Gelatin silver print, 9⅜ × 7⅛" (23.8 × 18.2 cm). A. Rodchenko and V. Stepanova Archive, Moscow.

11 and 12. Frame enlargements from the two opening shots of the film *Moscow in October* (*Moskva v Oktiabre*), directed by Boris Barnet. 1927.

13. Aleksandr Rodchenko. The Brianskii railway station, Moscow. 1927. Gelatin silver print, 9 × 6½" (22.6 × 16.5 cm). The Museum of Modern Art, New York. Gift of Alfred H. Barr, Jr.

Photography soon became his principal occupation, and during the short span of the next two or three years he made much of his best work.

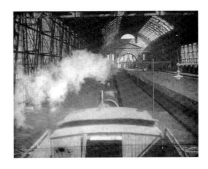

In broad outline, the development of Rodchenko's involvement with photography in the 1920s corresponds to the unfolding of European photographic modernism generally and to its German chapter in particular. Photography first appealed to the postwar avant-gardes not as a tool for capturing appearances but as a fluid process, linked to the vast resource of imagery in the illustrated press. Characteristic of this initial phase are the photogram and the photocollage—forms that do not require the use of a camera. Only later, in the second half of the 1920s, did the making of camera photographs come to play a prominent role in the new aesthetic. It follows that the style of these photographs—the "New Vision" or *Neue Sehen*, with its radical croppings and oblique perspectives—had its roots in the first, cameraless phase. Unlike their American contemporaries, who made a fetish of photography's purity and precision, the Europeans approached the medium with cavalier abandon.

11, 12.

In both phases, the new photographic vocabulary spread with astonishing rapidity, becoming common property not only of the sophisticated avant-gardes but of the mass vernacular. Photocollage was ubiquitous throughout systems of high and low culture by the mid-1920s—only five or six years after its identity as an art form had gelled. Before 1925, an avant-garde aesthetic of camera photography had yet to coalesce; by 1929, it was simultaneously codified in the massive *Film und Foto* exposition in Stuttgart[35] and celebrated in the pages of the popular press (fig. 14). The speed with which the aesthetic took hold is central to its meaning, and it obviates any argument over who invented the photogram or the photocollage, or who made the first picture from above or below. The rise of photographic modernism in Europe was not a case of radical discovery by a sophisticated elite but of a potent, chaotic vernacular embraced by an eager avant-garde whose disciplined creations were rapidly reabsorbed.

13.

An indispensable touchstone of this process was Moholy's *Malerei, Photographie, Film* (Painting, photography, film), published by the Bauhaus in mid-1925.[36] The book is at once a sophisticated manifesto and an accessible primer, its message articulated more through its illustrations than through its somewhat awkward text. Moholy advances a radically catholic definition of photography: it can see the very small or the very distant; it can stop time or trace movement through time; it can look up or down; it can make positives or negatives; with or without a camera, it can register patterns of light; its imagery can be combined in collage or with type, reproduced in the press or transmitted by telegraph, or extended into motion. Each of these incarnations of the medium is seen to share a kinship with all the others; together they present an irresistible challenge to habitual ways of picturing things—of understanding the world and our place in it. And this challenge is neither capricious nor subjective, for photography is a mechanical process whose operations are scientifically objective and therefore socially universal.

14.

14. "Topsy-turvy: Impressions of the Metropolis Berlin" (*Drunter und drüber: Eindrücke aus der Weltstadt Berlin*). *Kölnische Illustrierte Zeitung* no. 50 (1928), pp. 1,588 and 1,589. Courtesy Museum Folkwang, Essen.

15. László Moholy-Nagy, *Malerei, Photographie, Film* (Munich: Albert Langen Verlag, 1925), pp. 48 and 49.

The captions read, respectively: "English airplane squadron [Englisches Flugzeuggeschwader]. Photo: Sportspiegel" and *"The biggest clock in the world in Jersey City (U.S.A.) [Die grösste Uhr der Welt in Jersey City (U.S.A.)]. Photo: Zeitbilder. The experience of oblique vision and the surprise of proportions [Das Erlebnis der schrägen Sicht und die Überraschung der Proportionen]."*

16. László Moholy-Nagy, *Malerei, Photographie, Film* (Munich: Albert Langen Verlag, 1925), pp. 50 and 51.

The captions read, respectively: "St. Paul's Cathedral, London [St. Paulskirche, London]. Photo: Zeitbilder. The pews and people taken through the oculus [Die Bänke und Menschen durch die Glaskupple aufgenommen]" and *"The brutal power of a factory smokestack [Animalisch wirkende Kraft eines Fabrikschornsteines]. Photo: [Albert] Renger [-Patzsch]. Auriga Verlag."*

17. Unidentified photograph from the *Kölnische Illustrierte Zeitung*, reproduced as an illustration to Rodchenko, "The Paths of Modern Photography" (*Puti sovremennoi fotografii*), *Novyi Lef* no. 9 of 1928, p. 30. The Judith Rothschild Foundation, New York.

As Hausmann had put it as early as 1921, "Today, through the railway, the airplane, the photographic apparatus and the Roentgen ray, we have acquired such a power of discrimination that, thanks to the mechanical augmentation of our natural potentials, a new kind of optical knowledge has become possible for us."[37] Moholy wrote, "We may say that we see the world with entirely different eyes."[38]

Corresponding to Moholy's enthusiasm for the malleability of the photographic process is the diversity of his illustrations and their sources. Several are works of self-consciously advanced art, including a photogram by Man Ray; collages by Höch and Paul Citroën; and strips from an animated film by Viking Eggeling. But the great majority are drawn from photography's vernacular applications in science, journalism, advertising, and illustration. When Moholy set out to compose *Malerei, Photographie, Film*, in the summer of 1924, he had made photograms and photocollages but no photographs;[39] he corrected proofs for the book in May 1925,[40] before traveling in July to Paris, where he made his first camera pictures. By the time a revised edition of his book appeared, in 1927, he was able to add six of his own photographs. In other words, the first edition of the book appeared just as Moholy was expanding his own work from the first phase of European photographic modernism to the second—and as Rodchenko was doing the same.

There is little question that *Malerei, Photographie, Film* reached Rodchenko very quickly, and it is conceivable that the book's oblique views (figs. 15 and 16) provided the catalyst for the apartment-building series he made in the fall of 1925 (plates 168–73). But to raise the possibility is to risk both exaggerating its importance and missing its point. The great significance of Moholy's book in this context is not that it may have inflected one aspect or another of Rodchenko's unfolding photographic experiment, but that

15.

16.

it summarized in coherent form an understanding of the medium that both artists shared—and did so at a crucial point, when their enthusiasm for photography as multivalent process was broadening into a new style of camera imagery.

For one thing, Rodchenko the photocollagist had been clipping photographs from the press for years, and so was alert to the same pool of vernacular photography from which Moholy drew the illustrations for his book. In an essay of 1928 titled "The Paths of Modern Photography," Rodchenko contrasted the vitality of press photography to the "stereotyped photographs" of moribund "artistic photography," of which "some might imitate an etching, others a Japanese [print], and still others a 'Rembrandt.'"

> *Press photography is considered to be something of a lower order.*
>
> *But this applied photography, this lower order, has brought about a revolution in photography—by the competition among magazines and newspapers, by its vital and much-needed endeavors, and by performing when it is essential to photograph at all costs, in every kind of lighting and from every viewpoint.*[41]

This is an insightful summary of the explosion of photographic imagery that occurred when the dry plate freed the photographer from the tripod and the photomechanical revolution radically expanded photography's functions and audiences. The pressures of circumstance, opportunity, and competition inevitably generated new photographic forms, including unexpected croppings, viewpoints, and effects of light and shadow. Such pictures of course represented only a tiny minority within the great mass of banal photographs produced for instant consumption. It took the disciplined eyes of Rodchenko, Moholy, and others to recognize them as a powerful image of modernity. Rodchenko explained,

> *It's only over recent years that you'll sometimes come across different vantage points [in the photographically illustrated press]. I underline the word sometimes, since these new vantage points are few and far between.*
>
> *I buy a lot of foreign magazines and I collect photographs, but I have managed to put together only about three dozen pieces of this kind.*[42]

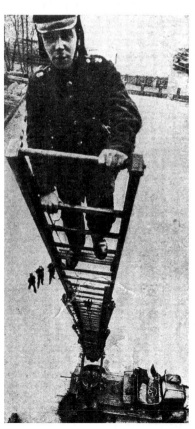

17.

18.

19.

Thus the vernacular press served the photographic avant-garde in two distinct
ways. Both literally and artistically the new medium of photocollage drew on the sheer
overabundant accumulation of imagery, in which the banal became piquant by virtue of
juxtaposition. Höch's scrapbook of the early 1930s—a sort of halfway stage between the
raw material and the finished collage—illustrates this function perfectly (fig. 18).[43] For
the new style of camera photography, the illustrated press functioned differently, as a
purveyor whose lawless appetite guaranteed the appearance, from time to time, of sur-
prising pictures such as the photograph of a fireman atop his ladder that Rodchenko
clipped from the *Kölnische Illustrierte Zeitung* to illustrate his essay (fig. 17). By seizing on
such pictures and distilling them from the undifferentiated mass, avant-gardists such as
Rodchenko and Moholy formed the outline of a distinct aesthetic.

Among the other illustrations accompanying Rodchenko's essay were two worm's-
eye photographs from Erich Mendelsohn's *Amerika: Bilderbuch eines Architekten*
(America: an architect's picture book; fig. 19, for example).[44] Published in January or
February 1926[45]—that is, shortly after Rodchenko had made his series "The Building on
Miasnitskaia Street" (*Dom na Miasnitskoi*), in the fall of 1925, but before he had achieved
full confidence as a photographer—Mendelsohn's book soon fomented a durable associ-
ation between progressive aspirations in architecture and the emerging photographic
style of mobile perspectives and oblique angles. (The magazine *Sovremenaia Arkitektura*,
founded in 1926, instantly favored the style, for example.[46])

By Rodchenko's own account, the oblique angle was the cornerstone of his pho-
tographic aesthetic, and it will be considered here at length.[47] But it was only one of
several interrelated devices of advanced European photography of the 1920s. Here again
Moholy's book is an excellent guide, for it stresses the full range of photography's capaci-
ties to depart from pictorial convention. At one time or another Rodchenko sampled

many of the new techniques, including multiple exposure (plate 148), dramatic play of light and shadow (plates 186 and 187), negative printing (plate 185), and the photogram, demonstrating his curiosity about advanced photographic work in the West. A case in point is a photogram of 1928, made with hair (fig. 20), which evidently was inspired by a photogram, made with string, that the Bauhaus graduate Umbo had sent to Rodchenko from Berlin for publication in *Novyi Lef* (fig. 21).[48] This was an exception, however: although Rodchenko taught his students to make photograms, he rarely made them himself.[49] In virtually every case, he took up such experimental techniques only to drop them almost as quickly. These brief engagements not only suggest his alertness to the West but, by failing to make a lasting mark on his work, help to define the particularity of his aesthetic.

20.

Apart from photocollage, photography for Rodchenko was unembellished camera photography, with its ready eye on the world. The mark of his control over the image was his choice of vantage point, whether or not the angle of view departed from the horizontal. In *Chauffeur* (*Shofer*, 1929; plate 248) and an untitled photograph from a series on the Moscow ambulance service (1929, plate 244), for example, the camera points straight ahead; the collagelike effect is created by spatial compression and the decisive cropping of the frame. In both cases the solution to the puzzle lies in the viewpoint, from which we may decipher the scene by reconstructing our place in it. This interplay between graphic surprise and immediacy of experience is at the heart of Rodchenko's brand of the New Vision style.

Another key element of Rodchenko's aesthetic was his practice of photographing in series. Hubertus Gassner, the first scholar to stress the importance of the practice, has linked it to Rodchenko's earlier work in painting and sculpture, in which he often elaborated a given formal problem through a series of permutations.[50] In photography, the practice of pursuing variant aspects of a single subject helped to establish the medium's modernist identity. Because each variant is different from the others, such a series plainly sets forth the malleability of photographic description, and working in series helped Rodchenko and others to learn to master it.

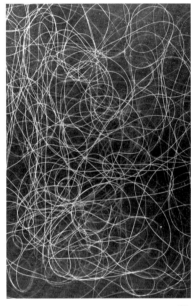

21.

Especially when using a roll-film camera such as the Leica, Rodchenko could make several frames in succession without deciding in advance whether he would eventually choose one and discard the rest (as photographers typically do) or would incorporate two or more frames in the finished work. Reproduced here for the first time are four works in which he chose the latter option, introducing the feel of cinematic mobility into still composites (plates 222–24 and 227). More often, beginning with the "Building on Miasnitskaia Street" pictures of 1925 (plates 168–73), he produced open-ended series of individual prints, which could be assembled and reassembled in a variety of combinations (plates 239 and 240, for example, and 241–43).

For Rodchenko, the modernist implications of the series principle were all the more sharply distilled in the oblique angle. The oblique registers as such by deviating

20. Aleksandr Rodchenko. Untitled photogram. 1928. Gelatin-silver print, 12⅝ × 10¼" (32 × 26 cm). A. Rodchenko and V. Stepanova Archive, Moscow.

21. Umbo (Otto Umbehr). Photogram. 1928. Reproduced in *Novyi Lef* no. 10 of 1928, p. 33.

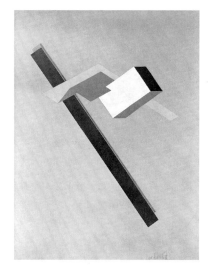

22.

23.

22. El Lissitzky. *Proun GK.* c. 1922. Gouache, brush and ink, and pencil on paper, 26 × 19¾" (66 × 50.2 cm). The Museum of Modern Art, New York.

23. Gustave Caillebotte. *Boulevard Seen from Above* (*Boulevard vu d'en haut*). 1880. Oil on canvas, 25⅝ × 21¼" (65.1 × 54 cm). Private collection, Paris.

from a norm—from the convention of looking, and photographing, straight ahead. Because most early hand-held cameras were held not to the eye but against the chest or stomach, while the photographer looked down into the viewfinder, Rodchenko called this norm "belly-button" photography. Like Moholy, he regarded it as a loathsome legacy of centuries of pictorial habit, an imposition of antiquated painting on the young medium of photography. Thus the oblique perspective signaled a dual liberation: of photography from painting and of the artist from the shackles of tradition.

Long denigrated as a passive mirror of reality, photography announced its ardent new identity merely by deflecting its regard from the horizontal. By obliging the viewer to register this deviation, the photographer claimed an active role in shaping the picture, and the medium's mechanical objectivity was transformed from a liability into an asset. Moreover, especially toward the vertical extremes of up and down, photographs made at oblique angles tend to collapse pictorial space and thus to resemble the planar arrangements of Synthetic Cubism, and of the styles of abstraction that issued from it. In this way advanced photography could measure its modernity both as a departure from an outmoded style of painting and as an affinity with a progressive one.

The affinity was not spurious, for the oblique angles of 1920s photography recovered and extended a rich tradition of painting, which had originated before the advent of abstraction and survived beyond it. A complex subject in itself, this development deserves a digression here, for it enriches our understanding of Rodchenko's photography. Cubism had broken the hegemony of perspective in part by multiplying its aspects, evoking an experience of seeing the subject from several points of view simultaneously. In the art of Malevich and his successors this association between the formal vocabulary of Cubism and the liberation of visual experience from the fixed regard of traditional perspective evolved into the conceit of a free-floating, weightless viewer, unmoored from worldly things. Lissitzky explained the imagery of his "Proun" series thus: "We saw that the surface of the Proun ceases to be a picture and turns into a structure around which we must circle, looking at it from all sides, peering down from above, investigating from below."[51] Malevich and Lissitzky set viewers free from the spot where perspective had planted them (fig. 22). Even so, their abstractions drew part of their meaning from the old instinctive analogy between the picture and a window on the world. (Malevich explicitly invoked that analogy in the mid-1920s when he composed a series of didactic panels comparing recent progress in painting to ever more freewheeling photographs, culminating in an equivalence between his Suprematist abstractions and aerial photographs [fig. 24].) In this respect, advanced nonobjective art extended a long tradition, in which the artist's gaze had taken progressively greater liberties in selecting a fragmentary image from the seamless field of perception.[52] This tradition had reached a peak in the late nineteenth century, when the progressive sense of the picture as the momentary glimpse of a mobile observer had yielded extreme, disorienting results (fig. 23).

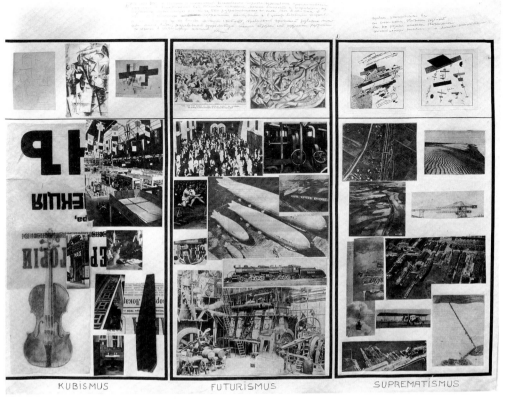

KUBISMUS FUTURISMUS SUPREMATISMUS

24.

The pursuit of perceptual contingency in nineteenth-century painting—its grasp of the world seen just now from just here—of course had parallels in contemporaneous literature. It was partly through analyzing this literature that Viktor Shklovsky and others, on the eve of the Revolution, had developed a theory of art as designed to dislodge the reader or viewer from habitual perceptions. For Shklovsky (later a colleague of Rodchenko's in the Lef group), the primary function of art was to recapture the immediacy of experience from the deadening influence of repetition and convention, by making the familiar seem unfamiliar and by calling attention to the formal devices that effected this "making strange."[53] The New Vision photography aesthetic and the oblique angle in particular aptly served this aim by forthrightly showing things from fresh points of view.

Although Rodchenko disdained Impressionism as an outmoded bourgeois art, his most original photographic experiments recaptured the momentum of an old tradition that had culminated in Impressionism but whose sensibilities had persisted within some forms of abstraction. An interesting parallel to this development exists in the work of Henri Cartier-Bresson, whose photographs of the early 1930s played games with conventions of pictorial narrative similiar to those that Rodchenko's photographs were playing with the spatial conventions of perspective—and in doing so brought to fruition possibilities that had first appeared half a century earlier in the paintings of Édouard Manet and his contemporaries.[54] The European interwar experiment in hand-held photography, with its taste for the ceaseless surprises of the freewheeling camera eye, was both a fresh adventure and a new chapter in a suspended story.[55]

24. Kasimir Malevich. Analytical chart. c. 1925. Cut-and-pasted photomechanical reproductions, printed papers, pencil drawings on paper and transparent paper, gelatin-silver prints, wood, and ink on paper, 25 × 32½" (63.5 × 82.6 cm). The Museum of Modern Art, New York.

For fledgling photographic modernism, the oblique perspective possessed the welcome advantage of simplifying one of photography's most demanding challenges: to translate three dimensions coherently into two. In views looking up or down, the sky or earth often functions as a blank plane against which the picture's elements are deployed as if in an abstract composition. A case in point is a series of pictures of pine trees that Rodchenko made in 1927 near Mayakovsky's dacha at Pushkino, near Moscow, which reduce the formal problem to a matter of dark shapes on a white ground (plates 195 and 196).[56] Rodchenko recalled how he came to make the pictures:

> At the dacha in Pushkino, I go for walks and look at nature: there a bush, there a tree, here a hollow, some nettles. . . . Everything is there by chance, disorganized, you don't know where to begin the photograph, there's nothing interesting. The pines aren't too bad at a pinch: very long, very bare, almost telephone poles.[57]

The recollection neatly elides content and form, for the chaos Rodchenko was struggling to overcome belonged both to nature and to photographic description. His pictures mastered both.

Rodchenko's Pushkino pictures, like those in his "Building on Miasnitskaia Street" series, may be read as either flat pattern or spatial plunge, much as that famous figure beloved of philosophers and perceptual psychologists may be grasped as duck or rabbit but not both at once. In the same year that he took the Pushkino photographs, however, Rodchenko began to achieve a fusion of these alternatives, notably in a more complex picture made of and from the building on Miasnitskaia Street (plate 228). The picture accommodates the opposing inclinations of the apartment building and the roof of a lower structure nearby, creating a taut balance.

In photography the viewer always stands where the photographer once stood, but otherwise the photographer has great power to shape the viewer's relationship to what lies within the frame. The extreme effects of the oblique perspective define the opposite poles of that power. The oblique can disengage the viewer from the scene, rendering it as a pattern of unfamiliar forms, unburdened of their worldly associations. Or it can aggressively implicate the viewer in the scene, evoking a vertiginous plunge into an all too palpable space. In fact most photographs involve an interplay between these two poles—between aesthetic contemplation and visceral experience, between what we imprecisely call abstraction and realism (for no photograph is ever either abstract or real). The richness of this interplay is at the heart of Rodchenko's best photographs, and nowhere more exquisitely than in *Assembling for a Demonstration* (*Sbor na demonstratsiiu*, 1928–30; plate 233).[58]

While the vitality of the picture arises from its many irregular details, its coherence stems from the clarity of its tripartite structure: two darker forms enclosing a lighter one, all three gently inclined. A detail of this structure suggests the sophistication of Rodchenko's mature photographic instincts: to make the picture, he leaned precariously over the railing of his balcony to ensure that the balcony below would not intrude its

dark form into the lighter courtyard, spoiling the image's planar simplicity.[59] It was all the more important for Rodchenko to establish a dominant geometry because otherwise the picture is formally so complex. This complexity arises not so much from the many scattered figures and puddles in the courtyard, for their uniformity of scale enables them to enliven the picture without threatening its coherence. It is a function, rather, of the steep recession from near to far, introduced by the balconies and especially by the figures upon them.

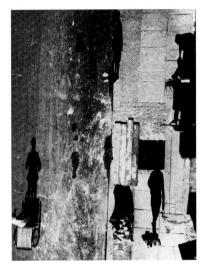

25.

This dimension of Rodchenko's picture may be highlighted in a comparison with Umbo's famous overhead Berlin street views of 1928 (fig. 25). By aligning the film plane of his camera in parallel with the pavement below, and especially by excluding all but air between the two, Umbo radically flattened his picture, dislocating it from the space of the observer. The picture's impact owes as much to this dislocation as to the striking shadows; indeed the depthlessness of the graphic field is what makes the shadows striking. In *Assembling for a Demonstration*, on the other hand, the observer's space is continuous with the space of the picture. Rodchenko beautifully articulated this continuity in the way he described the women on the balconies: their foreshortened figures mirror each other like the opposing axonometric arms of a Lissitzky Proun, defining an axis whose angle of deviation from the railings matches the railings' own deviation from the vertical edge of the frame. Bending over her dustpan, the lower figure adds a sun-struck grace note to the composition, while her shadow inverts the shape of the central puddle below. But these are persons as well as graphic shapes, intermediaries between the observer and the scene below—a role further enriched by the posture of the nearer woman, who, like us, gazes downward.

The title is misleading. The subject is less the group of children forming into ranks than the life of the courtyard as observed by a member of its community from the balcony of his own apartment, just across from the school where he taught. Taking Rodchenko's place, we see his immediate social world through his eyes. Gassner has interpreted the picture in this way, stressing the special role of the courtyard in Moscow life as an intermediate zone between private and public spheres—a sort of village within the metropolis.[60] Visiting Moscow in 1927, Walter Benjamin observed,

> There is one thing curious about the streets: the Russian village plays hide-and-seek in them. If you pass through any of the large gateways—they often have wrought-iron gratings, but I never encountered one that was locked—you find yourself at the threshold of a spacious settlement. . . . A farm or village opens out before you.[61]

Although Rodchenko's apartment building was a modern edifice, built in the first decade of the twentieth century, such is the world he observed from his vantage points on the top floor or the roof, looking down into the courtyards on either side. It is through the comings and goings of his intimate world—the changing times of day and season, the deliveries of horse carts—that the long series of photographs he accumulated be-

25. Umbo (Otto Umbehr). *Mysterious Street* (*Unheimliche Strasse*). 1928. Gelatin-silver print, 9⁵⁄₁₆ × 7" (23.7 × 17.8 cm). Galerie Rudolf Kicken, Cologne, and Phyllis Umbehr.

tween 1926 and 1930 elaborate their avant-garde experiment (plates 225–27 and 229–33). These pictures were not made on commission, and they had no use as propaganda. They describe not the official, public face of the Revolution but the rhythms of Rodchenko's personal environment. Moholy's photographs of the same period, close stylistically to Rodchenko's, are similar in this respect as well: although a few of them celebrate wonders of industrial technology—the radio tower in Berlin, or the Pont Transbordeur in Marseilles—a great number, perhaps the majority of them, were made among friends on vacation, at Ascona and elsewhere (fig. 26). For both artists the excitement of discovering new ways of looking at the world was bound up with the texture of familiar everyday experience.

This personal dimension of Rodchenko's work remained unexpressed in his resolutely impersonal theoretical statements. In 1928, in "The Paths of Modern Photography," he justified the oblique perspective as an imperative of modern urban experience:

> *The modern city with its multistory buildings, the specially designed factories and plants, the two- and three-story store windows, the streetcars, automobiles, illuminated signs and billboards, the ocean liners, airplanes . . . have redirected (only a little, it's true) the normal psychology of visual perception.*
>
> *It would seem that only the camera is capable of reflecting contemporary life.*[62]

Rodchenko's disclaimer—"only a little, it's true"—was an understatement. In 1928 he had never yet seen an ocean liner or flown in an airplane, and only rarely could he even have ridden in an automobile. While streetcars had been a prominent feature of Moscow life since before the Revolution, automobiles remained a rare luxury throughout the 1920s. There were no skyscrapers; Rodchenko's own eight-story apartment building was among the tallest buildings in a city then still largely composed of one- and two-floor structures. Only during his months in Paris in 1925 had Rodchenko experienced anything resembling the scene he evoked in his essay.

The gap between Rodchenko's image of modern technology and the backwardness of 1920s Moscow sets in relief a point that also applies to his contemporaries in the West. For even in Paris or Berlin—or New York—the dynamism of the modern metropolis was both an unfolding reality and an aesthetic ideal. Drawing the connection (or blurring the distinction) between the two had become a commonplace of artistic discourse, and in adopting it Rodchenko identified his art simultaneously with industrial progress and with progressive art in the West.[63] If we take him and other artists at their word, accepting their bold creations as mirrors of reality, we risk missing the role that aesthetics played in shaping their perceptions. It is worth keeping this in mind as we read the following passage from an essay by Moholy, also published in 1928. Following the same convention as Rodchenko, Moholy identified the "superimpositions and penetrations" of his art with "the visual and mental gymnastics" of "a city-dweller on his daily rounds":

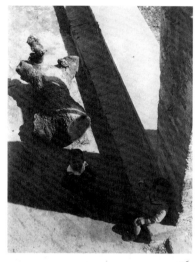

26.

26. László Moholy-Nagy. *Ascona.* 1926. Gelatin-silver print, 14⁷⁄₁₆ × 10⁷⁄₈" (36.7 × 27.7 cm). The Museum of Modern Art, New York. Anonymous gift.

Example: one rides in a tram, looks out through a window. There is a car behind. The windows of this car are also transparent. Through them one sees a shop which in its turn has transparent windows. In the shop there are people, buyers and salesmen. Somebody else opens the door. People pass by the shop. The traffic policeman stops a bicyclist. All this one grasps in a single moment because the window panes are transparent and everything that happens is seen by look-ing in the same direction.[64]

The passage concerns photocollage, but with only minor alterations it could be a description of a photograph by Rodchenko (plate 244, for example), or of a sequence from a film by his friend and Lef colleague Dziga Vertov.

Of all works of art, Vertov's films of the mid- and late 1920s are perhaps closest in spirit to Rodchenko's photography of the same period. Working with the same raw material (and not infrequently with nearly identical motifs) and using many of the same stylistic devices, the two men created an art that meets the world with open arms, eager for the reward of surprise. Like the contemporaneous film posters of Vladimir and Georgii Stenberg (fig. 27, for example), the films of Vertov and the photographs of Rodchenko project a buoyant mood of confidence and excitement. In this high-spirited work there is no hint of the violence and devastation of the recent civil war, or of the repressions that were soon to come.

The precocious Vertov had begun his career as a newsreel cameraman during the civil war. By the early 1920s he had articulated a radical theory of filmmaking, which overthrew the spatial and temporal unities of the traditional theater in favor of an aggregate of scenes drawn from life by the mobile camera eye:

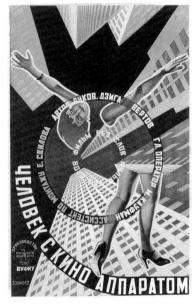

27.

I the machine show you the world as only I can see it.

I emancipate myself henceforth and forever from human immobility. I am in constant motion. *I approach objects and move away from them, I creep up on them, I clamber over them, I move alongside the muzzle of a running horse, I tear into a crowd at full tilt, I flee before fleeing soldiers, I turn over on my back, I rise up with aeroplanes, I fall and rise with falling and rising bodies.*

. . . I juxtapose any points in the universe *regardless of where I fixed them.*

My path leads toward the creation of a fresh perception of the world. I can thus decipher a world that you do not know.[65]

In *Cine-Eye* (*Kino glaz*) of 1924 and then in *Man with a Movie Camera* (*Chelovek c kino apparatom*) of 1929, Vertov and his brother, cameraman Mikhail Kaufman, realized this aesthetic. Their abrupt juxtapositions of montage and oblique perspectives of camera vision perform in concert, as twin expressions of the creative potentials of unbridled perception. The precipitous shots from above in *Cine-Eye*—for which Rodchenko designed the poster (plate 157)—are just as likely as Moholy's *Malerei, Photographie, Film* to have sparked his enthusiasm for oblique angles of view. But the relationship between

27. Vladimir and Georgii Stenberg. Poster for the film *Man with a Movie Camera* (*Chelovek c kino apparatom*), directed by Dziga Vertov. 1929. Offset lithograph, 41⅛ × 26⅛" (104.5 × 66.4 cm). Batsu Art Gallery, The Ruki Matsumoto Collection, Tokyo.

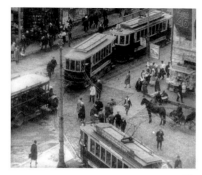

28.

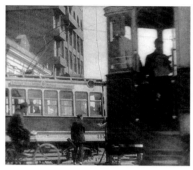

29.

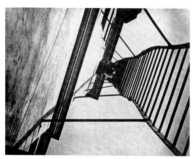

30.

28 and 29. Frame enlargements from the film *Man with a Movie Camera* (*Chelovek c kino apparatom*), directed by Dziga Vertov. 1929.

30. Publicity still for the film *Man with a Movie Camera* (*Chelovek c kino apparatom*), directed by Dziga Vertov. 1929. Gelatin-silver print, 8⅜ × 10⅞" (21.2 × 27.6 cm). The Museum of Modern Art, New York. Film Stills Archive.

This particular shot was not included in the film as it is currently known.

Vertov's films and Rodchenko's photographs is far deeper than any isolated formal similarity might suggest.

Indeed the relationship in general between film and still photography is rich and fundamental—especially to European photography's budding modernism of the 1920s and early '30s. It is also difficult to pin down. A photograph is a mute fragment, its keen purchase on the aspect of reality within the frame being matched by the utter absence of everything else—what lies beyond, the story that would explain it all. The rise of photographic modernism reflected the progressive discovery and mastery of this potent paradox: the recognition that the gap between how things appear in ordinary experience and how they appear in a photograph can be made elastic and subjected to artistic control. By replacing the apparent unity of conscious experience with fragmentary shots improbably but indelibly melded into a new unity by the sequential continuity of film, cinematic montage radically reconfigured the potentials of photography. This reconfiguration taught photographers much more than did the easily named devices of the close-up or the tracking shot: it helped them to see everyday visual experience as the infinitely malleable stuff of art, no less varied in the surprises it could yield than the colors laid out on the painter's palette.

The close relationship, personal and artistic, between Vertov and Rodchenko began in the early 1920s, when the former was beginning to explore montage and the latter the montagelike effects of photocollage. The subsequent give-and-take between the two may be too dense to be parsed. Certainly its character cannot be explained by reference alone to their many shared formal devices and motifs—the plunging perspectives and spatial elisions of their images, and the trams and pedestrians of Moscow's streets (figs. 28–30). Beyond these and embodied in them is a restless impatience with passivity and an active, even playful engagement with the world, full of enthusiasm and optimism.

Like the cut-and-paste abandon of Höch or Hausmann, Vertov's freewheeling montage has a manic feel. His high-spirited energy sometimes got the best of him, with the result that none of his films is fully resolved. But the ebullient quality of his energy is at work in many of Rodchenko's best pictures of the late 1920s. In *At the Telephone* (*Na telefone*) of 1928 (plate 249), the woman is unaccountably seen from directly above—unaccountably, because the photograph gives no hint of why she should be pictured from this odd perspective. But the picture is so good-natured that we never think to ask why, for there *is* no reason, except the freedom of the artistic chance.

Rodchenko and Vertov were true believers in the Revolution, in its promise of freedom and a new world, and they threw themselves into it with headlong, almost childlike abandon. This was the ideology of their work. By the late 1920s, however, it was an interpretation of Revolutionary ideology that those in power could not much longer allow others to hold.

In April of 1928, the year that Stalin launched the first Five-Year Plan of forced industrialization, Rodchenko was attacked by an anonymous author in the pages of the monthly journal *Sovetskoe Foto*. He responded to the attack, his Lef colleague Boris Kushner responded to his response, Rodchenko countered with another essay, and so on until Sergei Tret'iakov concluded the exchange in the November 1928 issue of *Novyi Lef*.[66] This episode, to which we owe Rodchenko's fullest explanations of his photographic outlook and ambitions (including the essay "The Paths of Modern Photography"), marked the onset of a climate of contentious debate, which raged throughout Soviet photographic culture for the next four or five years. Grasping its significance calls for a well-developed sense of irony, of the sort exhibited by Isaac Babel when he noted at the First Congress of the Union of Soviet Writers, held in Moscow in 1934, that the Party and the government had granted Soviet writers every right except one, the right to write badly.[67]

The initial attack on Rodchenko paired three of his photographs with three similar ones by Western photographers, including Moholy. The implication—snidely elucidated in the brief text—was that Rodchenko had plagiarized Western bourgeois ("imperialist") formalists, and that his celebrated aesthetic of oblique angles was therefore ideologically corrupt. The attack filled a single page and has often been reproduced in isolation, as it is again reproduced here (fig. 31). The context, however, is highly relevant.

Rodchenko was a founding member of the editorial board of *Sovetskoe Foto* in 1926, and it was probably at his urging that in mid-1927 the magazine began to reproduce photographs in the New Vision style, including two taken from Moholy's *Malerei, Photographie, Film*,[68] one from Mendelsohn's *Amerika*,[69] and several by Rodchenko himself.[70] But these, like the one-page attack on Rodchenko, were exceptional intrusions in an otherwise very bland publication. *Sovetskoe Foto* was founded by Narkompros, the People's Commissariat for Enlightenment, to promote amateur photography, and except for occasional articles on explicitly political subjects[71] it differed little from scores of similar publications around the world. Its full-page gravure reproductions were overwhelmingly devoted to Pictorialist landscapes of the most anodyne sort,[72] and almost every issue included illustrated pointers on the compositions or lighting effects of the old masters,[73] along with the usual technical tips.

This context is indispensable for understanding the character of the attack on Rodchenko. If he was guilty of plagiarism and bourgeois formalism, what then can be said of the retardataire Pictorialist aesthetic so earnestly promoted by *Sovetskoe Foto*? The evolution of modern art spawned many earnest debates (and occasional personal attacks) as individuals and groups sought to enlist others in their attempts to extend the tradition in one direction or another. But the Soviet photographic debates of the late 1920s and early '30s resemble such struggles only superficially. At bottom, despite the admirable frankness with which Rodchenko and others engaged in them, the debates

31.

31. "Illustrated Letter to the Publisher: Ours and Theirs" (*Illustrirovannoe pis'mo v redaktsiiu: Nashi i za-granitsa*). *Sovetskoe Foto* no. 4 of 1928.

The photographs on the right are by Rodchenko. The photographs on the left are by, from top to bottom, Ira W. Martin, Albert Renger-Patzsch, and László Moholy-Nagy.

were poisoned by cynical self-preservation, as individuals and groups sought the favor of an increasingly totalitarian regime.

The taste of this poison is encapsulated in a somewhat later instance of the increasingly vituperative attacks that continued to mount against Rodchenko through the early 1930s, even as he attempted to remake himself and his work in the image of Stalinism. In 1930 he produced a stunning group of photographs of individual Pioneers—the Soviet boy and girl scouts, aged from nine or ten to fourteen, who, if they behaved, would graduate to membership in the Komsomol and eventually the Party (plates 277–79). One of these, *Pioneer Girl* (*Pionerka*, plate 278), is among the most effective and powerful of all twentieth-century embodiments of political idealism. Seen from below, the girl is rendered monumental; she is resolute, indomitable in the sacrifice of her individuality to the impersonal sweep of history. Yet the critic Ivan Bokhanov contrived to denounce the picture (and Rodchenko), claiming, "The Pioneer girl has no right to look upward. That has no ideological content. Pioneer girls and Komsomol girls should look forward."[74]

One cannot read the remark with a straight face. As Aleksandr Lavrent'ev has written, "The hunt for the guilty had begun."[75] The hero of Mikhail Bulgakov's suppressed novel of the 1930s, *Master i Margarita* (*The Master and Margarita*), was hunted in just the same way as was Rodchenko:

> The articles, incidentally, did not stop. At first I simply laughed at them, then came the second stage: amazement. In literally every line of those articles one could detect a sense of falsity, of unease, in spite of their confident and threatening tone. I couldn't help feeling—and the conviction grew stronger the more I read—that the people writing these articles were not saying what they had really wanted to say and that this was the cause of their fury. And then came the third stage—fear. Don't misunderstand me. I was not afraid of the articles; I was afraid of something else which had nothing to do with them or with my novel. I started, for instance, to be afraid of the dark. I was reaching the stage of mental derangement. I felt, especially just before going to sleep, that some very cold, supple octopus was fastening his tentacles round my heart.[76]

The embrace of that octopus is the disheartening story of Rodchenko's life and career after 1930. Dictatorships win and wield their power only in part by exercising it directly. The rest, the greater part, is the work of ordinary human anxiety, fear, ambition, and self-interest under extraordinary pressure. Historian Sheila Fitzpatrick has traced these forces in Russia's cultural revolution of the late 1920s and early '30s, as they helped to ensure Stalin's consolidation of power by beginning the essential process of discrediting those, such as Mayakovsky and Rodchenko, who had genuine claims to revolutionary credentials.[77] The so-called debates over the appropriate photographic style for Communist ideology were an expression of this nefarious mechanism. Read closely and in isolation, the debates are meaningless, for the Soviet regime had already ceased to serve the ideology it continued to spout.[78]

Irretrievably committed to the ideals of the Revolution, Rodchenko stuck to the principle that the Bolshevik regime could do no wrong, and gradually yielded to the force of the attacks that had begun in *Sovetskoe Foto* in 1928 and culminated in the early 1930s. He did his best to reform, that is, to conform to what he perceived as the necessary if sometimes unwelcome or misguided demands of the evolving Communist society. By 1931, for example, only three years after he had defended the affinities between his work and Moholy's, he distanced himself from the "aesthetics of abstract 'left' photography like that of Man Ray, Moholy-Nagy, etc."[79] Inevitably, however, his retreat took the form of a series of holding actions against the onslaught, each less secure than the last. The Vкhuteмas school (renamed Vкhutein in 1928), where Rodchenko had been employed since 1920, was closed in 1930. Thereafter he struggled not only to recover his reputation but also to earn his living. By the mid-1930s he had become a marginal figure in Soviet culture, despite periodic glimmers of rehabilitation, such as the prominence and applause his work received at the *Exhibition of the Work of the Masters of Soviet Photography* (*Vystavka rabot masterov sovetskogo fotoiskusstva*) in Moscow in 1935 (fig. 32). He spent the last two decades of his life isolated, bitter, confused, demoralized, and poor.[80]

In his work, Rodchenko undertook to answer the attacks upon him by giving more and more of his energy to propaganda journalism, a subject treated at greater length in Leah Dickerman's essay in this volume. Although since 1921 he had been committed in principle to applied art, much of his photography had developed freely, without regard to practical function. From 1928 this dimension of his output began to shrink in proportion to his work, as both photographer and designer, for magazines such as *Daesh'* (Give

32. Rodchenko's photographs in *Exhibition of the Work of the Masters of Soviet Photography* (*Vystavka rabot masterov sovetskogo fotoiskusstva*), Moscow, 1935.

32.

your all), *Tridtsat' Dnei* (Thirty days), *Radioslushatel'* (Radio listener), and eventually *SSSR na Stroike* (*USSR in Construction*), the flagship propaganda monthly launched in 1930 and produced mainly for foreign consumption. In 1932 he signed a contract to supply photographs to Izogiz, the state art-publishing house. The contract led to a large body of work on life in Moscow, for a picture book that never appeared, and to a series of postcards of Moscow scenes, some made for the purpose, others from existing negatives (plates 258–61, for example). In 1933, however, Rodchenko was enjoined from photographing at large without a permit. He was restricted to traveling assignments for *SSSR na Stroike* and, in Moscow, to sporting events (plates 296–300), official parades (plates 312–15 and 318), the theater, and the circus—the dreamscape of his youth, which became the refuge of his beleaguered maturity (plates 301 and 302).

Rodchenko's extensive series on the life of Moscow, culminating in his work for Izogiz in 1932, is uneven in quality and consequently is less fully represented here than other aspects of his photography. Earlier, Rodchenko had often relied on tight framing and oblique angles to achieve the simple, graphic force of his pictures. These devices played a prominent role, for example, in his photo-stories on the AMO automobile factory (1929; plates 263–66 and 268–69) and the Vakhtan lumber mill (1930; plates 280–85). But his signature style was a limitation as well as a strength, for it did little to prepare him for the challenge of describing the sprawling flux of life in the street. In the early 1930s, as he broadened the scope of his view to encompass more complex scenes, his command over the structure of his pictures became less certain. The decline had a political dimension as well, since the book commissioned by Izogiz was intended to show how much life in Moscow had improved since 1917, and so called for Rodchenko to illustrate the saccharine fictions of what soon would be called Socialist Realism.[81] The relative weakness of the pictures Rodchenko made for himself in the late 1930s at the circus and the theater[82] also invites a political interpretation, for his retreat into the moody chiaroscuro and sentimentality of Pictorialism expressed his sense of isolation from the common cause he once had so eagerly served.

The best of Rodchenko's photography for the magazines, however, is on a par with his independent artistic experiments. Both *At the Telephone*, with its fanciful overhead viewpoint (plate 249), and the great photograph from the cab of an ambulance (plate 244), for example, were made on magazine assignments. And some of his photographs of the building of the canal between the White Sea and the Baltic in 1933 are among his most compelling (for example, plates 288 and 290).

Rodchenko made the canal pictures for the December 1933 issue of *SSSR na Stroike*, which he also designed. As Aleksandr Solzhenitsyn has demonstrated in unrelenting tones of caustic irony, the building of the canal was a brutal scheme of terror and death, thinly disguised as a public-works project—the first of Stalin's major gulags, in which some 200,000 people died.[83] In *SSSR na Stroike* the canal became grist for the most hyperbolic of Stalinist propaganda, to the effect that the hardship of forced labor had

enabled those who had strayed from Socialist ideals to reform themselves. As Leah Dickerman shows, the omniscient, patronizing voice that speaks through the magazine is the disembodied voice of Big Brother. But Rodchenko's best individual photographs of the canal project are exemplary achievements of his modernist experiment—acute fragments of perception, which explain nothing and take no side, but viscerally evoke the grim scene.

For celebrants of modernist innovation (and I am one), it is troubling that such fine pictures could have been made in the service of such an evil goal. But they were. The transformation of the Russian Revolution from utopian dream into murderous nightmare was so vast that, in stepping back to take in the sweep of the whole, we risk losing sight of the human details. Rodchenko's acceptance of the canal commission may have involved a degree of capitulation to forces he neither endorsed nor understood. But his writings suggest that he believed the wooden propaganda he had been hired to illustrate.[84] He appears to have thought, or to have convinced himself, that like the prisoners at work on the canal, he would be redeemed by his travails.

If so, he was mistaken. Throughout the 1930s he continued to receive occasional design commissions (for example, plates 306–11, 316, and 317), but he was increasingly ignored by those in power, progressively deprived of everything except his life. In May 1945, shortly after the close of World War II, he wrote in his diary, "I'm absolutely unneeded, whether I work or not, whether I live or not. I'm already as good as dead, and I'm the only one who cares that I'm alive. I'm an invisible man."[85]

In the mid-1930s, the great innovator who had boldly renounced easel painting took it up again. Drawing on Picasso's early circus imagery and its association of performer and artist, he created a series of paintings whose bright colors are at odds with their somber mood. Among them are imaginary self-portraits, unbearably sad to contemplate (fig. 33). In artistic terms the mood of resignation is more effectively expressed in a handful of personal photographs of the early and mid-1930s, such as the famous *Woman with a Leica* (*Devushka s Leikoi*), a portrait of Rodchenko's student Evgeniia Lemberg (plate 304). Overlaid with a grid of shadows (like a series of photographs by Moholy, which it recalls[86]), the picture has been celebrated as an icon of forward-looking modernism. It is perhaps more accurate to say that the picture looks back, with a gaze full of romantic melancholy—or nearly as full as Rodchenko's moving portrait of the defeated Stepanova (plate 305). Only his picture of his young daughter Varvara is full of hope (plate 303).

The great irony of the attacks that began to mount against Rodchenko in 1928, and of his subsequent gradual exclusion from official culture, is that his style was simultaneously becoming the cornerstone of Stalinist photographic propaganda. Simplified and homogenized, his oblique angles and dynamic forms established the public image of the five-year plan mentality (figs. 34 and 35).[87] Rodchenko's own sports and parade photographs of the 1930s are exemplary of this transformation: their bold forms and

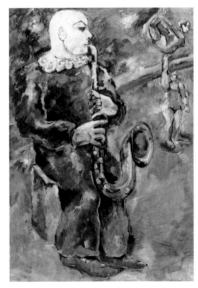

33.

33. Aleksandr Rodchenko. *Clown with Saxophone* (*Kloun s saksofonom*). 1938. Oil on canvas, 39⅜ × 31¹¹/₁₆" (100 × 80.5 cm). A. Rodchenko and V. Stepanova Archive, Moscow.

35.

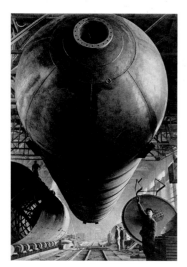
34.

sweeping lines project an impersonal image of indomitable power, but they derive from the mobile perspectives of the experimental modernist.

In this as in earlier chapters of Rodchenko's photographic career, his work evolved in close parallel with developments abroad. The adaptation of the modernist aesthetic to hortatory functions was an international phenomenon of the 1930s, blind to ideological distinctions. The German Leni Riefenstahl[88] and the American Margaret Bourke-White (fig. 36) embraced power as naïvely as any Soviet photographer. (Bourke-White, in fact, managed to serve capitalist and Communist masters simultaneously.[89]) What Stalin and Hitler shared with a magnate of capitalism such as Bourke-White's boss, Henry Luce (beyond an unquestioning enthrallment with heavy industry), was a talent for persuading a massive audience that life was as good as their picture of it. To achieve this, their artists did not overthrow modernism; they adapted it.

This adaptation was only the beginning of a long process. It was quite right for Rodchenko, like Moholy and Vertov and other pioneers of modernism, to identify his artistic inventions with the progressive spirit that had brought them to life. The originality of his work was not merely an expression of personal creativity; it issued from a collective effort, and in artistic terms it marked a decisive break with the past and so suggested a fresh future. As time passed, however, and the once-new artistic vocabulary became common property, it became detached from its original identity: there is no immutable link between a given set of artistic forms and a particular outlook or ideology. Today we often encounter the mobile perspectives and oblique angles of Rodchenko and Vertov in commercial advertisements, whose messages could hardly be more remote from Soviet culture of the late 1920s.

34. Arkadii Shaikhet. *Pulling up a Gas Tank.* 1930. Gelatin-silver print, 21¹³⁄₁₆ × 15" (55.4 × 38.2 cm). The Museum of Modern Art, New York. Joel and Anne Ehrenkranz Fund, Samuel J. Wagstaff, Jr., Fund, and Anonymous Purchase Fund.

35. Spread from *USSR in Construction* (*SSSR na Stroike*) no. 6 of 1932. Photographs by G. Zel'manov'ech (Georgii Zel'ma?) illustrating an article on the Tsentral'nyi Aero-Dinamicheskii Institut (Central Institute for Aerodynamics).

The twentieth century has been a century of extremes, and Rodchenko's art and life embody several of them. He was among the great innovators of the enormously creative modernist movement, and perhaps the most willing to abandon prior achievements and set forth into unmapped artistic territory. The inventive range of his work could not have existed without his admirably adventurous spirit, and this in turn could not have come to life in such force without the particularly fierce utopian illusion that both created the Bolshevik Revolution and was fueled by it. The most persuasive proof of this link lies in Rodchenko's diaries of the last twenty years of his life, which show in the most painful way that his adventurous spirit endured but, lacking any community of effort to which it could adhere, turned in upon itself in bitter futility.[90] There is perhaps no starker testimony to the essential symbiosis between the creative individual and the creativity of the culture to which he or she belongs. Both the flowering and the withering of Rodchenko's art are inseparable from the fortunes of the Revolution.

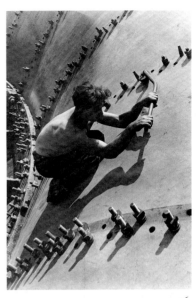

36.

In 1988, Boris Groys published a slim, unillustrated book titled *Gesamtkunstwerk Stalin*. Published four years later in English as *The Total Art of Stalinism*, the book brought a breath, a hurricane, of fresh air to the study of the Russian avant-garde of the 1920s and '30s, because its seriousness is laced liberally with wit and irony—and because its voice is the unfettered voice of a Russian.[91] Groys argues that with the advent of Stalinism the Russian avant-garde got what it asked for: an entirely new society in which art had achieved a wholly political function. Perhaps the argument goes too far in attributing political responsibility to artistic rhetoric; after all, although the avant-gardists sometimes behaved as if they wanted absolute power, they never in fact had it. But Groys's book has done us all a favor by piercing the pieties that have clung to the Russian Constructivists since they themselves advanced those pieties in support of their work.

The study of Russian Constructivism has been bedeviled by the appeal of comforting solutions. On the one hand lies the temptation to take the artists at their word, to believe that they were indeed building a new and better world. On the other lies the temptation to disengage the great innovations of Constructivist art from the political storm that first fostered and then killed it. But although Rodchenko's work was inspired by political ideals, it cannot be reduced to politics by other means; and although it was intimately involved with artistic developments in the West that were often far removed from Communist strivings, it cannot be reduced to an apolitical art of pure formal invention. It was the outgrowth of a passionate and deeply human engagement with one of the most vast and wrenching upheavals in modern history, and part of the challenge of studying it is to grasp that engagement in all its heroism, folly, brilliance, and defeat. From the comfort of the contemporary West this is not easy to do, but it is worth trying.

36. Margaret Bourke-White. *A Generator Shell, Dnieperstroi.* 1930. Gelatin-silver print, 13⅛ × 9⅛" (33.3 × 23.2 cm). The Museum of Modern Art, New York. Gift of the photographer.

Notes

1. Since I am not an expert in things Russian and do not speak or read the language, I have often lost my way. I am extremely grateful to Aleksandr Lavrent'ev, Leah Dickerman, and Anne-Laure Oberson for rescuing me repeatedly. I am thankful also to John Elderfield and John Szarkowski, who read the essay at an early stage, and to editor David Frankel, who read it over and over again. (I do not mean to suggest, of course, that anyone but myself bears responsibility for what I have written.)

I have made extensive use of Lavrent'ev's many publications, especially his *Alexander Rodchenko: Photography 1924–1954* (Cologne: Könnemann, 1995), which reproduced many photographs for the first time and made available a great deal of new information (including technical notes on each picture), and his *Rakursy Rodchenko* (Moscow: Iskusstvo, 1992), which Oberson kindly translated for me. I have relied heavily on Dickerman, "Aleksandr Rodchenko's Camera-Eye: Lef Vision and the Production of Revolutionary Consciousness" (Ph.D. dissertation, Columbia University, 1997), which is unpublished and which I am grateful to have had the privilege of reading; and Hubertus Gassner, *Rodčenko Fotografien*, with a foreword by Lavrent'ev (Munich: Schirmer/Mosel, 1982), still the only extensive analysis of Rodchenko's photographs to have appeared in print. I have also made considerable use of Aleksandr Rodchenko, *Opyty dlia budushchego: dnevniki, stati', pis'ma, zapiski* (Experiments for the future: diaries, articles, letters, notes), ed. O. V. Mel'nikov and V. I. Shchennikov, compiled by Lavrent'ev and V. Rodchenko (Moscow: Grant', 1996), which is the most comprehensive anthology of Rodchenko's own writings, including previously unpublished diaries of the late 1930s through the early 1950s. I have used the manuscript of an English translation by James West, commissioned by The Museum of Modern Art; page references, however, are to the Russian edition.

Finally I would like to note my debts to Evelyn Weiss, ed., *Alexander Rodtschenko Fotografien 1920–1938*, exh. cat. for the Museum Ludwig, Cologne (Cologne: Wienand Verlag, 1978); to David Elliott, ed., *Rodchenko and the Arts of Revolutionary Russia* (New York: Pantheon Books, 1979), a reprint of the catalogue of Elliott's pioneering Rodchenko exhibition at the Museum of Modern Art, Oxford; to Benjamin H. D. Buchloh, "From Faktura to Factography," *October* no. 30 (Fall 1984): 83–118; and to Margarita Tupitsyn, *The Soviet Photograph 1924–1937* (New Haven and London: Yale University Press, 1996). See also Elliott's review of Tupitsyn's book in *Slavic Review* 56 no. 2 (Summer 1997): 388–89.

2. In a good deal of the literature on modernist photography of the 1910s and '20s, European and American examples are regularly compared. But although the parallels are often interesting, advanced photography of the period evolved very differently on the two sides of the Atlantic, in part because of World War I. For this reason I have excluded references to American work, except for Margaret Bourke-White's work in Russia.

3. Ilya Ehrenburg, *Viza vremeni* (Berlin, 1929); quoted in translation in Joshua Rubenstein, *Tangled Loyalties: The Life and Times of Ilya Ehrenburg* (New York: Basic Books, Inc., 1996), p. 83.

4. Ludwig Kassák, quoted in Sibyl Moholy-Nagy, *Moholy-Nagy: Experiment in Totality*, 1950 (second ed. Cambridge, Mass.: The MIT Press, 1969), p. 21. Sibyl Moholy-Nagy incorrectly cites the passage as an excerpt from Kassák's introduction to Kassák and László Moholy-Nagy, *Buch neuer Künstler* (Vienna: MA, 1922). I have been unable to trace the correct source.

5. My summary of the technological revolution in photography, and of its wide-ranging implications, is deeply indebted to John Szarkowski, *Photography until Now* (New York: The Museum of Modern Art, 1990), especially chapters 5 and 6 (pp. 125–245). Szarkowski's account of the photomechanical revolution (chapter 6) is particularly original and valuable.

6. Nikolai Bukharin and Evgenii Preobrazhenskii, *Azbuka Kommunizma: Populiarnoe op"iasnenie programmy rossiiskoi kommunisticheskoi partii bol'shevikov*, 1919; quoted in translation in Richard Stites, *Revolutionary Dreams: Utopian Vision and Experimental Life in the Russian Revolution* (New York: Oxford University Press, 1989), p. 47.

7. Sergei Treti'akov, "Otkuda i kuda? (Perspektivy futurizma)," *Lef* no. 1 of 1923, p. 195; quoted in translation in Halina Stephan, *"Lef" and the Lef Front of the Arts*, *Slavistische Beiträge* vol. 142 (Munich: Verlag Otto Sagner, 1981), p. 61. The essay is published in English as "From Where to Where" in Anna Lawton and Herbert Eagle, eds. and trans., *Russian Formalism through Its Manifestoes, 1912–1928* (Ithaca: Cornell University Press, 1988), p. 208.

8. Alfred H. Barr, Jr., "Russian Diary," 1927–28, in *Defining Modern Art: Selected Writings of Alfred H. Barr, Jr.*, ed. Irving Sandler and Amy Newman (New York: Harry N. Abrams, Inc., 1986), p. 113.

9. Notably in an essay of 1921, "Liniia," published in English, trans. West, as "The Line," in *Art into Life: Russian Constructivism 1914–1932*, exh. cat. for the Henry Art Gallery, University of Washington, Seattle, with an introduction by Richard Andrews and Milena Kalinovska (New York: Rizzoli International Publications, Inc., 1990), p. 71. See also Lavrent'ev's essay in the present volume.

10. Rodchenko's first published photocollages (plates 60 and 61, for example) appeared as illustrations to an article on photomontage, "Pechatnyi material dlia kritiki smontirovannyi konstruktivistom Rodchenko," in *Kino-Fot* no. 1 of 1922, p. 13.

11. The original edition of the poem in book form (published by Glavlit in Moscow in 1923) has been reprinted in fascimile, together with translations into English and German, color reproductions of Rodchenko's photocollages and variants, and an essay by Lavrent'ev, "About This Book" (pp. 71–77): Vladimir Mayakovsky, *It* (Berlin: Ars Nicolai, 1994). See also Donald Karshan, "Rodtschenkos Meisterwerk: Majakowskis 'Pro eto'," in Weiss, ed., *Alexander Rodtschenko Fotografien 1920–1938*, pp. 70–72.

12. Mayakovsky, *It*, p. 39.

13. The kinship was first recognized in a brief unsigned essay on photomontage in *Lef* no. 4 of 1924, which cites Rodchenko's work, including the illustrations for *Pro eto*, and the work of George Grosz "and other Dadaists" as exemplary instances of the

new medium. See "Photomontage," trans. John E. Bowlt, in Christopher Phillips, ed., *Photography in the Modern Era: European Documents and Critical Writings, 1913–1940* (New York: The Metropolitan Museum of Art and Aperture, 1989), pp. 211–12, where the essay is tentatively attributed to Gustav Klucis.

14. The most rewarding general account is John Willett, *Art and Politics in the Weimar Period: The New Sobriety, 1917–1933* (New York: Pantheon Books, 1978).

15. In the essay "Rabota s Maiakovskim" (Working with Mayakovsky), written in 1939, Rodchenko recalls, "Volodia [i.e., Mayakovsky] was often abroad. The map of his travels Varvara [Stepanova] is now making reveals that in a year he made four trips on average. . . . He brought [home] entire suitcases of magazines, catalogues, and books. He gave all of it to Osia [Osip Brik], and there was a complete warehouse in his room. We would crowd into the room, look at things, argue and make plans. . . . After Osia had examined everything and all the newsworthy material had been used in the press, the magazines and books were distributed by specialty: I got art and photography. . . . [Mayakovsky] wasn't a collector, he gave to us everything he brought back. He brought us not just the art of the West, but its life, its breath, its essence, with all its virtues and shortcomings. He brought posters, catalogues, advertising prospectuses and handbills, and the latest novelties and photographs of views, productions and structures." From Rodchenko, *Opyty dlia budushchego*, pp. 236–37 (West translation). In *Alexander Rodchenko: Photography 1924–1954*, p. 14, Lavrent'ev writes that Zakhar Bykov, a student at Vkhutemas, recalled visiting Rodchenko's studio and finding the entire floor covered with piles of French and German periodicals—among them *Junge Welt, Moderne Illustrierte Zeitschrift, Kölnische Illustrierte Zeitung, Die Woche, Die Frau,* and *L'Illustration*—from which Rodchenko was clipping illustrations and classifying them by subject. The visit could not have occurred before 1926, when the *Kölnische Illustrierte Zeitung* was founded.

16. See Christina Lodder, "The Vkhutemas and the Bauhaus," in Gail

Harrison Roman and Virginia Haelstein Marquart, eds., *The Avant-Garde Frontier: Russia Meets the West, 1910–1930* (Gainesville: University Presses of Florida, 1992), pp. 196–237.

17. See Irina Antonowa and Jörn Merkert, eds., *Berlin-Moskau 1900–1950*, exh. cat. (Munich and New York: Prestel-Verlag, 1995), including Bernd Finkeldey, "Im Zeichen des Quadrates: Konstruktivisten in Berlin" (pp. 157–61). See also John Elderfield, *Kurt Schwitters* (London: Thames and Hudson, 1985), pp. 120–43; and Manfredo Tafuri, "U.S.S.R.—Berlin, 1922: From Populism to 'Constructivist International,'" in Joan Ockman, ed., *Architecture, Criticism, Ideology* (Princeton: Princeton Architectural Press, 1985), pp. 121–81.

18. Raoul Hausmann, "Photomontage," 1931. Published in English, trans. Joel Agee, in Phillips, ed., *Photography in the Modern Era*, p. 178.

19. El Lissitzky, "Our Book," 1926. Published in English, trans. Helene Aldwinckle, in *El Lissitzky: Life, Letters, Texts*, ed. and with an introduction by Sophie Lissitzky-Küppers, trans. Aldwinckle and Mary Whittall (Greenwich: New York Graphic Society, 1968), pp. 357–59.

20. See Maud Lavin, *Cut with the Kitchen Knife: The Weimar Photomontages of Hannah Höch* (New Haven: Yale University Press, 1993), especially chapter 2 (pp. 47–69); Ute Eskildsen, *Fotografie in deutschen Zeitschriften 1924–1933*, exh. cat. (Stuttgart: Institut für Auslandsbeziehungen, 1982); and Christian Ferber, ed., *Berliner Illustrirte Zeitung: Zeitbild, Chronik, Moritat für Jedermann 1892–1945* (Berlin: Ullstein, 1982).

21. The relationship between avant-garde photocollage and the graphic innovations of the photographically illustrated press is a complex subject. Broadly speaking, when photographs were introduced at the turn of the century they were used both sparingly and timidly at first. World War I created a huge market for pictures, fostering growth and experiment on both sides of the Atlantic, but it was not until the early 1920s, as Germany recovered from the postwar depression, that its illustrated press regularly featured the crowded, innovative layouts that

so closely resemble the photocollages of the avant-garde. The relationship between the two awaits thorough investigation, despite the value of the works by Lavin and Eskildsen cited in note 20, and the painstaking analysis of Höch's sources in Gertrud Jula Dech, *Schnitt mit dem Küchenmesser DADA durch die letzte weimarer Bierbauchkulturepoche Deutschlands: Untersuchen zur Fotomontage bei Hannah Höch* (Münster: Lit Verlag, 1981), and in Maria Makela and Peter Boswell, eds., *The Photomontages of Hannah Höch*, exh. cat. (Minneapolis: Walker Art Center, 1996). See also Matthew Teitelbaum et al., *Montage and Modern Life 1919–1942*, exh. cat. for the Institute of Contemporary Art, Boston (Cambridge, Mass.: The MIT Press, 1992).

22. Examples of the tire motif in Dadaist photocollage are John Heartfield's collage on the cover of *Der Dada 3* (reproduced here as fig. 1) and collages by Höch (reproduced in Makela and Boswell, eds., *The Photomontages of Hannah Höch*, plates 1, 9, and 10); by Hausmann (reproduced in *Raoul Hausmann 1886–1971*, exh. cat. [Berlin: Berlinische Galerie, 1994], p. 182); and by Heartfield and Grosz (reproduced in Peter Pachnicke and Klaus Honnef, eds., *John Heartfield* [New York: Harry N. Abrams, Inc., 1991], p. 68).

23. The *revarkhiv* consisted of dozens of photographs in the matter-of-fact style of newspaper photography, many or most of them anonymous, showing scenes from the Revolution and its aftermath. Rodchenko and Stepanova purchased the collection from the Soviet film agency Sovkino in 1926, and added to it occasionally for a number of years. Rodchenko used one of the *revarkhiv* pictures on the cover of *Novyi Lef* no. 3 of 1927 (plate 203), and reproduced a number of them in the magazine itself (e.g., nos. 8–9 of 1927, opposite pp. 16 and 17 and opposite p. 32; no. 3 of 1928, opposite p. 32; no. 4 of 1928, opposite pp. 32 and 33; and no. 5 of 1928, opposite p. 16). On the *revarkhiv* and its relationship to the Lef aesthetic of documentary fact, see Dickerman, "Aleksandr Rodchenko's Camera-Eye," pp. 207–15.

24. From Rodchenko, "Rabota s Maiakovskim," p. 229 (West translation, slightly altered here). The passage continues,

"I bought myself two cameras—a 13 × 18 with a triple bellows extension and a Dagor lens—this was a camera for shooting reproductions—and a Kodak pocket camera."

25. See Robert Delpire et al., eds., *Identités: de Disdéri au photomaton*, exh. cat. (Paris: Centre Nationale de la Photographie and Éditions du Chêne, 1985).

26. It should be noted in the same vein that Rodchenko's use of a blank studio backdrop in the Mayakovsky portraits, although sometimes interpreted as a bold stroke of spare modernism, need not be assigned any more elaborate motive than the expectation that the background would be cut away in the eventual photocollage.

27. Rodchenko, "Against the Synthetic Portrait, for the Snapshot," 1928. Published in English, trans. Bowlt, in Phillips, ed., *Photography in the Modern Era*, pp. 238–42. On the theoretical context see Dickerman, "Aleksandr Rodchenko's Camera-Eye," chapter 2 (pp. 69–135).

28. In *An Essay in Autobiography*, 1959, Boris Pasternak wrote that at the hands of Stalin's propagandists, Mayakovsky "began to be introduced forcibly, like potatoes under Catherine the Great. This was his second death. He had no hand in it." Quoted in Patricia Blake, "The Two Deaths of Vladimir Mayakovsky," published as an introduction to Mayakovsky, *The Bedbug and Selected Poetry*, trans. Max Hayward and George Reavey (Bloomington: Indiana University Press, 1960), p. 50.

29. Introduced in 1922, the Sept (or "seven" in French) could perform seven functions. In addition to taking both motion pictures and still frames, for example, it could print its negatives on positive film, project the film, and function as an enlarger for still photographs. See Brian Coe, *Cameras: From Daguerreotypes to Instant Pictures* (New York: Crown Publishers, Inc., 1978), p. 112.

30. In *Alexander Rodchenko: Photography 1924–1954*, Lavrent'ev states that Rodchenko acquired the Kodak Vest Pocket in 1925 (p. 20), but in the "List of Photographs" two portraits of Mayakovsky with his dog, dated 1924, are attributed to the Kodak (numbers 80 and 81, p. 328). These, however, are the only

two pictures attributed to the camera before Rodchenko's trip to Paris in 1925.

31. Because it could serve so many different functions, the 35-mm. Sept was much heavier and bulkier than the Leica. And it produced a smaller negative. Although both cameras used roll film of the same 35-mm. width, the frame of the Sept was horizontal across the width of the film; allowing for the sprocket holes, the Sept's frame measured 18 by 24 mm. (or about ¾ by 1 inch). The Leica's frame, horizontal along the length of the film, measured 24 × 36 mm. (or roughly 1 by 1½ inches). Thus the Leica both was more mobile and, since its negative was larger, produced pictures with greater detail.

32. Rodchenko's photograph of Konstantin Mel'nikov's pavilion is reproduced in Gassner, *Rodčenko Fotografien*, p. 73.

33. See, for example, Lavrent'ev, *Alexander Rodchenko: Photography 1924–1954*, nos. 155, 207, 227, 389, 392, 393, and 395.

34. The film's credits list Rodchenko as *Khudozhnik* (Artist). That he was responsible for choosing locations and camera positions and angles was told to me by Lavrent'ev.

35. See Eskildsen and Jan-Christopher Horak, eds., *Film und Foto der zwanziger Jahre: Eine Betrachtung der Internationalen Werkbundausstellung "Film und Foto" 1929* (Stuttgart: Hatje, 1979). The exposition's catalogue has been reprinted as *Internationale Ausstellung des Deutschen Werkbundes Film und Foto Stuttgart 1929*, ed. and with an introduction by Karl Steinorth (Stuttgart: Deutsche Verlags-Anstalt, 1979).

36. László Moholy-Nagy, *Malerei, Photographie, Film*, Bauhausbücher 8 (Munich: Albert Langen Verlag, 1925). The revised edition appeared as *Malerei, Fotografie, Film* (Munich: Albert Langen Verlag, 1927). The 1927 edition, translated into English by Janet Seligman and accompanied by a note by Hans M. Wingler and a postscript by Otto Stelzer, was published under the title *Painting, Photography, Film* in 1969 by The MIT Press, Cambridge, Mass., and Lund Humphries, London.

A Russian edition of the revised version, with an introduction by Alexei Fedorov-Davidov, was published as *Zivopis' ili fotografia* in Moscow in 1929 by the magazine

Sovetskoe Foto. Fedorov-Davidov's introduction, trans. Judith Szollosy, appears in Phillips, ed., *Photography in the Modern Era*, pp. 273–81.

37. Hausmann, "Die neue Kunst," *Die Aktion* 11 no. 19/20 (1921). Quoted in translation in Phillips, "Twenties Photography: Mastering Urban Space," in Jean Clair, ed., *The 1920s: Age of the Metropolis*, exh. cat. (Montreal: The Montreal Museum of Fine Arts, 1991), p. 215.

38. Moholy-Nagy, *Painting, Photography, Film*, p. 29.

39. A note on the copyright page of the first edition states that the book was put together (*zusammengestellt*) in the summer of 1924, but that technical difficulties delayed its publication. An apparent exception to the absence of camera photographs in Moholy's work before mid-1925 is the close-up photograph of a gramophone record on page 52 of the first edition (page 62 of the 1969 English-language edition), which is credited to "Moholy-Nagy bei von Löbbecke" (Moholy-Nagy at von Löbbecke's). The credit seems to imply, however, that Moholy did not make the picture himself but had it made in a professional studio. In any case, this isolated exception is not characteristic of Moholy's camera photographs, of which the first securely datable examples are from his trip to France in the summer of 1925. See Eleanor M. Hight, *Picturing Modernism: Moholy-Nagy and Photography in Weimar Germany* (Cambridge, Mass.: The MIT Press, 1995), p. 104.

40. Hight, in her *Moholy-Nagy: Photography and Film in Weimar Germany*, exh. cat. (Wellesley, Mass.: Wellesley College Museum, 1985), p. 29, states that Moholy's friend Viking Eggling died while Moholy was correcting proofs for the book. Eggling died on May 19, 1925.

41. Rodchenko, "The Paths of Modern Photography," 1928. Published in English, trans. Bowlt, in Phillips, ed., *Photography in the Modern Era*, p. 260.

42. Ibid., p. 257.

43. On Höch's scrapbook see Lavin, *Cut with the Kitchen Knife*, chapter 3 (pp. 71–122).

44. Erich Mendelsohn, *Amerika: Bilderbuch eines Architekten* (Berlin: Rudolf Mosse Buchverlag, 1926; rev. and enlarged ed.

1928). The first edition has been published in English, trans. Stanley Appelbaum, as *Erich Mendelsohn's "Amerika": 82 Photographs* (New York: Dover Publications, Inc., 1993). Many of the pictures in the book were in fact made by others, notably the Danish-born architect Knud Lönberg-Holm. On the book's context and wide influence see Jean-Louis Cohen's afterword to the French edition: *Amerika: Livre d'images d'un architecte* (Paris: Les Éditions du Demi-Cercle, 1992), pp. 225–41; Cohen, *Scenes of the World to Come: European Architecture and the American Challenge 1893–1960* (Paris: Flammarion, in association with the Canadian Centre for Architecture, Montreal, 1995), pp. 85–98; and Herbert Molderings, "Mendelsohn, Amerika und der 'Amerikanismus'," in the German facsimile of the 1926 edition (Brunswick: F. Vieweg, 1991), pp. 83–92.

45. A review of the book, by Lissitzky, appeared in *Stroitel'naia Promyschlennost'* no. 2 of 1926. See Lissitzky, "The Architect's Eye," published in English, trans. Alan Upchurch, in Phillips, ed., *Photography in the Modern Era*, pp. 221–26.

46. The magazine was edited by Rodchenko's Lef colleague Aleksei Gan, who invited Rodchenko and Stepanova to design layouts for it. See Lavrent'ev, *Rakursy Rodchenko*, p. 40.

47. Rodchenko's important essay of 1928, "The Paths of Modern Photography," in Phillips, ed., *Photography in the Modern Era*, concludes: "Photograph from all viewpoints except 'from the belly button,' until they all become acceptable. And the most interesting viewpoints today are those from above down and below up and their diagonals" (p. 262).

48. The Umbo photogram and a negative print derived from it were reproduced in *Novyi Lef* no. 10 of 1928, opposite pp. 32 and 33 respectively. See Molderings, *Otto Umbehr: Umbo 1920–1980* (Düsseldorf: Richter Verlag, 1995), p. 112 and plates 70 and 71. The apparent connection between Rodchenko's photogram and Umbo's was pointed out to me by Lavrent'ev.

49. See Szymon Bojko, "Die Kontroversen über Rodtschenko als Fotograf," in Weiss, ed., *Alexander Rodtschenko Fotografien 1920–1938*, p. 42. Bojko quotes from an article by Sergei

Urusevski, a former Vкhuтeмаs student, published in *Iskusstvo Kino* no. 12 of 1967, in which Urusevski recalls that Rodchenko taught his students to make photograms.

50. See Gassner, "Analytical Sequences," in Elliott, ed., *Rodchenko and the Arts of Revolutionary Russia*, pp. 108–11, and Gassner, *Rodčenko Fotografien*, passim.

51. Lissitzky, "Proun: Not Visions, BUT— World Reality," 1920. Published in English, trans. Aldwinckle, in *El Lissitzky*, ed. and with an introduction by Lissitzky-Küppers, p. 343.

52. This fascinating continuity is explored in Meyer Schapiro, "Mondrian: Order and Randomness in Abstract Painting," *Modern Art: 19th & 20th Centuries: Selected Papers* (New York: George Braziller, Inc., 1978), pp. 233–61.

53. The relationship between Rodchenko's work and the theories of Viktor Shklovsky and the Russian Formalists generally is considered in Dickerman, "Aleksandr Rodchenko's Camera-Eye," pp. 45–68.

54. See Peter Galassi, *Henri Cartier-Bresson: The Early Work*, exh. cat. (New York: The Museum of Modern Art, 1987), especially pp. 41–44.

55. The oblique view from above in photography, its precedents in nineteenth-century painting, and its broader cultural context and meanings are explored in two very useful texts: Wolfgang Kemp, "Das Neue Sehen: Problemgeschichtliches zur fotografischen Perspektive," *Foto-Essays zur Geschichte und Theorie der Fotografie* (Munich: Schirmer/Mosel, 1978), pp. 51–101; and Kirk Varnedoe, "Overview: The Flight of the Mind," chapter 5 in his *A Fine Disregard: What Makes Modern Art Modern* (New York: Harry N. Abrams, Inc., 1990), pp. 217–77.

56. Rodchenko made plates 195 and 196 at Pushkino in 1927 with the Kodak Vest Pocket camera. He made the very similar plate 194 with the Leica, which means that it cannot have been made before November 1928, when he acquired the camera. In conversation, Lavrent'ev has suggested to me that plate 194 might have been made in 1930 as part of the series on the Vakhtan lumber mill (see plates 280–85).

57. Rodchenko, in Brik, Mayakovsky, Rodchenko, and Shklovsky, "Zapisnaia

knizhka Lefa," *Lef* no. 6 of 1927. Quoted here in translation from Rodchenko (in French transliteration, Alexandre Rodtchenko), *Écrits complets sur l'art, l'architecture et la révolution*, ed. Lavrent'ev, trans. into French by Bernadette du Crest (Paris: Philippe Sers, 1988), p. 125.

58. Rodchenko made *Assembling for a Demonstration* with the Leica that he acquired in November 1928. Thus, although traditionally dated 1928, the picture was more likely made in 1929 or 1930 (especially as the scene does not correspond to typical winter weather in Moscow).

59. I learned this the hard way, in an attempt to repeat the picture on the spot, but it is easily deduced from the image itself.

60. Gassner, *Rodčenko Fotografien*, pp. 79–86. See also John Szarkowski, *Looking at Photographs: 100 Pictures from the Collection of The Museum of Modern Art* (New York: The Museum of Modern Art, 1973), p. 94.

61. Walter Benjamin, *Moscow Diary*, ed. Gary Smith, trans. Richard Sieburth (Cambridge, Mass.: Harvard University Press, 1986), p. 67.

62. Rodchenko, "The Paths of Modern Photography," in Phillips, ed., *Photography in the Modern Era*, pp. 258–59.

63. In a lively essay on this subject, Phillips notes the influence of Georg Simmel's essay of 1903, "The Metropolis and Mental Life," citing the English translation in Donald L. Levine, ed., *Georg Simmel on Individuality and Social Forms* (Chicago and London: University of Chicago Press, 1971). See Phillips, "Twenties Photography: Mastering Urban Space," pp. 209–25. See also Molderings, "Urbanism and Technological Utopianism: Thoughts on the Photography of Neue Sachlichkeit and the Bauhaus," in David Mellor, ed., *Germany: The New Photography 1927–33* (London: Arts Council of Great Britain, 1978), pp. 87–94.

64. Moholy-Nagy, "Photography is the Manipulation of Light," 1928, trans. Frederic Samson, in Andreas Haus, *Moholy-Nagy: Photographs and Photograms* (New York: Pantheon Books, 1980), p. 49.

65. Dziga Vertov, "Kinoki, Perevorot," *Lef* no. 3 of 1923, pp. 134–43. Published in English, trans. Richard Taylor, as "The Cine-Eyes: A

Revolution" in Taylor and Ian Christie, eds., *The Film Factory: Russian and Soviet Cinema in Documents* (Cambridge, Mass.: Harvard University Press, 1988), p. 93.

66. Because *Sovetskoe Foto* refused to print his response, Rodchenko published it in *Novyi Lef*, the house organ of the Lef group, where the remainder of the exchanges appeared. Beginning with the initial attack, the entire sequence has been published in English in Phillips, ed., *Photography in the Modern Era*, pp. 243–72.

67. See Lionel Trilling's introduction to the first English translation of Isaac Babel's collected stories (1955), reprinted as an appendix to Babel, *Collected Stories*, trans. David McDuff (London: Penguin Books, 1994), pp. 339–64. Babel's address to the 1934 writers' congress is discussed on pp. 341–43.

68. See *Sovetskoe Foto* no. 6 of 1927, pp. 163—a view from below of a clock in Jersey City (on the right in fig. 15 here)—and 181, an overhead view of the interior of St. Paul's Cathedral, London (on the left in fig. 16 here). In addition, *Sovetskoe Foto* no. 11 of 1927 reproduces on p. 352 a photograph of a radically foreshortened figure that would appear two years later in a popularization of Moholy's aesthetic: Werner Gräff, *Es kommt der neue Fotograf!* (Berlin: Verlag Hermann Reckendorf, 1929; reprint ed. Cologne: Verlag der Buchhandlung Walther König, 1978), p. 59.

69. Between pp. 248 and 249 of *Sovetskoe Foto* no. 8 of 1927 is an unpaginated sheet bearing two gravure reproductions: on one side, a Pictorialist landscape by B. Ulitin, and on the other a worm's-eye photograph of a New York skyscraper from Mendelsohn's *Amerika*.

70. *Sovetskoe Foto* no. 9 of 1927, for example, reproduces a Rodchenko photograph made in the Brianskii railway station (my fig. 13), on p. 272, and on p. 274, *Balconies*, from the "Building on Miasnitskaia Street" series (plate 169). *Sovetskoe Foto* no. 10 of 1927 reproduces *Mother* (plate 146), cropped on the cover and uncropped on p. 301; a bird's-eye view of the courtyard seen from Rodchenko's apartment building appears on p. 300. *Sovetskoe Foto* no. 8 of 1927 reproduces, on p. 232, Rodchenko's portrait of Nikolai Aseev (plate 198).

71. Notably the November 1927 issue, which celebrates the tenth anniversary of the Revolution.

72. Including, on p. 280 of *Sovetskoe Foto* no. 9 of 1927, the Rodchenko photograph reproduced here as fig. 10.

73. Rembrandt was the featured model in *Sovetskoe Foto* no. 2 of 1928, p. 55. Rodchenko was doubtless referring to this issue when he wrote in his response to the attack, "If there are one or two photographs resembling mine—well, one could find thousands comparable to the endless landscapes and heads published in your journal. ¶ You ought to publish a few more of our imitations, instead of Rembrandt imitations, in *Sovetskoe Foto!*" Rodchenko, "Downright Ignorance or a Mean Trick?" Published in English, trans. Bowlt, in Phillips, ed., *Photography in the Modern Era*, p. 248.

74. Ivan Bokhanov, quoted in Tupitsyn, *The Soviet Photograph 1924–1937*, p. 107. Tupitsyn cites Leonid Mezhericher's claim that Bokhanov made the remark at a meeting held in conjunction with the *Exhibition of the Work of the Masters of Soviet Photography* exhibition held in Moscow in 1935.

75. Lavrent'ev, "Photo-Dreams of the Avant-Garde," in Elliott, ed., *Photography in Russia 1840–1940*, exh. cat. for the Museum of Modern Art, Oxford (London: Thames and Hudson, Ltd., 1992), p. 68.

76. Mikhail Bulgakov, *Master i Margarita*, written between 1928 and 1940. Published in English, trans. Michael Glenny, as *The Master and Margarita* (London: Collins and Harvill Press, 1967), pp. 155–56.

77. See Sheila Fitzpatrick, "Cultural Revolution as Class War," in Fitzpatrick, ed., *Cultural Revolution in Russia, 1928–1931* (Bloomington: Indiana University Press, 1978), pp. 8–40.

78. A useful chronicle of the debates is provided in Tupitsyn, *The Soviet Photograph 1924–1937*, chapter 4 (pp. 99–126), although the author's analysis is hampered by an uncritical acceptance of the sincerity of the the debaters.

79. Rodchenko, quoted in ibid., p. 100. The essay is unsigned; Tupitsyn states that Lavrent'ev has attributed it to Rodchenko.

80. Rodchenko's diaries of this period constitute a moving self-portrait. They were published for the first time in *Opyty dlia budushchego*, pp. 292–400. I have read them in West's translation.

81. According to Lavrent'ev, the book was to have been titled *Dve Moskvy* (Two Moscows). Drawings by Kukryniksov (Mikhail V. Kupriianov, Porfirii N. Krylov, and Nikolai A. Sokolov) were to have represented Moscow before the Revolution; Rodchenko's photographs, the contemporary city. Rodchenko photographed extensively for the book from January to July 1932. In July he presented to Izogiz more than eighty finished prints, each numbered in sequence on the verso by Stepanova. The book was never published but the prints have come to light and are scheduled to be exhibited in December 1998 at the Sprengel Museum, Hannover, Germany.

Some of the photographs Rodchenko made for the book were used in the postcard series and in an unbound album titled *Ot Moskvy kupecheskoi k Moskve sotsiialisticheskoi* (From capitalist Moscow to socialist Moscow), published by Izogiz in 1932. The album also included pictures by several other photographers.

82. For an example of the theater photographs, see Lavrent'ev, *Alexander Rodchenko: Photography 1924–1954*, no. 388 (p. 294).

83. Aleksandr I. Solzhenitsyn, *The Gulag Archipelago 1918–1956: An Experiment in Literary Investigation III–IV*, trans. Thomas P. Whitney (New York: Harper & Row, 1975), pp. 80–120. See also Loren Graham, *The Ghost of the Executed Engineer: Technology and the Fall of the Soviet Union* (Cambridge, Mass.: Harvard University Press, 1993), pp. 61–65.

84. See particularly the essay "Perestroika khudozhnikov" (Reconstruction of an artist), *Sovetskoe Foto* nos. 5–6 of 1935: 19–21. It has been published in French, trans. du Crest, as "Transformation de l'artiste," in Rodchenko (transliterated Rodtchenko), *Écrits complets*, pp. 154–59.

85. Rodchenko, diary entry of May 28, 1945, *Opyty dlia budushchego*, p. 382 (West translation).

86. I refer to a series of pictures made on a balcony at Ascona in 1926, including *Puppen*

(Dolls), reproduced in Moholy-Nagy, *Painting, Photography, Film*, p. 92 (p. 90 of the second edition, *Malerei, Fotografie, Film*, of 1927).

87. A specific instance of the irony is that Arkadii Shaikhet, the author of fig. 34, was a leader of ROPF (Rossiiskoe ob"edineniie proletarskikh fotoreporterov—the Russian society of proletarian photo-reporters), which played a prominent role in the attacks on Rodchenko and other photographers of the October group.

Although Rodchenko was the most original and influential, he was deeply involved with many other talented Soviet photographers, such as Shaikhet, Eleazar Langman, and Boris Ignatovich. These artistic, professional, personal, and ideological relationships await sustained investigation, despite the beginnings made in such general works as Tupitsyn, *The Soviet Photograph 1924–1937*, and Elliott, ed., *Photography in Russia 1840–1940*, as well as in such anthologies as *Antologia sovetskoi fotografii*, ed. An. Vartanov, O. Suslova, and G. Chudakov, vol. 1, *1917–1940* (Moscow: Izdatel'stvo Planeta, 1986), and *Twenty Soviet Photographers 1917–1940*, ed. Grigory Chudakov, Rikje Draaijer, and Ger Fiolet (Amsterdam: Fiolet & Draaijer Interfoto, 1990), with text in Dutch, English, French, and German.

88. Leni Riefenstahl's sports photographs, excerpted from her film on the 1936 Olympics, bear a strong resemblance to Rodchenko's. See Riefenstahl, *Olympia* (Berlin: Ullstein, 1937), and the English-language edition of the German reprint of 1988 (New York: St. Martin's Press, 1994).

89. It was for *Fortune*, the business magazine founded by Henry Luce in 1930, that Bourke-White first traveled to the Soviet Union. She so impressed Stalin's minions that she was repeatedly invited to return, and was commissioned by Soviet government agencies to make photographs for state magazines. See Vicki Goldberg, *Margaret Bourke-White: A Biography* (New York: Harper & Row, 1986), pp. 125–35.

90. In Rodchenko, *Opyty dlia budushchego*, pp. 292–400 (West translation).

91. Boris Groys, *Gesamtkunstwerk Stalin*, 1988, published in English, trans. Charles Rougle, as *The Total Art of Stalinism: Avant-Garde, Aesthetic Dictatorship, and Beyond* (Princeton: at the University Press, 1992).

Varvara Rodchenko

Curators' Introduction

Varvara Aleksandrovna Rodchenko, born in 1925, was less than three years old when Alfred H. Barr, Jr., soon to become the first director of The Museum of Modern Art, visited her father and mother—Aleksandr Rodchenko and Varvara Stepanova—in Moscow. The quotation from her mother's diary in her memoir below is the counterpart of Barr's account of the visit, in a diary entry that reads as follows:

> *We [Barr and Jere Abbott] went with O'C [May O'Callahan] and [Ol'ga] Tret'iakova to see Rodchenko and his talented wife. Neither spoke anything but Russian but both are brilliant versatile artists. R. showed us an appalling variety of things—suprematist paintings (preceded by the earliest geometrical things I've seen, 1915, done with compass)—woodcuts, linoleum cuts, posters, book designs, photographs, kino set, etc., etc. He has done no painting since 1922, devoting himself to the photographic arts of which he is a master. R's wife is managing editor of* Kino. *When I showed her Mrs. Simon's film [*Hands, *by Stella Simon] she was much interested and asked for four stills to reproduce with an article. It will be fun to be paid in rubles (if any). I arranged to get photographs of Rodchenko's work for an article.*
>
> *We left after 11:30—an excellent evening—but I must find some painters if possible.*[1]

Rodchenko's relationship with the Museum thus began before the Museum was born.

Most of Varvara Rodchenko's memories of her father inevitably date from the early 1930s or later—that is, from the period in which the machinations of Stalinism first cornered the artist, then gradually eliminated him from official culture. Rodchenko's diaries from the mid-1930s until his death in 1956 are saturated with suffering, especially during World War II, when like millions of other Russians he and Stepanova spent much of their time and energy simply on finding enough to eat. The entry for August 11, 1943, reads in part:

> *Can it be that someday a middle-aged Mulia [Rodchenko's nickname for his only child] and her children will sit here, and that she'll look at my things and think: what a pity my father didn't live to see this, he's been recognized at last and there's a demand for his things. . . . People are buying them. . . . They're hanging in the museum. . . . [. . .]*
>
> *. . . My future Mulia, your late father can honestly tell you: and what he can tell you is that he wasn't certain, and even that he was totally uncertain, and that the uncertainty was like a disease. He didn't know why he kept working. And that there were times like now when he thought all his work would be destroyed, thrown out and not a single piece would be left anywhere. [. . .]*
>
> *Dear Mulia! Maybe you will be poisoned by all of this. . . . But I wish you no harm. Better to throw all of this away and live simply "like everybody else."*
>
> *But I did have fame and a European reputation, I was known in France, Germany, America.*
>
> *And now I have nothing.*[2]

Varvara Rodchenko did not choose to "throw all of this away." Living in the apartment on Miasnitskaia Street that her parents first occupied in 1922, she and her son, Aleksandr Lavrent'ev, have patiently preserved the artistic legacy of Rodchenko and Stepanova, making it available to the scholars and curators who arrived at first one by one, then in droves.

V. Kovrigin. Aleksandr Rodchenko
139 with his daughter Varvara. 1947.

One day in 1928—it was January 10—my mother, Varvara Stepanova, wrote a journal entry describing a visit she and my father, Aleksandr Rodchenko, had recently received:

> *Those Americans came to call: one of them dull, dry, and bespectacled—*
> *Professor Alfred Barr; the other cheerful and young—Jere Abbott. Surmised that*
> *Barr was traveling at Abbott's expense. Rodchenko speculated that Abbott was*
> *the child of wealthy parents.*
>
> *Barr is interested only in art—painting, drawing. He turned our whole apart-*
> *ment upside down. They made us show them all kinds of old junk. Toward the*
> *end Barr got all hot and bothered. Abbott is the one more interested in new art.*
>
> *Barr showed us a book on Russian art, in English, by [Louis] Lozowick.*
> *Everything was accurate—even the parts on the Constructivists—and there was*
> *a list of all their names.*
>
> *There's an entire chapter on Rodchenko. Barr made us check it for accuracy.*
> *O'C (an Irishwoman) was there, and she interpreted. There turned out to be*
> *only one error: that Rodchenko had been a student of Malevich. This was*
> *pointed out to Barr, and the passage was underlined.*
>
> *In America this Barr lectures on art.*[1]

My parents didn't know at the time that Barr would become the director of New York's Museum of Modern Art. When my father was working at the Muzei zhivopisnoi kul'tury [the Museum of Painterly Culture], and was living near the Pushkin Museum on the Volkhonka, in the 1920s, he dreamed of creating such a museum in Moscow.

Many years have passed, more than forty, since my father's death. Everything around has changed: people, objects, buildings, even the air. So one wants to remember what kind of person he was, what he was like in the morning and in the evening, at the dinner table and in his room, how he dressed, how he spoke.

He liked to be called by his last name, simply "Rodchenko," or "Rodcha," with the accent on the first syllable—not the way they pronounce it in Europe or America, stressing the "e." He was tall for his time, six feet, just a hair shorter than Vladimir Mayakovsky. His voice was quiet and soft, his tone easily slipping into irony. His hair: in 1920 he began shaving his head. Many other of his friends in the Lef group later began doing the same: Mayakovsky, Osip Brik, Viktor Shklovsky, Sergei Tret'iakov.

He slept on a wide ottoman, his face to the wall. (He had gotten the ottoman into the apartment with the help of Mayakovsky, for whose small quarters at the Briks, on Vodop'iannyi Lane, it had been too wide.) I remember my father spending a lot of time at home. He would wear slippers, a soft flannel nightshirt, and a green felt fez. His room was often a little cold.

It is morning. He goes into the kitchen, brews coffee in a blue pot, toasts bread in the oven. Making breakfast for everyone. He saves pieces of stale black and white bread, cuts them up, and dries them into melba toast, salting them just a bit. He pays everyone a wake-up call: "Time to get up, I made you coffee." "Come have some tea." My mother is

still asleep, having worked until late . . . no answer. "I've already poured it back." Still silence. "Here, I've poured you another cup." He loved to make jokes at the table, spinning things he had heard on the radio or read in the paper into versions of his own: "They're awarding medals to children with many mothers." "The Heroine-Mother Medal is worn on the right side of the left breast."[2]

His work day would start with phone calls. My mother helped organize his business—meetings with publishers, proposals and orders for book or magazine designs. She had a calendar in which she would jot down the details of every call and pencil in appointments with authors, editors, and photographers.

My father also liked joking with people on the telephone. He might tell the photojournalist Elizaveta Ignatovich,

"And then he was a tenor. . . . "

"No, he lived as a bass and died as one."

Another telephone dialogue:

"Hard cookies?"

"Yes, they're regular cookies made of flour and sugar, but hardened in a stone oven."

He had a favorite joke, "Just about." Discussing a project, he would say, "I just about managed to finish it." But he was actually very precise. He kept a log of all his jobs, always signed his photographs, glued together folders for storing manuscripts, made dust jackets for books and magazines. He could repair shoes, make bookshelves, do electrical wiring, even make radios. He kept a set of carpentry and metalworking tools hanging on the wall in his darkroom.

The day has flown past unnoticed—it's already evening. My mother is still sitting on the white stool at her worktable, in her glasses and terry nightgown. Father is making tea again so as not to fall asleep.

When there was no pressing work, they would sit in the evenings and play cards or mah-jongg—the favorite game in our apartment. Mayakovsky taught it to us in 1925, when he had just visited America. My father made a set of wooden tiles. He polished them and he and my mother decorated all 144 of them with their own designs. The images were simple and geometric, in the spirit of my father's graphic compositions of 1918–20. They contained all the elements of his art: lines, circles, planes. Also, although there are really only three dragons in mah-jongg, white, green, and red, my father added one: he stuck a picture of Stepanova to a standard tile and wrote underneath it, "The Fourth Dragon."

When my parents' friends came over—the Lef members Lili and Osip Brik, Nikolai Aseev and his wife Oksana, Tret'iakov and his wife Ol'ga, Aleksei Kruchenykh—they would play mah-jongg until morning. As a joke they would rename the tiles and suits: the tile usually called "West Wind" they called "Volodia," in honor of Mayakovsky; "South Wind" they deliberately mispronounced to sound like the English word "sauce." Father always collected the most difficult hands. My mother would keep score.

In 1937 my parents bought two Chinese mah-jongg sets, genuine and complete, in ivory and bamboo. By this time a different group was sitting around the table; Lef had disbanded a decade before, and this was a different time, with different projects and different friends. Elizaveta Ignatovich would often visit, with her husband the movie cameraman Kirill Dombrovskii. I knew how to play too, but they would only let me join in when one of the regular players was talking on the telephone or had gone off to make tea.

In the summer my father loved to sunbathe. There was a balcony on the south side of the apartment, and he set up a chaise longue there and would lie out on it in the mornings. His bald head would tan to the same dark brown as the rest of him. He took a lot of pictures of his friends there: Lili Brik, Vitalii Zhemchuzhnyi, my mother, Aleksei Gan, Nikolai Ladovskii. In fact this eighth-floor balcony was always being used as a studio, in winter as well as spring, summer, and fall. Father loved to sit there and watch what was happening below: neighbors' comings and goings, demonstrations, children playing.

My father always remembered his friends' and relatives' birthdays. On holidays he would try to make gifts for everyone, and would write sweet and silly letters. He looked forward to his own birthday as well, and the day before it he would always say that he was "about to be born." The surname "Rodchenko" contains the root "*rod*," which appears in the Russian words for "birth" and "to give birth." Father used to joke that with that name he was fated to be always "giving birth"—to a painting or photograph, say, or a design project.

After 1924, my father's passion was photography, because of its novelty and its capacity for variety. An ineradicable part of his working life, it was also his main source of entertainment. He built himself a studio, painting the walls and ceiling black and installing tables for chemical baths and enlargers. He often went into this darkroom to "practice witchcraft," as he would say—to turn pieces of white paper into images of his friends and relatives or of the Moscow streets, or into reportage. He and his Leica were one being, inseparable until the end of his life. In 1934, he wrote in his journal, "I want to make completely unbelievable photos, the kind that never existed before, pictures that are so true to life that they are life itself. I want my photographs to be at once simple and complex, so that they will shock and astound people. I must achieve this so that photography can begin to be considered a form of art." And he did take bold photographs—dramatically foreshortened images, lyrical images, images that showed his love of people. He was often criticized in those years, on account of his so-called formalism. Today, though, we still need his art.

Translated from the Russian by Michael Goldman Donally.

Notes to the Curators' Introduction

1. Alfred H. Barr, Jr., "Russian Diary," in *Defining Modern Art: Selected Writings of Alfred H. Barr, Jr.*, ed. Irving Sandler and Amy Newman (New York: Harry N. Abrams, Inc., 1986), p. 113. Barr dates the visit a week before Stepanova does, on January 3, 1928. His traveling companion, Jere Abbott, became Associate Director under Barr at The Museum of Modern Art in 1929. May O'Callahan often translated for Barr and Abbott during their stay in Moscow; Ol'ga Tret'iakova, who spoke English, was the wife of Sergei Tret'iakov, Rodchenko's friend and colleague in the Lef group.

2. Rodchenko, diary entry, August 11, 1943, in Rodchenko, *Opyty dlia budushchego: dnevniki, stat'i, pis'ma, zapiski* (Experiments for the future: diaries, articles, letters, notes), ed. O. V. Mel'nikov and V. I. Shchennikov (Moscow: Grant', 1996), p. 382 (James West translation).

Ellipses in square brackets indicate this quotation's omissions from the text as published; ellipses unaccompanied by square brackets are present in the text as published.

Notes

1. Varvara Stepanova, *Chelovek ne mozhet zhit' bez chuda. Pis'ma, poeticheskie opyty, zapiski khudozhnitsy*, ed. O. V. Mel'nikov, compiled by V. Rodchenko and A. Lavrent'ev (Moscow: Izd. "Sfera," 1994), p. 222.

2. Translator's note: Both of these jokes revolve around an actual medal that was given to "heroine mothers," women who had given birth to six children.

PLATES **1915–1939**

1.

1. *Two Figures* (*Dve figury*). c. 1916.
Oil on canvas. 33¼ × 26⅞"
(84.4 × 68.2 cm)

2.

2–4. Line and compass drawings.
1915. Pen and ink on paper

2–3. 10 1/16 × 8 1/4" (25.5 × 21 cm)

4. 10 1/16 × 8 1/16" (25.5 × 20.5 cm)

3.

146

4.

5.

6.

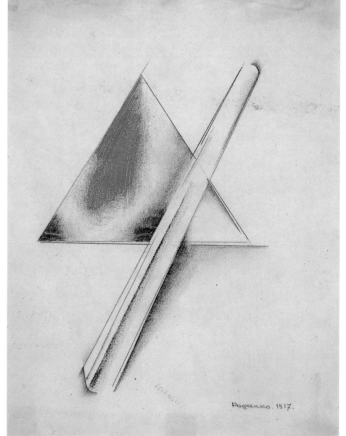

5–8. Designs for lamps for the
Café Pittoresque, Moscow. 1917

5. Black and colored pencil on paper.
10 15/16 × 8 1/4" (27.8 × 21 cm)

6. Ink on paper. 10 7/16 × 8 1/16"
(26.5 × 20.5 cm)

7. Black and colored pencil on paper.
10 7/16 × 8 1/16" (26.5 × 20.5 cm)

8. Pencil on paper. 32 1/8 × 18 1/2"
(81.5 × 47 cm)

7.

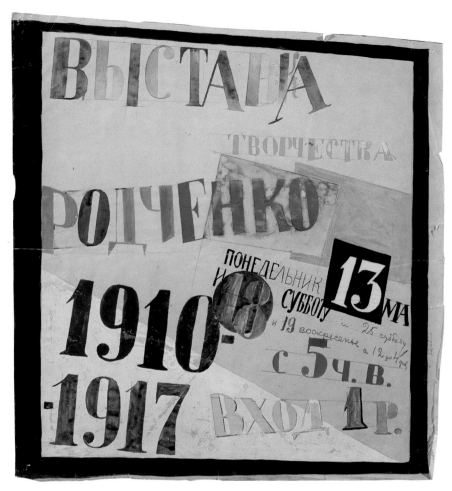

9.

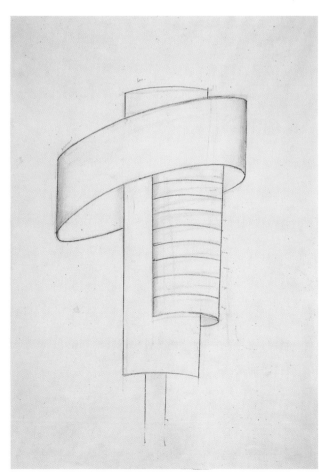

8.

9. Design for poster for *Exhibition of Works by Rodchenko 1910–1917* (*Vystavka tvorchestva Rodchenko 1910–1917*), Moscow. 1917. Watercolor, gouache, and pencil on paper. 20⅝ × 19¼" (52.3 × 49 cm)

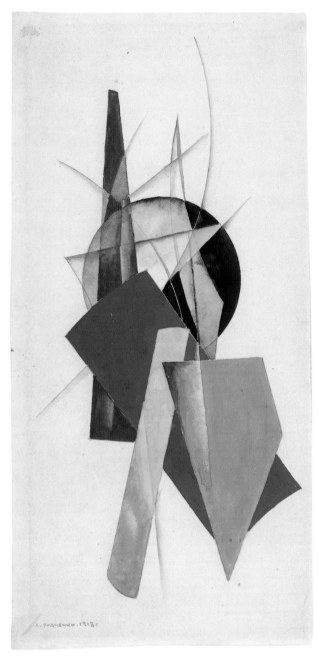

10.

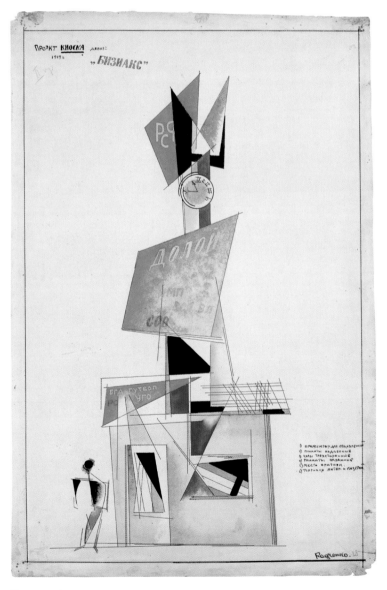

10. *Composition* (*Kompozitsiia*). 1918.
Gouache on paper. 13 × 6⅜"
(33 × 16.2 cm)

11. *Design for a Kiosk* (*Proekt kioska*).
1919. Gouache and pen and ink on
paper. 20¹⁄₁₆ × 13⅝" (51 × 34.5 cm)

11.

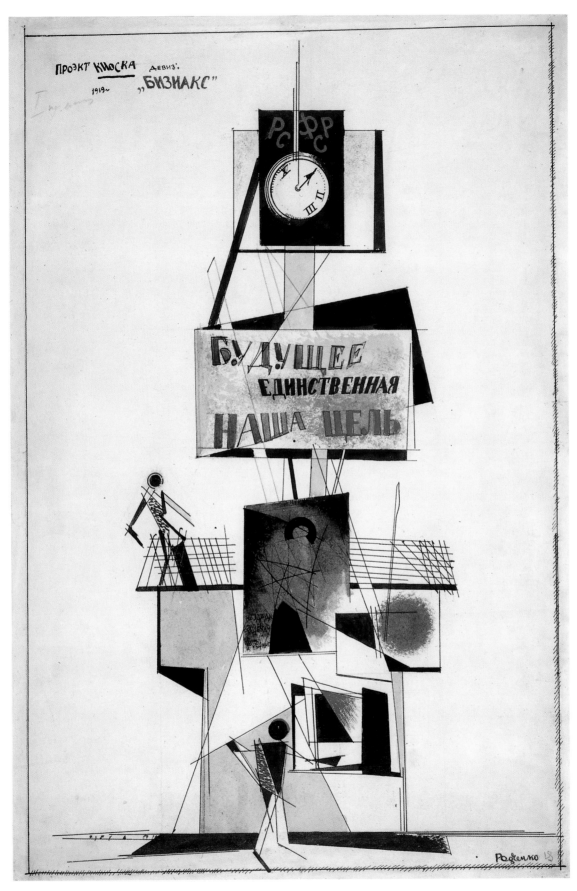

12.

12. *Design for a Kiosk* (*Proekt kioska*).
1919. Black and colored india ink on
151 paper. 20 15/16 × 13 1/2" (53.2 × 34.3 cm)

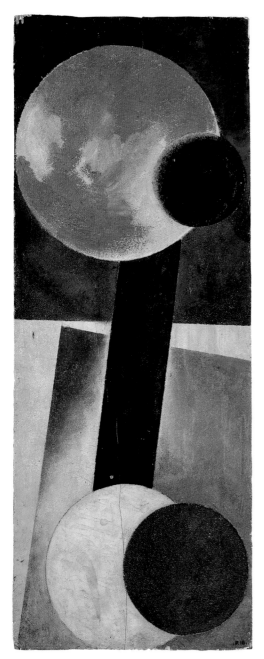

13.

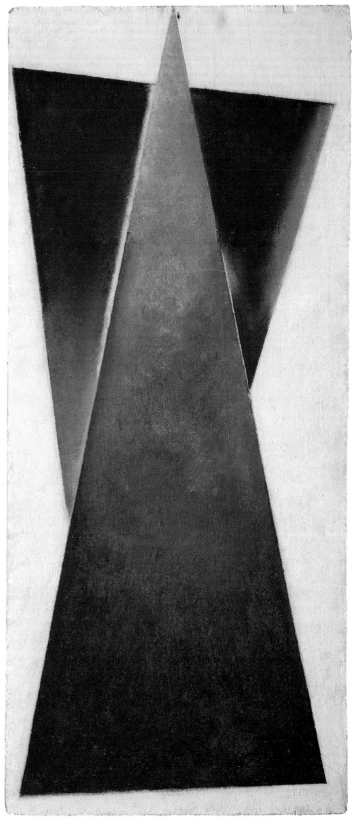

13. *Non-Objective Composition*
(*Bespredmetnaia kompozitsiia*). 1918.
Oil on wood. 20⅞ × 9⅞"
(53 × 25 cm)

14. *Non-Objective Composition no. 53*
(*Bespredmetnaia kompozitsiia n. 53*).
1918. Oil on plywood. 28¾ × 12¹³⁄₁₆"
(73 × 32.5 cm)

14.

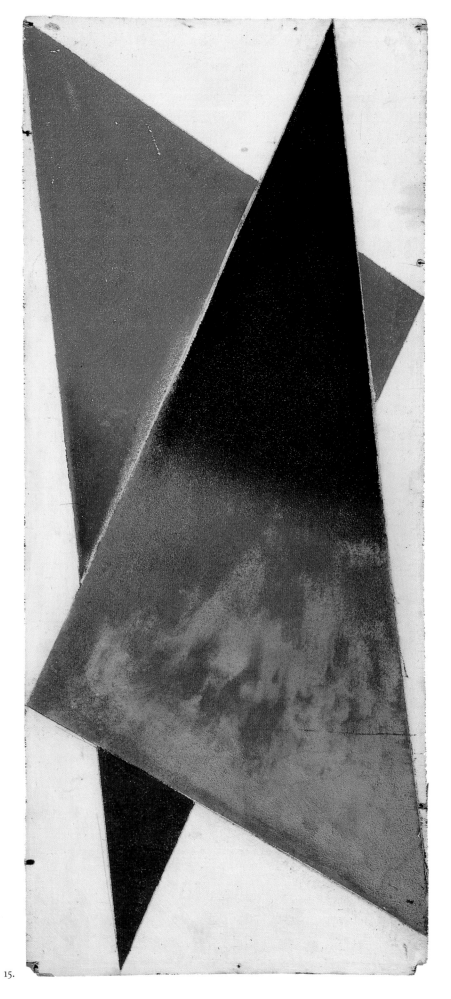

15.

15. *Non-Objective Composition*
(*Bespredmetnaia kompozitsiia*). 1918.
Oil on wood. 28⅜ × 12³⁄₁₆"
(72 × 31 cm)

153

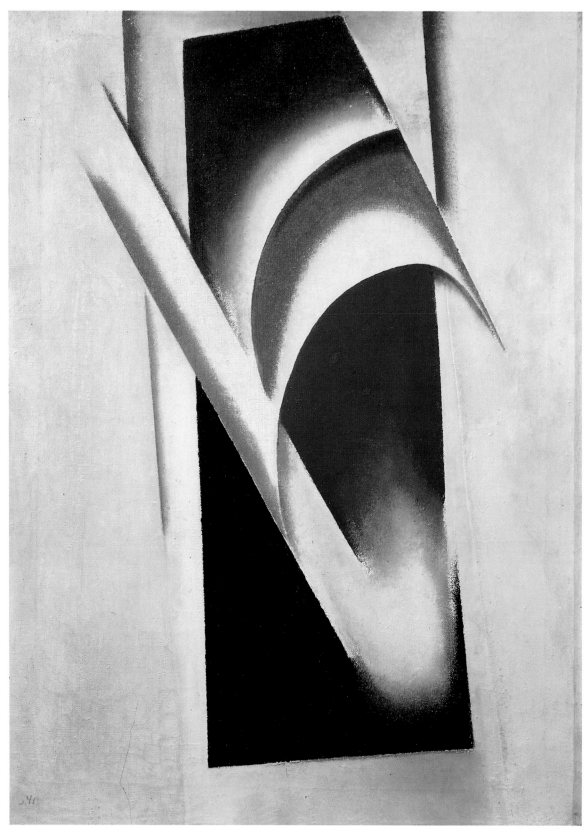

16.

16. *Composition no. 56*
(*Kompozitsiia n. 56*). 1918. Oil on
canvas. 27^{15}/$_{16}$ × 20½" (71 × 52 cm)

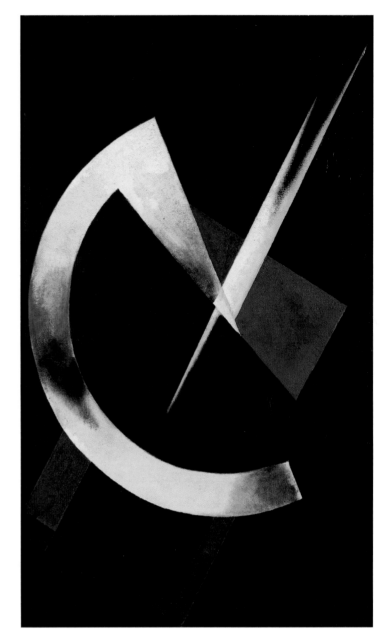

18.

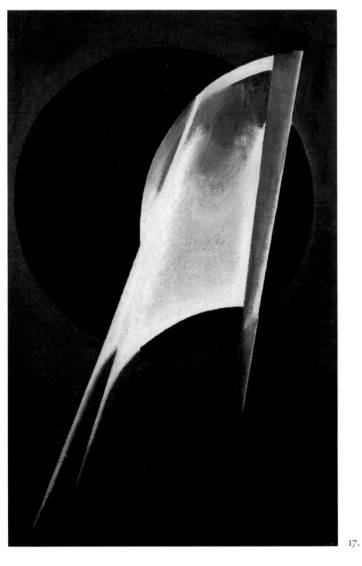

17.

17. *Composition no. 71 (Flying Form)* (*Kompozitsiia n. 71 [Letiashchaia forma]*). 1918. Oil on canvas. 36¼ × 23¼" (92 × 59 cm)

18. *Composition no. 86 (66) (Density and Weight)* (*Kompozitsiia n. 86 [66] [Plotnost' i ves]*). 1919. Oil on canvas. 48³⁄₁₆ × 28¹⁵⁄₁₆" (122.3 × 73.5 cm)

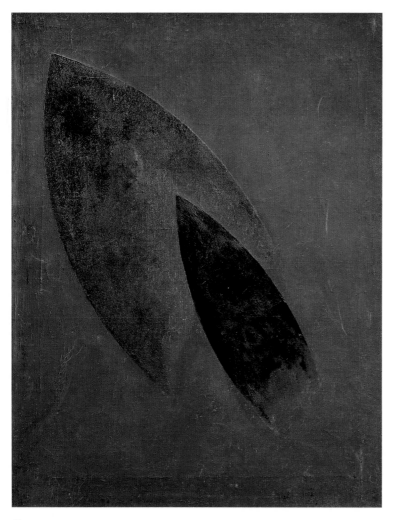

19.

19. *Composition no. 81 (Black on Black)*
(Kompozitsiia n. 81 [Chernoe na cher-
nom]). 1918. Oil on canvas. 32¼ × 25⅝"
(82 × 65 cm)

20. *Composition no. 64 (84) (Black on*
Black) (Kompozitsiia n. 64 [84] [Chernoe
na chernom]). 1918. Oil on canvas.
28¹⁵⁄₁₆ × 29⁵⁄₁₆" (73.5 × 74.5 cm)

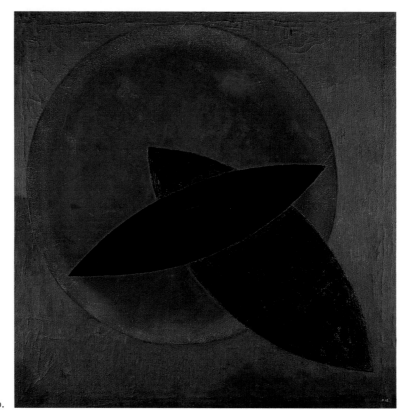

20.

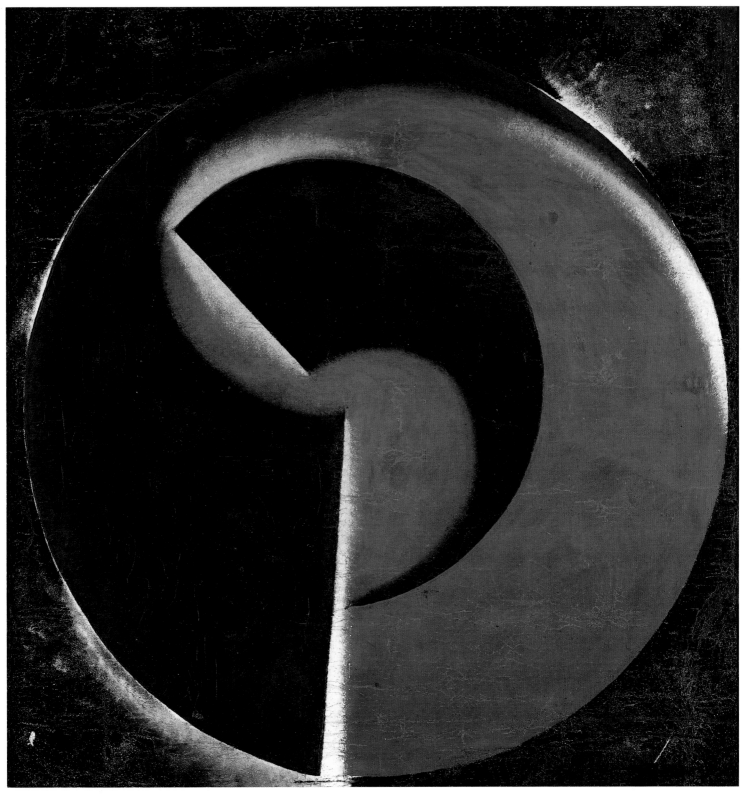

21.

21. *Non-Objective Painting no. 80 (Black on Black)* (*Bespredmetnaia zhivopis' n. 80 [Chernoe na chernom]*). 1918. Oil on canvas. 32¼ × 31¼" (81.9 × 79.4 cm)

22.

23.

24.

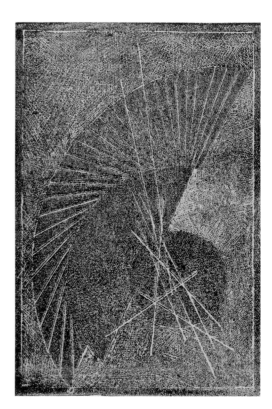

25.

22–25. *Rodchenko Prints* (*Graviury Rodchenko*). 1919. Four from a port-folio of thirteen linocut prints

22. (cover). 6¼ × 4¼"
(15.6 × 10.7 cm)
23. 6⁷⁄₁₆ × 4½" (16.4 × 11.4 cm)
24. 6⁷⁄₁₆ × 4⁷⁄₁₆" (16.4 × 11.3 cm)
25. 6½ × 4½" (16.5 × 11.5 cm)

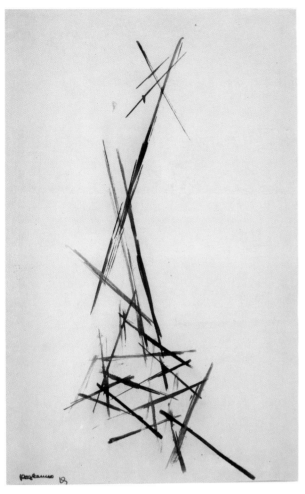

26.

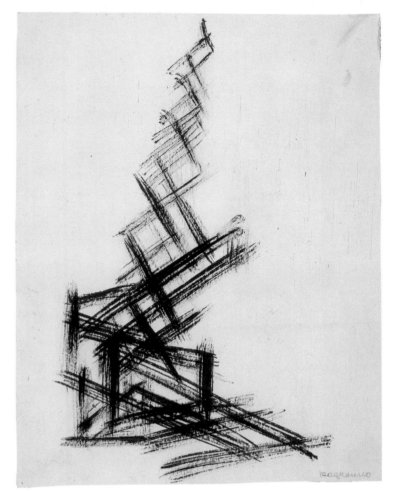

27.

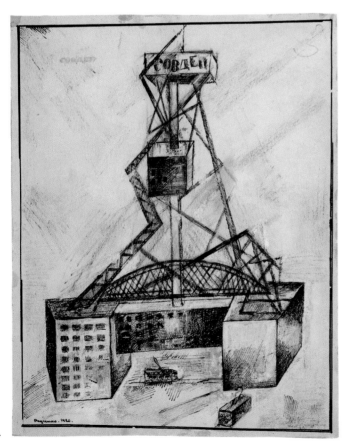

28.

26. Architectonic drawing. 1919.
From the series "City with
Observatory" (*Gorod c verkhnim
fasadom*). Pen and ink on paper.
14 × 8⅝" (35.5 × 22 cm)

27. Architectonic drawing. 1920.
From the series "City with
Observatory" (*Gorod s verkhnim
fasadom*). Pen and ink on paper
mounted on cardboard. 10¼ × 8¼"
(26 × 21 cm)

28. Sketch for a project for Sovdep
(the Soviet of Deputies Building),
Moscow. 1920. From the series
"City with Observatory" (*Gorod s
verkhnim fasadom*). Pen and ink and
gouache on paper. 10¼ × 8⅛"
(26 × 20.7 cm)

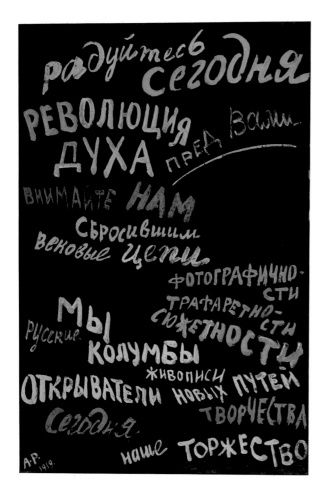

29.

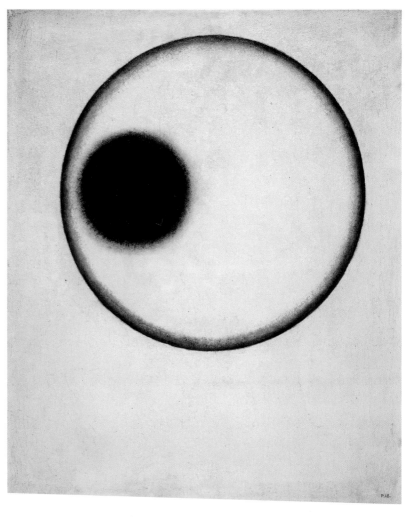

30.

29. Poster for the *10th State Exhibition* (*10aia gosudarstvennaia vystavka*), Moscow. 1919. Gouache on black paper. 20½ × 12¹¹⁄₁₆" (52 × 32.2 cm)

Rejoice, today the revolution of the spirit is before you. We have thrown away the age-old chains of the photographic, banality, subjectivity. We are the Russian doves of painting, discoverers of new paths of creation. Today our creation.

30. *Composition no. 60* (*Kompozitsiia n. 60*). 1918. From the series "Concentration of Color" (*Kontsentratsiia tsveta*). Oil on canvas. 24 × 19¹¹⁄₁₆" (61 × 50 cm)

160

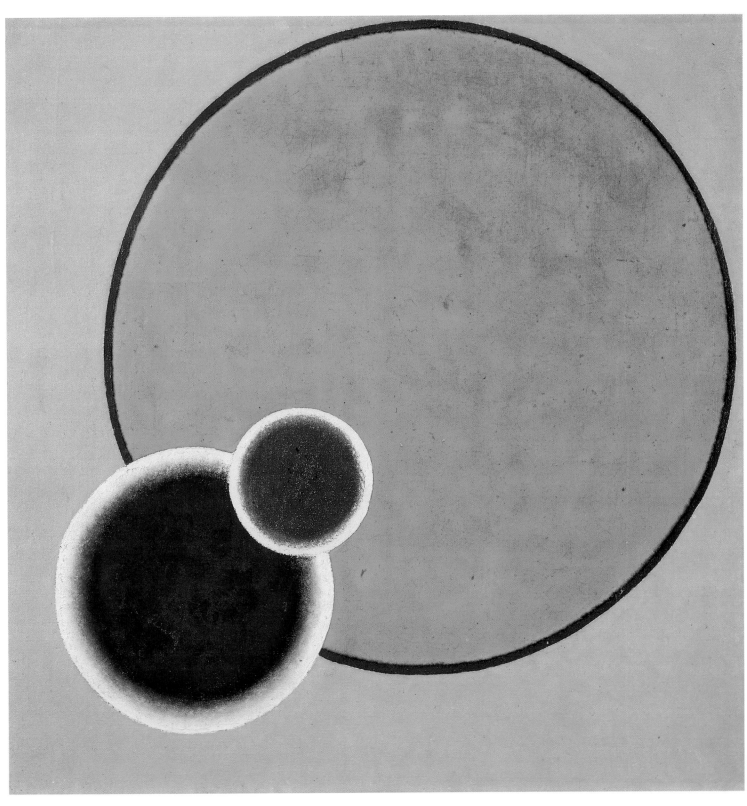

31.

31. *Composition no. 113 on Yellow Ground* (*Kompozitsiia n. 113 na zheltom fone*). 1920. From the series "Concentration of Color" (*Kontsentratsiia tsveta*). Oil on

161 canvas. 27¾ × 27¾" (70.5 × 70.5 cm)

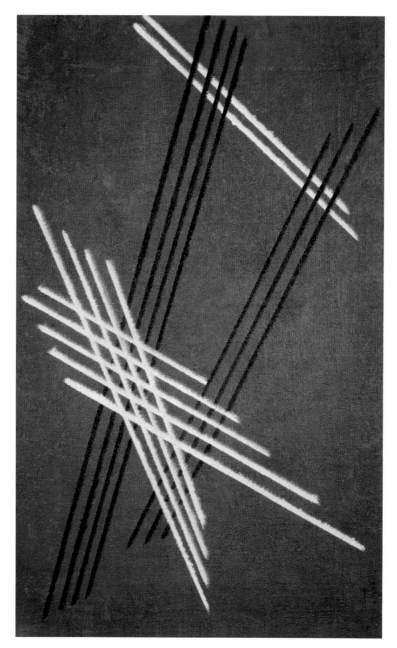

32.

33.

32. *Construction no. 92 (on Green)*
(*Konstruktsiia n. 92 [na zelenom]*).
1919. Oil on canvas. 28¾ × 18⅛"
(73 × 46 cm)

33. Sketch for the cover of
Linearism (*Liniizm*), an unpub-
lished treatise by Rodchenko. 1920.
Pen and ink on graph paper.
7¹¹⁄₁₆ × 6¹⁵⁄₁₆" (19.5 × 17.6 cm)

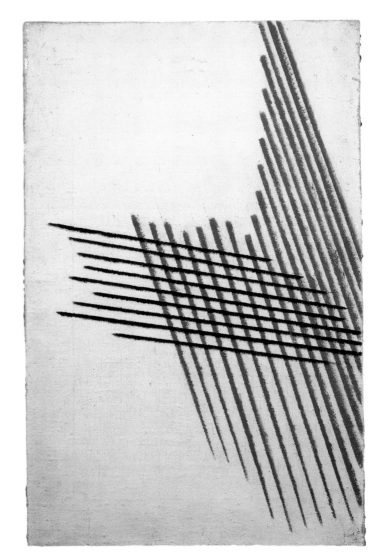

35.

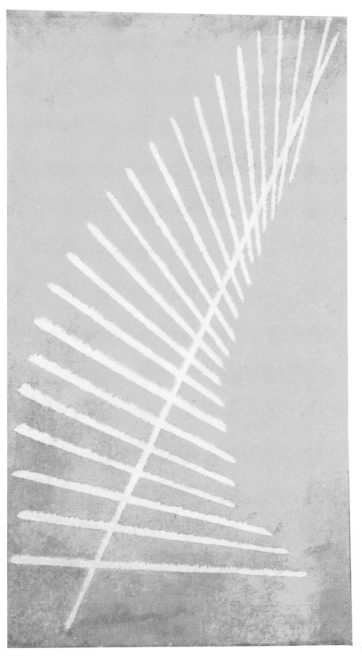

34.

34. *Construction no. 89 (on Light Yellow)* (*Konstruktsiia n. 89 [na svetlo-zheltom]*). 1919. Oil on canvas. 26⁹⁄₁₆ × 15¾" (67.5 × 40 cm)

35. *Construction no. 90 (on White)* (*Konstruktsiia n. 90 [na belom]*). 1919. Oil on canvas. 26¾ × 17¾" (68 × 45 cm)

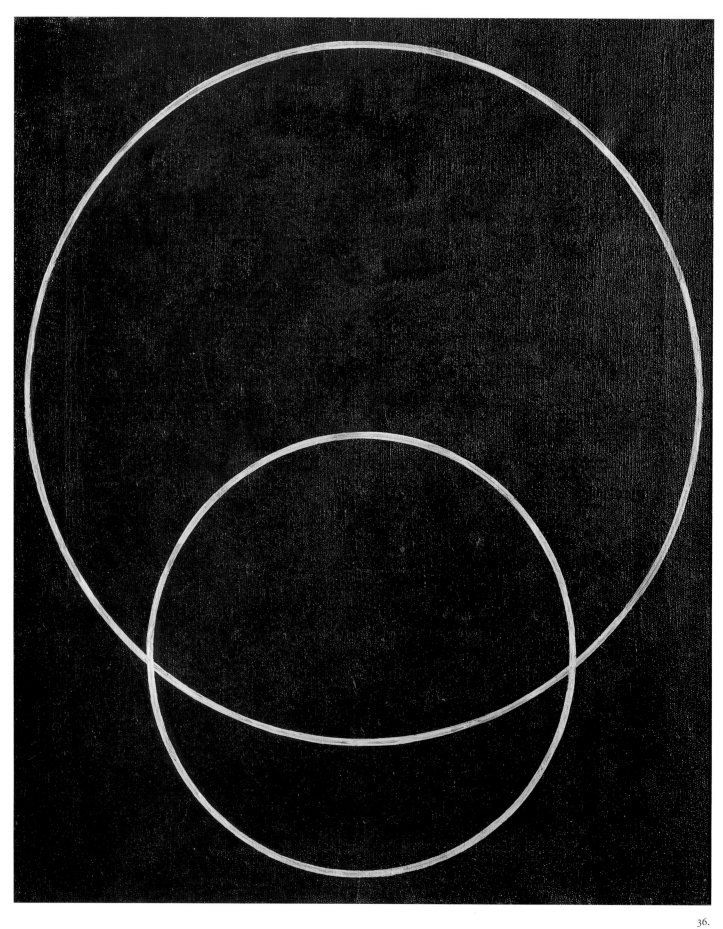

36. *Construction no. 127 (Two Circles)*
(*Konstruktsiia n. 127 [Dva kruga]*).
1920. Oil on canvas. 24⅝ × 20⅞"
(62.5 × 53 cm) **164**

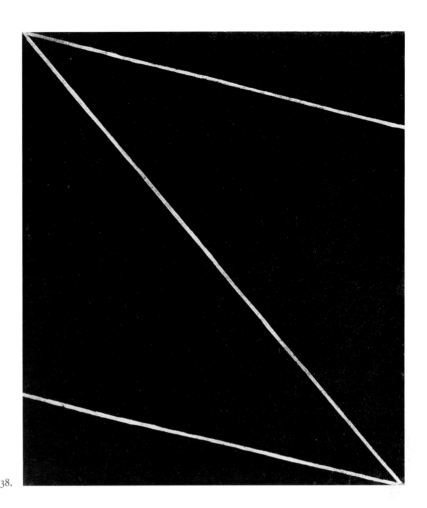

38.

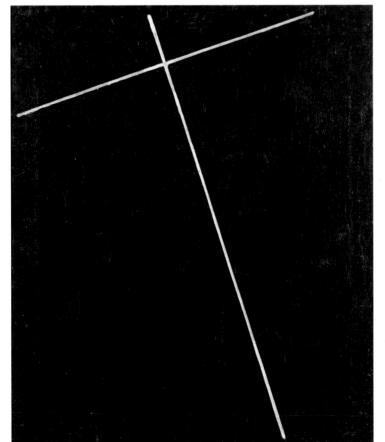

37.

37. *Construction no. 128 (Line)*
(*Konstruktsiia n. 128 [Liniia]*). 1920.
Oil on canvas. 24⅜ × 20⅞"
(62 × 53 cm)

38. *Construction no. 126 (Line)*
(*Konstruktsiia n. 126 [Liniia]*). 1920.
Oil on canvas. 22¹³/₁₆ × 20¹/₁₆"
(58 × 51 cm)

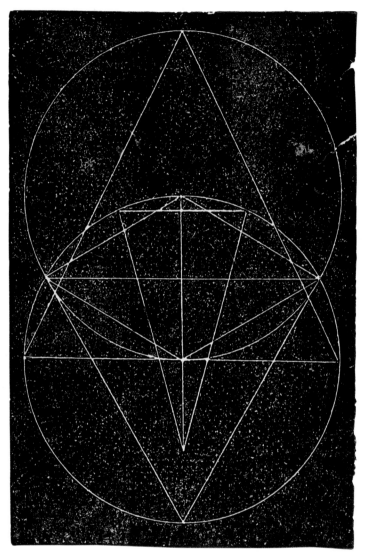

39.

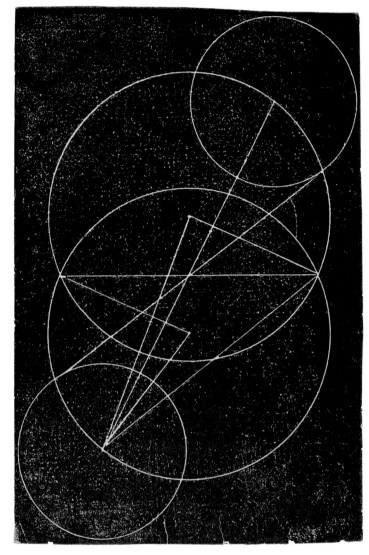

40.

39. Construction *No. 58*. 1921.
Linocut. 8⅞ × 5¹⁵⁄₁₆" (22.5 × 15 cm)

40. Construction *No. 60*. 1921.
Linocut. 8⅞ × 5¹⁵⁄₁₆" (22.5 × 15 cm)

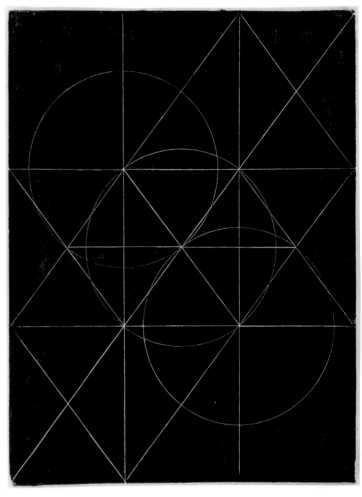

42.

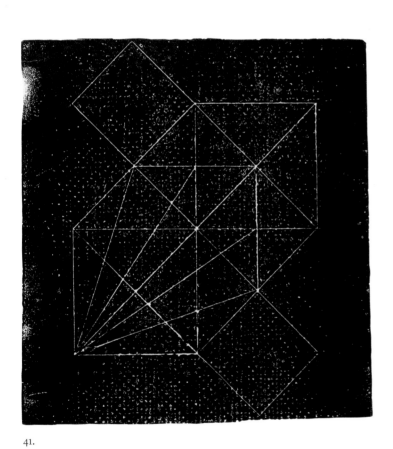

41.

41. Construction. 1921. Linocut.
7⁵⁄₁₆ × 6¹¹⁄₁₆" (18.5 × 17 cm)

42. Construction. 1921. Linocut.
7¹³⁄₁₆ × 6" (19.8 × 15.3 cm)

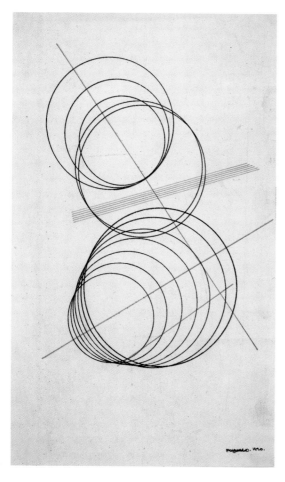

43.

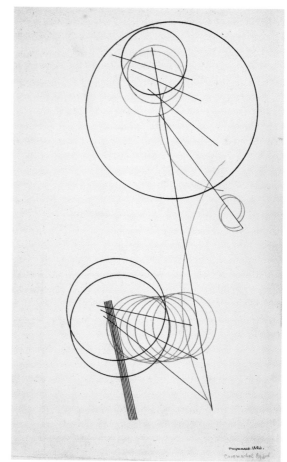

44.

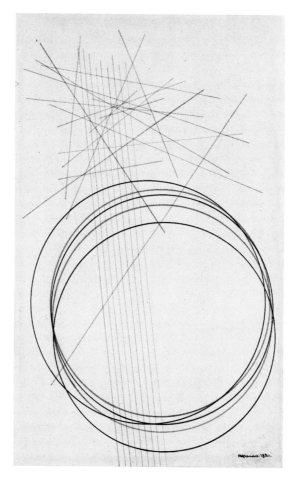

45.

43–45. Linear constructions. 1920.
Pen and black and colored ink
on paper

43. 12¾ × 7¹¹⁄₁₆" (32.4 × 19.5 cm)
44. 12¹¹⁄₁₆ × 7⅞" (32.2 × 20 cm)
45. 12¾ × 7¾" (32.4 × 19.7 cm)

46. *Construction no. 106 (on Black)*
(*Konstruktsiia n. 106 [na chernom]*).
1920. Oil on canvas. 40⅛ × 27⁹⁄₁₆"
(102 × 70 cm)

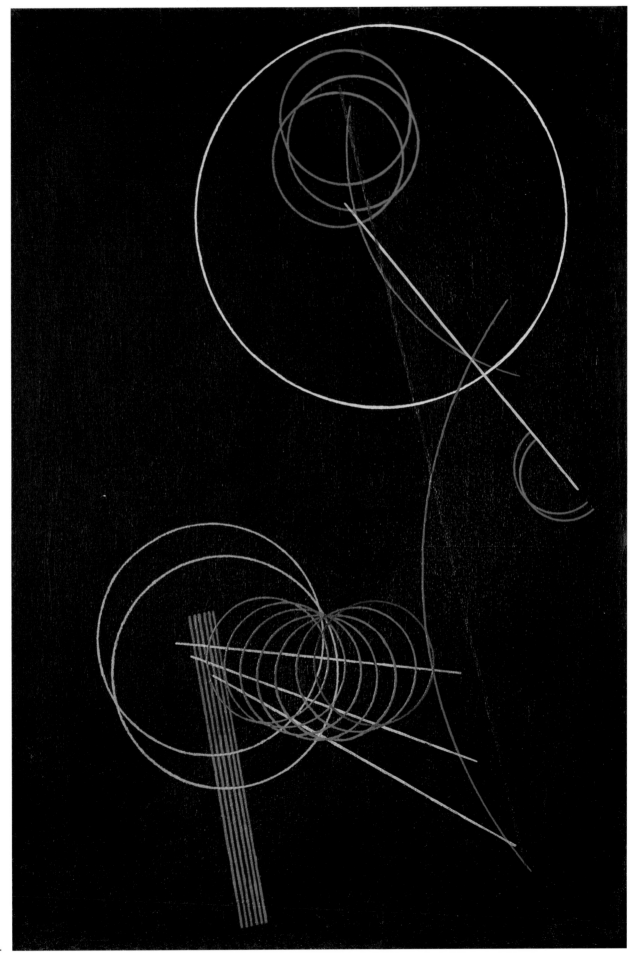

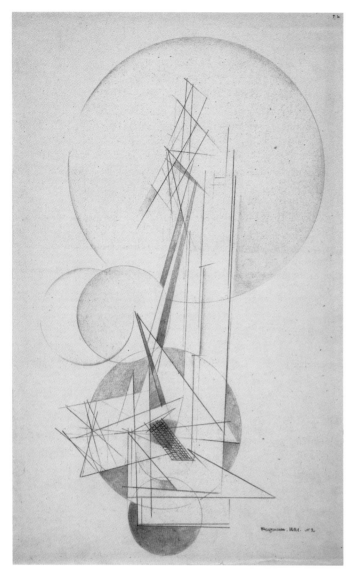

47.

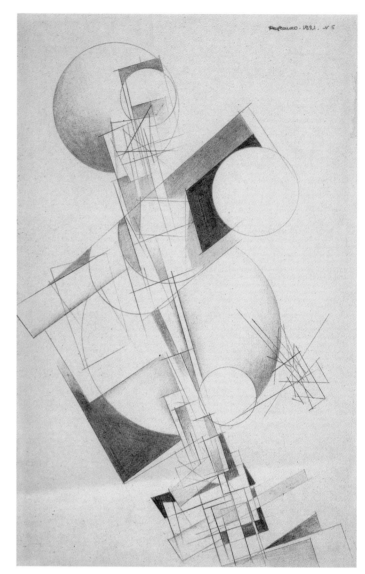

48.

47. Constructive composition *No. 2*.
1921. Pencil on paper. 13⁵⁄₁₆ × 8⁹⁄₁₆"
(33.8 × 21.7 cm)

48. Constructive composition *No. 5*.
1921. Pencil on paper. 13¾ × 8¹¹⁄₁₆"
(35 × 22 cm)

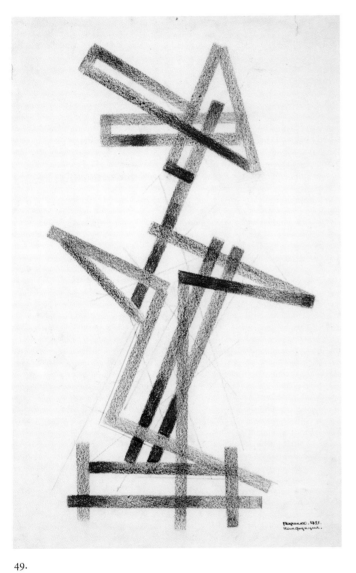

49.

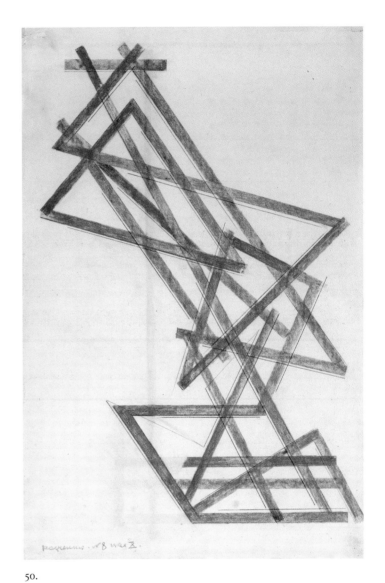

50.

49. *Construction no. 17* (*Konstruktsiia n. 17*). 1921. Black and colored crayon on paper. 19¹¹⁄₁₆ × 12⁷⁄₈" (50 × 32.7 cm)

50. Construction *No. 8*. 1921. Colored pencil on paper. 19⅛ × 12¹³⁄₁₆" (48.5 × 32.5 cm)

51.

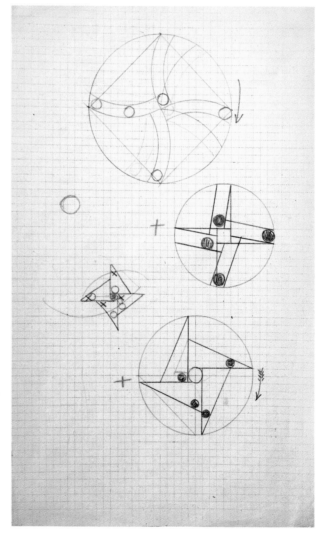

51. Sketches for spatial constructions.
1921. Pencil on graph paper.
6 × 6¹⁵⁄₁₆" (15.2 × 17.6 cm)

52. Project for a perpetual motion
machine. 1921. Pencil on graph
paper. 14 × 8¹¹⁄₁₆" (35.5 × 22.5 cm)

52.

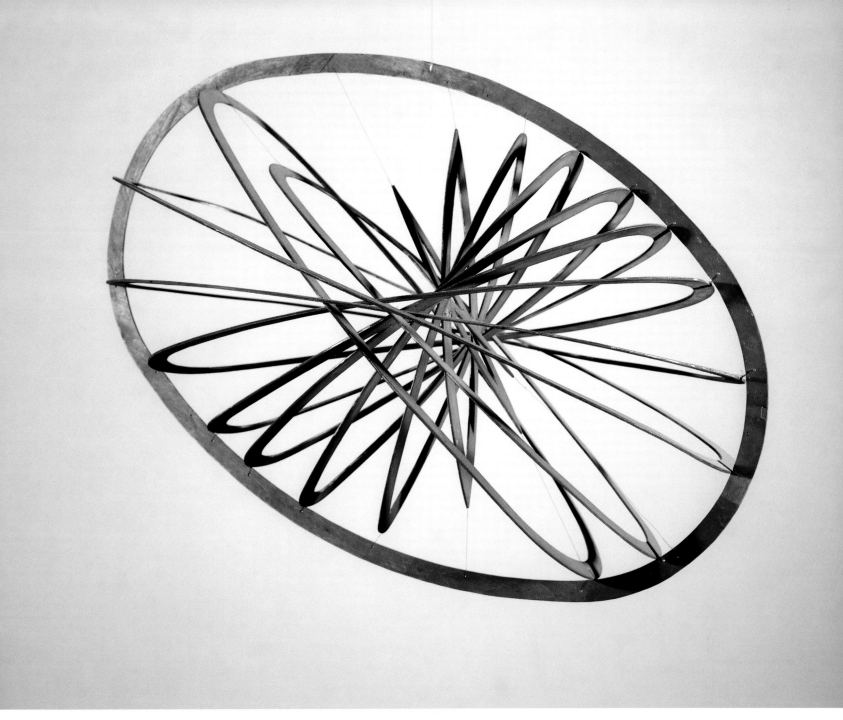

53.

53. *Spatial Construction no. 12*
(*Prostranstvennaia konstruktsiia n.
12*). c. 1920. From the series "Light-
Reflecting Surfaces" (*Ploskosti
otrazhaiushchie svet*). Plywood painted
with aluminum paint and wire.
24 × 32 15/16 × 18 ½" (61 × 83.7 × 47 cm)

54.

55.

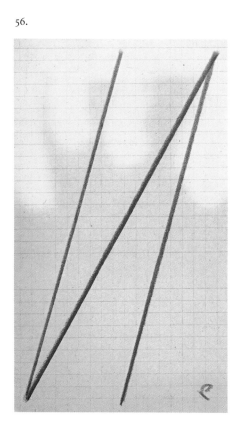

56.

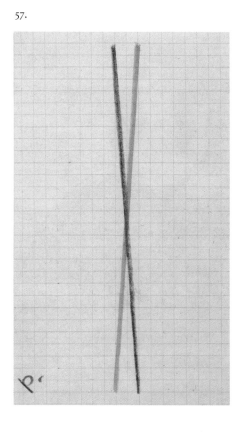

57.

54. *Pure Red Color* (*Chistyi krasnyi
tsvet*), *Pure Yellow Color* (*Chistyi
zheltyi tsvet*), *Pure Blue Color*
(*Chistyi sinii tsvet*). 1921. Oil on
canvas. Each panel 24⅝ × 20¹¹⁄₁₆"
(62.5 × 52.5 cm)

55–57. Three variant pages from cat-
alogues for the exhibition *5x5=25*,
Moscow. 1921. Colored crayon on
graph paper. Each 6³⁄₁₆ × 3¹¹⁄₁₆"
(15.7 × 9.4 cm)

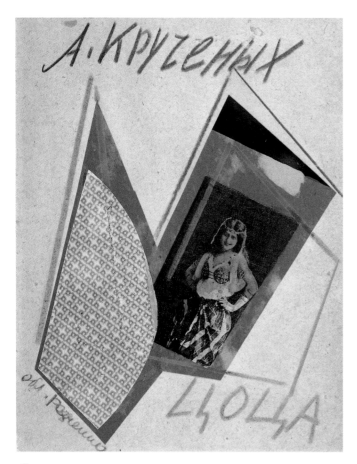

58.

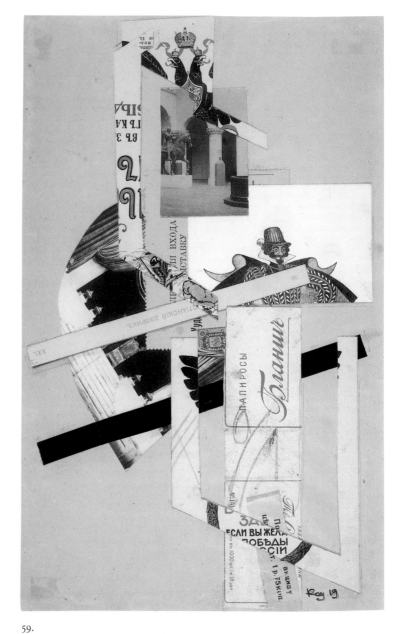

59.

58. Cover design for the book
Tsotsa, by Aleksei Kruchenykh. 1921.
Cut-and-pasted papers and colored
pencil on paper. 7 × 5⁷⁄₁₆"
(17.8 × 13.8 cm)

59. Untitled. 1919. Cut-and-pasted
printed papers and photographs on
paper. 10¹³⁄₁₆ × 6⁷⁄₈" (27.5 × 17.5 cm)

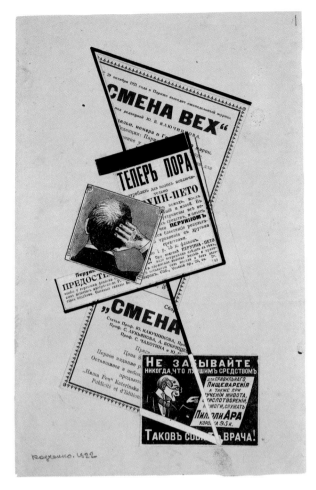

60.

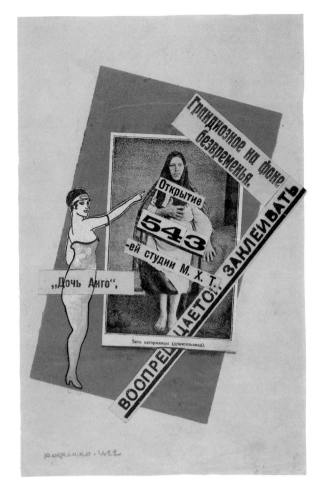

61.

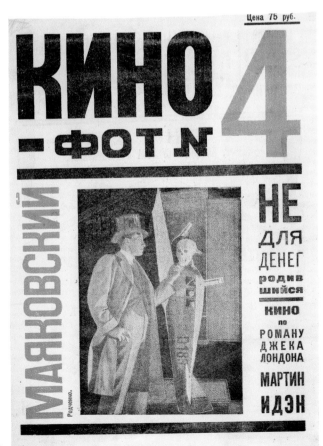

62.

60. Untitled. 1922. Cut-and-pasted
printed papers on paper.
10⁷⁄₁₆ × 6¹¹⁄₁₆" (26.5 × 17 cm)

61. Untitled. 1922. Cut-and-pasted
printed papers on paper.
10⁵⁄₈ × 6¹¹⁄₁₆" (27 × 17 cm)

62. Cover of the magazine *Kino-Fot*
(Cine-Photo) no. 4 of 1922, a special
issue on Mayakovsky. Letterpress.
11⁷⁄₁₆ × 8¹¹⁄₁₆" (29 × 22 cm)

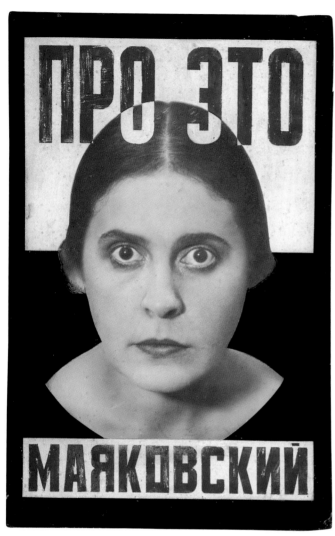

63.

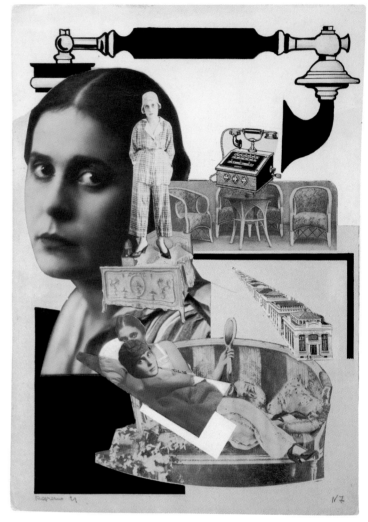

64.

63–64. Maquettes for illustrations
for *About This* (*Pro eto*), a poem by
Vladimir Mayakovsky. 1923

63. Cover. Cut-and-pasted gelatin-
silver photograph, ink, and gouache
on paper. 9⁷⁄₁₆ × 6½" (24 × 16.5 cm)

64. Cut-and-pasted printed papers,
gelatin-silver photographs, and ink
on cardboard. 13½ × 9⅝"
(34.3 × 24.4 cm). Illustration
accompanied by the lines

**She's in bed, lying awake, — / He. /
A telephone on the table.**

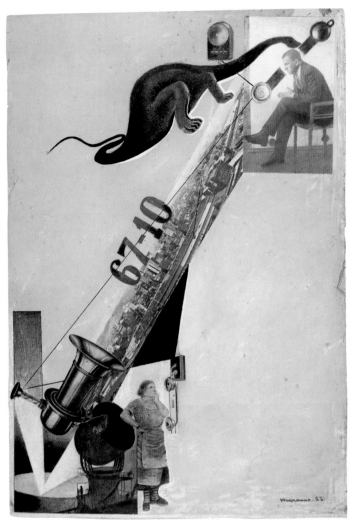

65.

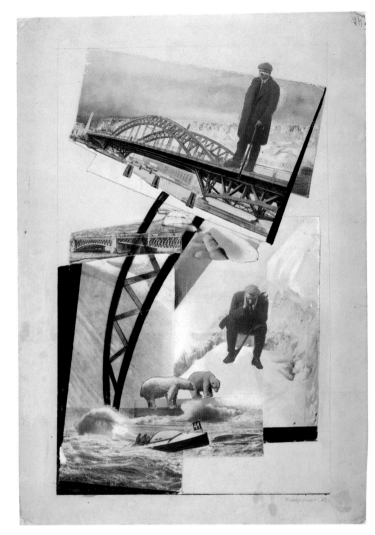

66.

65–66. Maquettes for illustrations for *About This* (*Pro eto*), a poem by Vladimir Mayakovsky. 1923. Cut-and-pasted printed papers, gelatin-silver photographs, ink, and gouache on cardboard

65. 13⅞ × 9⅝" (35.3 × 24.4 cm).
Illustration accompanied by the lines
Came / out of the cord / jealousy crawling / a cave-dwelling troglodyte monster.

66. 16⅜ × 11⁹⁄₁₆" (41.5 × 29.4 cm).
Illustration accompanied by the lines
I paw at my ears— / in vain! / I hear / my / my own voice / the knife of my voice cuts me through my paws.

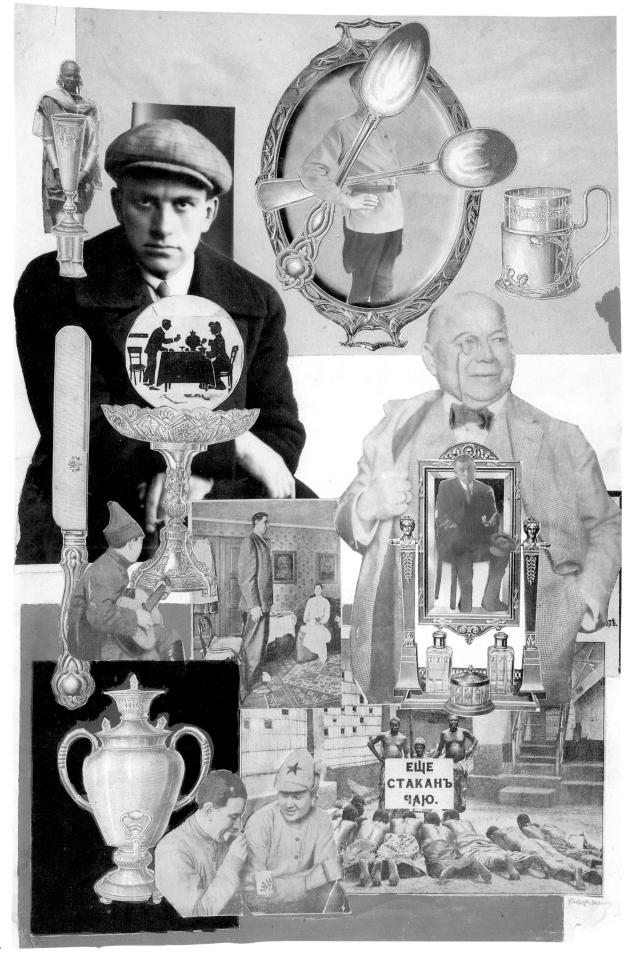

ЕЩЕ
СТАКАНЪ
ЧАЮ.

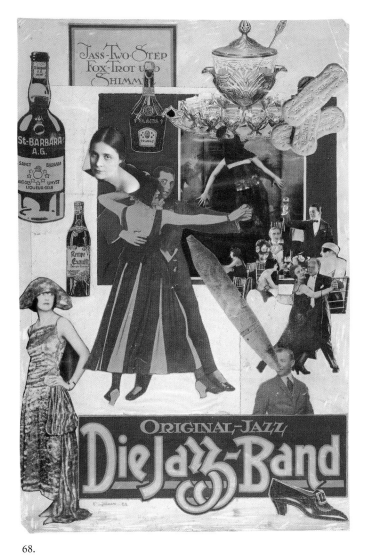

68.

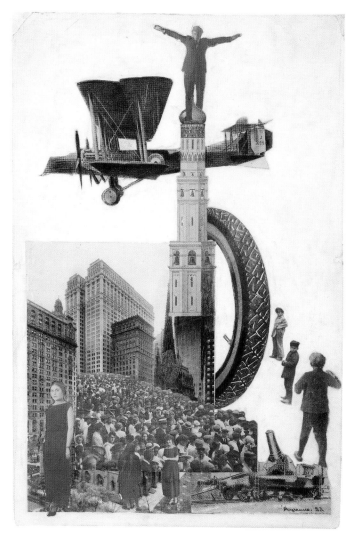

69.

67–69. Maquettes for illustrations
for *About This* (*Pro eto*), a poem by
Vladimir Mayakovsky. 1923. Cut-and-
pasted printed papers and gelatin-
silver photographs on cardboard

67. 16¾ × 12¹³⁄₁₆" (42.5 × 32.5 cm).
Illustration accompanied by the lines

**And the century stands / as it was /
Unwhipped / domesticity's mare
won't move.**

68. 18⅞ × 12⅝" (48 × 32 cm).
Illustration accompanied by the lines

**And again / the walls of the burn-
ing steppe / ring and sigh in the
ear with the two-step.**

69. 14 × 9¼" (35.5 × 23.5 cm).
Illustration accompanied by the lines

**I catch my balance, /
waving terribly.**

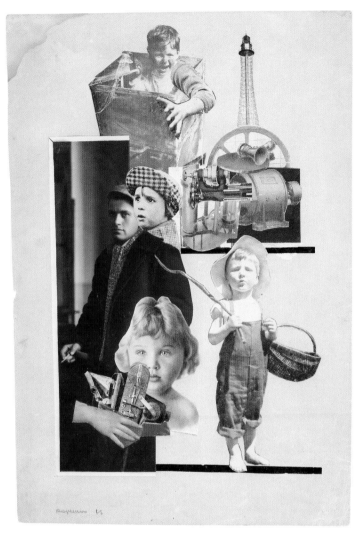

70.

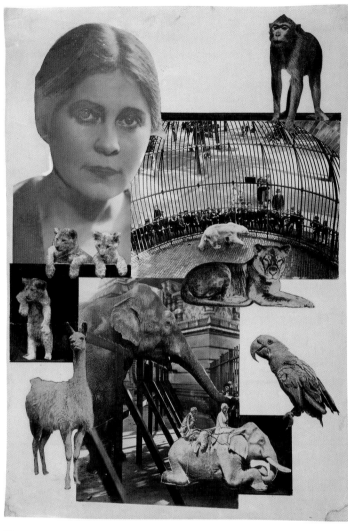

71.

70–71. Maquettes for illustrations for
About This (*Pro eto*), a poem by
Vladimir Mayakovsky. 1923

70. Cut-and-pasted printed papers,
gelatin-silver photographs, and ink
on cardboard. 13⅞ × 9⅝"
(35.2 × 24.5 cm). Illustration
accompanied by the lines

**Four times I'll age, / four times
growing younger.**

71. Cut-and-pasted printed papers
and gelatin-silver photographs on
cardboard. 13¾ × 9⁹⁄₁₆"
(35 × 24.3 cm). Illustration
accompanied by the lines

**And she / —she loved animals— /
also will come to the zoo.**

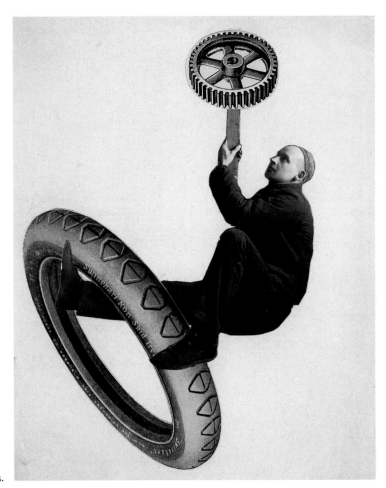

73.

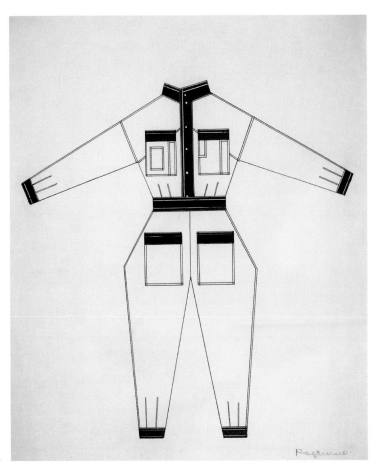

72.

72. Design for "production clothing" (*prozodezhda*). 1922. Ink on paper. 14⁹⁄₁₆ × 11¹³⁄₁₆" (37 × 30 cm)

73. *Self-Caricature* (*Avtosharzh*). 1922. Cut-and-pasted printed papers and gelatin-silver photograph on paper. 7¼ × 5⅞" (18.5 × 15 cm)

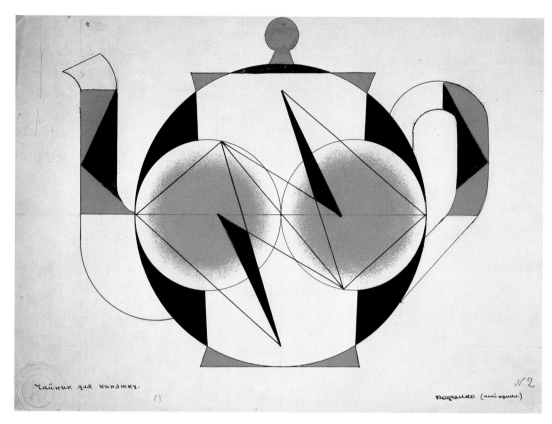

74.

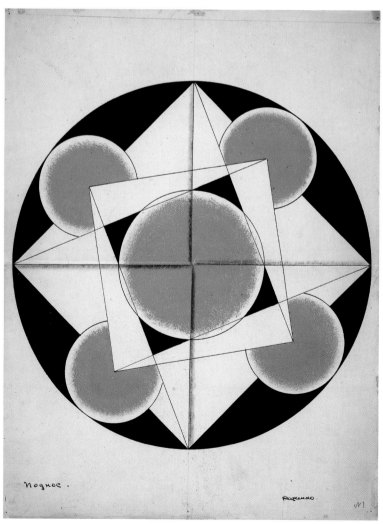

74–75. Designs for a tea set. 1922.
Ink and gouache on paper

74. *Tea pot* (*Chainik dlia kipiatku*).
10⅝ × 14¹¹⁄₁₆" (27 × 37.2 cm)

75. *Tea tray* (*Podnos*). 22¹³⁄₁₆ × 17⅝"
(58 × 44.8 cm)

75.

76.

77.

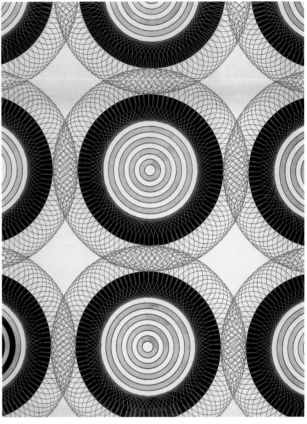

78.

76–78. Fabric designs. 1924. Ink and gouache on paper

76. 7½ × 9⁷⁄₁₆" (19 × 24 cm)
77. 11⅜ × 11⅛" (29.7 × 29.3 cm)
78. 16⅝ × 12¹¹⁄₁₆" (42.2 × 32.2 cm)

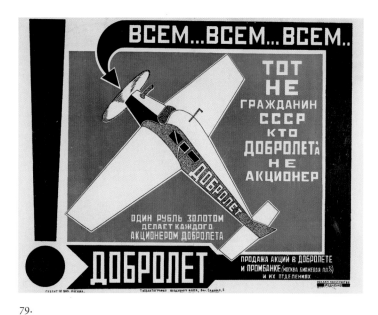

79.

80.

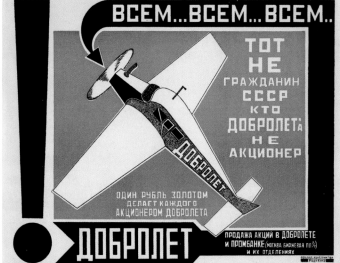

81.

82.

79–82. Advertising posters for the
state airline Dobrolet. 1923.
Lithography

79. 13¾ × 17¾" (34.9 × 45.1 cm)
80. 14¾ × 18" (37.5 × 45.7 cm)
81. 13⅞ × 18⅛" (35.2 × 46 cm)
82. 14⁷⁄₁₆ × 18" (36.7 × 45.7 cm)

**Everyone ... Everyone ...
Everyone. ... He who is not a
stockholder in Dobrolet is not
a citizen of the USSR. / One
gold ruble makes anyone a
stockholder in Dobrolet.**

83. Advertising poster for the state
airline Dobrolet. 1923. Lithography.
42 × 28" (106.7 × 71.1 cm)

**Shame on you, your name is
not yet on the list of Dobrolet
stockholders. / The whole
country follows this list.**

ДОБРОЛЕТ

Стыдитесь, вашего имени еще нет в списке акционеров добролета

ВСЯ страна следит за этим списком

АКЦИИ ДОБРОЛЕТ

АКЦИЯ N... ДОБРОЛЕТ ЭТО СОКРАЩЕННОЕ НАЗВАНИЕ РОССИЙСКОГО О-ВА ДОБРОВОЛЬНОГО ВОЗДУШНОГО ФЛОТА

АКЦИЯ N... ДОБРОЛЕТ ВОССТАНОВИТ АВИАЦИОННУЮ ПРОМЫШЛЕННОСТЬ

АКЦИЯ N... ДОБРОЛЕТ УСИЛИТ ПРОМЫШЛЕННОСТЬ АВИАЦИЕЙ

АКЦИЯ N... ОДИН РУБЛЬ ЗОЛОТОМ ДЕЛАЕТ КАЖДОГО АКЦИОНЕРОМ ДОБРОЛЕТА

РЕКЛАМ КОНСТРУКТОР ТЕЛ. РОДЧЕНКО 37-68

ПРОДАЖА АКЦИЙ МОСКВА. ПРОМБАНК. ИЛЬИНКА БИРЖЕВАЯ ПЛ. 2/7 И ВО ВСЕХ ОТДЕЛЕНИЯХ ДОБРОЛЕТА И ПРОМ ГОС БАНКА

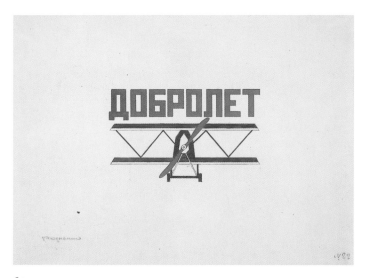

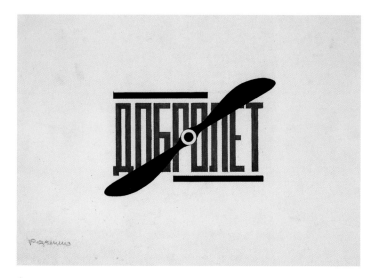

84.

85.

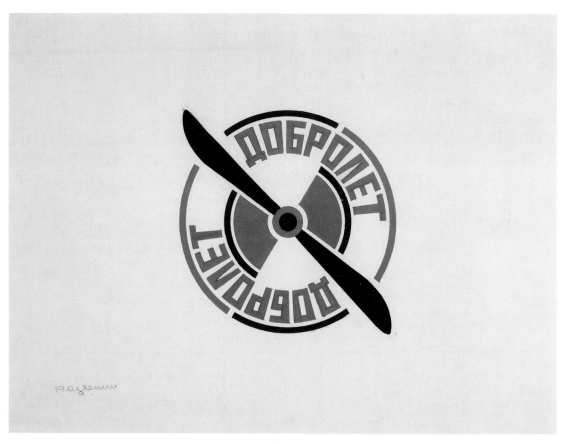

84–86. Designs for insignia for the
state airline Dobrolet. 1923. Ink and
gouache on paper

84. 8¼ × 11¹³⁄₁₆" (21 × 30 cm)
85. 8¹⁄₁₆ × 11¼" (20.4 × 28.6 cm)
86. 8¼ × 11¹¹⁄₁₆" (21 × 29.7 cm)

86.

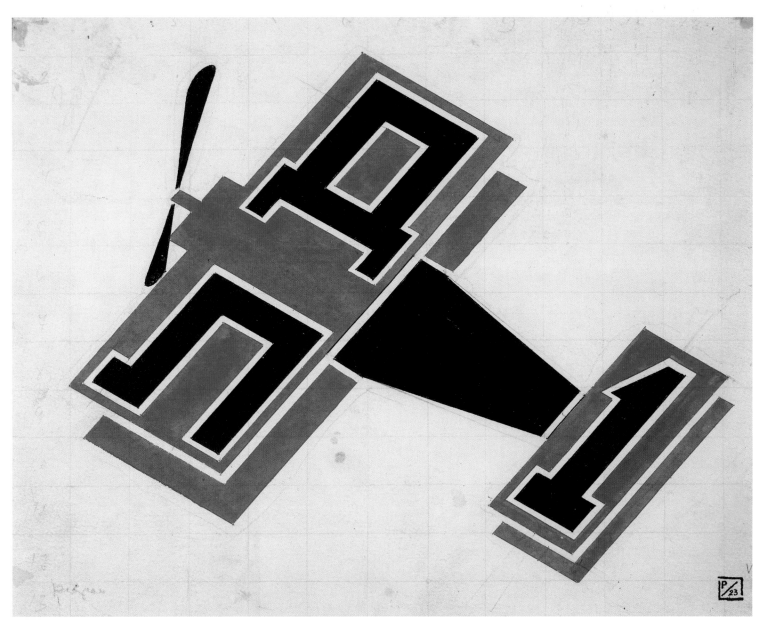

87.

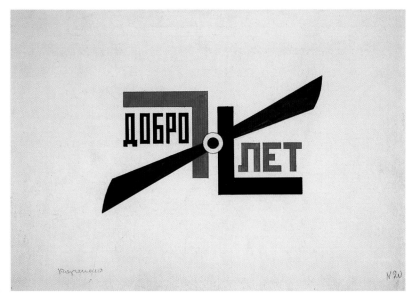

88.

87–88. Designs for insignia for the state airline Dobrolet. 1923. Ink and gouache on paper

87. 10¼ × 12³⁄₁₆" (26 × 31 cm)
88. 8¼ × 11⅝" (21 × 29.6 cm)

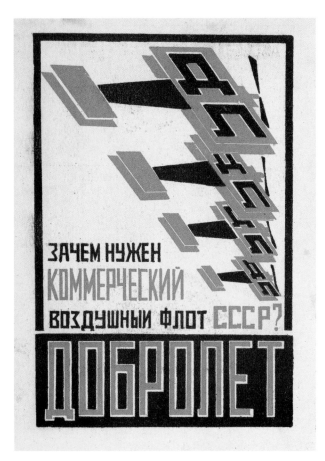

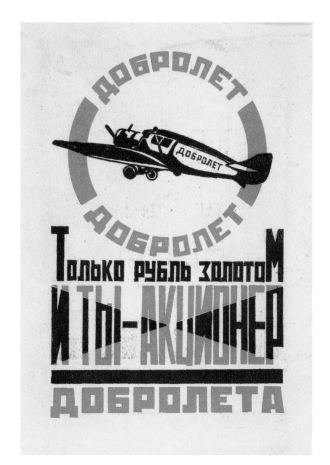

89.

90.

91.

89–90. Covers for stock-offering prospectuses for the state airline Dobrolet. 1923. Letterpress. Each c. 6½ × 4½" (16.5 × 11.5 cm)

89. **Why is a commercial Soviet airline necessary? Dobrolet.**

90. **Only one gold ruble and you are a stockholder in Dobrolet.**

91. Letterhead for the state airline Dobrolet. 1923. Letterpress. 6½ × 8" (16.5 × 20.3 cm)

92a.

b.

c.

d.

e.

f.

g.

h.

i.

j.

92. Jewelry for the state airline
Dobrolet. 1924–26. Enamel on cast
brass

a–f. Pins. Each ¾" (1.9 cm) diameter
g. Pair of cufflinks. Each ⁹⁄₁₆ × ⅞"
(1.4 × 2.2 cm)
h. Pin. ⅝ × ⅞" (1.6 × 2.2 cm)
i. Pin. ¹⁵⁄₁₆" (2.4 cm) diameter
j. Button. ⅝" (1.6 cm) diameter

93.

94.

95.

96.

97.

98.

93–98. Wrappers for Nasha Industriia (Our industry) caramels, from the Krasnyi Oktiabr' (Red October) factory, Moscow. 1923. Lithography. Texts by Vladimir Mayakovsky

93. 3¼ × 3" (8.3 × 7.6 cm)
In springtime, the earth is black, / fluffed up like cotton wool. / Grain elevator, give larger seed / to the ploughed field.

94. 3¼ × 3" (8.3 × 7.6 cm)
Don't stand there on the bank of the river / until old age, / it's better to throw a bridge / over the river.

95. 3⅛ × 2¹⁵⁄₁₆" (8 × 7.5 cm)
Look closely at the connecting rods / pay close attention to the boiler / Well — everywhere we should / lay the rails

96. 3⅛ × 2¹⁵⁄₁₆" (8 × 7.5 cm)
Let the tractor / plough the meadow.

97. 3⅛ × 2¹⁵⁄₁₆" (8 × 7.5 cm)
Old fellow, don't be lame, / grab on to the new: / Lay the tram tracks / from village to city.

98. 3⅜ × 3⅛" (8.6 × 8 cm)
Here, with this very generator / one can move the mountain / and relieve our misfortune.

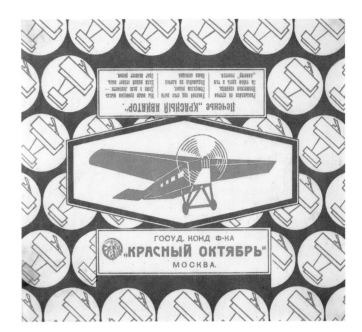

100.

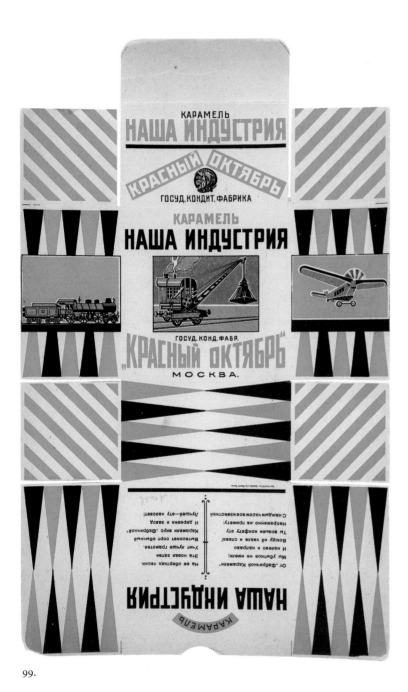

99.

99–100. Boxes for the Krasnyi Oktiabr' (Red October) factory, Moscow. 1923. Lithography

99. Box for Nasha Industriia (Our industry) caramels. 14^{15}⁄$_{16}$ × 9¼" (38 × 23.5 cm). Text by Vladimir Mayakovsky

From the "Factory Caramel" / we had no losses. / From left and right / and everywhere come praise and fame! / Take this candy / with all certainty as a sign. / The songs on its covers / become more and more known. / This new venture / teaches better than a textbook. / "Factory-made" caramels / force out ordinary-tasting ones. / The village and the factory / will call them the best!

100. Box for Krasnyi Aviator (Red aviator) cookies. 10⅛ × 11^{1}⁄$_{16}$" (25.7 × 28.1 cm). Text by Nikolai Aseev

Scatter among the bushes, / enemy cavalry. / Here and there the "Aviator" pursues you. / Nation of generals, crawl away growling under the table. / Our aviation rises higher. / We are propagating the idea everywhere / even on candies: / If the sky is ours / the enemy will crawl away like a crab.

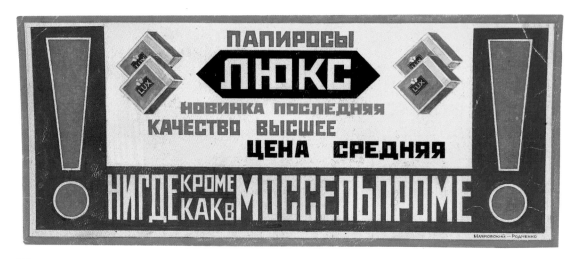

101.

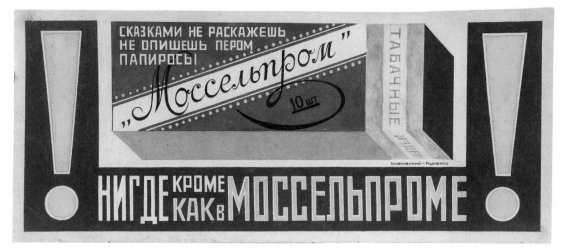

102.

101–3. Maquettes for advertising designs for the state grocery concern Mossel'prom (Moscow agricultural industry). 1923. Gouache on paper. Texts by Vladimir Mayakovsky

101. Advertisement for Liuks (Luxe) cigarettes. 7½ × 17⅞" (19 × 45.4 cm)

Cigarettes Liuks / latest novelty / higher quality / reasonable price. / Nowhere else as at Mossel'prom.

102. Advertisement for Mossel'prom cigarettes. 7½ × 17¹⁵⁄₁₆" (19.1 × 45.5 cm)

No story can tell / no pen can describe / Mossel'prom cigarettes. / Nowhere else as at Mossel'prom.

103. Advertisement for Krasnaia Zvezda (Red star) cigarettes. 8¹⁵⁄₁₆ × 17⅝" (22.7 × 44.8 cm)

All smokers, / always and every- where, / prefer / Krasnaia Zvezda. / Nowhere else as at Mossel'prom.

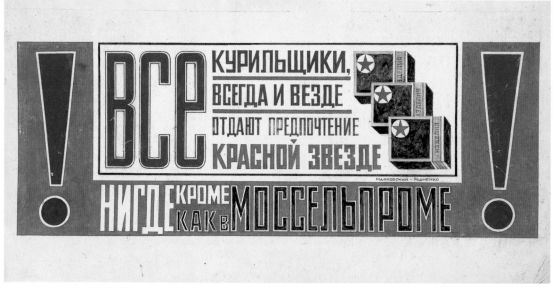

103.

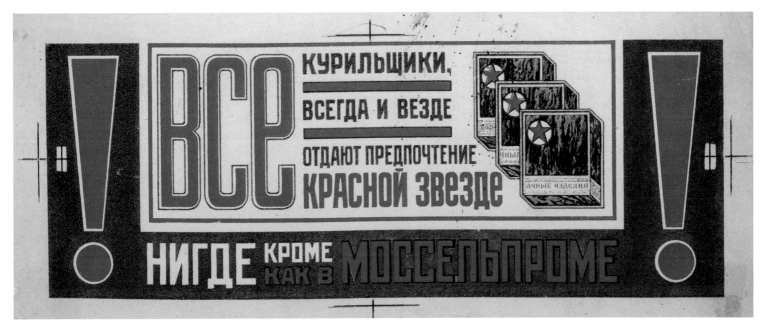

104.

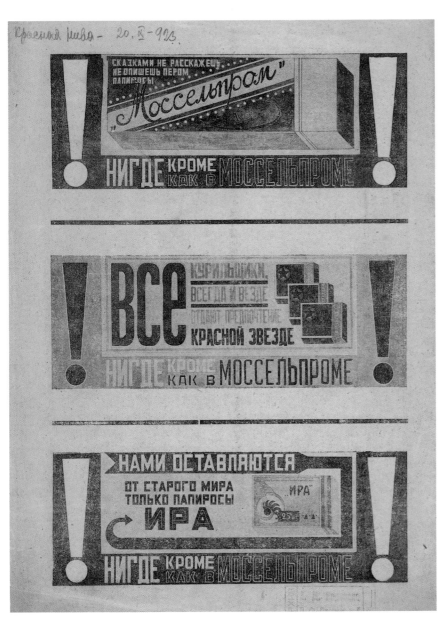

105.

104–5. Advertisements for the state grocery concern Mossel'prom (Moscow agricultural industry). 1923. Texts by Vladimir Mayakovsky

104. Advertisement for Krasnaia Zvezda (Red star) cigarettes. Lithography. 3¾ × 8⅜"
(9.5 × 21.3 cm)

All smokers, / always and everywhere, / prefer / Krasnaia Zvezda. / Nowhere else as at Mossel'prom.

105. Cigarette advertisements reproduced in the magazine *Krasnaia Niva* (Red field), October 20, 1923. Letterpress. 12³⁄₁₆ × 9⅛"
(31 × 23.2 cm)

No story can tell, no pen can describe / Mossel'prom cigarettes. Nowhere else as at Mossel'prom. / All smokers, always and everywhere, prefer Krasnaia Zvezda. / Nowhere else as at Mossel'prom. / Only Ira cigarettes remain with us from the old world. Nowhere else as at Mossel'prom.

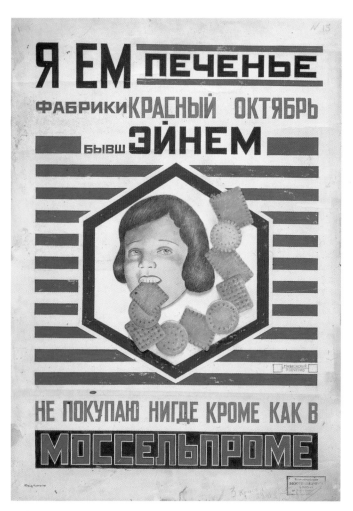

106.

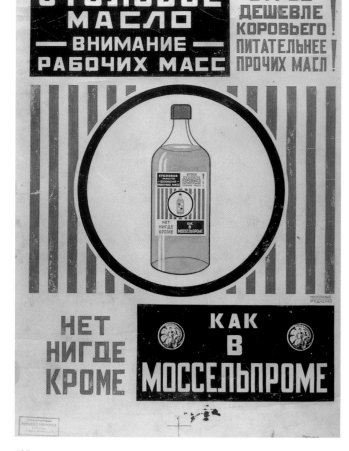

107.

106–7. Maquettes for advertising designs for the state grocery concern Mossel'prom (Moscow agricultural industry). 1923. Gouache on paper. Texts by Vladimir Mayakovsky

106. Advertisement for cookies from the Krasnyi Oktiabr' (Red October) factory. 32 × 21¾" (81.3 × 55.2 cm)

I eat cookies / from the Krasnyi Oktiabr' factory, / formerly Einem. / I don't buy anywhere except at / Mossel'prom.

107. Advertisement for table oil. 33 × 20" (83.8 × 50.8 cm)

Cooking oil / Attention working masses / Three times cheaper than butter! More nutritious than other oils! / Nowhere else as at Mossel'prom.

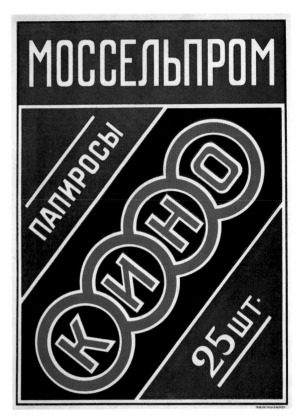

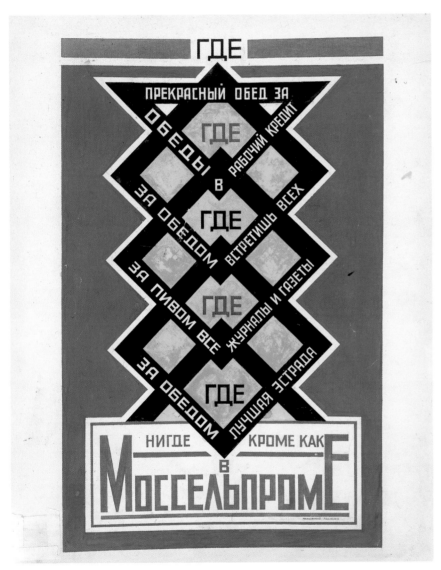

108.

109.

108–9. Advertising designs for the state grocery concern Mossel'prom (Moscow agricultural industry)

108. Maquette for advertisement for the Mossel'prom cafeteria. 1923. Gouache on paper. 19¼ × 13⅜" (49 × 34 cm). Text by Vladimir Mayakovsky

Where can you get a fantastic lunch for—? / Where can you get lunch on workers' credit? / Where can you meet everyone for lunch? / Where can you read all the newspapers and magazines over a beer? / Where is the best lunch-time stage? / Nowhere else as at Mossel'prom.

109. Advertisement for Kino (Cine) cigarettes. 1924. Lithography. 12⅝ × 9¹³⁄₁₆" (32.1 × 25 cm)

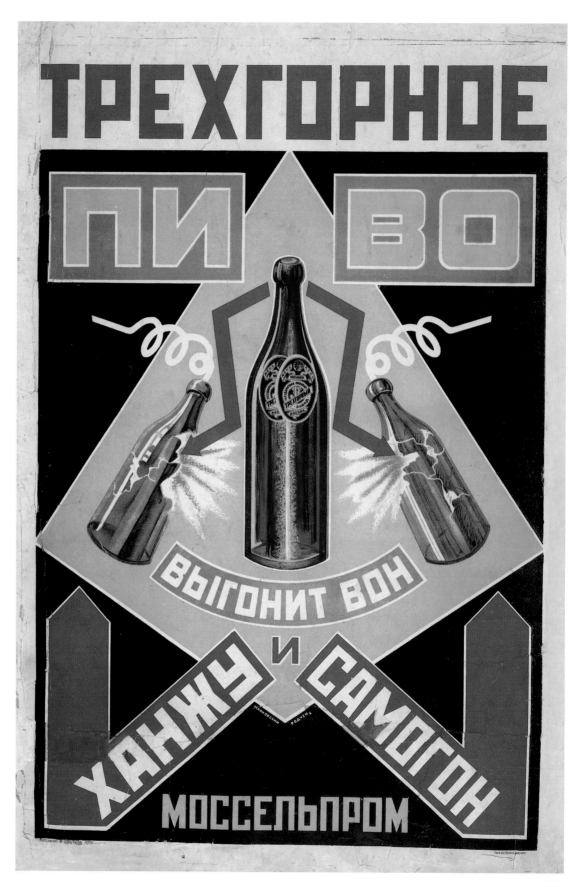

110. Advertisement for the state
grocery concern Mossel'prom
(Moscow agricultural industry).
Advertisement for Trekhgornoe
(Three peaks) beer. 1925.
Lithography. 28⅛ × 19⅛"
(71.5 × 48.5 cm). Text by Vladimir
Mayakovsky

**Trekhgornoe beer drives out
hypocrisy and moonshine.**

110.

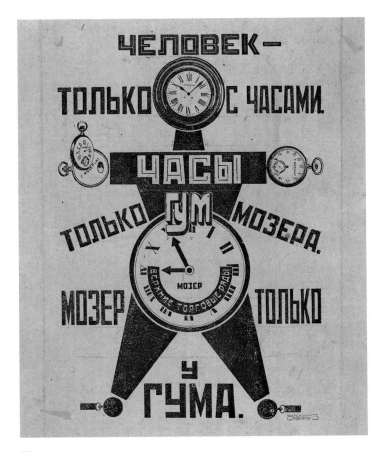

111.

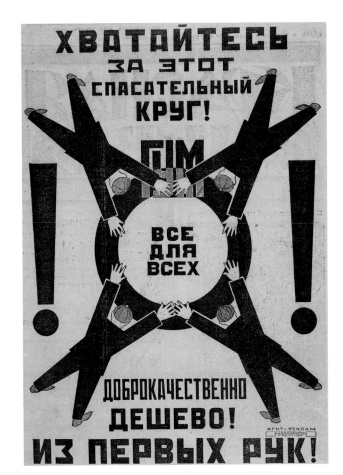

112.

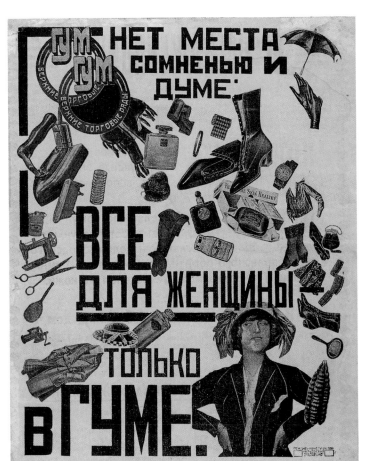

113.

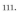

111–13. Advertisements for the state
department store GUM (State univer-
sal store). 1923. Letterpress. Texts by
Vladimir Mayakovsky

111. Advertisement for Mozer
watches, sold at GUM. 7 1/16 × 6 1/16"
(18 × 15.4 cm)
**A man needs a watch. A watch
from Mozer only. Mozer only
at GUM.**

112. Advertisement for GUM.
11 11/16 × 8 7/8" (29.7 × 22.5 cm)
**Hold on to this lifesaver! / GUM /
Everything for everyone / Good
quality and cheap! / Firsthand!**

113. Advertisement published in the
magazine *Krasnaia Niva* (Red field),
June 30, 1923. 10 5/16 × 8 3/8"
(26.2 × 21.2 cm)
**No place for doubts and thoughts /
Everything for women / Only
at GUM.**

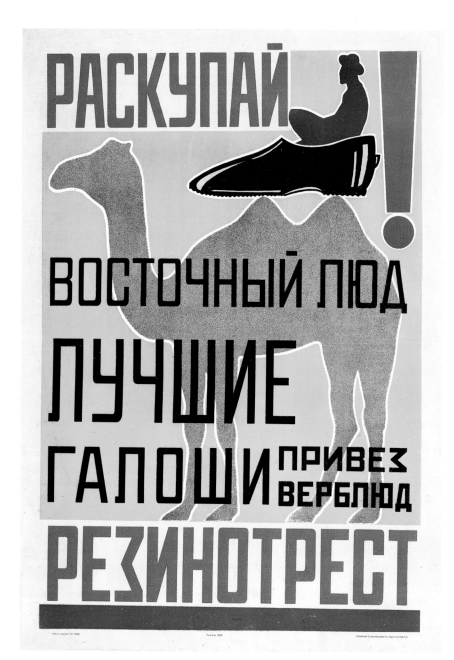

114.

114–15. Advertisements for
Rezinotrest (Rubber trust). 1923.
Lithography. Texts by Vladimir
Mayakovsky

114. 28¼ × 19⁵⁄₁₆" (71.7 × 50.3 cm)
 **Buy! / People of the Orient! / The
 best galoshes brought on camel /
 Rezinotrest.**

115. 28³⁄₈ × 20¹¹⁄₁₆" (72 × 52.5 cm).
Text in Turkish
 **Camels / brought the best
 galoshes / People of the Orient /
 Hurry up buy boots / Rezinotrest.**

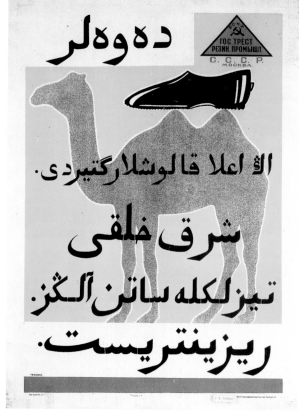

115.

116a.

b.

c.

d.

e.

f.

g.

h.

116. Bookmarks for the publishing
company Novost' (News). 1923.
Gouache on cardboard

a. 5⅞ × 4¾" (15 × 12 cm)
b. 5⁵⁄₁₆ × 5⅛" (13.5 × 13 cm)
c. 3¹⁵⁄₁₆ × 4⁵⁄₁₆" (10 × 11 cm)

d. 5⁵⁄₁₆ × 6⅛" (13.5 × 15.5 cm)
e. 4¾ × 3⅜" (12 × 8.5 cm)
f. 4⅞ × 3⅞" (12.3 × 9.8 cm)
g. 5¹⁄₁₆ × 3⅞" (12.8 × 9.8 cm)
h. 3⅛ × 5⁵⁄₁₆" (8 × 13.5 cm)

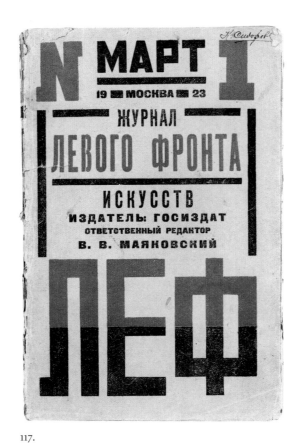

117.

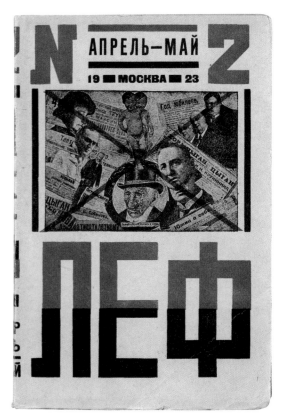

118.

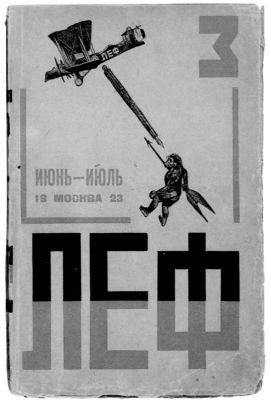

119.

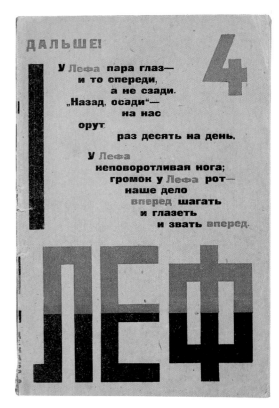

120.

117–20. Covers of the magazine
Lef (Left) nos. 1, 2, and 3 of 1923,
and no. 4 of 1924. Letterpress.

117–119. Each c. 9¼ × 6³⁄₁₆"
(23.5 × 15.8 cm)
120. 8¹⁵⁄₁₆ × 6⅛" (22.7 × 15.6 cm)

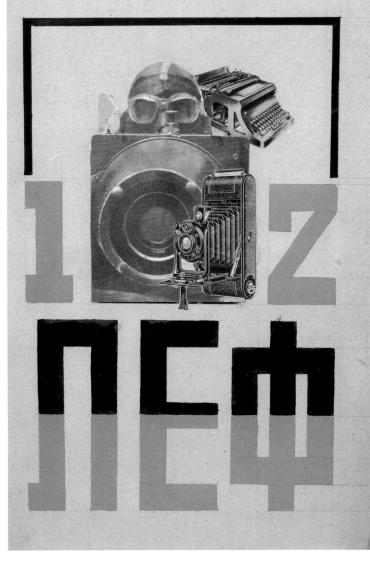

122.

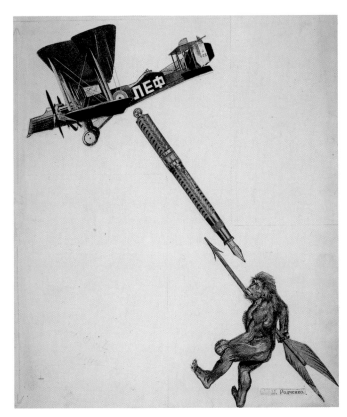

121.

121. Maquette for the cover of *Lef*
(Left) no. 3 of 1923. Cut-and-pasted
printed papers on paper.
12 1/16 × 10 7/16" (31 × 26.5 cm)

122. Maquette for unpublished
variant cover of *Lef* no. 1–2 of 1923.
Cut-and-pasted printed papers, ink,
and gouache on paper. 10 5/8 × 7 1/4"
(27 × 18.4 cm)

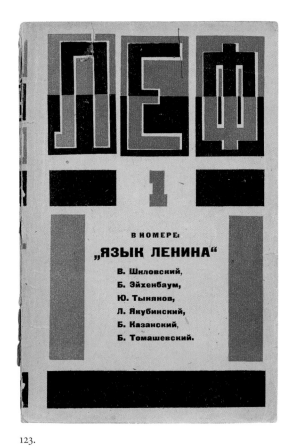

123.

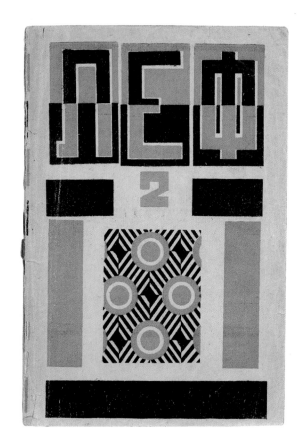

124.

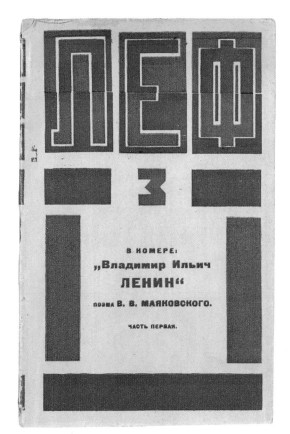

125.

123–25. Covers of the magazine *Lef*
(Left) nos. 1 and 2 of 1924, and no. 3
of 1925. Letterpress

123. 9 × 6" (22.8 × 15.2 cm)
124. 8⅞ × 6" (22.5 × 15.2 cm)
125. 9⅛ × 5⅞" (23.2 × 14.9 cm)

126.

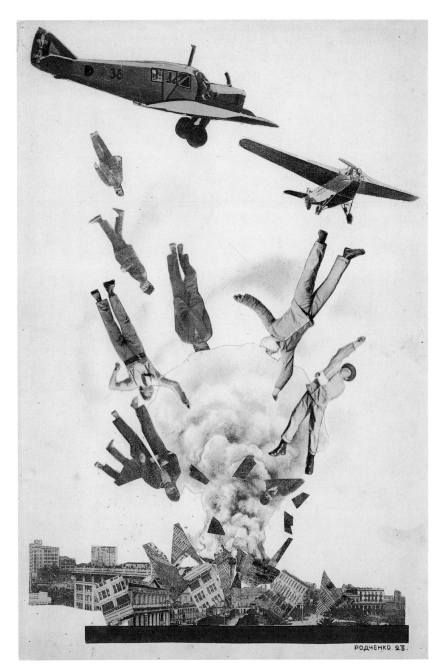

127.

126. Cover of the anthology *Flight: Aviation verses* (*Let: Avio stikhi*). 1923. Letterpress. 9¹³/₁₆ × 6³/₁₆" (24.9 × 15.6 cm)

127. Maquette for *Crisis* (*Krizis*), an illustration for the anthology *Flight: Aviation verses* (*Let: Avio stikhi*). 1923. Cut-and-pasted printed papers on paper. 14³/₈ × 9¹¹/₁₆" (36.5 × 24.6 cm)

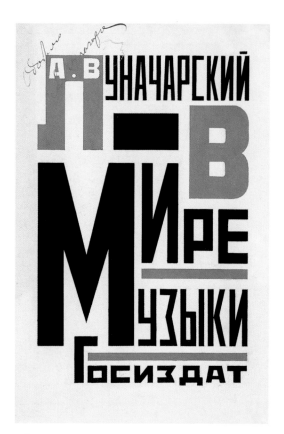

128.

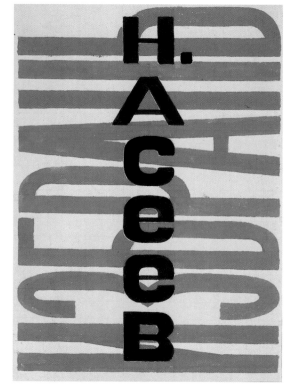

129.

128. Maquette for the cover of the book *In the World of Music* (*V mire muzyki*), by Anatoly Lunacharsky. 1923. Gouache on paper. 9⁷⁄₁₆ × 6⅛" (24 × 15.5 cm)

129. Maquette for the cover of the book *Selected* (*Izbran'*), by Nikolai Aseev. 1923. Gouache on paper. 8⅝ × 6½" (22 × 16.5 cm)

130. Cover of the book *Altogether* (*Itogo*), by Sergei Tret'iakov. 1924. Lithography. 9⅛ × 6³⁄₁₆" (23.3 × 15.8 cm)

131. Cover of the book *Mayakovsky Smiles, Mayakovsky Laughs, Mayakovsky Mocks* (*Maiakovskii ulybaetsia, Maiakovskii smeetsia, Maiakovskii izdevaetsia*), by Vladimir Mayakovsky. 1923. Letterpress. 6⅞ × 5¼" (17.5 × 13.2 cm)

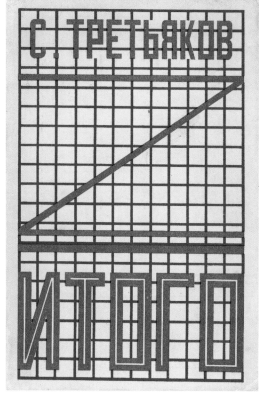

130.

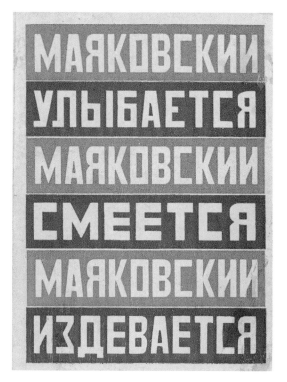

131.

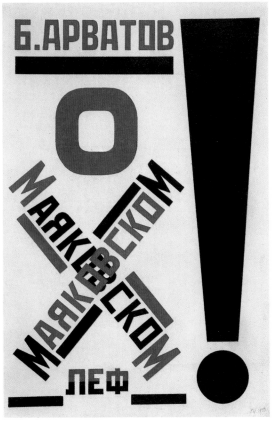

132.

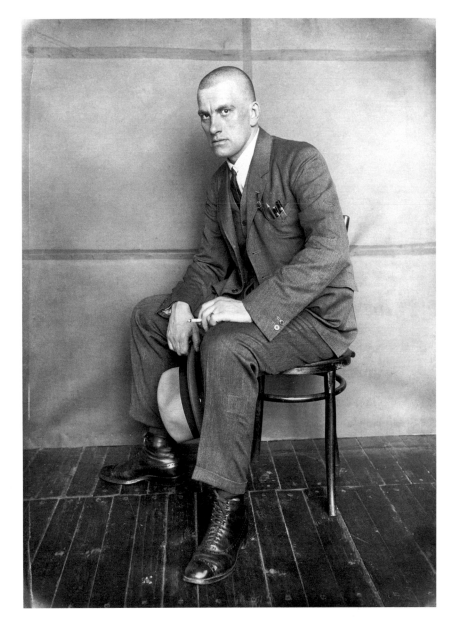

133.

132. Maquette for the cover of
the book *On Mayakovsky* (*O
Maiakovskom*), by Boris Arvatov.
1923. Gouache on paper. 9⅛ × 6"
(23.2 × 15.4 cm)

133. Vladimir Mayakovsky. 1924.
Gelatin-silver print. 15¹¹⁄₁₆ × 8¹¹⁄₁₆"
(39.9 × 22.1 cm)

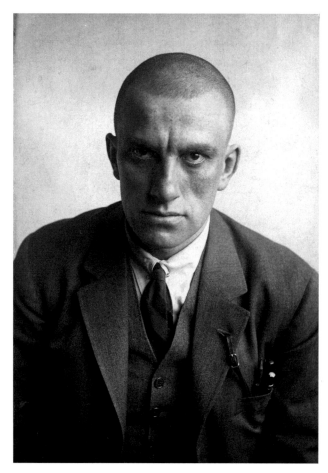

134.

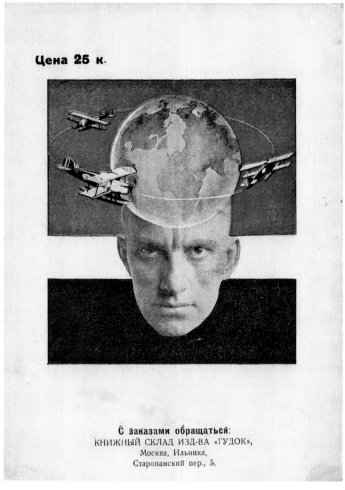

134. Vladimir Mayakovsky. 1924.
Gelatin-silver print. 4³/₁₆ × 2¹⁵/₁₆"
(10.7 × 7.5 cm)

135. Back cover of the book
*Conversation with the Finance
Inspector about Poetry* (*Razgovor s
fininspektorom o poesii*), by Vladimir
Mayakovsky. 1926. Letterpress.
6⁷/₈ × 5" (17.4 × 12.9 cm)

135.

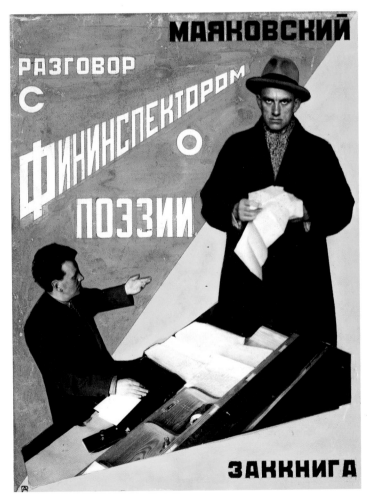

136.

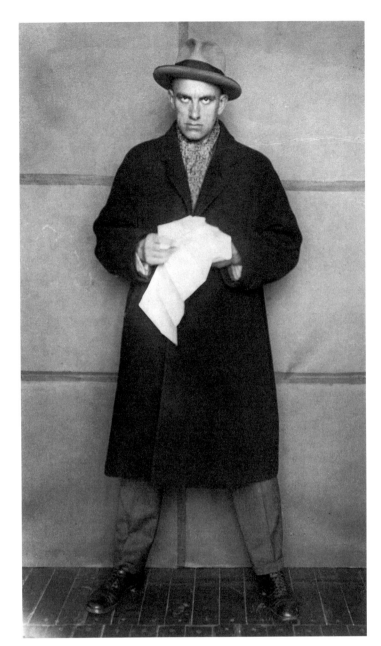

137.

136. Maquette for the front cover of the book *Conversation with the Finance Inspector about Poetry* (*Razgovor s fininspektorom o poesii*), by Vladimir Mayakovsky. 1926. Cut-and-pasted gelatin-silver photographs and gouache on paper. 11⁵⁄₁₆ × 8⁹⁄₁₆" (28.7 × 21.7 cm)

137. Vladimir Mayakovsky. 1924. Gelatin-silver print. 11⁵⁄₈ × 6¹³⁄₁₆" (29.5 × 17.3 cm)

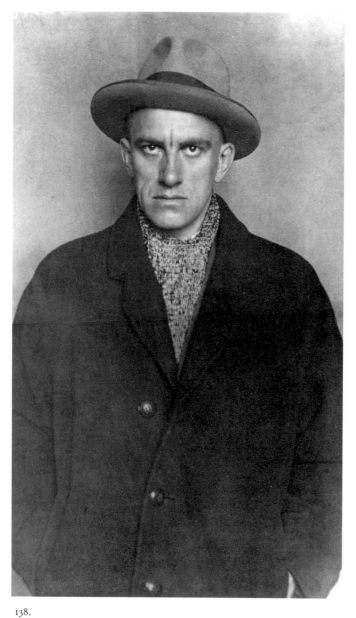

138.

138. Vladimir Mayakovsky. 1924.
Gelatin-silver print. $11^{7}/_{16} \times 6^{13}/_{16}$"
(29 × 17.3 cm)

139. Two-page spread from the mag-
azine *SSSR na Stroike* (*USSR in
Construction*) no. 7 of 1940, a special
commemorative issue on Vladimir
Mayakovsky. Gravure. 16 × 23"
(40.7 × 58.5 cm)

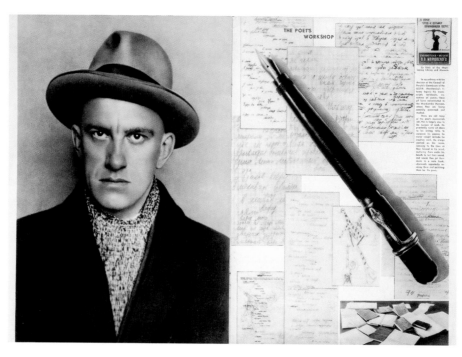

139.

141.

140.

140. Vladimir Mayakovsky. 1924.
Gelatin-silver print. 6 11/16 × 4 3/8"
(16.9 × 11.2 cm)

141. Vladimir Mayakovsky. 1924.
Gelatin-silver print. 11 3/8 × 8 1/2"
(28.8 × 21.5 cm)

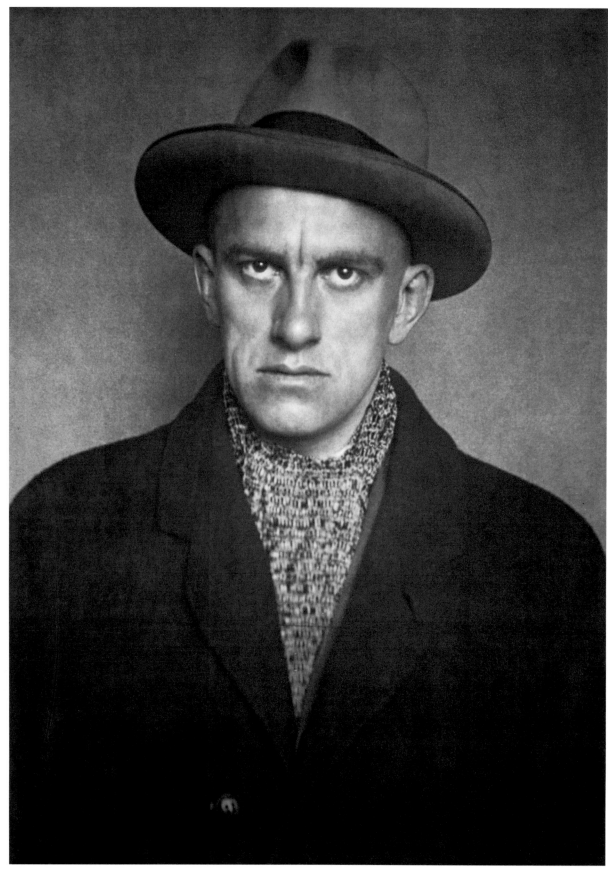

142.

142. Vladimir Mayakovsky. 1924.
Gelatin-silver print. 19⅛ × 13⅞"
(48.7 × 35.2 cm)

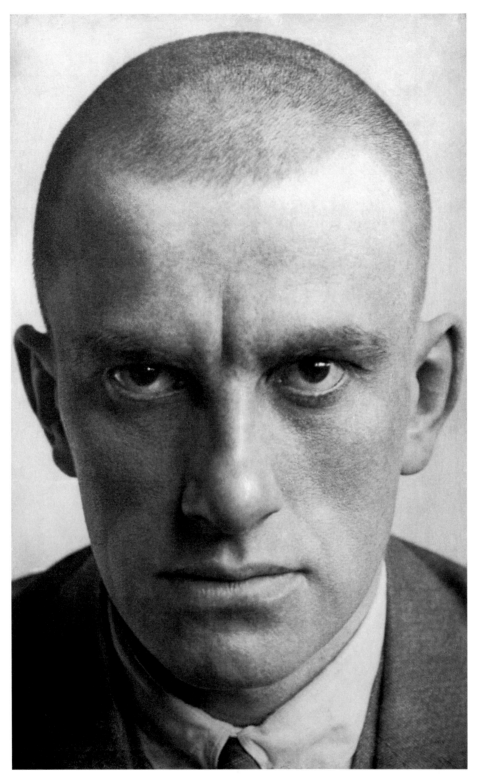

143.

143. Vladimir Mayakovsky. 1924.
Gelatin-silver print. 23½ × 14⅝"
(59.7 × 37.1 cm)

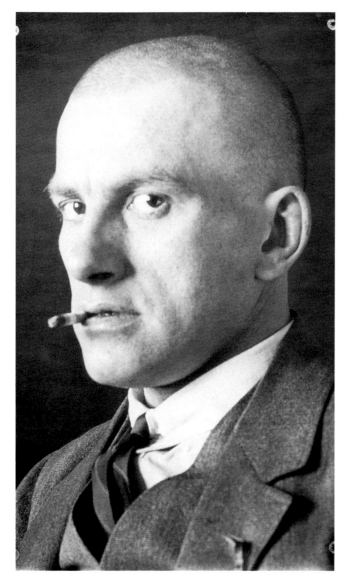

144.

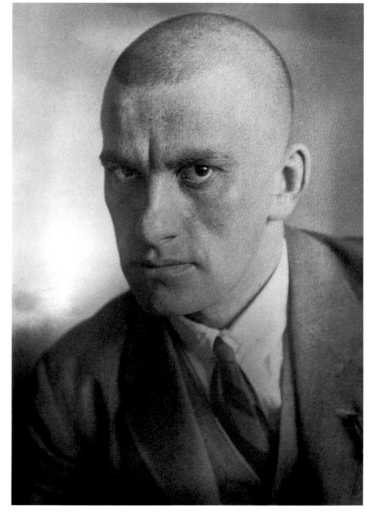

144. Vladimir Mayakovsky. 1924.
Gelatin-silver print. 19⅜ × 11⅝"
(49.2 × 29.6 cm)

145. Vladimir Mayakovsky. 1924.
Gelatin-silver print. 16¼ × 11⁷⁄₁₆"
(41.2 × 29 cm)

145.

146. *Mother* (*Mat'*). 1924.
Gelatin-silver print. 8⅞ × 6½"
(22.5 × 16.5 cm)

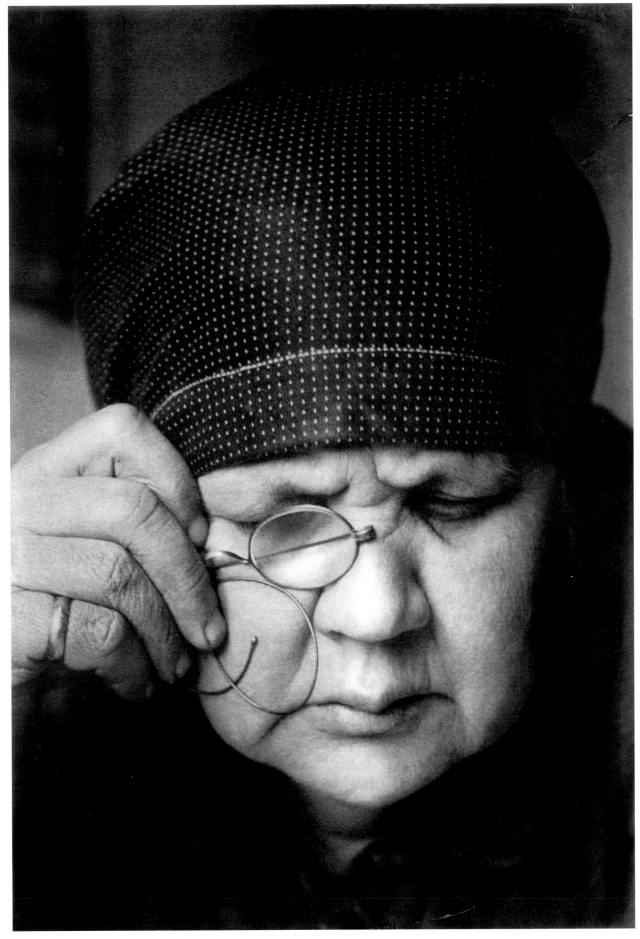

146.

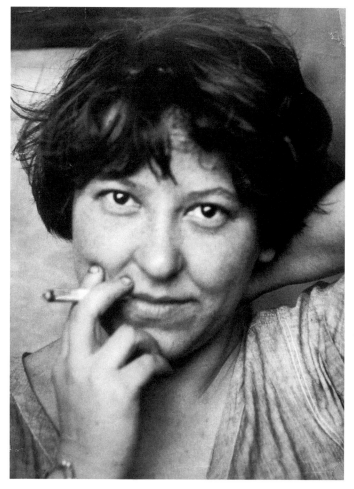

147.

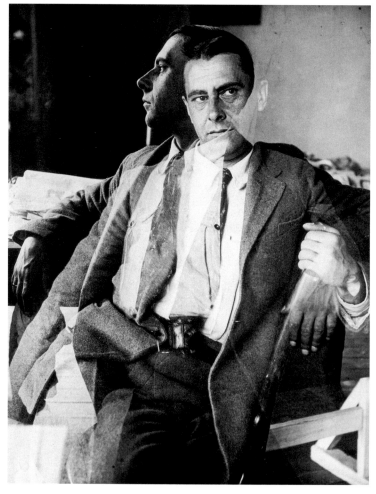

148.

147. Varvara Stepanova. 1924.
Gelatin-silver print. 15¾ × 11"
(40 × 28 cm)

148. Aleksandr Shevchenko. 1924.
Gelatin-silver print. 11⅝ × 9 1/16"
(29.5 × 23 cm)

149. Osip Brik. Unpublished illustra-
tion for the cover of the magazine
Lef (Left). 1924. Gouache on gelatin-
silver print. 9¼ × 7⅛" (23.6 × 18 cm)

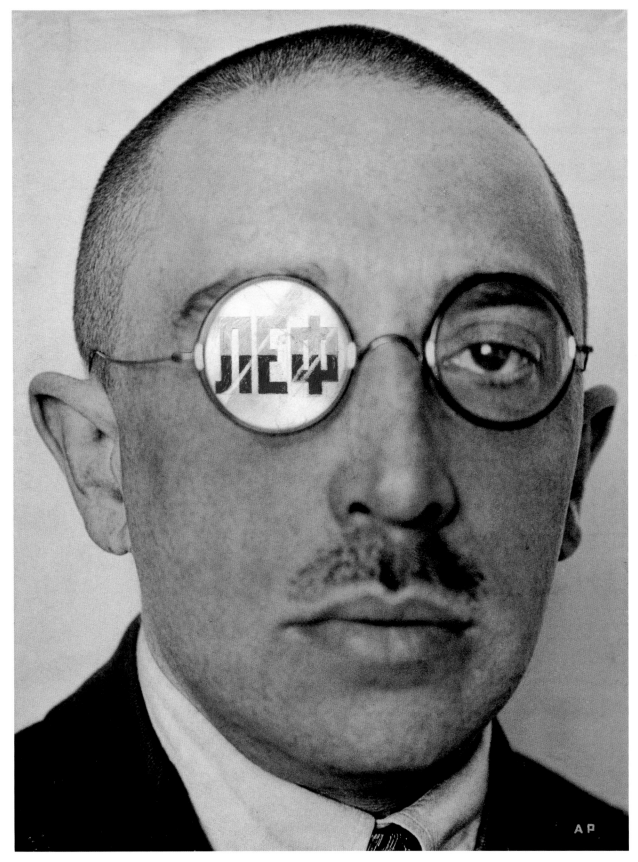

149.

150.

151.

150–53. Four of the ten covers of the serial novel *Mess Mend or a Yankee in Petrograd* (*Mess Mend ili Ianki v Petrograde*), by Jim Dollar (Marietta Shaginian). 1924. Letterpress. Each 7 × 5" (17.8 × 12.7 cm)

150. No. 1: *The Mask of Revenge* (*Maska mesti*)

151. No. 2: *The Mystery of the Sign* (*Taina znaka*)

152. No. 8: *The Police Genius* (*Genii syska*)

153. No. 9: *The Yankees Are Coming* (*Ianki edut*)

152.

153.

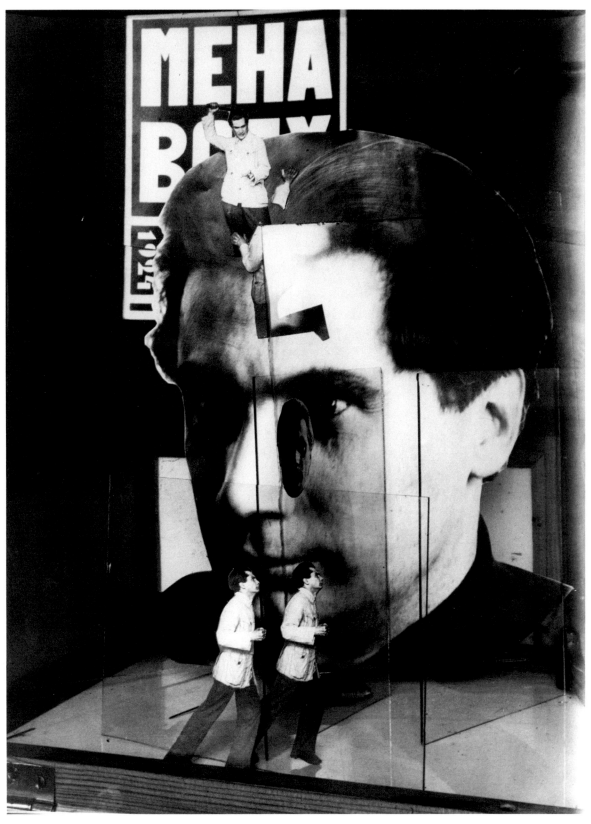

154.

154. Maquette for an unpublished
cover of *Change All* (*Mena Vsekh*),
an anthology of Constructivist
poetry. 1924. Gelatin-silver print.
9¼ × 7″ (23.5 × 17.8 cm)

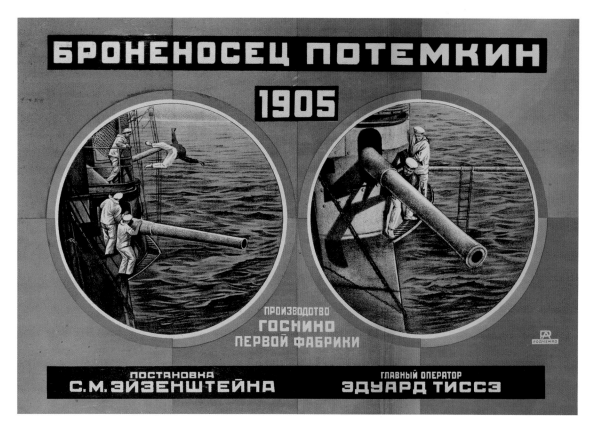

155.

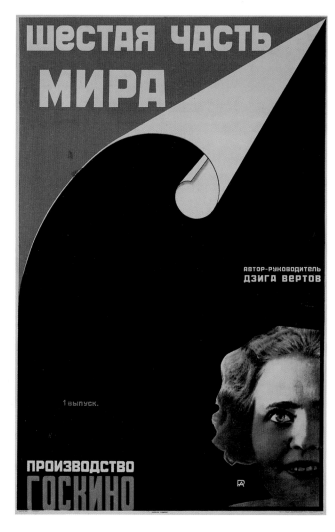

155. Poster for the film *Battleship Potemkin* (*Bronenosets Potemkin*), by Sergei Eisenstein. 1925. Lithography. 28¼ × 42½" (71.7 × 107.9 cm)

156. Poster for the film *The Sixth Part of the World* (*Shestaia chast' mira*), by Dziga Vertov. 1926. Lithography. 42 × 27⅜" (106.7 × 69.5 cm)

157. Poster for the film *Cine-Eye* (*Kino glaz*), by Dziga Vertov. 1924. Lithography. 35¾ × 26¾" (90.8 × 67.9 cm)

156.

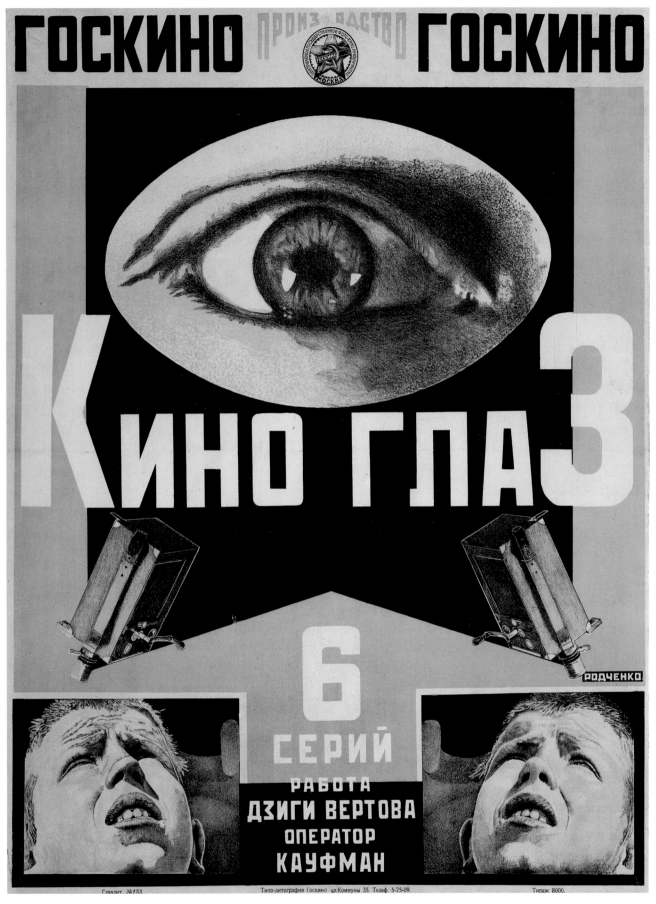

158.

159.

158–59. Covers of catalogues for the *Exposition Internationale des Arts Décoratifs et Industriels Modernes,* Paris, 1925

158. Cover for the catalogue *L'Art Décoratif U.R.S.S.: Moscou-Paris 1925.* Lithography. 10⁹⁄₁₆ × 7¹³⁄₁₆" (26.8 × 19.9 cm)

159. Cover for the catalogue *Section URSS.* Letterpress. 6¹⁵⁄₁₆ × 5¼" (7.7 × 3.4 cm)

Right: Photographs made by Rodchenko to document the USSR Workers' Club (*Rabochii klub SSSR*), which he designed and installed at the exposition

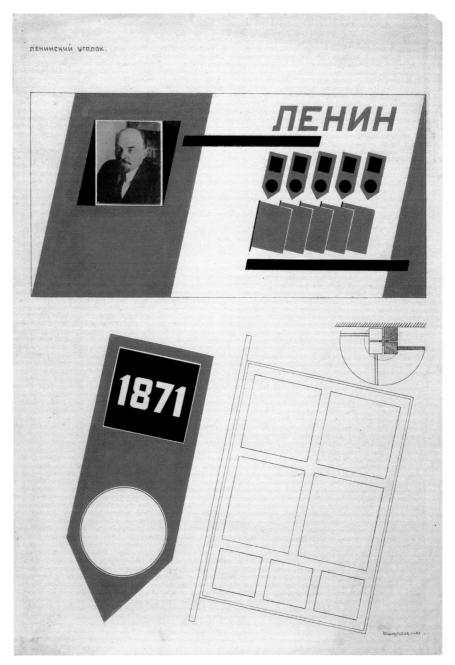

160.

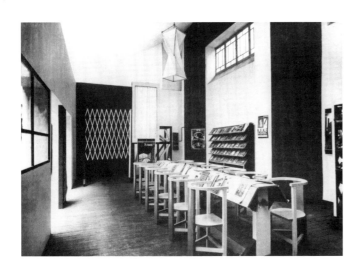

160. Design for the Lenin Corner in the USSR Workers' Club (*Rabochii klub SSSR*) at the *Exposition Internationale des Arts Décoratifs et Industriels Modernes*, Paris, 1925. Black and red india ink and pasted gelatin-silver photograph on paper. 14⁵⁄₁₆ × 10" (36.3 × 25.5 cm)

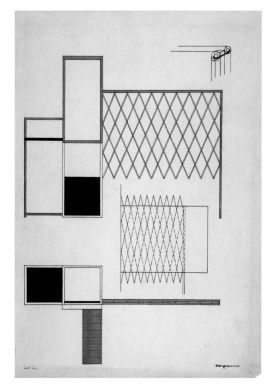

161.

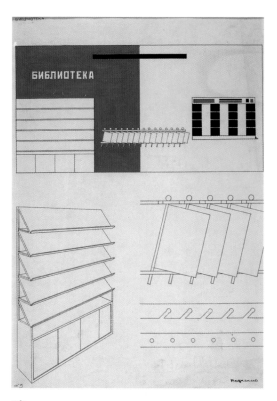

162.

161–64. Designs for the USSR Workers' Club (*Rabochii klub SSSR*) at the *Exposition Internationale des Arts Décoratifs et Industriels Modernes*, Paris, 1925

161. Collapsible rostrum. Black and red india ink on paper. 14¼ × 10" (36.2 × 25.5 cm)

162. Library. Black and red india ink on paper. 14⅜ × 10" (36.5 × 25.5 cm)

163. Club entry and announcement panels. Black and red india ink and pencil on paper. 14³⁄₁₆ × 10" (36 × 25.5 cm)

164. Lamp. Black and green india ink on paper. 14⅜ × 10" (36.5 × 25.5 cm)

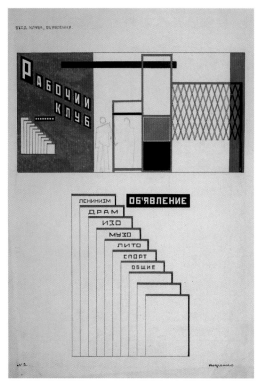

163.

164.

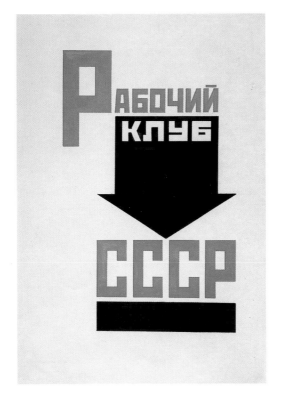

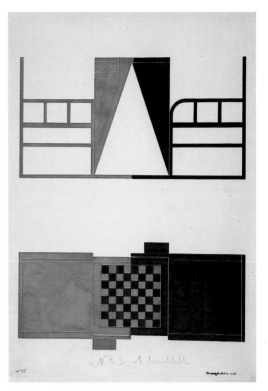

165.

166.

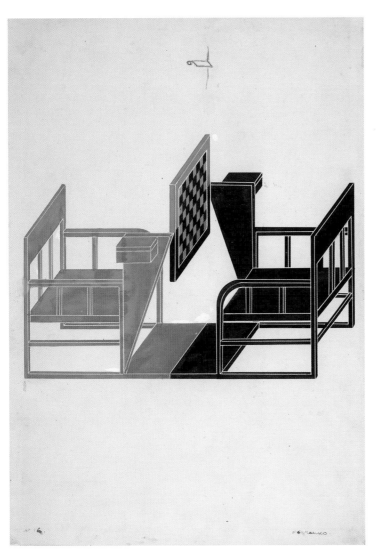

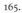

167.

165–67. Designs for the USSR Workers' Club (*Rabochii klub SSSR*) at the *Exposition Internationale des Arts Décoratifs et Industriels Modernes*, Paris, 1925

165. Entry sign. Black and red india ink on paper. 14¼ × 10" (36.2 × 25.5 cm)

166. Chess table. Black and red india ink and gouache on paper. 14⅜ × 10" (36.5 × 25.5 cm)

167. Chess table. Black and red india ink and gouache on paper. 14⅜ × 10" (36.5 × 25.5 cm)

168.

168–69. From the series "The
Building on Miasnitskaia Street"
(*Dom na Miasnitskoi*). 1925.
Gelatin-silver prints

168. *Balconies* (*Balkony*). 9¼ × 11⅝"
(23.5 × 29.5 cm)

169. *Balconies* (*Balkony*). 15⁷⁄₁₆ × 9"
(39.2 × 22.8 cm)

169.

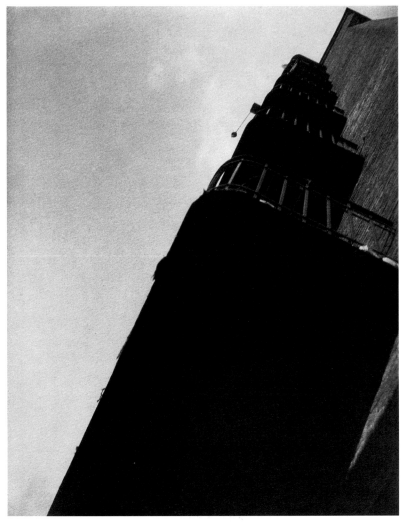

170.

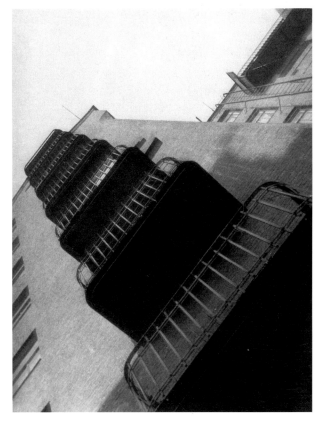

171.

170–71. From the series "The Building on Miasnitskaia Street" (*Dom na Miasnitskoi*). 1925. Gelatin-silver prints

170. *Balconies* (*Balkony*). 11⅜ × 9¹⁄₁₆" (29 × 23 cm)

171. *Balconies* (*Balkony*). 11⅞ × 9⁷⁄₁₆" (30.2 × 24 cm)

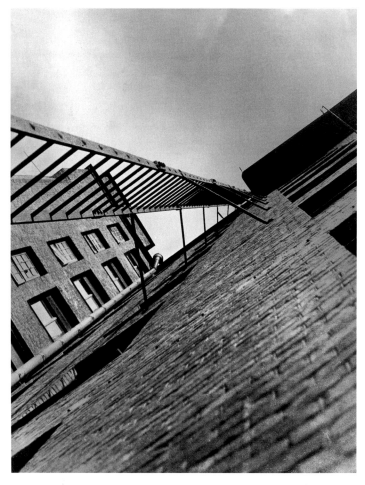

172.

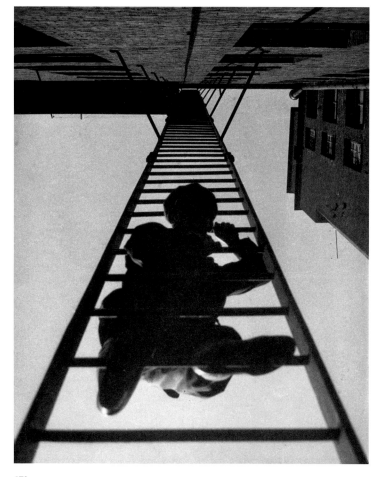

173.

172–73. From the series "The
Building on Miasnitskaia Street"
(*Dom na Miasnitskoi*). 1925.
Gelatin-silver prints

172. *Fire Escape* (*Pozharnaia lestnitsa*).
10⅛ × 7¾" (25.7 × 19.7 cm)

173. *Fire Escape* (*Pozharnaia lestnitsa*).
11⁷⁄₁₆ × 9⅛" (29.1 × 23.2 cm)

174.

175.

176.

177.

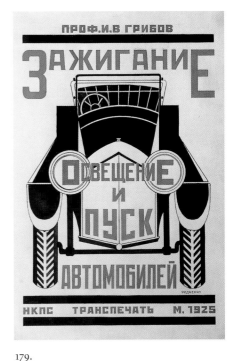

179.

175. Cover of *Railroad Assessor* (*Zh/dorozhnyi taksirovshchik*), by V. N. Batitskii. Letterpress. 9⅝ × 7" (24.4 × 17.7 cm)

178. Cover of *The Scientific Organization of Labor* (*Nauchnaia organizatsiia truda*), by Frederick Taylor. Letterpress. 9⁵⁄₁₆ × 6⁹⁄₁₆" (23.7 × 16.7 cm)

174–79. Book covers for the publishing house Transpechat' (Transport press), Moscow. 1925

174. Cover of *Radio Technics* (*Radiotekhnika*), by Ia. Faivush. Letterpress. 8⅞ × 5⅞" (22.5 × 15 cm)

176. Cover of *Contemporary Techniques of Electric Lighting* (*Sovremennoe sostoianie tekhniki elektricheskogo osveshcheniia*), by V. D. Radvanskii. Letterpress. 8¹³⁄₁₆ × 5¹³⁄₁₆" (22.4 × 14.8 cm)

177. Maquette for the cover of *Aircraft Engines* (*Aviatsionnye dvigateli*), by L. Marks. Cut-and-pasted letterpress, india ink, and gouache on paper. 11⅛ × 6¹¹⁄₁₆" (28.2 × 17 cm)

179. Cover of *The Ignition, Lighting, and Starting of Automobiles* (*Zazhiganie osveshchenie i pusk avtomobilei*), by I. V. Gribov. Letterpress. 7¹³⁄₁₆ × 5⅝" (19.8 × 14.2 cm)

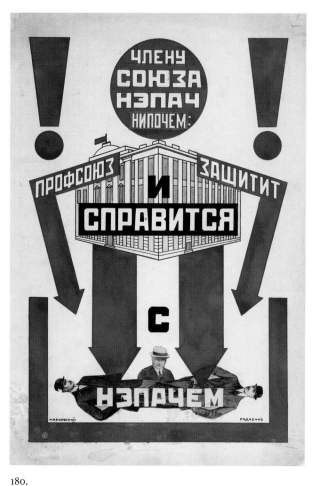

180.

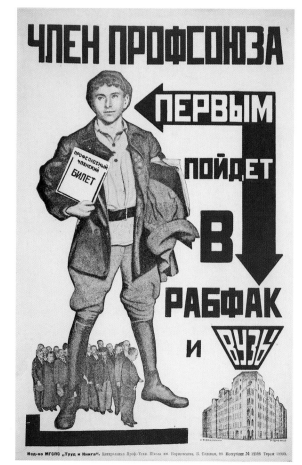

181.

180–81. Trade union posters. 1925.
Texts by Vladimir Mayakovsky

180. Maquette. Cut-and-pasted
printed papers, black and red india
ink, and pencil on paper. 15⅝ ×
10⅞" (39.7 × 27.5 cm)

**The union member thinks nothing
of the NEP [New Economic Policy]
man / The professional union
defends [the worker] and deals
with the NEP man.**

181. Lithography. 14¹/₁₆ × 9¹⁵/₁₆" (35.7
× 25.3 cm)

**The union member is the first to
enter the workers' faculty of
higher educational institutions.**

182. Cover of the book *For a
Living Il'ich [Lenin]* (*K zhivomu
Il'ichu*), an anthology of
memorial poetry published by
the Lef group and MAPP (the
Moscow Association of Prole-
tarian writers). 1924. Letterpress.
6⅞ × 5" (17.5 × 12.7 cm)

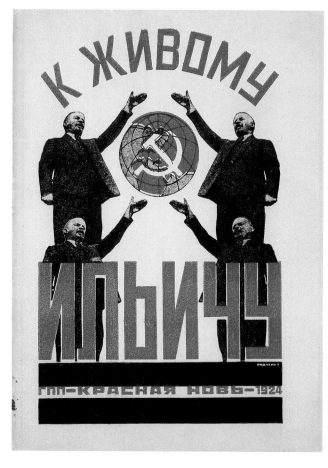

182.

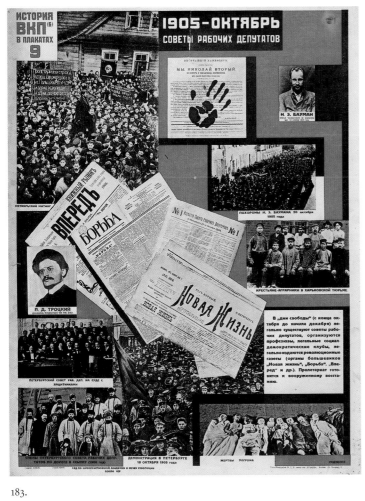

183.

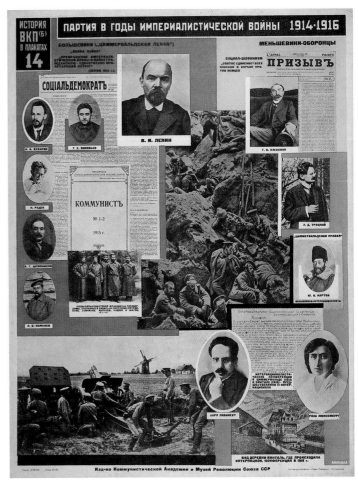

184.

183–84. From "The History of the VKP(b) [All-Russian Communist Party (Bolshevik)] in Posters" (*Istoria VKP(b) v plakatakh*). 1925–26. A series of twenty-five lithographic posters

183. *1905—October: Soviets of the Workers' Deputies* (*1905—Oktiabr': Sovety rabochikh deputatov*). No. 9 in the series. 26 × 20½" (66 × 52.1 cm)

184. *The Party in the Years of the Imperialist War 1914–1916* (*Partiia v gody imperialisticheskoi voiny 1914–1916*). No. 14 in the series. 26⅞ × 20½" (68.3 × 52.1 cm)

185.

185. *Rumba.* 1928. Gelatin-silver
print. 15 × 9⅝" (38 × 24.4 cm)

186–87. Illustrations for the unpub-
lished children's book *Auto-Animals*
(*Samozveri*), by Sergei Tret'iakov.
1926–27. Gelatin-silver prints

186. *Elephant* (*Slon*).
9⅛ × 6¹¹⁄₁₆" (23.2 × 17 cm)

187. *Roly-Poly* (*Karakatitsa*).
9⅛ × 6⅞" (23.2 × 17.5 cm)

186.

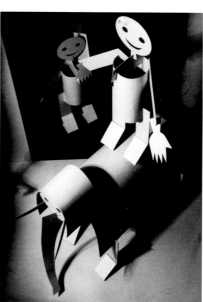

187.

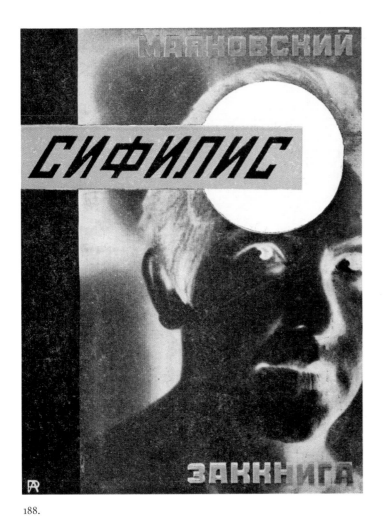

188.

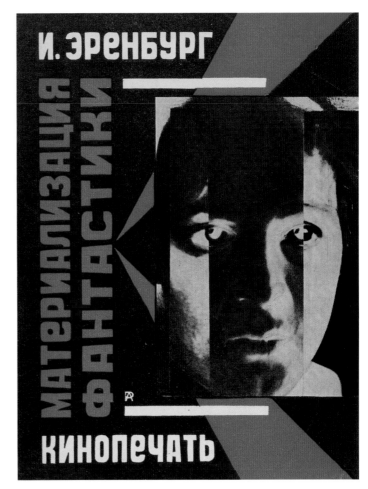

189.

188. Cover of the book *Syphilis* (*Sifilis*), by Vladimir Mayakovsky. 1927. Letterpress. 6¼ × 4¾" (15.8 × 12 cm)

189. Cover of the book *Materialization of the Fantastic* (*Materializatsia Fantastiki*), by Ilya Ehrenburg. 1927. Letterpress. 6⅞ × 5¹³⁄₁₆" (17.5 × 13.2 cm)

190.

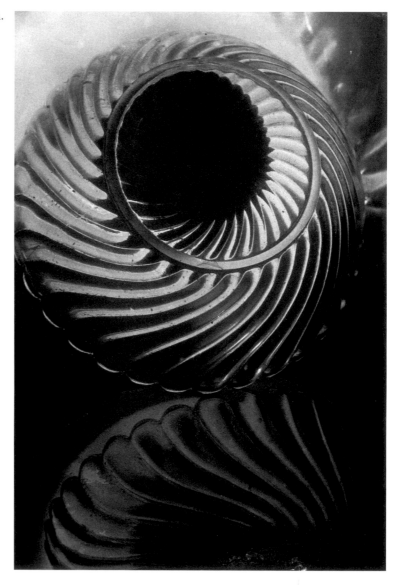

191.

190. *Down with Bureaucracy* (*Doloi biurokratizm*). 1927. Gelatin-silver print. 5⁵⁄₁₆ × 7⅛" (13 × 17.2 cm)

191. *The Vase* (*Vasa*). 1928. From the series "Glass and Light" (*Steklo i svet*). Gelatin-silver print. 6⅞ × 4¾" (17.5 × 12.2 cm)

234

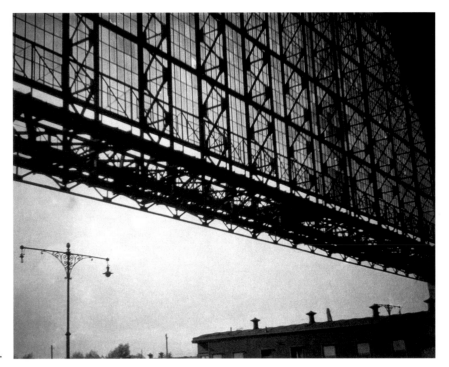

193.

192.

192. *Wall of the Brianskii Railway Station* (*Stena Brianskogo vokzala*). 1927. Gelatin-silver print. 8¹⁵⁄₁₆ × 4¾" (22.7 × 12.1 cm)

193. The Brianskii railway station, Moscow. 1927. Gelatin-silver print. 9⁷⁄₁₆ × 13¾" (24 × 35 cm)

194.

195.

194. Pine trees. c. 1930. Gelatin-silver
print. 9 × 11⁷⁄₁₆" (22.9 × 29 cm)

195. *Pine Trees, Pushkino* (*Sosny,
Pushkino*). 1927. Gelatin-silver print.
6¹⁵⁄₁₆ × 4¹⁵⁄₁₆" (17.6 × 12.6 cm)

196. *Pine Trees, Pushkino* (*Sosny,
Pushkino*). 1927. Gelatin-silver print.
8¹³⁄₁₆ × 6¼" (22.5 × 15.9 cm)

196.

197.

197. Sergei Tret'iakov. 1928.
Gelatin-silver print. 11⁷⁄₁₆ × 9¼"
(29 × 23.4 cm)

198. Nikolai Aseev. 1927.
Gelatin-silver print. 6⁷⁄₁₆ × 8⁷⁄₈"
(16.3 × 22.5 cm)

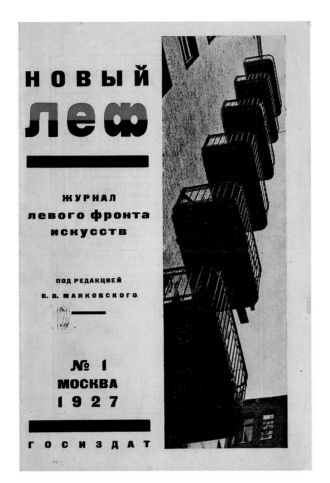

199.

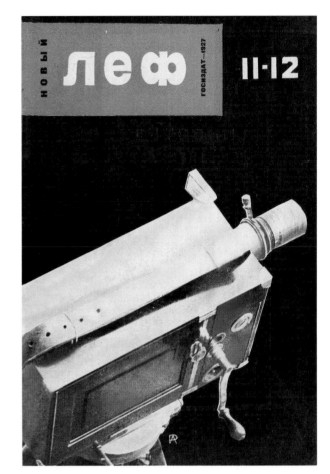

200.

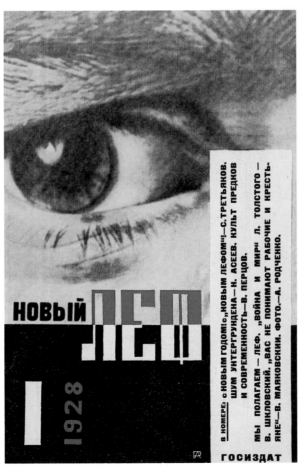

201.

199–201. Covers of the magazine
Novyi Lef (New left) nos. 1 and 11–12
of 1927, and no. 1 of 1928. Letterpress.
Each c. 9 1/16 × 5 7/8" (23 × 15 cm)

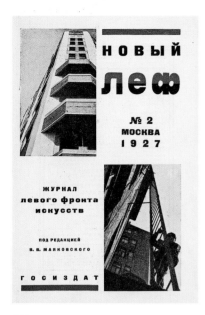

202.

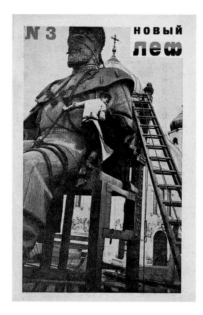

203.

204.

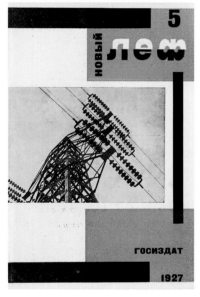

205.

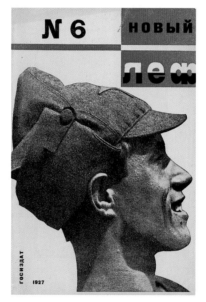

206.

207.

208.

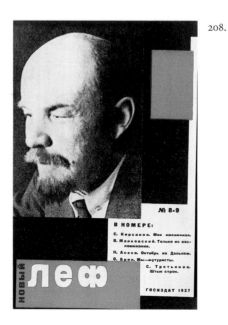

209.

202–9. Covers of the magazine
Novyi Lef (New left) nos. 2, 3, 4, 5, 6,
7, 8–9, and 10 of 1927. Letterpress.
Each c. 9 1/16 × 5 7/8" (23 × 15 cm)

210.

211.

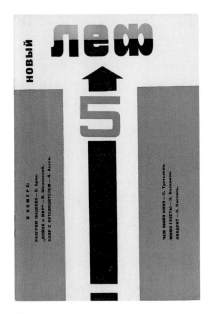

212.

213.

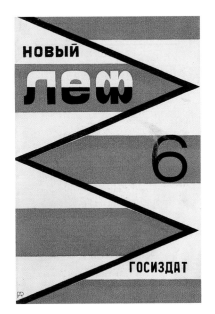

214.

215.

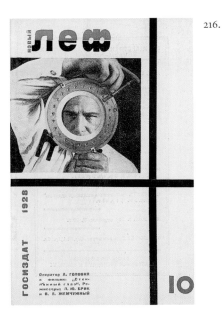

216.

217.

210–17. Covers of the magazine
Novyi Lef (New left) nos. 2, 3, 4, 5, 6,
7, 10, and 11 of 1928. Letterpress.
Each c. 9¹⁄₁₆ × 5⁷⁄₈" (23 × 15 cm)

218.

219.

218–19. Front and back covers of the magazine *Novyi Lef* (New left) nos. 8 and 9 of 1928. Letterpress. Each c. 9 1/16 × 11 3/4" (23 × 29.8 cm)

220.

221.

220. Front and back covers of the
magazine *Novyi Lef* (New left) no. 12
of 1928. Letterpress. 9¹⁄₁₆ × 11¾"
(23 × 29.8 cm)

221. Front and back covers of
the book *No. S*, by Vladimir
Mayakovsky. 1928. Letterpress.
7⅛ × 10½" (18.1 × 26.7 cm)

222.

222. *Street Trade* (*Ulichnaia torgovliia*). 1928. Gelatin-silver prints. Diptych; each print 4⅝ × 6" (11.8 × 15.2 cm)

223. *Street Trade* (*Ulichnaia torgovliia*). 1928. Gelatin-silver prints. Triptych; each print 3⅜ × 4⅞" (8.2 × 11.3 cm)

223.

224.

224. *Street Trade* (*Ulichnaia torgovliia*). 1928. Gelatin-silver prints. Diptych; top print 4½ × 5¹³⁄₁₆" (11.5 × 14.8 cm), bottom print 4⅝ × 5¹³⁄₁₆" (11.8 × 14.8 cm)

225.

226.

225. Courtyard. 1928–30. Gelatin-
silver print. 12 × 9¼" (30 × 23 cm)

226. Courtyard. 1928–30. Gelatin-
silver print. 5⅜ × 3⅜" (13.6 × 8.6 cm) **246**

227.

227. Courtyards. 1926–28. Four gelatin-
silver prints mounted together. Two
prints 5½ × 3¾" (8 × 5.3 cm),
two prints 3¾ × 5½" (5.3 × 8 cm)

247

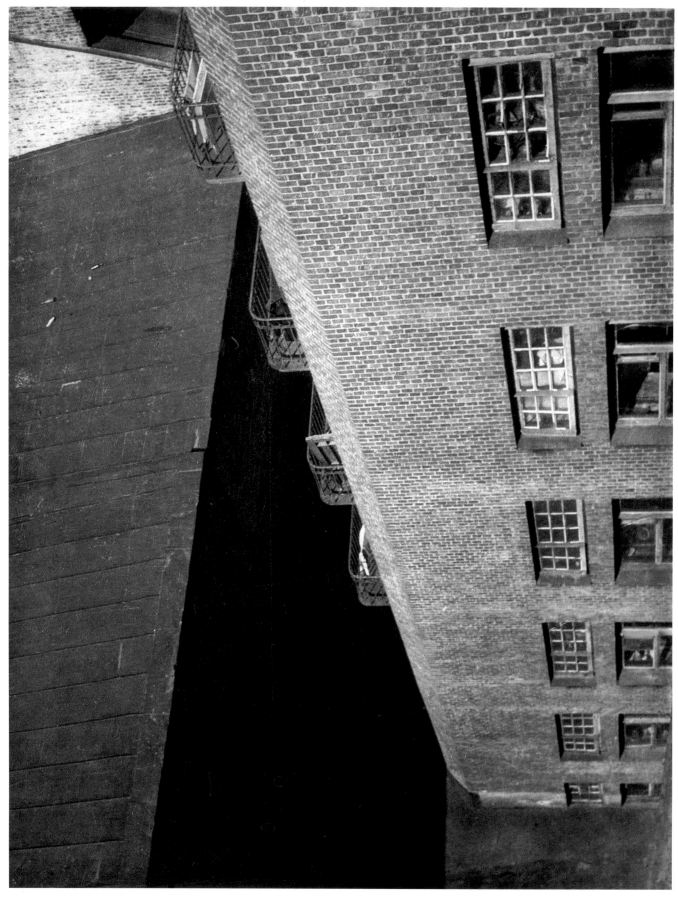

228. Untitled. 1926–27. From
the series "The Building on
Miasnitskaia Street" (*Dom na
Miasnitskoi*). Gelatin-silver print.
11¹¹⁄₁₆ × 9⅛" (30 × 23.5 cm)

248

229.

230.

229. *The Courtyard of Vкhuтemas*
(*Dvor Vкhuтemasa*). 1926–28.
Gelatin-silver print. 9⅛ × 6¹¹⁄₁₆"
(23.2 × 17 cm)

230. *The Courtyard of Vкhuтemas*
(*Dvor Vкhuтemasa*). 1926–28.
Gelatin-silver print. 5⅝ × 2¹⁵⁄₁₆"
(14.2 × 7.5 cm)

231.

231. *The Courtyard of Vкнитемаs*
(*Dvor Vкнитеmasa*). 1928–30.
Gelatin-silver print. 7¾ × 11⁹⁄₁₆"
(20 × 29 cm)

232. *The Courtyard of Vкнитемаs*
(*Dvor Vкнитеmasa*). 1928–30.
Gelatin-silver print. 6¾ × 9⅜"
(16.8 × 22.8 cm)

232.

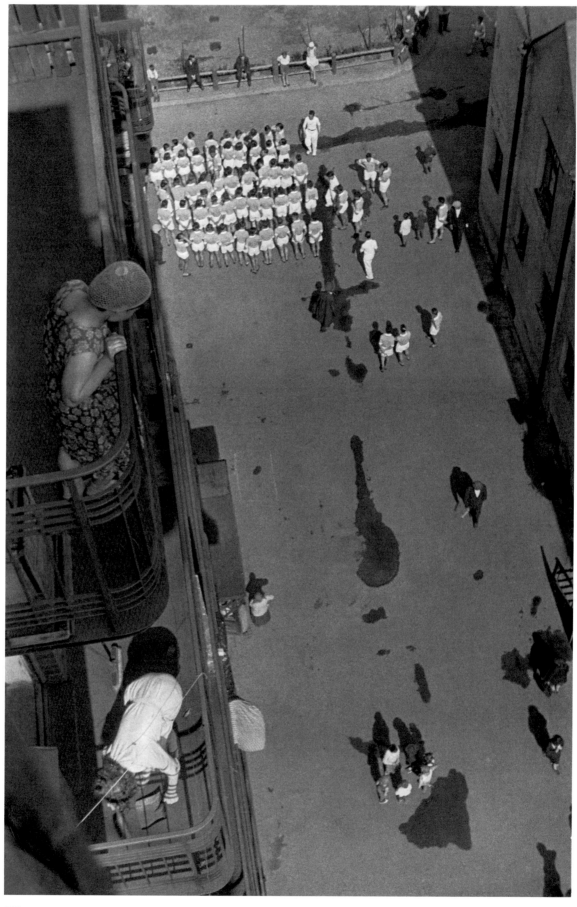

233.

233. *Assembling for a Demonstration*
(*Sbor na demonstratsiiu*). 1928–30.
Gelatin-silver print. 19½ × 13⅞"
(49.5 × 35.3 cm)

234.

234. *Apartment Building by [Moisei]
Ginzburg on Nivinskii Boulevard*
(*Dom Ginzburga na Nivinskom
bul'vare*). 1929. Gelatin-silver print.
9⁷⁄₁₆ × 11¾" (24 × 29.8 cm)

235. *Planetarium* (*Planetarii* [the
Moscow planetarium, designed
by Mikhail Barsh and Mikhail
Siniavskii]). 1929. Gelatin-silver
print. 9⁷⁄₁₆ × 11¹¹⁄₁₆" (24 × 29.7 cm)

235.

237.

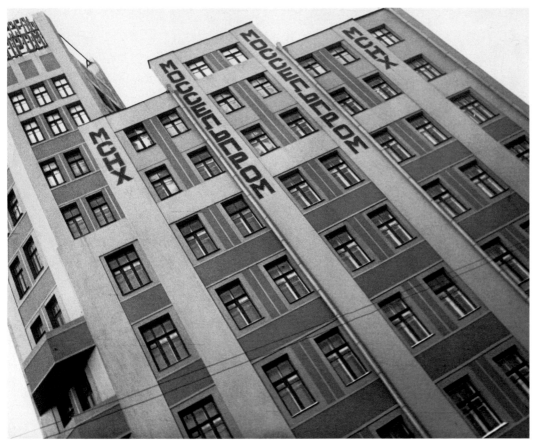

236.

236. *The Mossel'prom Building* (*Dom Mossel'proma*). 1932. Gelatin-silver print. 9⁵⁄₁₆ × 11¾" (23.8 × 30 cm)

237. *Pravda Stairway* (*Lestnitsa izdatel'stva "Pravda"*). 1930–31. Gelatin-silver print. 8¼ × 11⅝" (21 × 29.5 cm)

238. Untitled. 1932. Gelatin-silver
print. 11⅝ × 9¹/₁₆" (29.5 × 23 cm) **254**

240.

239.

239. *Square by the Bolshoi Theater*
(*Skver u Bol'shogo teatra*). 1932.
Gelatin-silver print. 11⅝ × 9 1/16"
(29.5 × 23 cm)

240. *Theater Square* (*Teatral'nyi skver*).
1932. Gelatin-silver print. 11½ × 8¾"
(29.2 × 22.3 cm)

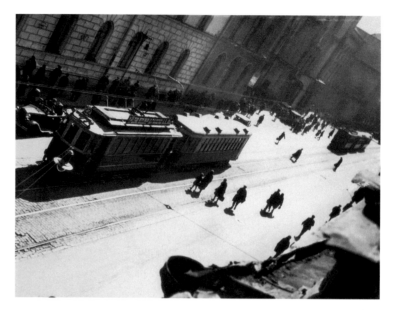

241.

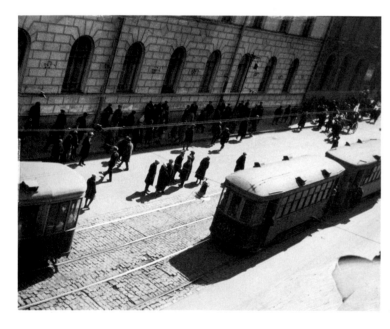

242.

241–43. Untitled. 1929–32. From the
series "Miasnitskaia Street. Traffic"
(*Miasnitskaia ulitsa. Dvizhenie*).
Gelatin-silver prints

241. 8⅞ × 11⅝" (22.5 × 29.5 cm)
242. 9 1/16 × 11¾" (23 × 29.8 cm)
243. 8 15/16 × 11½" (22.7 × 29.2 cm)

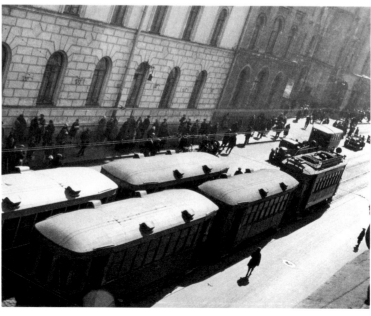

243.

244.

244. Untitled. 1929. From a series
on the Moscow ambulance service.
Gelatin-silver print. 7⁵⁄₁₆ × 11"
(18.5 × 28 cm)

245.

245. *Walking Figure* (*Idushchaia figura*). 1928. Gelatin-silver print.
14⅜ × 21⁷⁄₁₆" (36.5 × 54.5 cm)

247.

246.

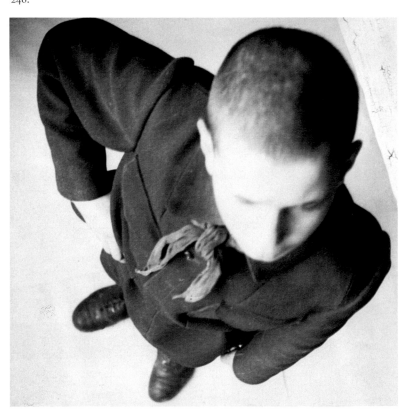

246. *Pioneer* (*Pioner*). 1928.
Gelatin-silver print. 4⅞ × 5″
(12.4 × 12.7 cm)

247. *Steps* (*Lestnitsa*). 1930.
Gelatin-silver print. 14⅜ × 21⁷⁄₁₆″
(36.5 × 54.5 cm)

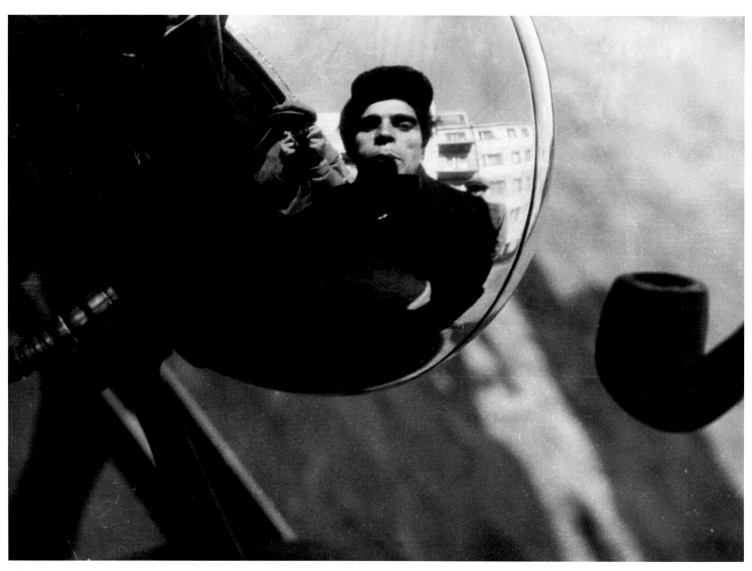

248.

248. *Chauffeur* (*Shofer*). 1929.
Gelatin-silver print. 11¾ × 16½"
(29.8 × 41.8 cm) **260**

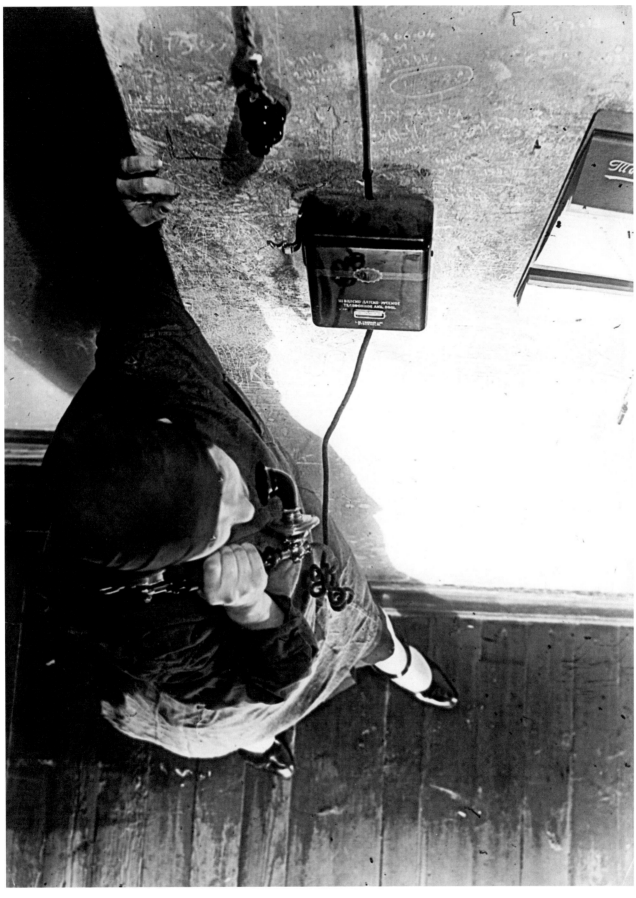

249.

249. *At the Telephone* (*Na telefone*). 1928. From a series on the production of a newspaper. Gelatin-silver print. 15½ × 11½" (39.5 × 29.2 cm)

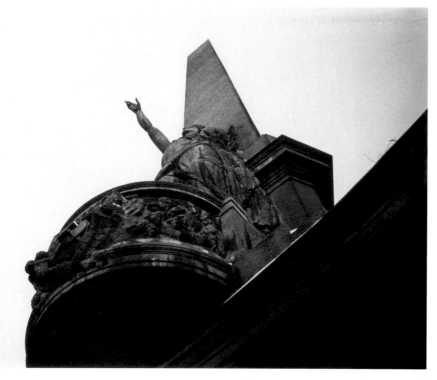

250.

250. *Monument to Freedom*
(*Pamiatnik svobody*). 1930–32.
Gelatin-silver print. 11⁹⁄₁₆ × 12¹¹⁄₁₆"
(29.4 × 32.2 cm)

251. Demonstration. 1932.
Gelatin-silver print. 11⅝ × 8⅜"
(29.5 × 21.3 cm)

251.

253.

252.

252. Renovation. 1929–30. Gelatin-silver print. 7¹⁵/₁₆ × 11³/₁₆" (20.2 × 28.5 cm)

253. *The Song* (*Pesnia*). 1931. Gelatin-silver print. 11¹³/₁₆ × 9⁹/₁₆" (30 × 24.4 cm)

254.

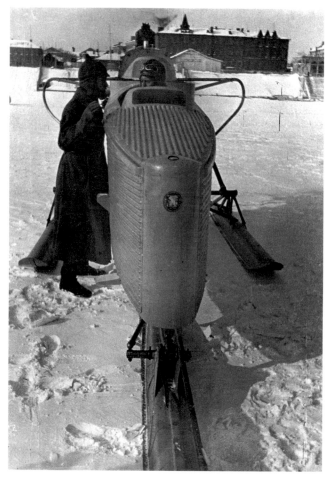

254. *Asphalt Paving* (*Asfal'tirovanie*).
1929. From a series on the construc-
tion of Leningrad Boulevard,
Moscow. Gelatin-silver print.
9⅝ × 11¹³⁄₁₆" (24.4 × 30 cm)

255. Snow sledge. 1929–32.
Gelatin-silver print. 11½ × 8⅛"
(29.3 × 20.6 cm)

255.

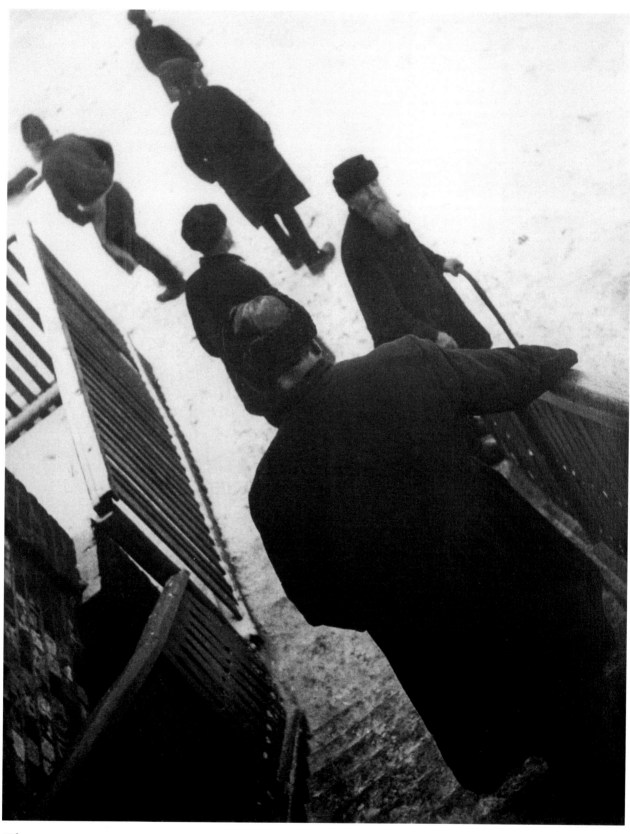

256.

256. *Kulaks* (*Kulaki*). 1928.
Gelatin-silver print. 11⅜ × 9¹⁄₁₆"
(29 × 23 cm)

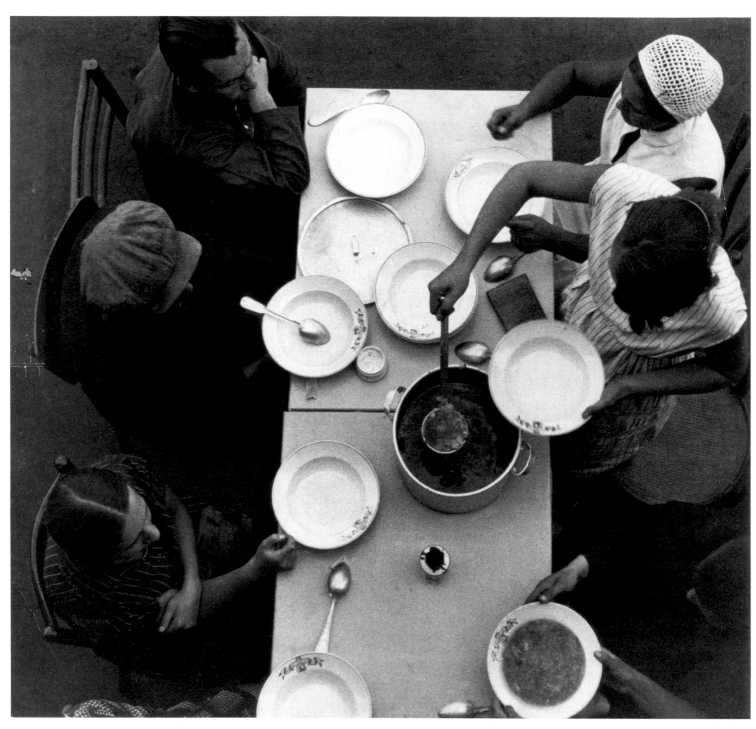

257.

257. *Lunch* (*Obed*). 1929. From the
series "Factory Canteen" (*Fabrika-
kukhnia*). Gelatin-silver print.
9¼ × 10¼" (23.5 × 26 cm) **266**

258.

259.

260.

261.

258 – 61. From a series of postcards published by Izogiz in 1932. Gravure

258. *Theater Avenue* (*Teatral'nyi proezd*). 1932. 3¹¹⁄₁₆ × 5⅛" (9.4 × 13.1 cm)

259. *Park of Culture and Rest* (*Park kul'tury i otdykha*). 1932. 3¾ × 4⅞" (9.4 × 12.3 cm)

260. *Radio Listener* (*Radioslushatel'*). 1927. 3¾ × 4⅞" (9.4 × 12.4 cm)

261. *Bolshoi Theater* (*Bol'shoi teatr*). 1932. 3⅝ × 4¾" (9.2 × 12 cm)

262.

263.

262. Cover for the magazine *Daesh'*
(Give your all) no. 6 of 1929.
Letterpress. 11⅞ × 9⅛"
(30.2 × 22.9 cm)

263. Maquette for *Lunch Break*
(*Obedennyi pereryv*), an illustration
in the magazine *Daesh'* (Give your
all) no. 14 of 1929, a special issue,
with design and photographs by
Rodchenko, on the AMO automo-
bile factory, Moscow. Pasted gelatin-
silver prints and ink on board.
11¹³⁄₁₆ × 9⁵⁄₁₆" (30 × 23.7 cm)

265.

264.

264–65. From the magazine *Daesh'*
(Give your all) no. 14 of 1929, a
special issue, with design and photo-
graphs by Rodchenko, on the AMO
automobile factory, Moscow.
Letterpress

264. Page from the photo-story.
$11^{15}/_{16} \times 9^{1}/_{8}$" (30.3 × 23.2 cm)

265. The magazine's cover, designed
by Rodchenko and Mechislav
Dobrokovskii. $11^{7}/_{8} \times 9$"
(30.2 × 22.9 cm)

266.

266. *Details of AMO Car (Detali AMO* [camshafts]). 1929. From a series on the AMO automobile factory, Moscow, for the magazine *Daesh'* (Give your all) no. 14 of 1929. Gelatin-silver print. 11⅝ × 15¹¹⁄₁₆" (29.6 × 39.8 cm)

267. Maquette for the cover of the book *AMO Factory (Zavod AMO),* by A. Sviatenko. 1929. Gouache and pasted paper on cardboard. 8¹¹⁄₁₆ × 5¹³⁄₁₆" (22 × 14.7 cm)

А. СВЯТЕНКО

ЗАВОД

АМО

ГОСУДАРСТВЕННОЕ ИЗДАТЕЛЬСТВО

267.

268.

269.

268–69. From a series on the AMO
automobile factory, Moscow, for the
magazine *Daesh'* (Give your all)
no. 14 of 1929. Gelatin-silver prints

268. *Details of AMO Car* (*Detali
AMO* [radiator grill]). 8⅜ × 11¾"
(21.3 × 29.8 cm)

269. *Details of AMO Car* (*Detali
AMO* [cogwheels]). 6⅜ × 9¹⁄₁₆"
(16.3 × 23 cm)

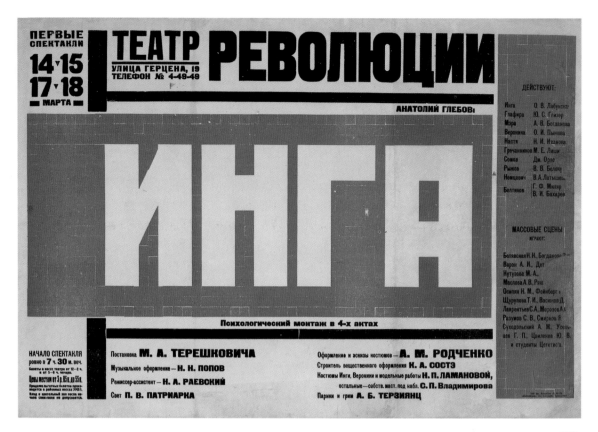

270. Poster for the play *Inga*,
by A. Glebov. 1929. Letterpress.
27$^{15}/_{16}$ × 42$^{15}/_{16}$" (71 × 109 cm)

271. Front and back covers of the
book *Speaker* (*Rechevik*), by
Sergei Tret'iakov. 1929.
Letterpress. 6$^{13}/_{16}$ × 10$^{3}/_{4}$"
(17.3 × 27.3 cm)

272.

272. Front and back covers of the
magazine *Zhurnalist* (Journalist)
no. 4 of 1930. Letterpress.
10⅞ × 16¼" (27.6 × 41.4 cm)

273.

273. Maquette for the cover of the
magazine *Za Rubezhom* (Abroad)
no. 2 of 1930. Cut-and-pasted
printed papers, gelatin-silver photo-
graph, and gouache on paper.
9⅞ × 6¹³⁄₁₆" (26 × 18 cm)

274. Maquette for *Political Football*
(*Politicheskii futbol*), illustration
for the magazine *Za Rubezhom*
(Abroad) no. 5 of 1930. Cut-and-
pasted printed papers and gouache
on paper. 20³⁄₁₆ × 13¾" (51.3 × 35 cm)

275. Maquette for "War of the
Future" (*Voina budushchego*),
illustration for the magazine *Za
Rubezhom* (Abroad) no. 2 of 1930.
Cut-and-pasted printed papers on
paper. 20¹⁄₁₆ × 13¾" (51 × 35 cm)

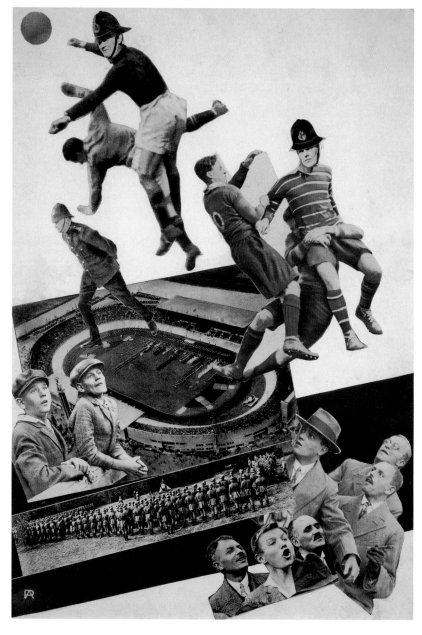

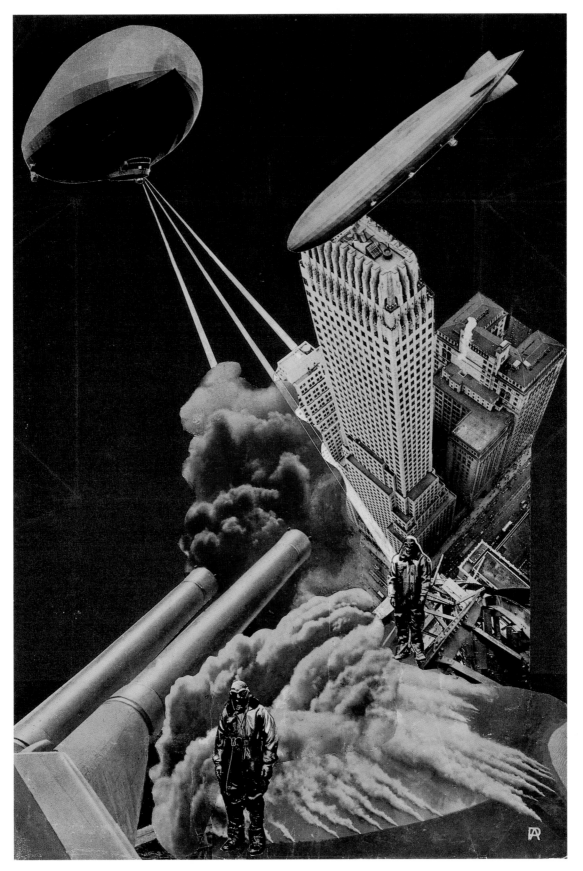

275.

276.

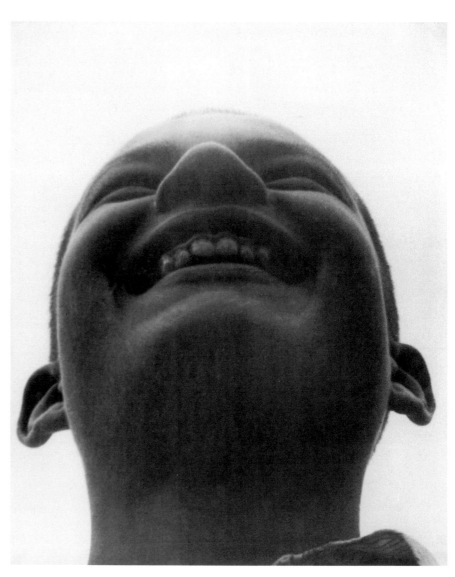

276. *The Smile* (*Ulybka* [Varvara
Stepanova]). 1931. Gelatin-silver
print. 11½ × 16¹⁵⁄₁₆" (29.2 × 43 cm)

277. *Pioneer* (*Pioner*). 1930.
Gelatin-silver print. 23⅝ × 19½"
(60 × 49.5 cm)

277.

278.

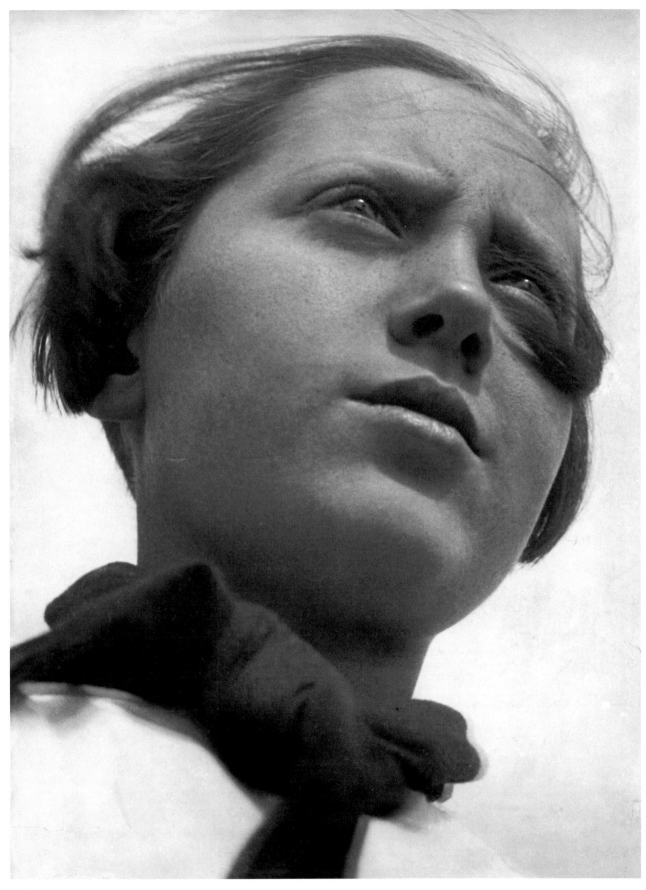

278. *Pioneer Girl (Pionerka)*. 1930.
Gelatin-silver print. 19½ × 14⁹⁄₁₆"
(49.6 × 37 cm)

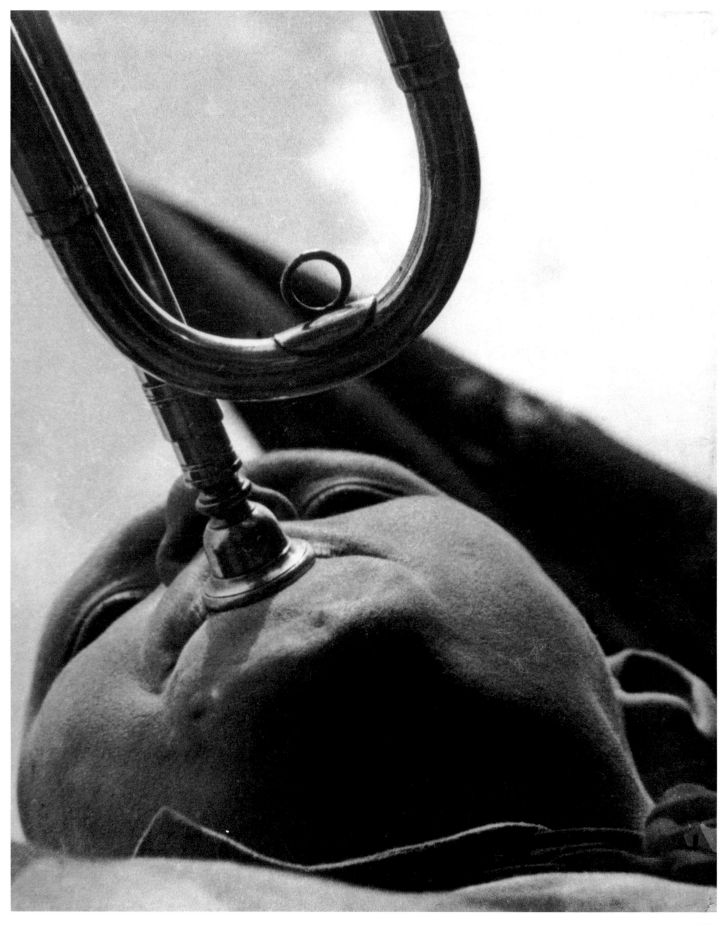

279. *Pioneer with a Bugle* (*Pioner-trubach*). 1930. Gelatin-silver print.
23¼ × 19¹⁄₁₆" (59 × 48.5 cm) **278**

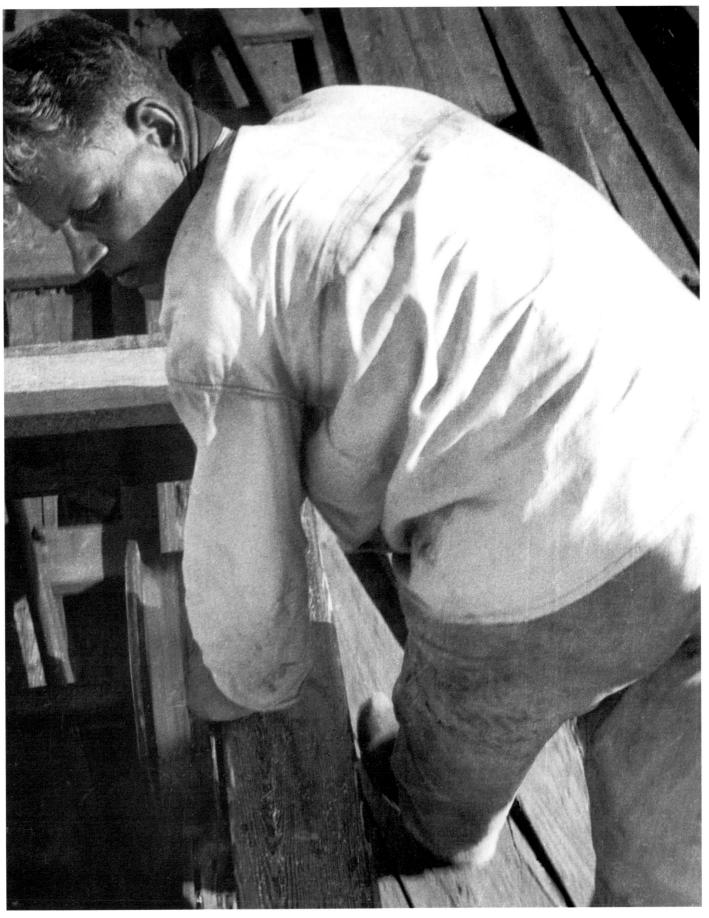

280. Sawmill worker. 1930. From a
series on a lumber mill in Vakhtan.
Gelatin-silver print. 11½ × 9¼"
(29.2 × 23.5 cm)

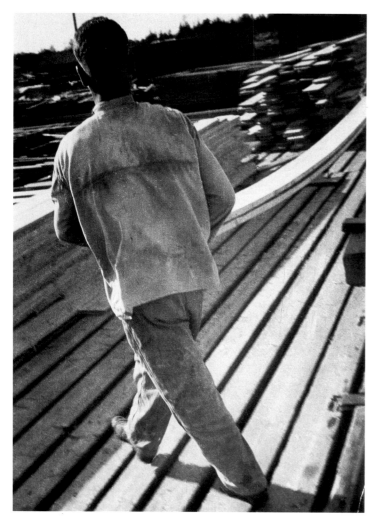

281.

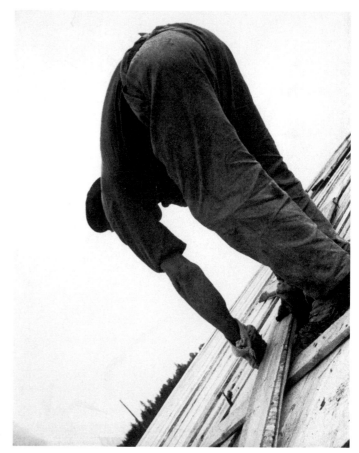

282.

283.

281–83. From a series on a
lumber mill in Vakhtan. 1930

281. Sawmill worker. 11⅜ × 8⅞"
(29 × 21.5 cm)

282. Sawmill worker. 11⁹⁄₁₆ × 9⁵⁄₁₆"
(29.3 × 23.6 cm)

283. Lumber. 9⅛ × 11½"
(23.1 × 29.3 cm)

285.

284.

284–85. From a series on a
lumber mill in Vakhtan. 1930

284. Sawmill worker. 11¹¹⁄₁₆ × 7¹¹⁄₁₆"
(29.7 × 19.6 cm)

285. Lumber. 8⁵⁄₁₆ × 12³⁄₁₆"
(21.2 × 31 cm)

286.

287.

286–87. From a series on the
construction of a canal between
the White Sea and the Baltic Sea, for
the magazine *SSR na Stroike* (*USSR
in Construction*) no. 12 of 1933,
designed and with photographs by
Rodchenko

286. Cover of the magazine.
Lithography. 16½ × 11 11/16"
(42 × 29.7 cm)

287. Spread in the magazine.
Gravure. 16½ × 23 3/16" (42 × 59 cm)

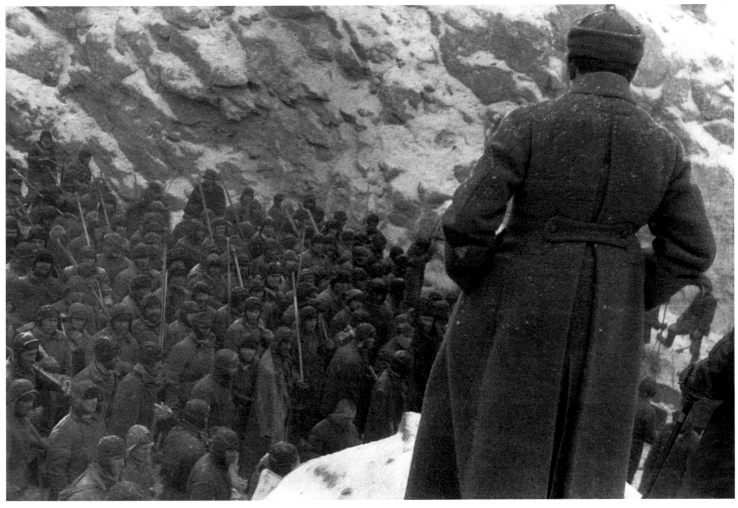

288.

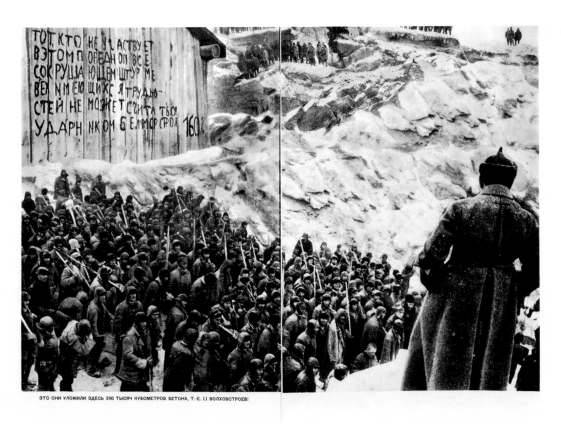

ЭТО ОНИ УЛОЖИЛИ ЗДЕСЬ 390 ТЫСЯЧ КУБОМЕТРОВ БЕТОНА, Т.-Е. 11 ВОЛХОВСТРОЕВ!

289.

288 – 89. From a series on the
construction of a canal between
the White Sea and the Baltic Sea,
for the magazine *SSSR na Stroike*
(*USSR in Construction*) no. 12
of 1933, designed and with photo-
graphs by Rodchenko

288. Guard and prisoners. Gelatin-
silver print. 11⁹/₁₆ × 17⁷/₁₆"
(29.3 × 44.3 cm)

289. Spread in the magazine.
Gravure. 16 ½ × 23 ³/₁₆"
(42 × 59 cm)

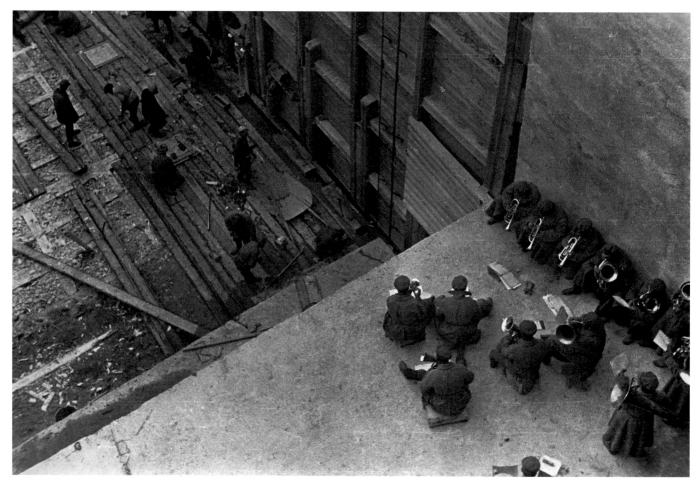

290.

290–94. From a series on the
construction of a canal between
the White Sea and the Baltic Sea, for
the magazine *SSSR na Stroike* (*USSR
in Construction*) no. 12 of 1933,
designed and with photographs by
Rodchenko

290. *Working with Orchestra* (*Rabota
c orkestrom*). Gelatin-silver print.
11⁷⁄₁₆ × 17¼" (29 × 43.9 cm)

291. Spread in the magazine.
Gravure. 16½ × 23¹³⁄₁₆" (42 × 59 cm)

292. *The Lock* (*Shliuz*). Gelatin-silver
print. 11⁷⁄₁₆ × 8" (29 × 20.2 cm)

293. *Barges in the Lock* (*Barzhi v
shliuze*). Gelatin-silver print.
17⅛ × 11⅝" (43.5 × 29.5 cm)

294. Spread in the magazine, with
foldouts. Gravure. 16½ × 45¹¹⁄₁₆"
(42 × 116 cm)

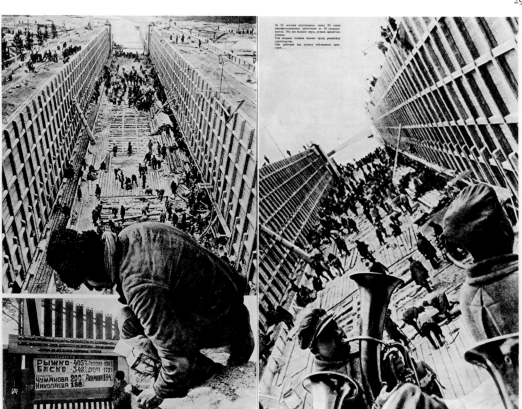

292.

293.

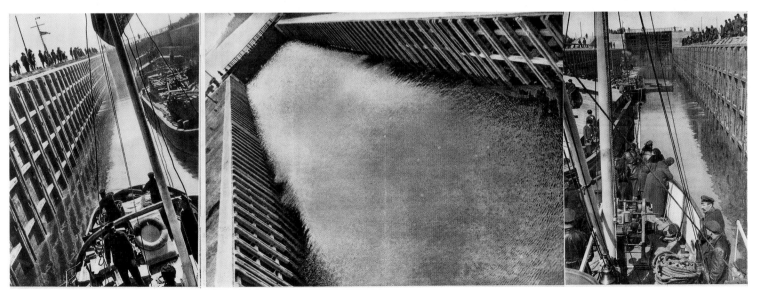

294.

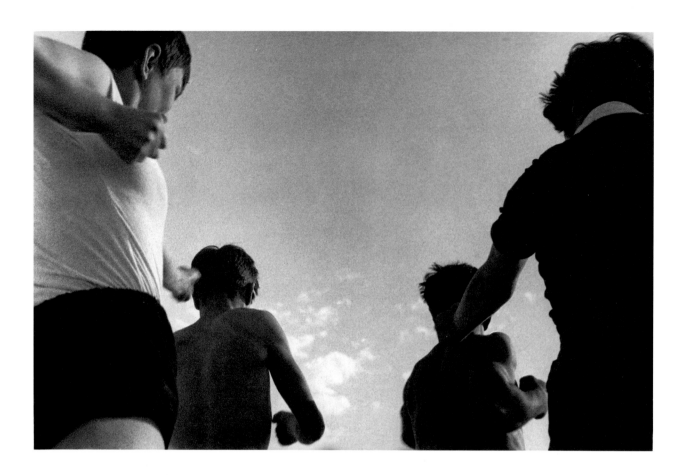

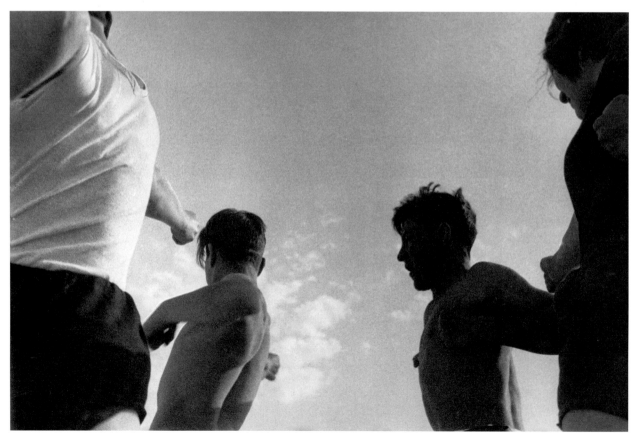

295.

295. *Morning Exercise* (*Utrenniaia
zariadka*). 1932. Gelatin-silver prints.
Diptych; each print 11⅜ × 17⁷⁄₁₆"
(28.9 × 44.2 cm)

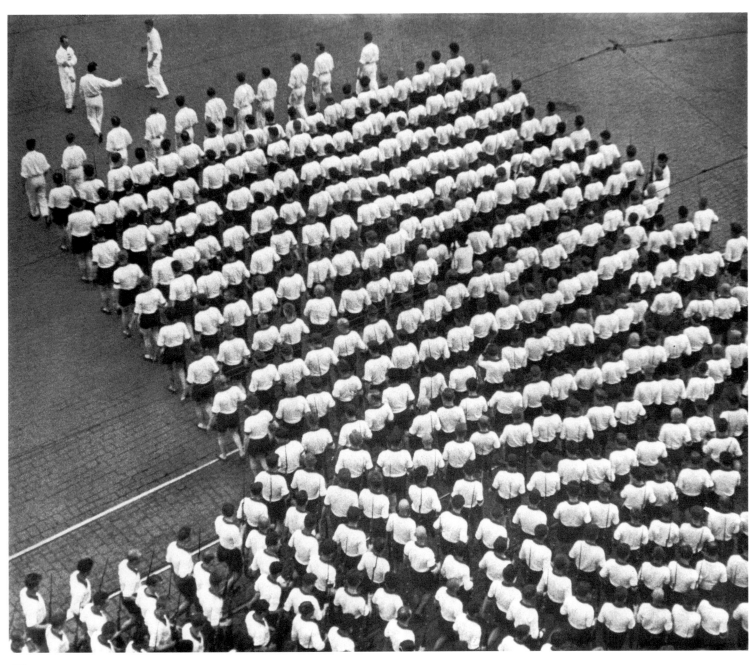

296.

296. *The Dynamo Sports Club*
(*Kolonna sportivnogo obshchestva
Dinamo*). 1935. Gelatin-silver print.
19⁵⁄₁₆ × 23¼" (49 × 59 cm)

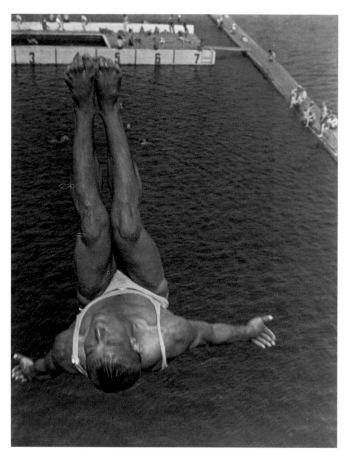

297.

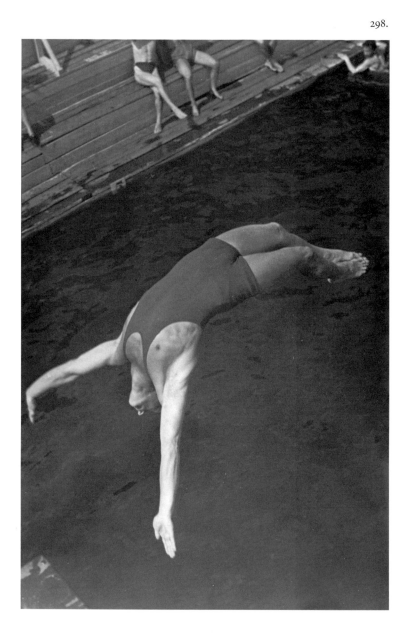

297. *Dive* (*Pryzhok v vodu*). 1934.
Gelatin-silver print. 11¹³/₁₆ × 9³/₁₆"
(30 × 23.4 cm)

298. *Dive* (*Pryzhok v vodu*). 1935.
Gelatin-silver print. 17³/₈ × 11³/₄"
(44.1 × 29.8 cm)

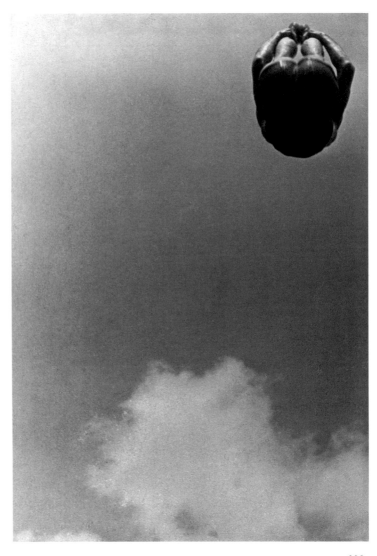

300.

299.

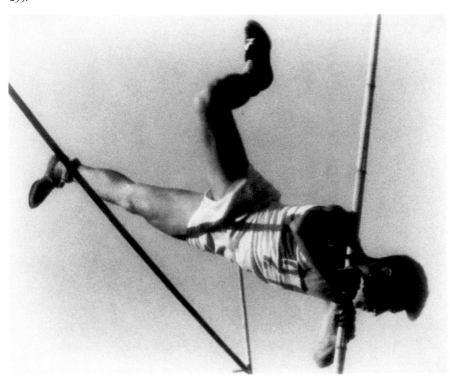

299. *Vault* (*Pryzhok*). 1936. Gelatin-silver print. 9⁷⁄₁₆ × 11¹⁵⁄₁₆" (24 × 30.4 cm)

300. *Dive* (*Pryzhok v vodu*). 1935. Gelatin-silver print. 15½ × 10¹⁵⁄₁₆" (39.5 × 27.8 cm)

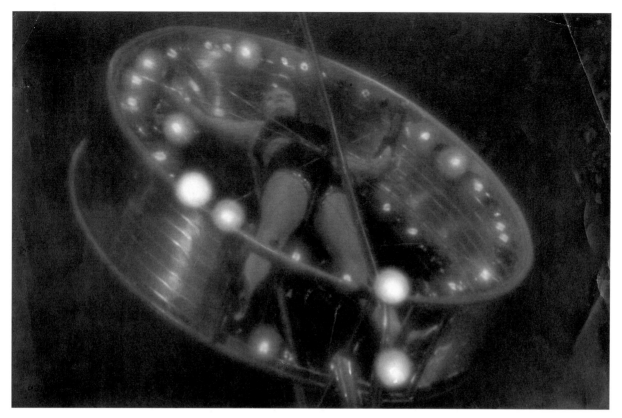

301.

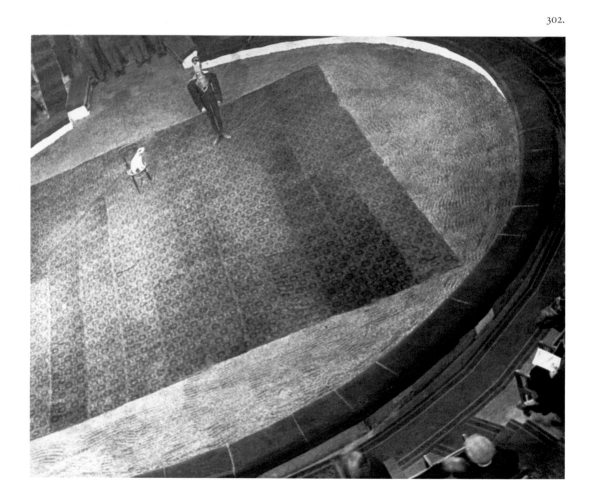

302.

301. *The Rhine Wheel* (*Reinskoe koleso*). 1935. Gelatin-silver print. 11⅜ × 18⅛" (29 × 46 cm)

302. *Circus* (*Tsirk*). 1935. Gelatin-silver print. 9⁷⁄₁₆ × 11¾" (24 × 29.9 cm)

303. *Morning Wash* (*Utrennii tualet* [Varvara Rodchenko]). 1932. Gelatin-silver print. 16½ × 11½" (41.9 × 29.2 cm)

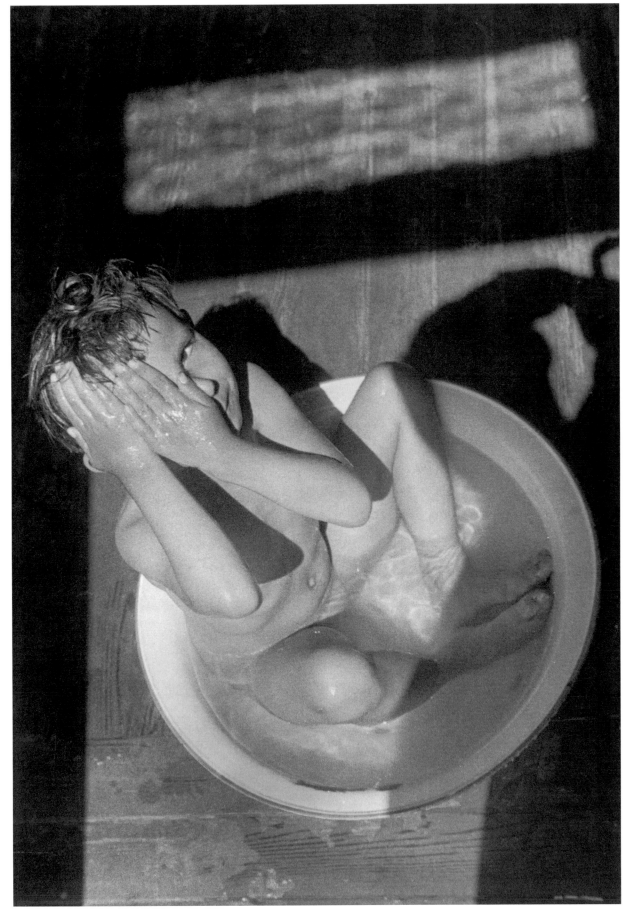

303.

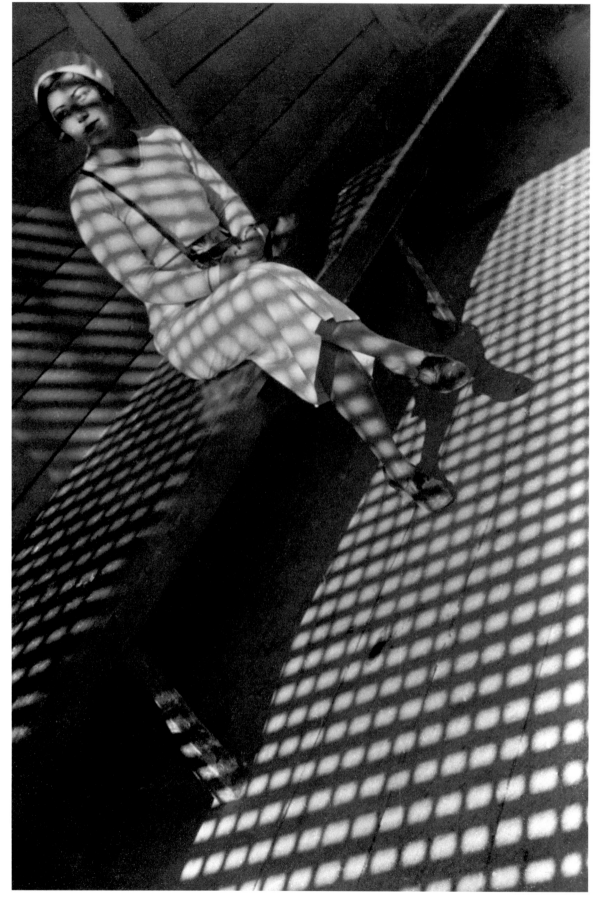

304. *Woman with a Leica* (*Devushka
s Leikoi* [Evgeniia Lemberg]). 1934.
Gelatin-silver print. 11¹³⁄₁₆ × 8"
(30 × 20.3 cm)

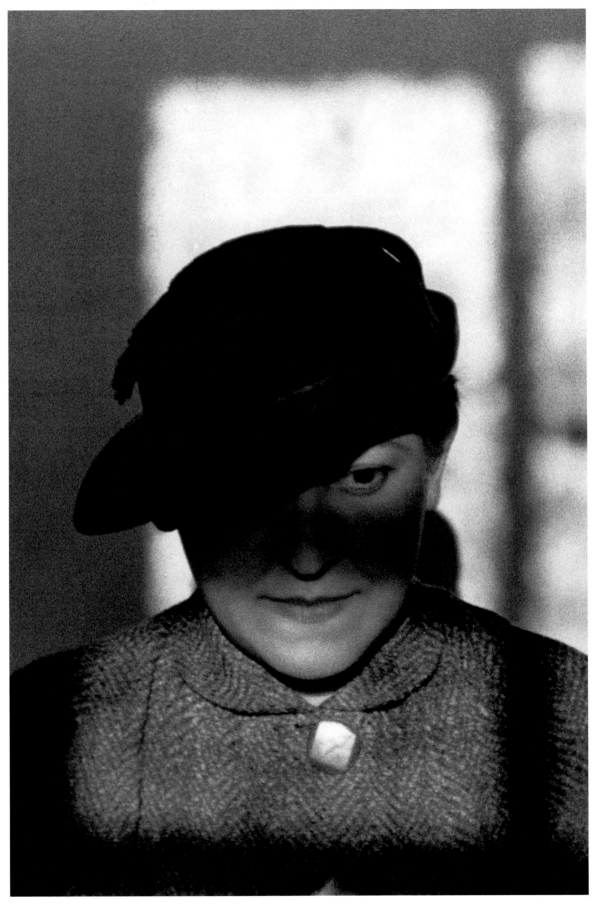

305.

305. Varvara Stepanova. 1936.
Gelatin-silver print. 14⅞ × 10"
(37.8 × 25.4 cm)

293

306.

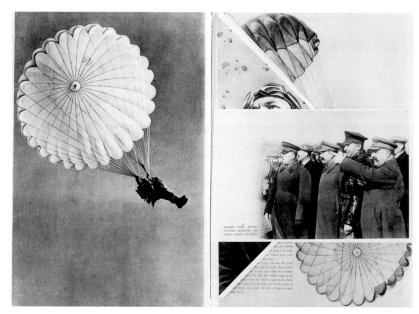

307.

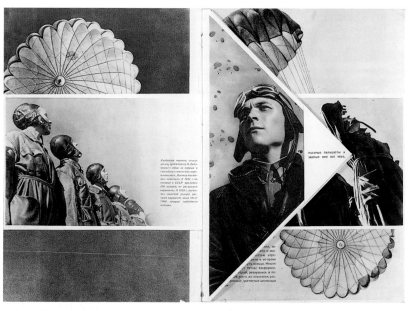

308.

306–11. Special issue on parachuting,
designed by Rodchenko and Varvara
Stepanova, for the magazine *SSSR na
Stroike* (*USSR in Construction*) no. 12
of 1935

306. Cover of the magazine.
Lithography. 16½ × 11 ¹¹⁄₁₆"
(42 × 29.7 cm)

307–10. Spreads in the magazine.
Gravure. 16½ × 23 ³⁄₁₆" (42 × 59 cm)

311. Spread in the magazine, with
foldout. Gravure. 33½ × 27"
(85.1 × 68.6 cm)

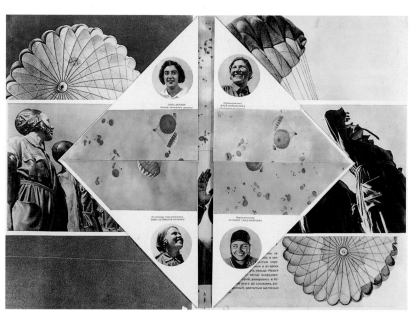

309.

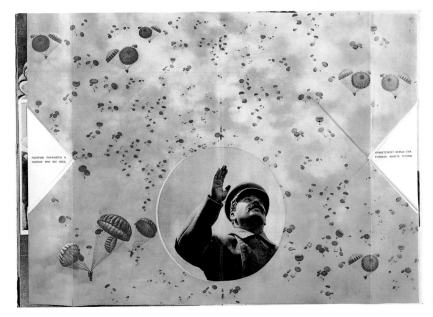

310.

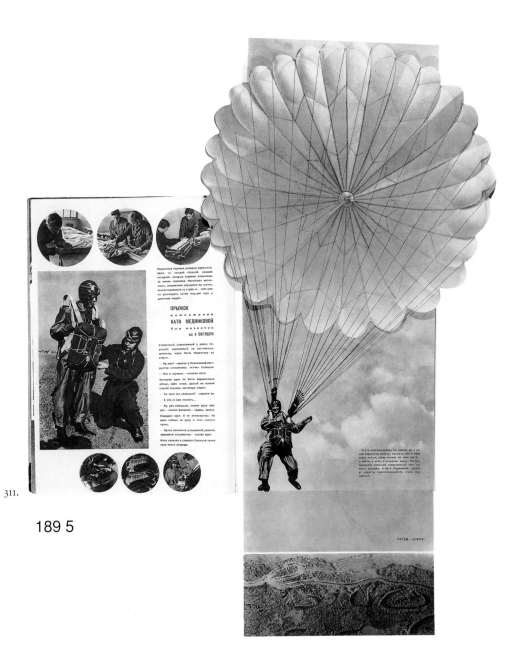

311.

189 5

312.

312. *Champions of Moscow*
(*Chempiony Moskvy*). 1937.
Gelatin-silver print. 18¾ × 10⅜"
(47.5 × 26.3 cm)

313. *Girls with Scarves* (*Devushki s
platkami*). 1935. Gelatin-silver print.
17¾ × 23⁷⁄₁₆" (45 × 59.5 cm)

315.

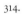
314.

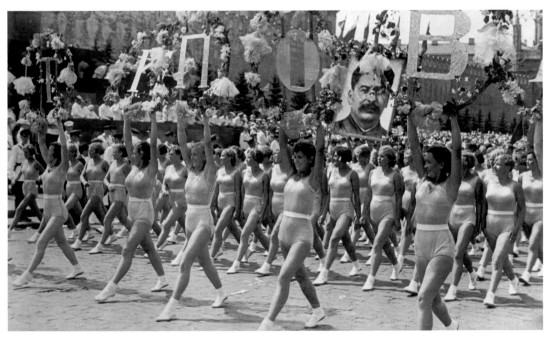

314. Physical-culture parade. 1936.
Gelatin-silver print. 11⅛ × 19⅛"
(28.2 × 48.6 cm)

315. *Ukrainian Delegation* (*Kolona
Ukrainy*). 1935. Gelatin-silver print.
9⅝ × 11½" (24.5 × 29.2 cm)

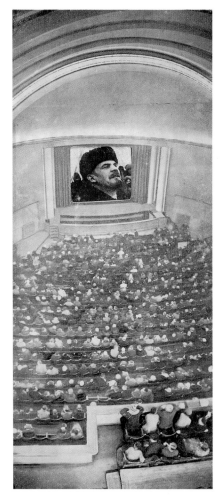

316.

316. Page, including foldout, from
the book *Soviet Cinema*, die cut to
reveal page below. Book design by
Rodchenko. 1935. Letterpress.
Page: 10¼ × 3¹⁄₁₆" (26 × 7.8 cm);
including foldout (as shown):
15¹⁵⁄₁₆ × 3¹⁄₁₆" (40.5 × 7.8 cm)

317. Two-page spread from the book
Soviet Aviation, published for the
New York World's Fair. Photocollage
and book design by Rodchenko.
1939. Gravure. Spread: 15³⁄₈ × 20¹⁄₈"
(39 × 51 cm)

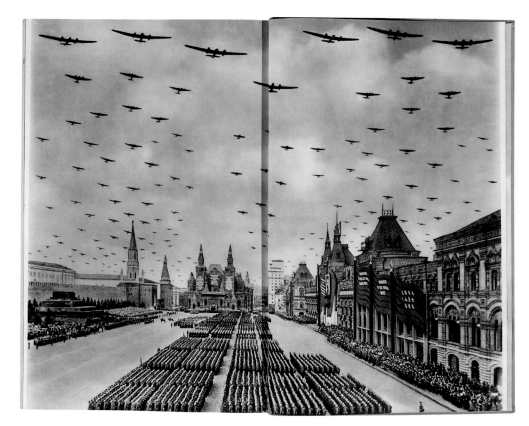

317.

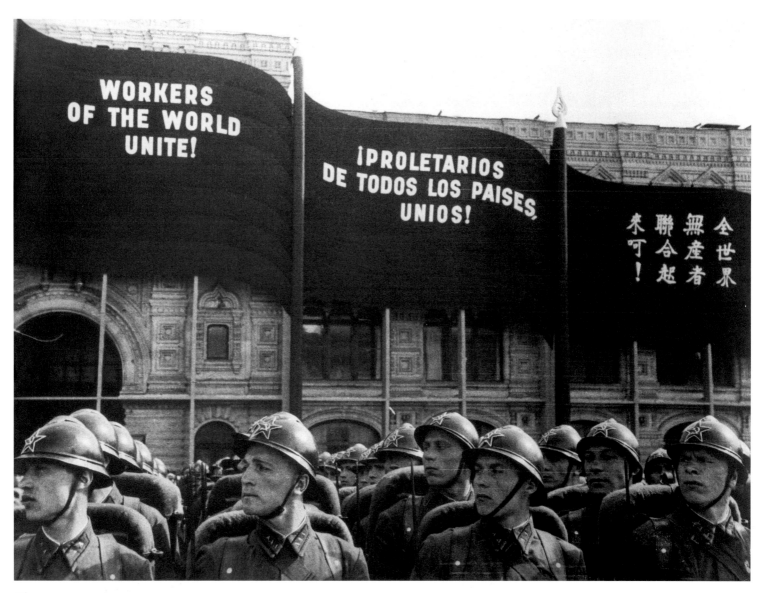

318.

318. *An Oath* (*Prisiaga*). 1935.
Gelatin-silver print. 16¹⁵/₁₆ × 23"
(43 × 58.5 cm)

Rodchenko in Kazan, July 2, 1914.

Until 1918, Russia adhered to the Julian or Old Style calendar, which lagged behind the Gregorian or New Style calendar followed in Western Europe. The discrepancy was removed by government decree on February 1, 1918 (Old Style), which became February 14, 1918 (New Style). Throughout this book, dates before February 1, 1918 (Old Style), follow the Old Style calendar.

Chronology entries are dated as precisely as possible and ordered according to their dates. Entries for which no precise dates are available appear at the beginning of the year in which they fall.

The last entry for each year is a list of exhibitions in which Rodchenko's work was included. The list is restricted to exhibitions in Russia, plus a small number of significant exhibitions abroad. Not included in the list are the five or six photographic salons outside Russia in which, on average, Rodchenko exhibited each year from 1926 through the early 1940s.

1891

November 23 (December 5 New Style):
Aleksandr Mikhailovich Rodchenko born in Saint Petersburg. Father, Mikhail Mikhailovich Rodchenko (born 1852), is a prop man in the theater; mother, Ol'ga Evdokimovna Paltusova (born 1865), is a washerwoman.

Rodchenko's parents, Ol'ga Evdokimovna Paltusova and Mikhail Mikhailovich Rodchenko, in Kazan in the early 1900s. Photograph by A. Shumilov'.

1905

By this year, family has moved to Kazan.

August 20: Receives a certificate of elementary education from the Kazan school board.

1907

Father dies.

1908

Begins two years of apprenticeship as a dental technician.

1910

September: Enrolls in the department of figurative arts in the Kazan School of Fine Arts (*Kazanskaia khudozhestvennaia shkola*). Gives drawing lessons.

1912

Writes poems and tries to have them published, without much success.

1913

Exhibitions
2nd Periodic Exhibition of Painting (2aia periodicheskaia vystavka kartin), Kazan. Organized by the Kazan School of Fine Arts.
3rd Periodic Exhibition of Painting (3aia periodicheskaia vystavka kartin), Kazan. Organized by the Kazan School of Fine Arts.

1914

Meets Varvara Fedorovna Stepanova (born 1894), also a student at the Kazan School of Fine Arts.

February 20: Attends lecture and performance presented in Kazan by Russian Futurists David Burliuk, Vasilii Kamenskii, and Vladimir Mayakovsky. Becomes an adherent of Futurism (which in Russia designates a wide range of avant-garde

experiment). Purchases a photograph of Mayakovsky.

June 7: Although his lack of formal secondary education prevents him from receiving a diploma, obtains a certificate stating that he has completed the course of painting and drawing at the Kazan School of Fine Arts.

July 19 (August 1 New Style): Germany declares war on Russia. World War I begins.

August: To rid the city's name of its Germanic connotation, Saint Petersburg is renamed Petrograd.

Exhibition
5th Painting Exhibition (5aia vystavka kartin), Perm. Organized by the Perm Society of Friends of Painting, Sculpture, and Architecture (*Permskoe obshchestvo liubitelei zhivopisi, vaianiia i zodchestva*).

1915

October: This month or shortly thereafter moves to Moscow and enrolls in the Graphic Section of the Stroganov School of Applied Art (*Stroganovskoe khudozhestvenno-promyshlennoe uchilishche*).

1916

March: Opening of *The Store* (*Magazin*), Moscow. Organized by Vladimir Tatlin in a rented shop at 17 Petrovka Street, the exhibition includes Rodchenko's compass-and-ruler drawings. Other exhibitors are Ivan Bruni, Alexandra Exter, Ivan Kliun, Kasimir Malevich, Vera Prestel', Lyubov Popova, Nadezhda Udal'tsova, Maria Vasil'eva, and Tatlin himself.

Spring–Summer: Departs for military service as operations manager of a hospital train.

Exhibitions

The Store (*Magazin*), Moscow. March.
Modern Painting (*Sovremennaia zhivopis'*), Moscow.

1917

February 22: Severe shortages of bread spark the February Revolution, a series of strikes, demonstrations, and mutinies in Petrograd that radically destabilize the government.

March 2: Tsar Nicholas II abdicates in favor of his brother, Grand Duke Michael. Provisional Government is formed.

March 3: Grand Duke Michael abdicates, ending the rule of the Romanov dynasty.

March 10–12: Delegates of artists' groups meet in Petrograd to organize the Union of Art Workers (Soiuz deiatelei iskusstv), asserting independence from state control.

April 16: Vladimir Il'ich Lenin, leader of the Bolshevik party, arrives in Petrograd from exile in Zurich, on a special train provided by the German foreign ministry.

Summer: Rodchenko is a founder of Profsoiuz (Professional'nyi soiuz khudozhnikov-zhivopistsev, Professional Union of Artist-Painters) and becomes the secretary of its "left" or avant-garde division, the Young Federation (Molodaia federatsiia). Although relatively small, this "left" federation is assertive enough to get four of its members (Mayakovsky, Nathan Altman, Nikolai Punin, and Vsevolod Meyerhold) on the union's organizing committee.

Fall: With Tatlin and others, assists Georgii Yakulov in designing the Café Pittoresque on Kuznetskii Most in Moscow. Rodchenko designs lamps and makes large-scale working drawings from Yakulov's rough sketches. The café will open on January 30, 1918.

October 25: The October Revolution. Bolshevik Red Guards overthrow the Provisional Government in Petrograd. Before the end of the month, the new government establishes Narkompros (Narodnyi komissariat prosveshcheniia, the People's Commissariat of Enlightenment) to administer education and culture. Anatoly Lunacharsky is appointed commissar.

November 28: Proletkul't (Proletarskaia kul'tura, the Proletarian Culture association) is formally established in Petrograd. Drawing on principles established before the Revolution, Proletkul't aims to foster a proletarian culture through working-class organizations.

December: Rodchenko is discharged from military service.

December 7: Establishment of the Cheka (Chrezvychainaia komissiia po bor'be s kontr-revoliutsiei i sabotazhem, the Special Commission for Combatting Counter-Revolution and Sabotage), the Soviet security organ.

Exhibition

Exhibition of Works by Rodchenko 1910–1917 (*Vystavka tvorchestva Rodchenko 1910–1917*), Moscow. March or May.

1918

Becomes a member of the presidium of the soviet of Profsoiuz.

January 29: Establishment of Izo (Otdel izobrazitel'nykh iskusstv, the Section of Visual Arts), a department of Narkompros. Painter David Shterenberg is appointed head of the Petrograd section, which includes Vladimir Mayakovsky, Osip Brik, and Nathan Altman. Tatlin is head of the Moscow section, which includes Malevich, Kandinsky, Rodchenko, and others.

Rodchenko will assist Olga Rozanova, head of the Art and Production Subsection (Khudozhestvenno-promyshlennyi podotdel) of Izo, in visiting workshops and studios and raising money to revive craft production. He will be named head of the Museum Bureau (Muzeinoe biuro) of Izo, and of its Moscow centerpiece, the Museum of Painterly Culture (Muzei zhivopisnoi kul'tury), and will be assisted in these positions by Stepanova. Over the next three years, the Museum Bureau will acquire 1,926 works of modern and contemporary art by 415 artists and will organize thirty provincial museums, to which it will distribute 1,211 works.

February: A Moscow branch of Proletkul't is established. Rodchenko will teach a course on the theory of painting here.

February 1: By government decree, the Gregorian (New Style) calendar in use throughout Western Europe is adopted in Russia; February 1, 1918, becomes February 14, 1918.

March: The Bolshevik party is renamed the Communist Party. The government moves Russia's capital from Petrograd to Moscow.

March 3: Russia signs a treaty with Germany at Brest-Litovsk, Lithuania, ending its involvement in World War I.

April 8: Leon Trotsky is appointed commissar of war.

April 13: Lenin signs a decree establishing a Plan for Monumental Propaganda (*Plan monumental'noi propagandy*), to be administered by Narkompros and calling for the creation of monuments to revolutionary leaders, and to historical figures admired by the Bolsheviks, to replace those of the tsarist era.

April–May: Civil war breaks out in Russia.

Spring: Rodchenko publishes in the anarchist magazine *Anarkhiia*.

Summer: The Bolsheviks impose a series of radical economic policies, part ideological, part pragmatic, that come to be called "war communism." All industrial and economic assets are nationalized and put at the service of the state and the army; the economy is subjected to central planning; forced labor is introduced; and an almost total prohibition on free trade produces a virtually moneyless economy, with barter becoming a basic form of exchange. The often forcible requisitioning of grain will strain relations between the Soviet government and the rural population nearly to the breaking point.

Second half of the year: Works for the first time in abstract sculpture, producing a

series of spatial constructions that he calls "white sculptures."

July 7: The government issues a decree closing all non-Bolshevik daily newspapers in Moscow.

December 11 and 13: The First and Second Free State Art Workshops (Pervye i vtorye svobodnye gosudarstvennye khudozhestvennye masterskie, or Svomas) are opened in Moscow, amalgamating and replacing the Stroganov School of Applied Art, the Moscow School of Painting, Sculpture, and Architecture (Moskovskoe uchilishche zhivopisi, vaianiia i zodchestva), and a handful of private studios. The Free State Art Workshops will make art education free to all students, regardless of social and educational background. Students will have a say in the selection of their teachers—a condition often unfavorable to Futurist artists.

Exhibitions

1st Exhibition of Painting (*1aia vystavka kartin*), Moscow. Organized by Profsoiuz.

5th State Exhibition: "From Impressionism to Non-Objective Art" (*5aia gosudarstvennaia vystavka: "Ot Impressionizma do bespredmetnogo iskusstva"*), Moscow. Organized under the auspices of Izo Narkompros.

5 Years of Work (*5 let raboty*), club of the Young Federation for New Art (Molodaia federatsiia novogo iskusstva), Moscow.

Untitled group exhibition, club of the Young Federation for New Art, Moscow.

1919

Produces a series of linocuts; executes his first collages using printed materials; starts work on a series of architectural drawings, and also on a series of spatial constructions that can be stored flat and then opened up into three-dimensional hanging forms.

Joins the Collective of Painterly, Sculptural, and Architectural Synthesis (Zhivskul'ptarkh, the Kollektiv zhivopisno-skul'pturno-arkhitekturnogo sinteza). Wins first prize in a competition,

organized by the collective, to design a newspaper kiosk.

January: In Vyborg, near Petrograd, Osip Brik and Vladimir Mayakovsky announce the creation of Komfut, a group of "*Kommunisty-futuristy*" (Communists-Futurists) intended as a subset of a Party unit, and dedicated to developing a political Futurism and to pursuing concerns with both cultural policy and "Communist consciousness."

Aleksandr Drevin, Lyubov Popova, Rodchenko, Stepanova, Aleksandr Vesnin, and Nadezhda Udal'tsova form Asskranov (Assotsiatsiia krainikh novatorov, Association of Radical Innovators), in opposition to Malevich's Suprematism.

March: Creation of the Politburo, or inner cabinet of the government. Leading members include Lenin, Lev Kamenev, Joseph Stalin, and Grigorii Zinoviev.

April 27: Opening of the *10th State Exhibition: Non-Objective Creation and Suprematism* (*10aia gosudarstvennaia vystavka: Bespredmetnoe tvorchestvo i Suprematizm*). Rodchenko shows his "Black on Black" (*Chernoe na chernom*) series, in response to Kasimir Malevich's "White on White" (*Beloe na belom*) canvases.

June: End-of-year exhibition of the First Free State Art Workshops, organized to stress the collective nature of the artists' work. In the fall, some of these artists, as well as Konstantin Medunetskii and Georgii and Vladimir Stenberg, will form a loose association, Obmokhu (*Obshchestvo molodykh khudozhnikov*, the Society of Young Artists; this summer exhibition will later be often misidentified as the first Obmokhu exhibition).

September 15: With Stepanova, moves into Vasily Kandinsky's apartment at 8 Dolgii Lane (now Burdenko Street).

December: Proletkul't becomes an autonomous body within Narkompros.

Exhibitions

10th State Exhibition: Non-Objective Creation and Suprematism (*10aia gosudarstvennaia*

Rodchenko's and Stepanova's studio in Vasily Kandinsky's Moscow apartment, c. 1920.

vystavka: Bespredmetnoe tvorchestvo i Suprematizm), Moscow. Organized by Izo Narkompros. April.

11th State Exhibition (*11aia gosudarstvennaia vystavka*), Moscow. Organized by Izo Narkompros.

3rd Exhibition of Painting (*III vystavka kartin*), Ryazan. Organized by the public-education department of the Ryazan regional government.

1st State Painting Exhibition of Local and Moscow Artists (*1aia gosudarstvennaia vystavka kartin mestnykh i moskovskikh khudozhnikov*), Vitebsk. Organized by the fine-arts section of the education department of the Vitebsk regional government.

1920

Organizes, designs, and participates in *Exhibition to the Third Congress of the Komintern* (*Vystavka k III kongressu kominterna*).

May: Formal establishment of Inkhuk (Institut khudozhestvennoi kul'tury, the Institute of Artistic Culture) under the auspices of Izo Narkompros. It has grown out of meetings among Kandinsky, Rodchenko, Stepanova, Vladimir Franketti, Viktor Shestakov, and others. Its initial program is formulated by Kandinsky.

May 2–16: The young artists who, since the preceding fall, have called their group Obmokhu present their first exhibition under that name.

October: Establishment of Vkhutemas (Vysshie gosudarstvennye khudozhestvenno-tekhnicheskie masterskie, or Higher State Artistic-Technical Workshops), replacing the Free State Art Workshops.

The Central Committee abrogates the independence of Proletkul't, placing it under the authority of Narkompros.

For the *19th State Exhibition* (*19aia gosudarstvennaia vystavka*), organized under the auspices of Izo Narkompros, Rodchenko prepares two essays, "Everything is Experiment" (*Vse-opyty*), which is displayed in the exhibition next to his work, and "The Line" (*Liniia*), which announces a new cycle of work. The exhibition opens on October 20, and here Rodchenko meets Vladimir Mayakovsky.

October 24: With Stepanova, moves out of Kandinsky's apartment.

Establishment of VAPP (*Vserossiiskaia assosiatsiia proletarskikh pisatelei*, the All-Russian Association of Proletarian Writers), committed to synthesizing literary models of nineteenth-century realism with a new didactic content.

November: Becomes a professor at Vкhuтемas, where he will teach "Construction," a mandatory course, and give the lectures "Initiative" and "Graphic Construction of a Plane" for one year.

November 5: With Stepanova, moves into an apartment in the building of the Museum Bureau, at 14 Volkhonka Street.

November 14: Aleksei Gan invites him to design for Gan's play *We* (*My*).

November 23: Formation of the General Working Group of Objective Analysis (*Obshchaia rabochaia gruppa ob'ektivnogo analiza*) within Inкhuк. Including Aleksei Babichev, Rodchenko, Stepanova, and others, it coheres in opposition to Kandinsky's program and leadership. Babichev would later write, "The psychological approach of Kandinsky sharply diverged from the views of those who considered the material, self-contained 'object' to be the substance of creation."

December: Model for Tatlin's *Monument to the Third International* (*Pamiatnik III Internationala*) exhibited in Moscow.

Exhibitions

Exhibition of the Four Painters Kandinsky,

Rodchenko, Sinezubov, Stepanova (*Vystavka chetyrekh khudozhnikov Kandinskii, Rodchenko, Sinezubov, Stepanova*), Moscow.

State Exhibition "Zhivskul'ptarkh" (*Gosudarstvennaia vystavka "Zhivskul'ptarkh"*), Moscow.

Exhibition to the Third Congress of the Komintern (*Vystavka k III kongressu kominterna*), Moscow.

1st State Exhibition of Art and Science (*1aia gosudarstvennaia vystavka iskusstva i nauki*), Kazan.

2nd Art Exhibition (*2aia khudozhestvennaia vystavka*), Sovetsk. Organized by the Subsection of the Department of Museums and Conservation of Monuments and Antiquities (Podotdel po delam museev i okhrany pamiatnikov iskusstva i stariny).

1st Kosmodem'iansk Exhibition for the Third Anniversary of the Great October Revolution (*1aia kozmodem'ianskaia vystavka k 3ei godovshchine velikoi oktiabr'skoi revolutsii*), Kosmodem'iansk. Organized by Izo.

19th State Exhibition (*19aia gosudarstvennaia vystavka*), Moscow. Organized under the auspices of Izo Narkompros. October.

1921

Wins first prize in a competition to design union insignia.

January–April: "Composition-construction" debates take place at Inкhuк, exploring the meaning of the two terms as approaches to artmaking, and leading to the formation of the Constructivist group. The debates stake out the terms of the group's opposition to Kandinsky's program.

February: Teaches drawing for one term at the Ceramics Faculty (Keramicheskii fakul'tet) of Vкhuтемas.

March: Lenin inaugurates the New Economic Policy (*Novaia ekonomicheskaia politika*, or NEP), which ends "war communism," reintroduces a money economy, and permits limited capitalist competition.

Communist forces under Trotsky suppress a mutiny of 10,000 sailors at the Kronstadt naval base near Petrograd.

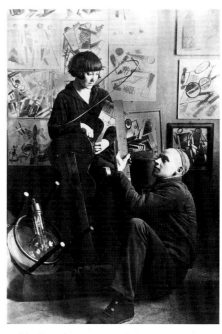

Rodchenko and Stepanova posing as itinerant musicians in their studio, 1921.

March 18: Forms the First Working Group of Constructivists (*Pervaia rabochaia gruppa konstruktivistov*) with Aleksei Gan, Karl Ioganson, Konstantin Medunetskii, Stepanova, and Georgii and Vladimir Stenberg.

May 22: Opening of the second Обмоkhu exhibition—called the *Second Spring Обмоkhu Exhibition* (*Vtoraia vesenniaia vystavka Обмоkhu*)—in Moscow. Ioganson, Medunetskii, the Stenberg brothers, and others exhibit, and Rodchenko shows spatial constructions.

Summer–Fall: Height of a famine that kills hundreds of thousands, probably millions, of Russians.

September–October: With Alexandra Exter, Lyubov Popova, Stepanova, and Aleksandr Vesnin, presents work in *5x5=25*, a two-part exhibition held at the Club of the All-Russian Union of Poets (Klub vserossiskogo soiuza poetov). Each artist shows five works in each part. The first part opens in September and features works especially produced for the occasion; Rodchenko exhibits *Line* (*Liniia*, 1920), *Grid* (*Kletka*, 1921), and the three monochrome paintings *Pure Red Color* (*Chistyi krasnyi tsvet*), *Pure Yellow Color* (*Chistyi zheltyi tsvet*), and *Pure Blue Color* (*Chistyi sinii tsvet*, all 1921), which are often referred to as a triptych. The

second part of the show, in October, is dedicated to works on paper.

November 24: Coining the slogan "Art into Life," more than twenty artists associated with Inкhuк declare their renunciation of the self-sufficient art object (and of easel painting in particular) and their intention to go into industry. This is the beginning of the Productivist phase of Constructivism.

November 26: Rodchenko reads his essay "The Line" (*Liniia*) at an Inкhuк meeting.

December: Kandinsky leaves Russia to teach at the Bauhaus, in Weimar, Germany.
Rodchenko works on free-standing sculptures made of identically sized wooden elements.

December 22: Stepanova delivers a paper defining the goals of Constructivism at an Inкhuк meeting, provoking extensive discussion.

Exhibitions

3rd Touring Fine Art Exhibition of the Regional Subsection of the Central Museum of Sovetsk (*3aia peredvizhnaia khudozhestvennaia vystavka sovetskogo raionnogo podotdela glavmuzeia*), Sovetsk.
Second Spring Обмокhu Exhibition (*Vtoraia vesenniaia vystavka Обмоكhu*), held in the former Mikhailova Salon, Moscow. May–June.
5x5=25 exhibition held at the Club of the All-Russian Union of Poets (Klub vserossiskogo soiuza poetov), Moscow. Part one September, part two October.

1922

Обмоكhu ceases to function.

February: Becomes the dean of the metal-working faculty (Metalloobrabatyvaiushchii fakul'tet, or Metfak) at Vкhuтемаs. Is replaced as the head of Izo's Museum Bureau.

February 6: The Cheka is replaced by the GPU (Gosudarstvennoe politicheskoe upravlenie, the State Political Administration).

February 22: Rodchenko and Stepanova are allocated an apartment at 21 Miasnitskaia Street, where they will live for the rest of their lives. The building is across the courtyard from Vкhuтемаs.

March: Establishment of AKhRR (*Assotsiatsiia khudozhnikov revoliutsionnoi Rossii*, Association of Artists of Revolutionary Russia). Adherents of nineteenth-century realism, its members will develop the style of Socialist Realism in the 1930s.

April 3: Stalin is elected general secretary of the Central Committee of the Communist Party.

April 16: Russia and Germany sign an accord of economic cooperation at Rapallo, Italy.

May: "First International Congress of Progressive Artists" held in Düsseldorf, Germany. In opposition to the Expressionist majority, artists including Theo van Doesburg, El Lissitzky, and Hans Richter form the International Section of Constructivists.

May 21: Release of the first number of *Kino-Pravda* (Cine-Truth), Dziga Vertov's series of twenty-three short documentary films.

May 25: Lenin suffers a stroke.

August: First issue of the magazine *Kino-Fot* (Cine-Photo). Editor Aleksei Gan invites Rodchenko to design its covers. Through Gan, Rodchenko meets Dziga Vertov.

October 15: Opening of the *First Russian Art Exhibition* (*Erste russische Kunstausstellung*), at the Galerie van Diemen, 21 Unter den Linden, Berlin. The exhibition, which includes work by Rodchenko, is Western Europe's first comprehensive overview of Russian modernist art. It will later travel to the Stedelijk Museum, Amsterdam.

November: At Vertov's invitation, Rodchenko designs intertitles for *Kino-Pravda* numbers 13 and 14.

December 30: Formal establishment of the Union of Soviet Socialist Republics (USSR) (Soiuz Sovetskikh Sotsialisticheskikh Respublik [CCCP]).

Exhibition

First Russian Art Exhibition (*Erste russische Kunstausstellung*), Galerie van Diemen, Berlin. October–December.

1923

Acquires a 13-by-18-cm. view camera to make copies, enlargements, and reductions for his photocollage work.
Begins to design advertisements and insignia for the state airline Dobrolet. This work soon leads to regular collaborations with Mayakovsky (who writes the slogans) on advertisements for the state grocery-concern Mossel'prom, the state candy-maker Krasnyi Oktiabr', the state department-store GUM, the state rubber-trust Rezinotrest, the state tea-producer Chaiupravlenie, and the state publishing-house Gosizdat.

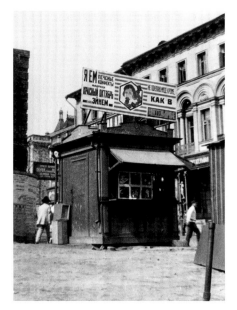

Rodchenko's advertising poster for Krasnyi Oktiabr' cookies displayed on a Mossel'prom kiosk, 1924.

Receives graphic design commissions, mainly for book covers and posters, from Gosizdat, Komakademiia (Communist academy), Krug (Circle), Molodaia gvardiia (Young guard), and Transpechat' (Transport press), and from the magazines *Krasnaia Nov'* (Red soil) and *Molodaia Gvardiia*.
Shows costume designs for Gan's play *We* in the *Exhibition of Moscow Stage Design 1918–1923* (*Vystavka teatral'no-dekorativnogo iskusstva Moskvy 1918–1923*).

His Metfak students at Vкhutemas exhibit furniture designs based on his principles of efficiency and multiple applications, including a bed that can double as an armchair, by N. Sobolev; a collapsible bookstand, by Zakhar Bykov; and a folding bed, by Peter Galaktionov.

January 16. First recorded reference to Lef (*Levyi front iskusstv*, the Left Front of the Arts), a group of avant-garde writers and intellectuals associated with Vladimir Mayakovsky and dedicated to defining a model of Revolutionary art practice, or, as the group informed the Central Committee of the Communist Party, "a Communist direction for all forms of art."

March: Manifesto of the Lef group (signed by Nikolai Aseev, Boris Arvatov, Osip Brik, Boris Kushner, Mayakovsky, Sergei Tret'iakov, and Nikolai Chuzhak) appears in the first issue of the group's magazine *Lef*, published with support from Narkompros. The press run of this first issue is 5,000; over the course of *Lef*'s seven issues (through January 1925) it will decline to 2,000. The first issue includes Rodchenko's drawings for "cinema cars," a mobile system of film projection that he has designed for the All-Russian Agricultural Exhibition (*Vserossiiskaia vystavka sel'sko-khoziaistva*), Moscow, but that are never produced.

Rodchenko will design all the covers of *Lef*, and will become the Lef group's principal visual artist. Filmmakers Sergei Eisenstein and Dziga Vertov, stage director Vsevolod Meyerhold, and literary theorist

Rodchenko. Design for "cinema cars" (*kino-avtomobilei*) for the All-Russian Agricultural Exhibition. 1923. Gouache on paper, remade by Varvara Rodchenko after a lost original. 12¹³⁄₁₆ × 19¹¹⁄₁₆" (32.5 × 50 cm).

Viktor Shklovsky will also become associated with the group.

April 21: Completes photocollage maquettes as the cover and illustrations for *About This* (*Pro eto*), a poem by Mayakovsky, which the poet has completed on February 11.

June 5: Publication of *Pro eto*.

July 1: The newspaper *Izvestiia* publishes a full-page advertisement for the department store GUM (Gosudarstvennyi universalnyi magazin, the State universal store) designed by Rodchenko with text by Mayakovsky, their first advertising collaboration.

December 18: László Moholy-Nagy, professor at the Bauhaus, writes to Rodchenko at Vкhutemas, inviting him to write a brochure on Constructivism for a series to be published by the Bauhaus. The brochure will never appear.

Winter of 1923–24: Makes a small number of photographs independent of his collage work.

Exhibition

Exhibition of Moscow Stage Design 1918–1923 (*Vystavka teatral'no-dekorativnogo iskusstva Moskvy 1918–1923*), Moscow.

1924

Viktor Shklovsky joins the editorial board of *Lef*.
Rodchenko stops working for Inкhuк.

January 21: Lenin dies.

January 26: The Second All-Union Congress of Soviets changes the name of Petrograd to Leningrad.

April: In his apartment on Miasnitskaia Street, using a 9-by-12-cm. plate camera, makes a series of six portraits of Mayakovsky, his first lasting work in photography. Soon begins to photograph family and friends.

October 31: Release of Dziga Vertov's film *Cine-Eye* (*Kino glaz*), for which Rodchenko designs the poster.

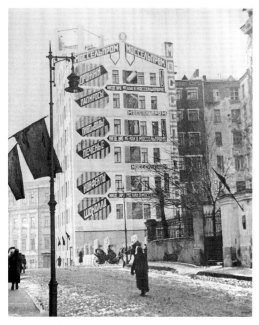

Rodchenko. The Mossel'prom Building decorated with his mural. 1925. Gelatin-silver print. The Pushkin State Museum of Fine Arts, Department of Private Collections, Moscow.

1925

Establishment of Ost (Obshchestvo khudozhnikov-stankovistov, the Society of Easel Painters), a group arguing for easel painting over the industrial design and photography embraced by the Constructivists. Unlike the AKhRR, however, Ost did not reject certain innovations of the pre-Revolutionary avant-garde.
Establishment of Voks (Vsesoiuznoe obshchestvo kul'turnykh sviazei s zagranitsei, the All-Union Society for Cultural Relations) to promote Soviet culture abroad.
Rodchenko publishes photo-reportage in the magazines *Ogonek* (The little flame), *Tridtsat' Dnei* (Thirty days), and *Ekran Rabochei Gazety* (Screen of the worker's newspaper).

January: Last published issue of *Lef*, which ceases publication after Gosizdat withdraws funding. An eighth issue is prepared but never appears.
A mural that Rodchenko has designed for the side of the Mossel'prom building in Moscow is completed by this month, when he photographs it in its finished state.

January 14: A daughter, Varvara Alexandrovna Rodchenko, is born to Stepanova and Rodchenko.

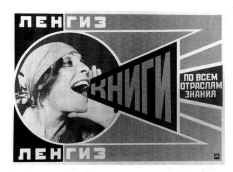

Rodchenko. Maquette for an advertisement for Lengiz, the Leningrad Section of the state publishing-house Gosizdat. 1924. Gouache and cut-and-pasted gelatin-silver photograph on paper, remade by Varvara Rodchenko in 1965 after a lost original. 27⁷/₁₆ × 33⁷/₈" (62 × 86 cm).
 Text: "Books in all disciplines." The model for the photograph is Lili Brik.

January 18: Release of Sergei Eisenstein's film *The Battleship Potemkin* (*Bronenosets Potemkin*), for which Rodchenko designs the poster.

March 23: Arrives in Paris by train, via Riga (March 19) and Berlin (March 20), as part of the delegation, headed by David Shterenberg, that will mount the Soviet exhibitions at the *Exposition Internationale des Arts Décoratifs et Industriels Modernes*. These exhibitions include six rooms in the Grand Palais, containing a model village reading room and a theater, as well as exhibits of crafts, works created at Vкhuтемаs, graphic design, advertising, and architecture; and also the Soviet Pavilion, designed by Konstantin Mel'nikov, and, at the Invalides, a model workers' club (*Rabochii klub*), designed by Rodchenko, who also executes its installation and that of the other exhibitions.
 In Paris, visits the Salon des Indépendants, which he finds mediocre, and meets Theo van Doesburg, Fernand Léger, and other artists, in meetings limited by the lack of a common language. Writes almost daily to Stepanova of his impressions of Paris: considers the advertising weak; admires Charlie Chaplin's *The Kid*. Also buys a 4-by-6.5-cm. Ica plate camera and a 35-mm. Sept (a movie camera that can also make still frames). Buys a second Sept for Dziga Vertov.

June 4: Soviet exhibitions open in the Grand Palais. Rodchenko wins silver medals in each of the four categories he has entered:

book design, outdoor advertising, theater design, and furniture design.

June 18: Leaves Paris for Moscow, by train.

Fall: Shooting from both above and below, makes "The Building on Miasnitskaia Street" (*Dom na Miasnitskoi*), a series of photographs of his apartment building.

Exhibitions

3rd Art Exhibition of Painting by Kaluga and Moscow Artists (*3aia khudozhestvennaia vystavka kartin kaluzhskikh i moskovskikh khudozhnikov*), Kaluga.
First Exhibition of Film Posters (*Pervaia vystavka kino-plakat*), Moscow.
Exposition Internationale des Arts Décoratifs et Industriels Modernes, Paris.

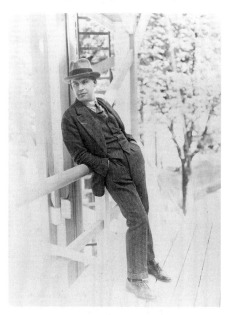

Rodchenko outside Konstantin Mel'nikov's Soviet Pavilion at the *Exposition Internationale des Arts Décoratifs et Industriels Modernes*, Paris, 1925.

1926

The magazine *Sovremennaia Arkhitektura* (Contemporary architecture) goes into publication, edited by Aleksei Gan. Rodchenko and Stepanova contribute to the first issues.
Begins to photograph regularly and to design costumes and sets for theater and film.
Commissioned by the Museum of the Revolution (Muzei revolutsii) and Komakademiia to create "The History

Rodchenko and Stepanova in the role of foreigners in a film test for Sergei Eisenstein's film *Old and New* (*Staroe i novoe*), 1926.

of the VKP(b) [All-Russian Communist Party (Bolshevik)] in Posters" (*Istoria VKP(b) v plakatakh*), a series of twenty-five posters illustrating the history of the Communist Party.

February: Joins the Association of Photo-Reporters (Assotsiatsiia fotoreporterov) but does not participate in its first exhibition, at the Press-House (Dom pechati).

March: The magazine *Sovetskoe Kino* (Soviet cinema) includes photographs from Rodchenko's "Building on Miasnitskaia Street" series of 1925. He will contribute photographs to the magazine regularly.

April: First issue of *Sovetskoe Foto* (Soviet photography), a monthly addressed primarily to amateur photographers, published under the auspices of Izo Narkompros. Rodchenko is a member of the editorial board.

June 10: An article in *Leningradskaia Pravda* criticizes the Leningrad Inкhuк as a "monastery on a state subsidy." Shortly thereafter the institute is closed.

Exhibition

2nd Exhibition of Film Posters (*2aia vystavka kino-plakat*), Moscow. Organized by the publishing house Teakinopechat' (Press for theater and cinema).

1927

Vapp is renamed Rapp (Rossiiskaia assotsiatsiia proletarskikh pisatelei, the Russian Association of Proletarian Writers).
The Moscow Inкhuк is closed.

Rodchenko collaborates on *Moscow in October* (*Moskva v Oktiabre*) by Boris Barnet, one of three films commissioned to celebrate the tenth anniversary of the October Revolution. Listed as "Artist" (*Khudozhnik*) in the film's credits, he selects locations and designates camera viewpoints and angles, many of them from above or below. In connection with the film, he photographs extensively in Moscow and makes a series of photographs of the Brianskii railway station, site of the film's opening scene. The film is released in November of this year.

Designs the sets, notably the hero's apartment, conceived as an exemplar of modern functional design, for the film *The Journalist* (*Zhurnalistka*), by Lev Kuleshov (released in October of this year). Also designs sets for the film *Al'bidum*, by Leonid Obolenskii.

Rodchenko's poster series "The History of the VKP(b) in Posters," of 1926, is published in the newspapers *Izvestiia* and *Pravda*.

January: First issue of the magazine *Novyi Lef*. Twenty-two monthly numbers (including one double number) will appear through December 1928, in editions ranging from 2,400 to 3,500. Rodchenko will design all of the covers and will contribute regularly to the contents.

Designs advertising poster for *Novyi Lef*, composed of portraits of Nikolai Aseev, Osip Brik, Sergei Eisenstein, Semen Kirsanov, Boris Kushner, Anton Lavinskii, Mayakovsky, P. Nezmanov, Boris Pasternak, Viktor Perstov, Rodchenko, Viktor Shklovsky, Stepanova, Tret'iakov, Dziga Vertov, and Vitalii Zhemchuzhnyi.

February: *Novyi Lef* number 2 publishes excerpts from Rodchenko's letters to Stepanova from Paris in 1925.

Summer: Exhibits photographs for the first time, in a Moscow exhibition organized by ODSK (Obshchestvo druzei sovetskogo kino, the Society of the Friends of Soviet Cinema).

December: Trotsky is expelled from the Communist Party at the Fifteenth Party Congress.

Exhibitions

All-Union Exhibition of Graphic Design (*Vsesoiuznaia poligraficheskaia vystavka*), Leningrad.

10 Years of Russian Xylography (*Russkaia ksilografiia za 10 let*), State Russian Museum (Gosudarstvennyi russkii muzei), Leningrad.

Exhibition organized by ODSK, Moscow.

1928

Beginning of the First Five-Year Plan, a program of industrialization and forced collectivization of agriculture.

Vkhutemas is reorganized as Vkhutein (Vysshii gosudarstvennyi khudozhestvenno-tekhnicheskii institut, the Higher State Artistic-Technical Institute).

In the exhibition *10 Years of Soviet Photography* (*Sovetskaia fotografiia za 10 let*), in Moscow, Rodchenko's pictures are shown in the photo-reportage section, not the "artistic photography" section. Following the exhibition, VOKS establishes a photographic section. Rodchenko sits on the section's committee. Through the wide-ranging contacts of VOKS, he will send photographs to an average of five or six foreign exhibitions, many of them Pictorialist salons, each year through 1941.

Designs sets for the film *Doll with Millions* (*Kukla s millionami*), by Sergei Komarov (released in December of this year).

Over the next four years, will publish photo-reportage in the magazines *Kniga i Revoliutsiia* (Book and revolution), *Kommunisticheskii Internatsional Molodezhi* (Communist international of youth), *Krasnoe Studenchestvo* (Red student days), *Pioner* (Pioneer), *Prozhektor* (Projector), *Sovetskoe Foto, Radioslushatel'* (Radio listener), *Smena* (Change), and *Zhurnalist* (Journalist).

January: Trotsky is deported from Moscow to Alma-Ata, Kazakhstan.

Scene from the film *Al'bidum*, directed by Leonid Obolenskii, 1927, with set designed by Rodchenko.

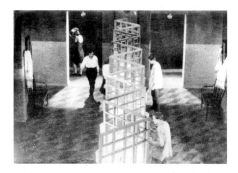

Scene from the film *Doll with Millions* (*Kukla s millionami*), directed by Sergei Komarov, 1928, with set designed by Rodchenko.

January 3: Alfred H. Barr, Jr., future founding director of The Museum of Modern Art, New York, visits Rodchenko and Stepanova at their apartment in Moscow.

AKhRR is renamed AKhR (Assotsiatsiia khudozhnikov revoliutsii, Association of Artists of the Revolution).

April: *Sovetskoe Foto* no. 4 of 1928 publishes an anonymous illustrated letter to the editor insinuating that Rodchenko has plagiarized his photographic style from Western "imperialist" photographers.

May–June: Accused of sabotage and conspiracy with foreign powers, mining engineers and technicians—"bourgeois experts"—from the Shakhty area of the Donets Basin undergo a show trial in Moscow. This is the start of the cultural revolution, the social complement to the First Five-Year Plan. The cultural revolution reasserts the rhetoric of class warfare, which had been moderated under the NEP.

June 5: The newly founded October (*Oktiabr'*) group of modernist artists, including painters Aleksandr Deineka and Diego Rivera, designers Gustav Klucis and Sergei Sen'kin, architects Moisei Ginzburg and

Installation of Rodchenko's work at the State Tretyakov Gallery, Moscow, late 1920s.

Rodchenko. *Director of the Zoo* (*Direktor zoosada*), costume for the play *Bedbug* (*Klop*). 1929. Colored pencil on paper, 14³⁄₁₆ × 10⅝" (36 × 27 cm). The Pushkin State Museum of Fine Arts, Department of Private Collections, Moscow.

Aleksandr Vesnin, and filmmakers Sergei Eisenstein and Esfir Shub, publishes its manifesto in *Pravda*, asserting that art must serve "working people" through the creation of "ideological propaganda" and "the production and direct organization of the collective way of life."

Summer: Mayakovsky resigns from *Novyi Lef*, followed by Osip Brik and Nikolai Aseev. Tret'iakov and Nikolai Chuzhak assume editorial control of the last five issues (August–December).

October 3: L. Averbakh of RAPP attacks Rodchenko's photograph of a pioneer as "monstrous."

November: Maks Tereshkovich, director of the Theater of the Revolution (Teatr revoliutsii), invites Rodchenko to design sets for the play *Inga*, by Anatolii Glebov. Explaining his participation in the production in his essay "A Discussion of the New Clothing and Furniture—A Task of Design," Rodchenko will emphasize the notion of rationality, the use of fold-out (rather than multiple-application) furniture (the better to suit everyday living conditions), and his preference for an "abundantly available" material, wood.

November 14: Delivers an illustrated lecture, "On the New Photography or Photo-Lef," at GAKHN (Gosudarstvennaia akademiia khudozhestvennykh nauk, the State Academy of Artistic Sciences).

November 25: Stepanova's diary records Rodchenko's purchase of a Leica for 350 rubles.

December 9: El Lissitzky, charged with assembling the Russian section of the

forthcoming *Film und Foto* exhibition in Stuttgart, visits Rodchenko to select photographs for the exhibition.

December 26: With Stepanova, Rodchenko completes the maquette for a book of photographs of his that have appeared in *Sovetskoe Foto, Sovetskoe Kino*, and *Novyi Lef*. Osip Brik is to write an introduction. The book is to be published under the auspices of Narkompros, but never appears.

Exhibitions

10 Years of Soviet Photography (*Sovetskaia fotografiia za 10 let*), Moscow and Leningrad. Organized by the State Academy of Artistic Sciences.

Russian Drawing in the 10 Years after the October Revolution (*Russkii risunok za 10 let Oktiabr'skoi revoliutsii*), State Tretyakov Gallery (Gosudarstvennaia Tret'iakovskaia galereia), Moscow.

1929

Sovetskoe Foto publishes a Russian edition of *Malerei, Photographie, Film* (Painting, photography, film, 1925), by László Moholy-Nagy, with an introduction by Aleksei Fedorov-Davidov, director of the State Tretyakov Gallery in Moscow and leading theorist of the October group. Rodchenko joins the interior design section of October.

January: Trotsky is exiled from the USSR.

January 2: Mayakovsky invites Rodchenko to work on his play *Bedbug* (*Klop*), at

Rehearsal for the play *Bedbug* (*Klop*), by Vladimir Mayakovsky, 1929. Left to right, seated: Dmitri Shostakovich and Vsevolod Meyerhold, and standing: Mayakovsky and Rodchenko. Photograph by A. Temerin.

the Meyerhold Theater (Teatr im. Vs. Meierkhol'da). Rodchenko will work on the project from January 14 to February 13. His designs are for the second half of the play, which is set in 1979, fifty years in the future. Designs for the first half of the play, set in the present day of 1929, are by the Kukrinskii brothers. Once Rodchenko has finished his work for *Bedbug*, he returns to designing modular furniture for Glebov's play *Inga*, to open later in the spring.

January 8: Release in Kiev of Dziga Vertov's film *Man with a Movie Camera* (*Chelovek c kino apparatom*).

February 18: Premiere of *Bedbug*, at the Meyerhold Theater, Moscow.

April: First issue of the magazine *Daesh'* (Give your all), closely associated with October. *Daesh'* will survive for fourteen issues, the last of them published in December of this year. Principal photographers for the magazine are Rodchenko and Boris Ignatovich.

Summer: After the *Film und Foto* exhibition in Stuttgart, enters into correspondence with co-organizer Jan Tschichold.

September: Anatoly Lunacharsky is replaced as commissar of Narkompros by Andrei Bubonov, formerly an administrator in the Red Army.

October: Mayakovsky and Osip Brik form REF (Revoliutsionnyi front iskusstv, Revolutionary Front of Art), announced as ideologically to the left of the Lef group.

November: Nikolai Bukharin is removed from the Politburo. Stalin is now without rivals.

Exhibitions

1st Exhibition of the Association of the Moscow Stage Designers (*1aia vystavka Moskovskoi assotsiatsii khudozhnikov-dekoratov*), Moscow.

Soviet Drawing (*Sovetskii risunok*), Kuibyshev.

Internationale Ausstellung des Deutschen Werkbunds Film und Foto, Stuttgart. May 18–July 17.

1930

Probably this year, Malevich is imprisoned for nearly three months by the NKVD (Narodnyi komissariat vnutrennykh del, the People's Commissariat for Internal Affairs), on suspicion of spying for Germany.

Rodchenko lectures on photography to heads of photographic clubs at the Institute of Graphic Design (Poligraficheskii institut) and the Association of Photo-Reporters.

January: Mayakovksy dissolves REF, declaring his intention to join RAPP, the leading conservative group opposed to the Lef group.

First issue of *SSSR na Stroike* (*USSR in Construction*), a lavish propaganda magazine printed in gravure and illustrated mainly with photographs. The monthly is issued in Russian, English, French, and German editions.

February: A photographic section of the October group is organized. Rodchenko is head of the section and writes its program. Other members include Dmitrii Debabov; Boris, Ol'ga, and Elizaveta Ignatovich; Vladimir Griuntal'; Roman Kamen; Eleazar Langman; Moriakin; Abram Shterenberg; and Vitalii Zhemchuzhnyi.

March 27: First general October exhibition opens at Gorky Park (Park kul'tury i otdykha im. Gorkogo, or Park of culture and rest named after Gorky), Moscow. The photography section, organized by Rodchenko and Stepanova, includes the magazine *Radioslushatel'*, designed by Stepanova and illustrated with photographs by Griuntal', Boris Ignatovich, and Rodchenko.

Rodchenko photographing in Gorky Park, Moscow, 1929–30. Photograph by Anatolii Skurikhin.

April 14: Death of Mayakovsky, recorded as a suicide.

July: First issue of the magazine *Za Rubezhom* (*Abroad*). Rodchenko will design many of its covers.

August–November: With the film director Leon Letkar, travels to Vakhtan to shoot the documentary *Chemical Treatment of the Forest* (*Khimizatsiia lesa*). The film will never be released. During the trip makes a series of photographs at a lumber mill.

Exhibitions

First October exhibition, Gorky Park, Moscow. Opens March 27.

20 Years of the Work of Mayakovsky (*20 let raboty Maiakovskogo*), Writers' Club (Klub pisatelei), Moscow.

Exhibition of Drawings (*Vystavka risunkov*), Perm.

Revolutionary and Socialist Themes (*Revoliutsionnaia i sotsialisticheskaia tematika*), State Tretyakov Gallery, Moscow.

1931

Establishment of ROPF (Rossiiskoe ob"edinenie proletarskikh fotoreporterov, the Russian Society of Proletarian Photo-Reporters), a group opposed to the October group. Among its leaders are Maks Al'pert, Semen Fridliand, Iakov Khalip, and Arkadii Shaikhet. The magazine *Proletarskoe Foto* (the renamed *Sovetskoe Foto*) acts as its mouthpiece. (*Sovetskoe Foto* is called *Proletarskoe Foto* between September of this year and the end of 1933.)

Designs the costumes and sets for the revue *Sixth Part of the World* (*Shestaia chast' mira*), by Aleksandr Zharov, and directed

by Nikolai Gorchakov, at the Music-Hall Theater.

Set designer for the film *What will you be?* (*Kem byt'*?), directed by Vitalii Zhemchuzhnyi and based on a children's book by Mayakovsky.

Begins lecturing on photography at the Soiuzfoto agency.

May: The October photographers' section opens an exhibition at the Press-House. Rodchenko shows his photographs from Vakhtan.

June: John Heartfield, in Moscow since April, presents his work at an exhibition of photomontage organized by October at Gorky Park.

October 10: Jan Tschichold writes asking Rodchenko to send about sixty photographs for a prospective monograph in a series of books he is preparing with Franz Roh. The book will never appear.

Exhibitions

Exhibition of the photographers' section of October at the Press-House, Moscow. May.

October exhibition of photomontage in Gorky Park, Moscow. June.

1932

In this and the following year, at least five million Russian peasants die of a famine imposed by the government to break resistance to the collectivization of agriculture.

Rodchenko designs the sets and costumes for the play *The Army of the World* (*Armiia mira*), by Lev Nikulin, directed by Iurii Zavadskii at the Zavadskii Theater.

Teaches a course on photography at the Institute of Graphic Design.

Makes photo-vitrines for the Dynamo (Dinamo) stadium.

January: This month's *Proletarskoe Foto* includes attacks on the October group. On January 25, Rodchenko is expelled from October for resistance to the "practical reconstruction of the group."

February: *Proletarskoe Foto* publishes workers' criticisms of photographs by members of October, notably Rodchenko's pictures of

Portrait of Rodchenko. 1930s. Photograph by Eleazar Langman.

pioneers. It also publishes an open letter signed by eighteen members of October, including Rodchenko (not yet expelled when the letter was written), apologizing for the group's mistakes.

April 15: Signs a one-year contract to supply photographs to Izogiz (the State Publishing House for Art). The contract calls for Rodchenko to supply a minimum of forty photographs per month at ten rubles each, for a monthly salary of 400 rubles. Additional photographs will earn from ten to twelve rubles each, depending on quality. The contract leads to, among other things, the publication of a series of approximately forty postcards of Moscow scenes, published in editions ranging from 10,000 to 25,000, and to the preparation of *Dve Moskvy* (Two Moscows), a book documenting Moscow before the Revolution (through drawings) and after it (through Rodchenko's photographs). The book will never appear. Rodchenko's work is, however, included in the photo-album *From Capitalist Moscow to Socialist Moscow* (*Ot Moskvy kupecheskoi k Moskve sotsialisticheskoi*).

April 23: The Central Committee of the Communist Party decrees the abolition of all artistic associations, together with their publications, and calls for a single union of artists.

June: In Moscow, former members of the abolished artists' associations establish Mossкн (Moskovskoe otdelenie soiuza sovetskikh khudozhnikov, the Moscow branch of the Union of Soviet Artists).

Exhibitions
Exhibition dedicated to the work of Vladimir Mayakovsky, Moscow. Organized by the Museum of Literature (Muzei literatury).

1933

A law requiring a permit to photograph openly in Moscow henceforth restricts Rodchenko's photographic work to official parades and sporting events, the circus, the theater, commissions outside Moscow, and private pictures.
Rodchenko joins Mossкн.

February: Commissioned by Izogiz to travel to Karelia to photograph the construction of the White Sea (Belomorsk) Canal, which connects the White Sea and the Baltic. Spends two weeks at the canal.

March 13: Departs on a second trip to the White Sea Canal.

Summer: Third and final trip to the canal to photograph its inauguration. On the three trips together, has made a total of some 4,000 negatives.

July 18: Rodchenko's mother dies in Moscow while he is photographing at the White Sea Canal.

December: *SSSR na Stroike* publishes a special issue on the White Sea Canal, designed by Rodchenko and largely illustrated with his photographs.
Over the next eight years Rodchenko and Stepanova will work regularly on *SSSR na Stroike*.

Exhibition
15 Years of Artists of the RSFSR [Russian Soviet Federal Socialist Republic] (Khudozhniki RSFSR [Rossiiskaia Sovetskaia Federativnaia Sotsialisticheskaia Respublika] za 15 let), Moscow.

1934

Travels to the Crimea and the Donets Basin on photographic assignments from Izogiz.
With Stepanova, designs *10 Years of Soviet Uzbekistan* (*10 let sovetskogo Uzbekistana*), an album of photographs.

August 17–December 2: First All-Union Congress of Soviet Writers, Moscow. Here Andrei Zhdanov outlines the doctrine of "Socialist Realism."

December: Politburo member Sergei Kirov is assassinated. The assassination becomes the occasion for Stalin to initiate a series of "purges"—prosecutions and executions for treason and counterrevolution—that will last through 1938.

Rodchenko on his balcony, 1934.

1935

With Stepanova, designs issues on Kazakhstan and parachuting for *SSSR na Stroike* and the photograph albums *First Cavalry* (*Pervaia konnaia*) and *Soviet Cinema*.
Begins to photograph the gymnastic and military parades on Red Square. A permit is required for each event.
Wins second prize for his photograph *Girls with Scarves* (*Devushki s platkami*) at a Moscow competition organized by the Soiuzfoto agency and the newspaper *Rabochaia Moskva* (*Worker's Moscow*).
Starts painting again. Works on a series on the theme of the circus, in both painting and photography.
Retires from the photography exhibition committee of Voкs.

April 24–May 7: *Exhibition of the Work of the Masters of Soviet Photography* (*Vystavka rabot masterov sovetskogo foto-iskusstva*), organized by the newly formed Professional Union of Photo-Cine Workers (Profsoiuz kinofotorabotnikov), which Rodchenko joins. This is a juried exhibition to which each potential exhibitor is permitted to submit up to twenty photographs. Rodchenko is one of the nine jurors (who include both former members of Ropf and former members of the

October group). He participates in the installation of the exhibition, which takes place in the exhibition hall on Kuznetskii Most (once the site of the Café Pittoresque, which Rodchenko had helped to design in 1917). The exhibition, and the critical reaction to it, temporarily restore Rodchenko's reputation, and he rejoins the editorial committee of *Sovetskoe Foto* and contributes articles to the magazine, including a series on "Young Masters," the first of which is devoted to Iakov Khalip.

Exhibitions

17 Years of Artists of the Soviet Theater (*Khudozhniki sovetskogo teatra za 17 let*), Moscow. Organized by Narkompros.

Exhibition of the Work of the Masters of Soviet Photography (*Vystavka rabot masterov sovetskogo foto-iskusstva*), Moscow.

1936

Onset of the most intense period of the great purges. Over the next three years, more than seven million people will be arrested, of whom some three million will be executed or will die in prison or labor camps.

Trial and execution of Kamenev and Zinoviev.

With Stepanova, Rodchenko designs an issue on timber exports for *SSSR na Stroike*.

Publishes an apologia, "Reconstruction of an Artist," in *Sovetskoe Foto* no. 5–6 of 1936.

1937

Tret'iakov is arrested. The precise date of his death, shortly thereafter, is unknown.

With Stepanova, Rodchenko designs an issue on gold for *SSSR na Stroike*.

Wins an award for his photographs of gymnastic parades and events in the *First All-Union Exhibition of Photography* (*Pervaia vsesoiuznaia vystavka fotoiskusstva*), Moscow.

Resigns from the editorial board of *Sovetskoe Foto*.

Exhibitions

First All-Union Exhibition of Photography (*Pervaia vsesoiuznaia vystavka fotoiskusstva*), Moscow and Leningrad.

20 Years of Soviet Photography (*20 let sovetskoi fotografii*), Moscow. Opens November 26.

1938

Trial and execution of Nikolai Bukharin.

With Stepanova, Rodchenko designs issues on the Moscow–Volga Canal, elections in the Supreme Soviet, and Kiev for *SSSR na Stroike*.

With Stepanova, designs the photograph album *Red Army* (*Krasnaia armiia*).

Exhibitions

Exhibition of Soviet Photographic Art (*Vystavka sovetskogo fotoiskusstva*), held at the Museum of Culture named after Vitautas, Kaunas, Lithuania.

Exhibition of the work of Vladimir Mayakovsky, Sochi.

Exhibition of artistic photography, Writers' Club, Moscow.

1939

Vsevolod Meyerhold arrested.

Death of Nikolai Chuzhak, arrested this or the previous year.

With Stepanova, Rodchenko designs issues on the All-Union Agricultural Exhibition (*Vsesoiuznaia sel'skokhoziaistvennaia vystavka*) and the kolkhoz for *SSSR na Stroike*, and the photograph albums *Soviet Aviation*, *Procession of the Youth*, and others for the New York World's Fair.

May 2–June 3: On a commission from the State Mayakovsky Museum (Gosudarstvennyi muzei Maiakovskogo), Moscow, writes a memoir on his collaboration with Mayakovsky, "Working with Mayakovsky" (*Rabota s Maiakovskim*). It will appear in *Smena* no. 3 of 1940.

August 23: Germany and the USSR sign a nonagression pact.

September 1: Germany invades Poland. Two days later, Britain and France declare war on Germany. World War II has begun.

Exhibition

In Honor of the 18th Party Congress (*V podarok XVIII s"ezdu partii*), Moscow. March.

1940

With Stepanova, designs an issue on Mayakovsky for *SSSR na Stroike*.

With Georgii Petrusov, makes photographs for an issue of *SSSR na Stroike* on the circus. Because of the war, the issue never appears.

Works on a series of drawings inspired by the music of Sergei Prokofiev.

August 21: Trotsky assassinated in Mexico.

1941

With Stepanova, designs an issue on the history of GOELRO, the agency for the electrification of Russia, for *SSSR na Stroike*.

SSSR na Stroike ceases publication.

June 22: Germany launches invasion of the USSR.

August: With Stepanova and daughter Varvara, Rodchenko is evacuated to Molotov in the province of Perm, about 1,000 miles from Moscow.

October: Moves to the village of Ocher, 100 miles from Molotov. Designs advertisements and signboards for the local cinema and newspaper.

1942

Meyerhold dies in prison.

January: Rodchenko returns to Molotov.

Marriage of Rodchenko and Stepanova.

April–May: Works as a photographer for the newspaper *Travel with Stalin* (*Stalinskaia putevka*), published by the provincial railway of Perm.

September: Returns to Moscow.

Works on the design of photographic exhibitions for the Soviet Bureau of Information (Sovinformbiuro).

1943

Works on a series of paintings, "Decorative Composition" (*Dekorativnaia kompozitsiia*), and on a series of drawings on the theme of the circus.

Rodchenko. *Streamlined Ornament* (*Obtekaemyi ornament*). 1943. Oil on canvas, 19½ × 13¾" (49.6 × 35 cm). The Pushkin State Museum of Fine Arts, Department of Private Collections, Moscow.

Rodchenko with his painting *Clown with Saxophone* (*Kloun s saksofonom*), 1947. Photograph by V. Kovrigin.

October–November: Designs the exhibition *History of the VKP(b)* (*Istoriia VKP[b]*) at the Museum of the Revolution.

December: Starts work as artistic director of the House of Technology (Dom tekhniki), earning 3,000 rubles a month.

1945

With Stepanova, designs the photograph albums *Cinematographic Art of Our Country* (*Kinoiskusstvo nashei rodiny*) and *5 Years of Work Reserves* (*5 let trudovykh rezervov*).

May: Concludes work at the House of Technology.

May 7: Germany surrenders unconditionally to the Allies, ending World War II in Europe.

1946

Exhibition

Moscow Exhibition of Professional Photographers (Moskovskaia vystavka professionalnykh fotografov).

1947

With Stepanova, designs the photograph album *25 Years of the Soviet Socialist Republic of Kazakhstan* (*25 let Kazakhstan SSR*).

With daughter Varvara, begins designing the book *10 Years of Soviet Literature* (*10 let sovetskoi literatury*). The book will never appear.

1948

Jury member for the exhibition *The Great Patriotic War in Artistic Photography* (*Velikaia otechestvennaia voina v khudozhestvennoi fotografii*; "Great Patriotic War" is the Russian name for World War II).

With Stepanova, designs a series of posters about Mayakovsky.

Exhibition

First Exhibition of Book Artists (*Pervaia vystavka khudozhnikov knigi*), Moscow. Organized by the Moscow Association of Artists (Moskovskii soiuz sovetskikh khudozhnikov).

1949

Begins to design costumes for the ballet *Sleeping Beauty* (*Spiashchaia krasavitsa*), for a competition at the Bolshoi Theater, but a serious illness forces him to abandon the project.

1950

Exhibition

Book Exhibition at the Academy of Arts (*Knizhnaia vystavka v akademii khudozhestv*), Moscow. Organized by Glavpoligrafizdat (Glavnoe poligraficheskoe izdatel'stvo, Central Graphic Design Publisher).

1951

November: Expelled from membership in the graphic arts section of Mosskh.

1952

January: Restored to membership in Mosskh.

1953

With Stepanova, begins design on the album *300 Years of the Reunification of Ukraine to Russia* (*300-letie vossoedineniia Ukrainy s Rossiei*), finishing it the following year.

1955

Begins work on illustrations for Mayakovsky's poem *Well!* (*Khorosho*). Finished the following year, this will be his last work.

Exhibition

Exhibition of Artistic Photography (*Vystavka khudozhestvennoi fotografii*), Moscow. Organized by the Central House of Journalists (Tsentral'nyi dom zhurnalista).

1956

December 3: Dies in Moscow.

1957

Exhibition

First Posthumous Exhibition (*Pervaia posmertnaia vystavka*), Central House of Journalists, Moscow.

1958

May 20: Stepanova dies.

The Catalogue is generally chronological in order and corresponds to the sequence of reproductions in the plate section. The headings under which the works are grouped are intended to make the catalogue easy to use; in a few cases, the sequence of the plates demands that a work related to a group but not strictly belonging to it is listed within it.

Every effort has been made to identify titles that Rodchenko himself applied to his works, or that accrued to them during his lifetime. These titles are rendered in italic type. Many works left untitled by the artist are often known by descriptive titles; these are set in roman type.

Many of Rodchenko's works can be dated with considerable precision. For others, however, notably a large number of photographs made between 1928 and 1932, the evidence is less conclusive. Some works in the latter group are dated here according to longstanding but anecdotal traditions, which later scholarship may revise.

The medium designation for printed materials identifies the printing process: letterpress (relief printing), lithography, or gravure. In the medium designation for collages, the term "printed papers" may accommodate materials in one or more of these processes. The term "papers" may include both printed and blank paper.

In the dimensions, height precedes width, followed, when applicable, by depth.

Rodchenko's photographic prints comprise a wide range of paper stock, surface texture, and color. They are presented here in uniform duotone reproductions, however, on the principle that it would be hopeless, indeed misleading, to attempt to capture the variety of the originals. Every effort has been made to ensure that all of the prints shown in the exhibition were made during Rodchenko's fully active photographic career—that is, between 1924 and about 1940. To suggest the range of variations of Rodchenko's prints from a given negative (variations not only in paper stock and printing style, but also in cropping and size), the exhibition includes two prints from each of four negatives of

1924 from his series of portraits of Vladimir Mayakovsky. Catalogue numbers 134, 138, 140, and 141 are believed to represent the character of prints made before Mayakovsky's death in 1930; catalogue numbers 142–45 are believed to represent the character of prints made from the same negatives after 1930, when the posthumous cult of Mayakovsky as a hero of the Revolution gave a new function to Rodchenko's portraits. (The matter is still more complicated because numbers 138 and 142 both were printed from Rodchenko's own copy negative, which he was obliged to use after the original negative was broken in the late 1920s.)

Transliteration of the Russian alphabet throughout this book follows the Library of Congress system, except when the name of an individual or place is more easily identifiable by a familiar English spelling. The Catalogue of the Exhibition includes both translations and transliterations of the texts that appear in many of Rodchenko's graphics.

Painting, c. 1916

1. *Two Figures* (*Dve figury*). c. 1916. Oil on canvas. 33¼ × 26⅞" (84.4 × 68.2 cm). A. Rodchenko and V. Stepanova Archive, Moscow.

Line and compass drawings, 1915

2. Pen and ink on paper. 10¹⁄₁₆ × 8¼" (25.5 × 21 cm). A. Rodchenko and V. Stepanova Archive, Moscow.

3. Pen and ink on paper. 10¹⁄₁₆ × 8¼" (25.5 × 21 cm). A. Rodchenko and V. Stepanova Archive, Moscow.

4. Pen and ink on paper. 10¹⁄₁₆ × 8¹⁄₁₆" (25.5 × 20.5 cm). A. Rodchenko and V. Stepanova Archive, Moscow.

Lamp designs for the Café Pittoresque, Moscow, 1917

5. Black and colored pencil on paper. 10¹⁵⁄₁₆ × 8¼" (27.8 × 21 cm). A. Rodchenko and V. Stepanova Archive, Moscow.

6. Ink on paper. 10⁷⁄₁₆ × 8¹⁄₁₆" (26.5 × 20.5 cm). A. Rodchenko and V. Stepanova Archive, Moscow.

7. Black and colored pencil on paper. 10⁷⁄₁₆ × 8¹⁄₁₆" (26.5 × 20.5 cm). A. Rodchenko and V. Stepanova Archive, Moscow.

8. Pencil on paper. 32⅛ × 18½" (81.5 × 47 cm). The Pushkin State Museum of Fine Arts, Department of Private Collections, Moscow.

Paintings, sculpture, and works on paper, 1917–21

9. Design for poster for *Exhibition of Works by Rodchenko 1910–1917* (*Vystavka tvorchestva Rodchenko 1910–1917*), Moscow. 1917. Watercolor, gouache, and pencil on paper. 20⅝ × 19¼" (52.3 × 49 cm). The Pushkin State Museum of Fine Arts, Department of Private Collections, Moscow.

10. *Composition* (*Kompozitsiia*). 1918. Gouache on paper. 13 × 6⅜" (33 × 16.2 cm). The Museum of Modern Art, New York. Gift of the artist.

11. *Design for a Kiosk* (*Proekt kioska*). 1919. Gouache and pen and ink on paper. 20¹⁄₁₆ × 13⅝" (51 × 34.5 cm). A. Rodchenko and V. Stepanova Archive, Moscow.

Design for a kiosk. Biziaks motto. 1. Projector for signalization. 2. Suspended posters. 3. Three-sided clocks. 4. Posters' screens. 5. Speaker's platform. 6. Sale of literature and newspaper (*Proekt kioska. Deviz biziaks. 1. Prozhektor dlia ob"iavlenii. 2. Plakaty podvesnye. 3. Chasy trekhstoronnie. 4. Plakaty ekrannye. 5. Mesto oratora. 6. Torgovlia liter i gazetoi*).

12. *Design for a Kiosk* (*Proekt kioska*). 1919. Black and colored india ink on paper. 20¹⁵⁄₁₆ × 13½" (53.2 × 34.3 cm). The Pushkin State Museum of Fine Arts, Department of Private Collections, Moscow.

Design for a kiosk. Biziaks motto. / The future is our only goal (*Proekt kioska. Deviz biziaks. / Budushchee edinstvennaia nasha tsel'*).

13. *Non-Objective Composition* (*Bespred-metnaia kompozitsiia*). 1918. Oil on wood. 20⅞ × 9⅞" (53 × 25 cm). State Russian Museum, St. Petersburg.

14. *Non-Objective Composition no. 53* (*Bespredmetnaia kompozitsiia n. 53*). 1918. Oil on plywood. 28¾ × 12¹³⁄₁₆" (73 × 32.5 cm). State Russian Museum, St. Petersburg.

15. *Non-Objective Composition* (*Bespred-metnaia kompozitsiia*). 1918. Oil on wood. 28⅜ × 12³⁄₁₆" (72 × 31 cm). Astrakhan State Picture Gallery named after B. M. Kustodiev.

16. *Composition no. 56* (*Kompozitsiia n. 56*). 1918. Oil on canvas. 27¹⁵⁄₁₆ × 20½" (71 × 52 cm). State Russian Museum, St. Petersburg.

17. *Composition no. 71 (Flying Form)* (*Kompozitsiia n. 71 [Letiashchaia forma]*). 1918. Oil on canvas. 36¼ × 23¼" (92 × 59 cm). A. Rodchenko and V. Stepanova Archive, Moscow.

18. *Composition no. 86 (66) (Density and Weight)* (*Kompozitsiia n. 86 [66] [Plotnost' i ves]*). 1919. Oil on canvas. 48³⁄₁₆ × 28¹⁵⁄₁₆" (122.3 × 73.5 cm). State Tretyakov Gallery, Moscow.

19. *Composition no. 81 (Black on Black)* (*Kompozitsiia n. 81 [Chernoe na chernom]*). 1918. Oil on canvas. 32¼ × 25⅝" (82 × 65 cm). State Russian Museum, St. Petersburg.

20. *Composition no. 64 (84) (Black on Black)* (*Kompozitsiia n. 64 [84] [Chernoe na chernom]*). 1918. Oil on canvas. 28¹⁵⁄₁₆ × 29⁵⁄₁₆" (73.5 × 74.5 cm). State Tretyakov Gallery, Moscow.

21. *Non-Objective Painting no. 80 (Black on Black)* (*Bespredmetnaia zhivopis' n. 80 [Chernoe na chernom]*). 1918. Oil on canvas. 32¼ × 31¼" (81.9 × 79.4 cm). The Museum of

Modern Art, New York. Gift of the artist, through Jay Leyda.

22–25. *Rodchenko Prints 1919* (*Graviury Rodchenko 1919*). 1919. Four from a portfolio of thirteen linocut prints. 22 (cover): 6¼ × 4¼" (15.6 × 10.7 cm). 23: 6⁷⁄₁₆ × 4½" (16.4 × 11.4 cm). 24: 6⁷⁄₁₆ × 4⁷⁄₁₆" (16.4 × 11.3 cm). 25: 6½ × 4½" (16.5 × 11.5 cm). A. Rodchenko and V. Stepanova Archive, Moscow.

26. Architectonic drawing. 1919. From the series "City with Observatory" (*Gorod s verkhnim fasadom*). Pen and ink on paper. 14 × 8⅝" (35.5 × 22 cm). The Pushkin State Museum of Fine Arts, Department of Private Collections, Moscow.

27. Architectonic drawing. 1920. From the series "City with Observatory" (*Gorod s verkhnim fasadom*). Pen and ink on paper mounted on cardboard. 10¼ × 8¼" (26 × 21 cm). The Pushkin State Museum of Fine Arts, Department of Private Collections, Moscow.

28. Sketch for a project for Sovdep (the Soviet of Deputies Building), Moscow. 1920. From the series "City with Observatory" (*Gorod s verkhnim fasadom*). Pen and ink and gouache on paper. 10¼ × 8⅛" (26 × 20.7 cm). A. Rodchenko and V. Stepanova Archive, Moscow.

29. Poster for the *10th State Exhibition: Non-Objective Art and Suprematism* (*10aia gosudarstvennaia vystavka: Bespredmetnoe tvorchestvo i Suprematizm*), Moscow. 1919. Gouache on black paper. 20½ × 12¹¹⁄₁₆" (52 × 32.2 cm). The Pushkin State Museum of Fine Arts, Department of Private Collections, Moscow.

Rejoice, today the revolution of the spirit is before you. We have thrown away the age-old chains of the photographic, banality, subjectivity. We are the Russian doves of painting, discoverers of new paths of creation. Today our creation (*Raduites' sevodnia revoliutsiia dukha pred vami vnimaite nam sbrosivshim vekovye tsepi fotografichenosti trafaretnosti siuzhetnosti my russkie kolumby zhivopisi otkryvateli novykh putei tvorchestva sevodnia nashe tvorchestvo*).

30. *Composition no. 60* (*Kompozitsiia n. 60*). 1918. From the series "Concentration of Color" (*Kontsentratsiia tsveta*). Oil on canvas. 24 × 19¹¹⁄₁₆" (61 × 50 cm). A. Rodchenko and V. Stepanova Archive, Moscow.

31. *Composition no. 113 on Yellow Ground* (*Kompozitsiia n. 113 na zheltom fone*). 1920. From the series "Concentration of Color" (*Kontsentratsiia tsveta*). Oil on canvas. 27¾ × 27¾" (70.5 × 70.5 cm). The Pushkin State Museum of Fine Arts, Department of Private Collections, Moscow.

32. *Construction no. 92 (on Green)* (*Konstruktsiia n. 92 [na zelenom]*). 1919. Oil on canvas. 28¾ × 18⅛" (73 × 46 cm). Kirov Regional Art Museum named after V. and A. Vasnetsovy.

33. Sketch for the cover of *Linearism* (*Liniizm*), an unpublished treatise by Rod-chenko. 1920. Pen and ink on graph paper. 7¹¹⁄₁₆ × 6¹⁵⁄₁₆" (19.5 × 17.6 cm). A. Rodchenko and V. Stepanova Archive, Moscow.

34. *Construction no. 89 (on Light Yellow)* (*Konstruktsiia n. 89 [na svetlo-zheltom]*). 1919. Oil on canvas. 26⁹⁄₁₆ × 15¾" (67.5 × 40 cm). The Pushkin State Museum of Fine Arts, Department of Private Collections, Moscow.

35. *Construction no. 90 (on White)* (*Konstruktsiia n. 90 [na belom]*). 1919. Oil on canvas. 26¾ × 17¾" (68 × 45 cm). A. Rodchenko and V. Stepanova Archive, Moscow.

36. *Construction no. 127 (Two Circles)* (*Konstruktsiia n. 127 [Dva kruga]*). 1920. Oil on canvas. 24⅝ × 20⅞" (62.5 × 53 cm). The Pushkin State Museum of Fine Arts, Department of Private Collections, Moscow.

37. *Construction no. 128 (Line)* (*Konstruktsiia n. 128 [Liniia]*). 1920. Oil on canvas. 24⅜ × 20⅞" (62 × 53 cm). The Pushkin State Museum of Fine Arts, Department of Private Collections, Moscow.

38. *Construction no. 126 (Line)* (*Konstruktsiia n. 126 [Liniia]*). 1920. Oil on canvas. 22¹³⁄₁₆ × 20¹⁄₁₆" (58 × 51 cm). Private collection, cour-tesy Annely Juda Fine Art, London.

39. Construction *No. 58*. 1921. Linocut. 8⅞ × 5¹⁵⁄₁₆" (22.5 × 15 cm). A. Rodchenko and V. Stepanova Archive, Moscow.

40. Construction *No. 60*. 1921. Linocut. 8⅞ × 5¹⁵⁄₁₆" (22.5 × 15 cm). A. Rodchenko and V. Stepanova Archive, Moscow.

41. Construction. 1921. Linocut. 7⁵⁄₁₆ × 6¹¹⁄₁₆" (18.5 × 17 cm). A. Rodchenko and V. Stepanova Archive, Moscow.

42. Construction. 1921. Linocut. 7¹³⁄₁₆ × 6" (19.8 × 15.3 cm). A. Rodchenko and V. Stepanova Archive, Moscow.

43. Linear construction. 1920. Pen and black and colored ink on paper. 12¾ × 7¹¹⁄₁₆" (32.4 × 19.5 cm). The Pushkin State Museum of Fine Arts, Department of Private Collections, Moscow.

44. Linear construction. 1920. Pen and black and colored ink on paper. 12¹¹⁄₁₆ × 7⅞" (32.2 × 20 cm). A. Rodchenko and V. Stepanova Archive, Moscow.

45. Linear construction. 1920. Pen and black and colored ink on paper. 12¾ × 7¾" (32.4 × 19.7 cm). The Museum of Modern Art, New York. Given anonymously.

46. *Construction no. 106 (on Black)* (*Konstruktsiia n. 106 [na chernom]*). 1920. Oil on canvas. 40⅛ × 27⁹⁄₁₆" (102 × 70 cm). The Pushkin State Museum of Fine Arts, Department of Private Collections, Moscow.

47. Constructive composition *No. 2*. 1921. Pencil on paper. 13⁵⁄₁₆ × 8⁹⁄₁₆" (33.8 × 21.7 cm). A. Rodchenko and V. Stepanova Archive, Moscow.

48. Constructive composition *No. 5*. 1921. Pencil on paper. 13¾ × 8¹¹⁄₁₆" (35 × 22 cm). A. Rodchenko and V. Stepanova Archive, Moscow.

49. *Construction no. 17* (*Konstruktsiia n. 17*). 1921. Black and colored crayon on paper. 19¹¹⁄₁₆ × 12⅞" (50 × 32.7 cm). State Tretyakov Gallery, Moscow.

50. Construction *No. 8*. 1921. Colored pencil on paper. 19⅛ × 12¹³⁄₁₆" (48.5 × 32.5 cm). A. Rodchenko and V. Stepanova Archive, Moscow.

51. Sketches for spatial constructions. 1921. Pencil on graph paper. 6 × 6¹⁵⁄₁₆" (15.2 × 17.6 cm). A. Rodchenko and V. Stepanova Archive, Moscow.

52. Project for a perpetual motion machine. 1921. Pencil on graph paper. 14 × 8¹¹⁄₁₆" (35.5 × 22.5 cm). A. Rodchenko and V. Stepanova Archive, Moscow.

53. *Spatial Construction no. 12* (*Prostranstvennaia konstruktsiia n. 12*). c. 1920. From the series "Light-Reflecting Surfaces" (*Ploskosti otrazhaiushchie svet*). Plywood painted with aluminum paint and wire. 24 × 32¹⁵⁄₁₆ × 18½" (61 × 83.7 × 47 cm). The Museum of Modern Art, New York. Acquisition made possible through the extraordinary efforts of George and Zinaida Costakis, and through the Nate B. and Frances Spingold, Matthew H. and Erna Futter, and Enid A. Haupt Funds.

54. *Pure Red Color* (*Chistyi krasnyi tsvet*), *Pure Yellow Color* (*Chistyi zheltyi tsvet*), *Pure Blue Color* (*Chistyi sinii tsvet*). 1921. Oil on canvas. Each panel 24⅝ × 20¹¹⁄₁₆" (62.5 × 52.5 cm). A. Rodchenko and V. Stepanova Archive, Moscow.

55. Variant page from a catalogue for the exhibition *5x5=25*, Moscow. 1921. Colored crayon on graph paper. 6³⁄₁₆ × 3¹¹⁄₁₆" (15.7 × 9.4 cm). A. Rodchenko and V. Stepanova Archive, Moscow.

56. Variant page from a catalogue for the exhibition *5x5=25*, Moscow. 1921. Colored crayon on graph paper. 6³⁄₁₆ × 3¹¹⁄₁₆" (15.7 × 9.4 cm). The Museum of Modern Art, New York. Gift of Mrs. Alfred H. Barr, Jr.

57. Variant page from a catalogue for the exhibition *5x5=25*, Moscow. 1921. Colored crayon on graph paper. 6³⁄₁₆ × 3¹¹⁄₁₆" (15.7 × 9.4 cm). Getty Research Institute, Research Library, Los Angeles.

Collages, 1919–22

58. Cover design for the book *Tsotsa*, by Aleksei Kruchenykh. 1921. Cut-and-pasted papers and colored pencil on paper. 7 × 5⁷⁄₁₆" (17.8 × 13.8 cm). A. Rodchenko and V. Stepanova Archive, Moscow.

59. Untitled. 1919. Cut-and-pasted printed papers and photographs on paper. 10¹³⁄₁₆ × 6⅞" (27.5 × 17.5 cm). The Pushkin State Museum of Fine Arts, Department of Private Collections, Moscow.

60. Untitled. 1922. Cut-and-pasted printed papers on paper. 10⁷⁄₁₆ × 6¹¹⁄₁₆" (26.5 × 17 cm). A. Rodchenko and V. Stepanova Archive, Moscow.

61. Untitled. 1922. Cut-and-pasted printed papers on paper. 10⅝ × 6¹¹⁄₁₆" (27 × 17 cm). The Pushkin State Museum of Fine Arts, Department of Private Collections, Moscow.

62. Cover of the magazine *Kino-Fot* (Cine-Photo) no. 4 of 1922 (October), a special issue on Mayakovsky. Letterpress. 11⁷⁄₁₆ × 8¹¹⁄₁₆" (29 × 22 cm). The Pushkin State Museum of Fine Arts, Department of Private Collections, Moscow.

Maquettes for illustrations for *About This* (*Pro eto*), a poem by Vladimir Mayakovsky, 1923

An excerpt from the poem was printed as a caption below each of the eight internal illustrations.

63. Cover. Cut-and-pasted gelatin-silver photograph, ink, and gouache on paper. 9⁷⁄₁₆ × 6½" (24 × 16.5 cm). State Mayakovsky Museum, Moscow.

64. Cut-and-pasted printed papers, gelatin-silver photographs, and ink on cardboard. 13½ × 9⅝" (34.3 × 24.4 cm). State Mayakovsky Museum, Moscow.

She's in bed, lying awake, — / He. / A telephone on the table (*V posteli ona, ona lezhit, — / On. / Na stole telefon*).

65. Cut-and-pasted printed papers, gelatin-silver photographs, ink, and gouache on cardboard. 13⅞ × 9⅝" (35.3 × 24.4 cm). State Mayakovsky Museum, Moscow.

Came / out of the cord / jealousy crawling / a cave-dwelling troglodyte monster (*Polzlo / iz shnurna / skrebushcheisia revnosti / vremen trogladitskik togdashene chudishche*).

66. Cut-and-pasted printed papers, gelatin-silver photographs, ink, and gouache on cardboard. 16⅜ × 11⁹⁄₁₆" (41.5 × 29.4 cm). State Mayakovsky Museum, Moscow.

> I paw at my ears — / in vain! / I hear / my / my own voice / the knife of my voice cuts me through my paws (*Ia ushi lapliu — / naprasnye mnesh'! / slyshu / moi / moi sobstvennyi golos / mne lapy dyriavit golosa nozh*).

67. Cut-and-pasted printed papers and gelatin-silver photographs on cardboard. 16¾ × 12¹³⁄₁₆" (42.5 × 32.5 cm). State Mayakovsky Museum, Moscow.

> And the century stands / as it was / Unwhipped / domesticity's mare won't move (*I eto stoit stolet'ia / kak bylo / ne b'iot / i ne tronulas' byta kobyla*).

68. Cut-and-pasted printed papers and gelatin-silver photographs on cardboard. 18⅞ × 12⅝" (48 × 32 cm). State Mayakovsky Museum, Moscow.

> And again / the walls of the burning steppe / ring and sigh in the ear with the two-step (*I snova / sten raskalennye stepi / pod ukhom zveniat i vzdyvaiot v tustepe*).

69. Cut-and-pasted printed papers and gelatin-silver photographs on cardboard. 14 × 9¼" (35.5 × 23.5 cm). State Mayakovsky Museum, Moscow.

> I catch my balance, / waving terribly (*Lovliu ravnovesie, / strashno mashu*).

70. Cut-and-pasted printed papers, gelatin-silver photographs, and ink on cardboard. 13⅞ × 9⅝" (35.2 × 24.5 cm). State Mayakovsky Museum, Moscow.

> Four times I'll age, / four times growing younger (*Chetyrezhdy sostarios', / chetyrezhdy omolozhennyi*).

71. Cut-and-pasted printed papers and gelatin-silver photographs on cardboard. 13¾ × 9⁹⁄₁₆" (35 × 24.3 cm). State Mayakovsky Museum, Moscow.

> And she / — she loved animals — / also will come to the zoo (*I ona / —ona zverei liubila — / tozhe stupit v sad*).

Printed copies of Pro eto *shown in the exhibition belong to the collections of The Judith Rothschild Foundation, New York, and The*

Museum of Modern Art, New York, Gift of Philip Johnson, Jan Tschichold Collection.

Works on paper, 1922

72. Design for "production clothing" (*prozodezhda*). Ink on paper. 14⁹⁄₁₆ × 11¹³⁄₁₆" (37 × 30 cm). The Pushkin State Museum of Fine Arts, Department of Private Collections, Moscow.

73. *Self-Caricature (Avtosharzh).* Cut-and-pasted printed papers and gelatin-silver photograph on paper. 7¼ × 5⅞" (18.5 × 15 cm). A. Rodchenko and V. Stepanova Archive, Moscow.

Designs for a tea set, 1922

74. *Tea pot (Chainik dlia kipiatku).* Ink and gouache on paper. 10⅝ × 14¹¹⁄₁₆" (27 × 37.2 cm). A. Rodchenko and V. Stepanova Archive, Moscow.

75. *Tea tray (Podnos).* Ink and gouache on paper. 22¹³⁄₁₆ × 17⅝" (58 × 44.8 cm). A. Rodchenko and V. Stepanova Archive, Moscow.

Fabric designs, 1924

76. Ink and gouache on paper. 7½ × 9⁷⁄₁₆" (19 × 24 cm). A. Rodchenko and V. Stepanova Archive, Moscow.

77. Ink and gouache on paper. 11⅜ × 11⅛" (29.7 × 29.3 cm). A. Rodchenko and V. Stepanova Archive, Moscow.

78. Ink and gouache on paper. 16⅝ × 12¹¹⁄₁₆" (42.2 × 32.2 cm). The Pushkin State Museum of Fine Arts, Department of Private Collections, Moscow.

Advertising posters for the state airline Dobrolet, 1923

79. Lithography. 13¾ × 17¾" (34.9 × 45.1 cm). Collection Merrill C. Berman.

> Everyone . . . Everyone . . . Everyone. . . . He who is not a stockholder in Dobrolet is not a citizen of the USSR. / One gold ruble makes anyone a stockholder in Dobrolet (*Vsem . . . Vsem . . . Vsem. . . . tot ne grazhdanin SSSR kto dobroleta ne aktsioner. / Odin rubl' zolotom delaet kazhdogo aktsionerom dobroleta*).

80. Lithography. 14¾ × 18" (37.5 × 45.7 cm). A. Rodchenko and V. Stepanova Archive, Moscow.

> Everyone . . . Everyone . . . Everyone. . . . He who is not a stockholder in Dobrolet is not a citizen of the USSR. / One gold ruble makes anyone a stockholder in Dobrolet (*Vsem . . . Vsem . . . Vsem. . . . tot ne grazhdanin SSSR kto dobroleta ne aktsioner. / Odin rubl' zolotom delaet kazhdogo aktsionerom dobroleta*).

81. Lithography. 13⅞ × 18⅛" (35.2 × 46 cm). The Museum of Modern Art, New York. Given anonymously.

> Everyone . . . Everyone . . . Everyone. . . . He who is not a stockholder in Dobrolet is not a citizen of the USSR. / One gold ruble makes anyone a stockholder in Dobrolet (*Vsem . . . Vsem . . . Vsem. . . . tot ne grazhdanin SSSR kto dobroleta ne aktsioner. / Odin rubl' zolotom delaet kazhdogo aktsionerom dobroleta*).

82. Lithography. 14⁷⁄₁₆ × 18" (36.7 × 45.7 cm). A. Rodchenko and V. Stepanova Archive, Moscow.

> Everyone . . . Everyone . . . Everyone. . . . He who is not a stockholder in Dobrolet is not a citizen of the USSR. / One gold ruble makes anyone a stockholder in Dobrolet (*Vsem . . . Vsem . . . Vsem. . . . tot ne grazhdanin SSSR kto dobroleta ne aktsioner. / Odin rubl' zolotom delaet kazhdogo aktsionerom dobroleta*).

83. Lithography. 42 × 28" (106.7 × 71.1 cm). Collection Merrill C. Berman.

> Shame on you, your name is not yet on the list of Dobrolet stockholders. / The whole country follows this list (*Stydites', vashego imeni eshche net v spiske aktsionerov Dobroleta. / Vsia strana sledit za etim sniskom*).

Insignia designs for the state airline Dobrolet, 1923

84. Ink and gouache on paper. 8¼ × 11¹³⁄₁₆"
(21 × 30 cm). The Pushkin State Museum of
Fine Arts, Department of Private Collections,
Moscow.

85. Ink and gouache on paper. 8¹⁄₁₆ × 11¼"
(20.4 × 28.6 cm). A. Rodchenko and
V. Stepanova Archive, Moscow.

86. Ink and gouache on paper. 8¼ × 11¹¹⁄₁₆"
(21 × 29.7 cm). The Pushkin State Museum of
Fine Arts, Department of Private Collections,
Moscow.

87. Ink and gouache on paper. 10¼ × 12³⁄₁₆"
(26 × 31 cm). The Pushkin State Museum of
Fine Arts, Department of Private Collections,
Moscow.

88. Ink and gouache on paper. 8¼ × 11⅝"
(21 × 29.6 cm). A. Rodchenko and
V. Stepanova Archive, Moscow.

**Stock-offering prospectuses and letterhead
for the state airline Dobrolet, 1923**

89. Cover for stock-offering prospectus.
Letterpress, mounted on gray board. 6⅜ ×
4⁹⁄₁₆" (16.2 × 11.6 cm); mount: 13¾ × 10¼"
(35 × 26 cm). A. Rodchenko and V. Stepanova
Archive, Moscow.

> **Why is a commercial Soviet airline
> necessary? Dobrolet (*Zachem nuzhen
> kommercheskii vozdushnyi flot SSSR?
> Dobrolet*).**

90. Cover for stock-offering prospectus.
Letterpress, mounted on gray board. 6⁹⁄₁₆ ×
4⅝" (16.6 × 11.7 cm); mount: 13¾ × 10¼"
(35 × 26 cm). A. Rodchenko and V. Stepanova
Archive, Moscow.

> **Only one gold ruble and you are a stock-
> holder in Dobrolet (*Tol'ko rubl' zolotom i ty
> aktsioner dobroleta*).**

91. Letterhead. Letterpress. 6½ × 8" (16.5 ×
20.3 cm). Collection Elaine Lustig Cohen.

**Jewelry for the state airline Dobrolet,
1924–26**

92. Enamel on cast brass.

a. Pin. ¾" (1.9 cm) diameter. The Judith
Rothschild Foundation, New York.

b. Pin. ¾" (1.9 cm) diameter. The Judith
Rothschild Foundation, New York.

c. Pin. ¾" (1.9 cm) diameter. The Judith
Rothschild Foundation, New York.

d. Pin. ¾" (1.9 cm) diameter. Howard
Schickler Fine Art, New York.

e. Pin. ¾" (1.9 cm) diameter. Howard
Schickler Fine Art, New York.

f. Pin. ¾" (1.9 cm) diameter. Howard
Schickler Fine Art, New York.

g. Pair of cufflinks. Each ⁹⁄₁₆ × ⅞" (1.4 ×
2.2 cm). Howard Schickler Fine Art,
New York.

h. Pin. ⅝ × ⅞" (1.6 × 2.2 cm). Collection
Svetlana Aronov.

i. Pin. ¹⁵⁄₁₆" (2.4 cm) diameter. Howard
Schickler Fine Art, New York.

j. Button. ⅝" (1.6 cm) diameter. Collection
Svetlana Aronov.

**Wrappers for Nasha Industriia (Our industry)
caramels, from the Krasnyi Oktiabr' (Red
October) factory, Moscow, 1923**

93. Lithography. 3¼ × 3" (8.3 × 7.6 cm).
Text by Vladimir Mayakovsky. Collection
Merrill C. Berman.

> **In springtime, the earth is black, / fluffed
> up like cotton wool. / Grain elevator, give
> larger seed / to the ploughed field (*Po
> vesne zemlia cherna / vzbita slovno vata. /
> Pokrupnei davai zerna / pashne elevator*).**

94. Lithography. 3¼ × 3" (8.3 × 7.6 cm).
Text by Vladimir Mayakovsky. Collection
Merrill C. Berman.

> **Don't stand there on the bank of the river /
> until old age, / it's better to throw a
> bridge / over the river (*Ty ne stoi u reki / do**

*sedogo veku, / luchshe most perekin' /
cherez etu reku*).

95. Lithography. 3⅛ × 2¹⁵⁄₁₆" (8 × 7.5 cm). Text
by Vladimir Mayakovsky. A. Rodchenko and
V. Stepanova Archive, Moscow.

> **Look closely at the connecting rods / pay
> close attention to the boiler / Well — every-
> where we should / lay the rails (*Prismotris'
> k shatunam / na kotel pritsel'sia /
> Khorosho — vsiudu nam / prolozhit' by
> rel'sy*).**

96. Lithography. 3⅛ × 2¹⁵⁄₁₆" (8 × 7.5 cm). Text
by Vladimir Mayakovsky. A. Rodchenko and
V. Stepanova Archive, Moscow.

> **Let the tractor / plough the meadow (*Pust'
> pashet lug / traktornyi plug*).**

97. Lithography. 3⅛ × 2¹⁵⁄₁₆" (8 × 7.5 cm). Text
by Vladimir Mayakovsky. A. Rodchenko and
V. Stepanova Archive, Moscow.

> **Old fellow, don't be lame, / grab on to the
> new: / Lay the tram tracks / from village to
> city (*Starina ne khromai / Podtianis', chto
> molodo: / Provedemete tramvai / ot sela do
> goroda*).**

98. Lithography. 3⅜ × 3⅛" (8.6 × 8 cm).
Text by Vladimir Mayakovsky. Collection
Merrill C. Berman.

> **Here, with this very generator / one can
> move the mountain / and relieve our
> misfortune (*Etoio vot samoio mashinoio
> dinamoio / mozhno goru sdvinut' proch' /
> Gorio nashemy pomoch'*).**

**Boxes for the Krasnyi Oktiabr' (Red October)
factory, Moscow, 1923**

99. Box for Nasha Industriia (Our industry)
caramels. Lithography. 14¹⁵⁄₁₆ × 9¼" (38 × 23.5
cm). Text by Vladimir Mayakovsky. The
Pushkin State Museum of Fine Arts,
Department of Private Collections, Moscow.

> **From the "Factory Caramel" / we had no
> losses. / From left and right / and every-
> where come praise and fame! / Take this
> candy / with all certainty as a sign. / The
> songs on its covers / become more and
> more known. / This new venture / teaches
> better than a textbook. / "Factory-made"
> caramels / force out ordinary-tasting**

ones. / The village and the factory / will call them the best! (*Ot "Fabrichnoi Karameli" / my ubytkov ne imeli. / I nalevo i napravo / vsiudu ei khvala i slava! / Ty voz'mi konfetu etu / nepremenno na primetu. / S kazhdym chasom vse izvestnei / na ee obertkakh pesni. / Eta novaia zateia / uchit luchshe gramoteia. / Vytesniaet sort obychnyi / karameli vkus "Fabrichnoi." / I derevnia i zavod / luchshei—etu nazovet!*).

100. Box for Krasnyi Aviator (Red aviator) cookies. Lithography. 10 1/8 × 11 1/16" (25.7 × 28.1 cm). Text by Nikolai Aseev. Collection Merrill C. Berman.

Scatter among the bushes, / enemy cavalry. / Here and there the "Aviator" pursues you. / Nation of generals, crawl away growling under the table. / Our aviation rises higher. / We are propagating the idea everywhere / even on candies: / If the sky is ours / the enemy will crawl away like a crab (*Rassypaisia po kustam / vrazheskaia konnitsa. / Za toboiu zdes' i tam / "Aviator" gonitsia. / Upolzai pod stol pycha / generalov natsiia, / podymaisia na plechakh / nasha aviatsiia. / My vezde provodim mysl' / dazhe v dele lakomstv: / esli nashei stanet vys' / vrag polezet rakom*).

Advertising designs for the state grocery concern Mossel'prom (Moscow agricultural industry), 1923–25

101. Maquette for an advertisement for Liuks (Luxe) cigarettes. 1923. Gouache on paper. 7 1/2 × 17 7/8" (19 × 45.4 cm). Text by Vladimir Mayakovsky. Howard Schickler Fine Art, New York.

Cigarettes Liuks / latest novelty / higher quality / reasonable price. / Nowhere else as at Mossel'prom (*Papirosy Liuks / novinka posledniaia / kachestvo vysshee / tsena sredniaia. / Nigde krome kak v Mossel'prome*).

102. Maquette for an advertisement for Mossel'prom cigarettes. 1923. Gouache on paper. 7 1/2 × 17 15/16" (19.1 × 45.5 cm). Text by Vladimir Mayakovsky. Howard Schickler Fine Art, New York.

No story can tell / no pen can describe / Mossel'prom cigarettes. / Nowhere else as at Mossel'prom (*Skazkami ne raskazhesh' / ne opishesh' perom / papirosy Mossel'prom. / Nigde krome kak v Mossel'prome*).

103. Maquette for an advertisement for Krasnaia Zvezda (Red star) cigarettes. 1923. Gouache on paper. 8 15/16 × 17 5/8" (22.7 × 44.8 cm). Text by Vladimir Mayakovsky. Howard Schickler Fine Art, New York.

All smokers, / always and everywhere, / prefer / Krasnaia Zvezda. / Nowhere else as at Mossel'prom (*Vse kyril'shchiki, / vsegda i vezde / otdaiut prednochtenie / Krasnoi Zvezde. / Nigde krome kak v Mossel'prome*).

104. Advertisement for Krasnaia Zvezda (Red star) cigarettes. 1923. Lithography. 3 3/4 × 8 3/8" (9.5 × 21.3 cm). Text by Vladimir Mayakovsky. Collection Merrill C. Berman.

All smokers, / always and everywhere, / prefer / Krasnaia Zvezda. / Nowhere else as at Mossel'prom (*Vse kyril'shchiki, / vsegda i vezde / otdaiut prednochtenie / Krasnoi Zvezde. / Nigde krome kak v Mossel'prome*).

105. Cigarette advertisements reproduced in the magazine *Krasnaia Niva* (Red field), October 20, 1923. Letterpress. 12 3/16 × 9 1/8" (31 × 23.2 cm). Text by Vladimir Mayakovsky. A. Rodchenko and V. Stepanova Archive, Moscow.

No story can tell, no pen can describe / Mossel'prom cigarettes. / Nowhere else as at Mossel'prom (*Skazkami ne raskazhesh', ne opishesh' perom / papirosy Mossel'prom. / Nigde kak v Mossel'prome*). All smokers, always and everywhere, prefer Krasnaia Zvezda. / Nowhere else as at Mossel'prom (*Vse kyril'shchiki, vsegda i vezde, otdaiut prednochtenie Krasnoi Zvezde. / Nigde krome kak v Mossel'prome*). Only Ira cigarettes remain with us from the old world. / Nowhere else as at Mossel'prom (*Nami ostavlia iutsia ot starogo mira tol'ko papirosy Ira. / Nigde krome kak v Mossel'prome*).

106. Maquette for an advertisement for cookies from the Krasnyi Oktiabr' (Red October) factory. 1923. Gouache on paper. 32 × 21 3/4" (81.3 × 55.2 cm). Text by Vladimir Mayakovsky. Howard Schickler Fine Art, New York.

I eat cookies / from the Krasnyi Oktiabr' factory, / formerly Einem. / I don't buy anywhere except at / Mossel'prom (*Ia em pechen'e / fabriki Krasnyi Oktiabr' / byvsh Einem. / Ne pokypaiu nigde krome kak v / Mossel'prome*).

107. Maquette for an advertisement for table oil. 1923. Gouache on paper. 33 × 20" (83.8 × 50.8 cm). Text by Vladimir Mayakovsky. Collection Merrill C. Berman.

Cooking oil / Attention working masses / Three times cheaper than butter! More nutritious than other oils! / Nowhere else as at Mossel'prom (*Stolovoe maslo / Vnimanie rabochikh mass / Vtroe deshevle korov'ego! Pitatel'nee prochikh maslo! / Net nigde krome kak v Mossel'prome*).

108. Maquette for an advertisement for the Mossel'prom cafeteria. 1923. Gouache on paper. 19 1/4 × 13 3/8" (49 × 34 cm). Text by Vladimir Mayakovsky. Howard Schickler Fine Art, New York.

Where can you get a fantastic lunch for—? / Where can you get lunch on workers' credit? / Where can you meet everyone for lunch? / Where can you read all the newspapers and magazines over a beer? / Where is the best lunchtime stage? / Nowhere else as at Mossel'prom (*Gde prekrasnyi obed za—? / Gde obedy v rabochii kredit? / Gde za obedom vstretish' vsekh? / Gde za pivom vse zhurnaly i gazety? / Gde za obedom luchshaia estrada? Nigde krome kak v Mossel'prome*).

109. Advertisement for Kino (Cine) cigarettes. 1924. Lithography. 12 5/8 × 9 13/16" (32.1 × 25 cm). Collection Merrill C. Berman.

110. Advertisement for Trekhgornoe (Three peaks) beer. 1925. Lithography. 28 1/8 × 19 1/8" (71.5 × 48.5 cm). Text by Vladimir Mayakovsky. The Pushkin State Museum of Fine Arts, Department of Private Collections, Moscow.

Trekhgornoe beer drives out hypocrisy and moonshine (*Trekhgornoe pivo vygonit von khanzhu i samogon*).

Advertisements for the state department store GUM (State universal store), 1923

111. Advertisement for Mozer watches, sold at GUM. Letterpress. 7 1/16 × 6 1/16" (18 × 15.4 cm). Text by Vladimir Mayakovsky. Collection Merrill C. Berman.

A man needs a watch. A watch from Mozer only. Mozer only at GUM (*Chelovek tol'ko s chasami. Chasy tol'ko Mozera. Mozer tol'ko u GUMa*).

112. Advertisement for GUM. Letterpress. 11 11/16 × 8 7/8" (29.7 × 22.5 cm). Text by Vladimir Mayakovsky. The Pushkin State Museum of Fine Arts, Department of Private Collections, Moscow.

Hold on to this lifesaver! / GUM / Everything for everyone / Good quality and cheap! / Firsthand! (*Khvataites' za etot spasetel'nyi krug! / GUM / Vse dlia vsekh / dobrokachestvenno deshevo! / Iz pervykh ruk!*).

113. Advertisement for GUM published in the magazine *Krasnaia Niva* (Red field), June 30, 1923. Letterpress, mounted on board. 10 5/16 × 8 3/8" (26.2 × 21.2 cm); mount: 13 3/4 × 10 1/4" (35 × 26 cm). Text by Vladimir Mayakovsky. A. Rodchenko and V. Stepanova Archive, Moscow.

No place for doubts and thoughts / Everything for women / Only at GUM (*Net mesta somnen'iu i dume / Vse dlia zhenshchiny / Tol'ko v GUMe*).

Advertisements for Rezinotrest (Rubber trust), 1923

114. Lithography. 28 1/4 × 19 15/16" (71.7 × 50.3 cm). Text by Vladimir Mayakovsky. Collection Merrill C. Berman.

Buy! / People of the Orient! / The best galoshes brought on camel / Rezinotrest (*Raskupai! / Vostochnyi liod! / Luchshie galoshi privez verbliud / Rezinotrest*).

115. Lithography. 28 3/8 × 20 11/16" (72 × 52.5 cm). Text by Vladimir Mayakovsky. The Pushkin State Museum of Fine Arts, Department of Private Collections, Moscow.

(In Turkish:) Camels / brought the best galoshes / People of the Orient / Hurry up buy boots / Rezinotrest.

Bookmarks for the publishing company Novost' (News), 1923

116. Gouache on cardboard. A. Rodchenko and V. Stepanova Archive, Moscow.

a. 5 7/8 × 4 3/4" (15 × 12 cm)
b. 5 5/16 × 5 1/8" (13.5 × 13 cm)
c. 3 15/16 × 4 5/16" (10 × 11 cm)
d. 5 5/16 × 6 1/8" (13.5 × 15.5 cm)
e. 4 3/4 × 3 3/8" (12 × 8.5 cm)
f. 4 7/8 × 3 7/8" (12.3 × 9.8 cm)
g. 5 1/16 × 3 7/8" (12.8 × 9.8 cm)
h. 3 1/8 × 5 5/16" (8 × 13.5 cm)

Covers of the magazine *Lef* (Left, or Left front of the arts), 1923–25

117. *Lef* no. 1 of 1923. Letterpress. 9 3/16 × 6 3/16" (23.3 × 15.8 cm). The Judith Rothschild Foundation, New York.

118. *Lef* no. 2 of 1923. Letterpress. 9 1/4 × 6 3/16" (23.5 × 15.8 cm). The Judith Rothschild Foundation, New York.

119. *Lef* no. 3 of 1923. Letterpress. 9 1/4 × 6 3/16" (23.5 × 15.8 cm). The Judith Rothschild Foundation, New York.

120. *Lef* no. 4 of 1924. Letterpress. 8 15/16 × 6 1/8" (22.7 × 15.6 cm). Howard Schickler Fine Art, New York.

121. Maquette for the cover of *Lef* no. 3 of 1923. Cut-and-pasted printed papers on paper. 12 1/16 × 10 7/16" (31 × 26.5 cm). A. Rodchenko and V. Stepanova Archive, Moscow.

122. Maquette for unpublished variant cover of *Lef* no. 1–2 of 1923. Cut-and-pasted printed papers, ink, and gouache on paper. 10 5/8 × 7 1/4" (27 × 18.4 cm). A. Rodchenko and V. Stepanova Archive, Moscow.

123. *Lef* no. 1 of 1924. Letterpress. 9 × 6" (22.8 × 15.2 cm). The Judith Rothschild Foundation, New York.

124. *Lef* no. 2 of 1924. Letterpress. 8 7/8 × 6" (22.5 × 15.2 cm). The Judith Rothschild Foundation, New York.

125. *Lef* no. 3 of 1925. Letterpress. 9 1/8 × 5 7/8" (23.2 × 14.9 cm). The Judith Rothschild Foundation, New York.

Book covers, 1923–24

126. Cover of the anthology *Flight: Aviation verses* (*Let: Avio stikhi*). 1923. Letterpress. 9 13/16 × 6 3/16" (24.9 × 15.6 cm). Collection Stephen and Jane Garmey.

127. Maquette for *Crisis* (*Krizis*), an illustration for the anthology *Flight: Aviation verses* (*Let: Avio stikhi*). 1923. Cut-and-pasted printed papers on paper. 14 3/8 × 9 11/16" (36.5 × 24.6 cm). A. Rodchenko and V. Stepanova Archive, Moscow.

128. Maquette for the cover of the book *In the World of Music* (*V mire muzyki*), by Anatoly Lunacharsky. 1923. Gouache on paper. 9 7/16 × 6 1/8" (24 × 15.5 cm). The Pushkin State Museum of Fine Arts, Department of Private Collections, Moscow.

129. Maquette for the cover of the book *Selected* (*Izbran'*), by Nikolai Aseev. 1923. Gouache on paper. 8 5/8 × 6 1/2" (22 × 16.5 cm). The Pushkin State Museum of Fine Arts, Department of Private Collections, Moscow.

130. Cover of the book *Altogether* (*Itogo*), by Sergei Tret'iakov. 1924. Lithography. 9 1/8 × 6 3/16" (23.3 × 15.8 cm). The Judith Rothschild Foundation, New York.

131. Cover of the book *Mayakovsky Smiles, Mayakovsky Laughs, Mayakovsky Mocks* (*Maiakovskii ulybaetsia, Maiakovskii smeetsia, Maiakovskii izdevaetsia*), by Vladimir Mayakovsky. 1923. Letterpress. 6 7/8 × 5 1/4" (17.5 × 13.2 cm). The Pushkin State Museum of Fine Arts, Department of Private Collections, Moscow.

132. Maquette for the cover of the book *On Mayakovsky* (*O Maiakovskom*), by Boris Arvatov. 1923. Gouache on paper. 9⅛ × 6" (23.2 × 15.4 cm). A. Rodchenko and V. Stepanova Archive, Moscow.

Portraits of Vladimir Mayakovsky, 1924

133. Vladimir Mayakovsky. Gelatin-silver print. 15¹¹⁄₁₆ × 8¹¹⁄₁₆" (39.9 × 22.1 cm). Edwynn Houk Gallery, New York; PaceWildenstein-MacGill, New York; and Galerie Rudolf Kicken, Cologne.

134. Vladimir Mayakovsky. Gelatin-silver print. 4³⁄₁₆ × 2¹⁵⁄₁₆" (10.7 × 7.5 cm). Gilman Paper Company Collection, New York.

135. Back cover of the book *Conversation with the Finance Inspector about Poetry* (*Razgovor c fininspektorom o poesii*), by Vladimir Mayakovsky. 1926. Letterpress. 6⅞ × 5" (17.4 × 12.9 cm). Collection Jack Banning. Courtesy Ubu Gallery, New York.

136. Maquette for the front cover of the book *Conversation with the Finance Inspector about Poetry* (*Razgovor c fininspektorom o poesii*), by Vladimir Mayakovsky. 1926. Cut-and-pasted gelatin-silver photographs and gouache on paper. 11⁵⁄₁₆ × 8⁹⁄₁₆" (28.7 × 21.7 cm). Galerie Berinson, Berlin.

137. Vladimir Mayakovsky. Gelatin-silver print. 11⅝ × 6¹³⁄₁₆" (29.5 × 17.3 cm). A. Rodchenko and V. Stepanova Archive, Moscow.

138. Vladimir Mayakovsky. Gelatin-silver print. 11⁷⁄₁₆ × 6¹³⁄₁₆" (29 × 17.3 cm). A. Rodchenko and V. Stepanova Archive, Moscow.

139. Two-page spread from the magazine *SSSR na Stroike* (*USSR in Construction*) no. 7 of 1940, a special commemorative issue on Vladimir Mayakovsky. Gravure. 16 × 23" (40.7 × 58.5 cm). Collection Jack Banning. Courtesy Ubu Gallery, New York.

140. Vladimir Mayakovsky. Gelatin-silver print. 6¹¹⁄₁₆ × 4⅜" (16.9 × 11.2 cm). The Metropolitan Museum of Art, New York. Ford Motor Company Collection. Gift of Ford Motor Company and John C. Waddell, 1987.

141. Vladimir Mayakovsky. Gelatin-silver print. 11⅜ × 8½" (28.8 × 21.5 cm). Berlinische Galerie, Landesmuseum für Moderne Kunst, Photographie und Architektur; Photographische Sammlung.

142. Vladimir Mayakovsky. Gelatin-silver print. 19⅛ × 13⅞" (48.7 × 35.2 cm). Galerie Gmurzynska, Cologne.

143. Vladimir Mayakovsky. Gelatin-silver print. 23½ × 14⅝" (59.7 × 37.1 cm). Barry Friedman Ltd., New York.

144. Vladimir Mayakovsky. Gelatin-silver print. 19⅜ × 11⅝" (49.2 × 29.6 cm). Collection Manfred Heiting, Amsterdam.

145. Vladimir Mayakovsky. Gelatin-silver print. 16¼ × 11⁷⁄₁₆" (41.2 × 29 cm). Galerie Alex Lachmann, Cologne.

Portraits, 1924

146. *Mother* (*Mat'*). Gelatin-silver print. 8⅞ × 6½" (22.5 × 16.5 cm). Collection Manfred Heiting, Amsterdam.

147. Varvara Stepanova. Gelatin-silver print. 15¾ × 11" (40 × 28 cm). A. Rodchenko and V. Stepanova Archive, Moscow.

148. Aleksandr Shevchenko. Gelatin-silver print. 11⅝ × 9¹⁄₁₆" (29.5 × 23 cm). George Eastman House, Rochester, N.Y.

149. Osip Brik. Unpublished illustration for the cover of the magazine *Lef*. Gouache on gelatin-silver print. 9¼ × 7⅛" (23.6 × 18 cm). The Pushkin State Museum of Fine Arts, Department of Private Collections, Moscow.

Covers of the serial novel *Mess Mend or a Yankee in Petrograd* (*Mess Mend ili Ianki v Petrograde*), by Jim Dollar (Marietta Shaginian), 1924

The novel was issued in ten installments, each with a cover designed by Rodchenko.

150. No. 1: *The Mask of Revenge* (*Maska mesti*). Letterpress. 7 × 5" (17.8 × 12.7 cm). The Museum of Modern Art, New York. Kenneth Walker Fund.

151. No. 2: *The Mystery of the Sign* (*Taina znaka*). Letterpress. 7 × 5" (17.8 × 12.7 cm). The Museum of Modern Art, New York. Kenneth Walker Fund.

152. No. 8: *The Police Genius* (*Genii syska*). Letterpress. 7 × 5" (17.8 × 12.7 cm). The Museum of Modern Art, New York. Kenneth Walker Fund.

153. No. 9: *The Yankees Are Coming* (*Ianki edut*). Letterpress. 7 × 5" (17.8 × 12.7 cm). The Museum of Modern Art, New York. Kenneth Walker Fund.

The remaining six copies of the Mess Mend *series shown in the exhibition come from the collection of The Museum of Modern Art, New York. Kenneth Walker Fund.*

Graphic design, 1924–25

154. Maquette for an unpublished cover of *Change All* (*Mena vsekh*), an anthology of Constructivist poetry. 1924. Gelatin-silver print. 9¼ × 7" (23.5 × 17.8 cm). The Pushkin State Museum of Fine Arts, Department of Private Collections, Moscow.

155. Poster for the film *Battleship Potemkin* (*Bronenosets Potemkin*), by Sergei Eisenstein. 1925. Lithography. 28¼ × 42½" (71.7 × 107.9 cm). Collection Merrill C. Berman.

156. Poster for the film *The Sixth Part of the World* (*Shestaia chast' mira*), by Dziga Vertov. 1926. Lithography. 42 × 27⅜" (106.7 × 69.5 cm). Collection Merrill C. Berman.

157. Poster for the film *Cine-Eye* (*Kino glaz*), by Dziga Vertov. 1924. Lithography. 35¾ × 26¾" (90.8 × 67.9 cm). Collection Merrill C. Berman.

Catalogues for the *Exposition Internationale des Arts Décoratifs et Industriels Modernes*, Paris, 1925

158. Cover for the catalogue *L'Art Décoratif U.R.S.S.: Moscou-Paris 1925*. Lithography. 10⁹⁄₁₆ × 7¹³⁄₁₆" (26.8 × 19.9 cm). The Judith Rothschild Foundation, New York.

159. Cover for the catalogue *Section URSS*. Letterpress. 6¹⁵⁄₁₆ × 5¼" (7.7 × 3.4 cm). The Judith Rothschild Foundation, New York.

Designs for the USSR Workers' Club (*Rabochii klub SSSR*) at the *Exposition Internationale des Arts Décoratifs et Industriels Modernes*, Paris, 1925

160. Lenin Corner. Black and red india ink and pasted gelatin-silver photograph on paper. 14⁵⁄₁₆ × 10" (36.3 × 25.5 cm). A. Rodchenko and V. Stepanova Archive, Moscow.

161. Collapsible rostrum. Black and red india ink on paper. 14¼ × 10" (36.2 × 25.5 cm). A. Rodchenko and V. Stepanova Archive, Moscow.

162. Library. Black and red india ink on paper. 14⅜ × 10" (36.5 × 25.5 cm). The Pushkin State Museum of Fine Arts, Department of Private Collections, Moscow.

163. Club entry and announcement panels. Black and red india ink and pencil on paper. 14³⁄₁₆ × 10" (36 × 25.5 cm). A. Rodchenko and V. Stepanova Archive, Moscow.

164. Lamp. Black and green india ink on paper. 14⅜ × 10" (36.5 × 25.5 cm). The Pushkin State Museum of Fine Arts, Department of Private Collections, Moscow.

165. Entry sign. Black and red india ink on paper. 14¼ × 10" (36.2 × 25.5 cm). The Pushkin State Museum of Fine Arts, Department of Private Collections, Moscow.

166. Chess table. Black and red india ink and gouache on paper. 14⅜ × 10" (36.5 × 25.5 cm). A. Rodchenko and V. Stepanova Archive, Moscow.

167. Chess table. Black and red india ink and gouache on paper. 14⅜ × 10" (36.5 × 25.5 cm). The Pushkin State Museum of Fine Arts, Department of Private Collections, Moscow.

Photographs from the series "The Building on Miasnitskaia Street" (*Dom na Miasnitskoi*), 1925

168. *Balconies* (*Balkony*). Gelatin-silver print. 9¼ × 11⅝" (23.5 × 29.5 cm). A. Rodchenko and V. Stepanova Archive, Moscow.

169. *Balconies* (*Balkony*). Gelatin-silver print. 15⁷⁄₁₆ × 9" (39.2 × 22.8 cm). A. Rodchenko and V. Stepanova Archive, Moscow.

170. *Balconies* (*Balkony*). Gelatin-silver print. 11⅜ × 9¹⁄₁₆" (29 × 23 cm). A. Rodchenko and V. Stepanova Archive, Moscow.

171. *Balconies* (*Balkony*). Gelatin-silver print. 11⅞ × 9⁷⁄₁₆" (30.2 × 24 cm). A. Rodchenko and V. Stepanova Archive, Moscow.

172. *Fire Escape* (*Pozharnaia lestnitsa*). Gelatin-silver print. 10⅛ × 7¾" (25.7 × 19.7 cm). Private collection, New York.

173. *Fire Escape* (*Pozharnaia lestnitsa*). Gelatin-silver print. 11⁷⁄₁₆ × 9⅛" (29.1 × 23.2 cm). Collection CameraWorks, Inc., New York.

Book covers for the publishing house Transpechat' (Transport press), Moscow, 1925

174. Cover of *Radio Technics* (*Radiotekhnika*), by Ia. Faivush. Letterpress. 8⅞ × 5⅞" (22.5 × 15 cm). A. Rodchenko and V. Stepanova Archive, Moscow.

175. Cover of *Railroad Assessor* (*Zh/dorozhnyi taksirovshchik*), by V. N. Batitskii. Letterpress. 9⅝ × 7" (24.4 × 17.7 cm). A. Rodchenko and V. Stepanova Archive, Moscow.

176. Cover of *Contemporary Techniques of Electric Lighting* (*Sovremennoe sostoianie tekhniki elektricheskogo osveshcheniia*), by V. D. Radvanskii. Letterpress. 8¹³⁄₁₆ × 5¹³⁄₁₆" (22.4 × 14.8 cm). A. Rodchenko and V. Stepanova Archive, Moscow.

177. Maquette for the cover of *Aircraft Engines* (*Aviatsionnye dvigateli*), by L. Marks. Cut-and-pasted letterpress, india ink, and gouache on paper. 11⅛ × 6¹¹⁄₁₆" (28.2 × 17 cm). A. Rodchenko and V. Stepanova Archive, Moscow.

178. Cover of *The Scientific Organization of Labor* (*Nauchnaia Organizatsiia Truda*), by Frederick Taylor. Letterpress. 9⁵⁄₁₆ × 6⁹⁄₁₆" (23.7 × 16.7 cm). The Pushkin State Museum of Fine Arts, Department of Private Collections, Moscow.

179. Cover of *The Ignition, Lighting, and Starting of Automobiles* (*Zazhiganie osveshchenie i pusk avtomobilei*), by I. V. Gribov. Letterpress. 7¹³⁄₁₆ × 5⅝" (19.8 × 14.2 cm). A. Rodchenko and V. Stepanova Archive, Moscow.

Graphic design and photography, 1924–30

180. Maquette for trade union poster. 1925. Cut-and-pasted printed papers, black and red india ink, and pencil on paper. 15⅝ × 10⅞" (39.7 × 27.5 cm). Text by Vladimir Mayakovsky. State Mayakovsky Museum, Moscow.
The union member thinks nothing of the NEP [New Economic Policy] man / The professional union defends [the worker] and deals with the NEP man (*Chlenu soiuza nepach ne pochem / Profsoiuz zashchitit i spravitsia / s nepachem*).

181. Trade union poster. 1925. Lithography. 14¹⁄₁₆ × 9¹⁵⁄₁₆" (35.7 × 25.3 cm). Text by Vladimir Mayakovsky. A. Rodchenko and V. Stepanova Archive, Moscow.
The union member is the first to enter the workers' faculty of higher-educational institutions (*Chlen profsoiuza pervym poidet v rabfak i vuza*).

182. Cover of the book *For a Living Il'ich [Lenin]* (*K zhivomu Il'ichu*), an anthology of memorial poetry published by the Lef group and Mapp (the Moscow Association of Proletarian Writers). 1924. Letterpress. 6⅞ × 5" (17.5 × 12.7 cm). The Pushkin State

Museum of Fine Arts, Department of Private Collections, Moscow.

183. *1905—October: Soviets of the Workers' Deputies (1905—Oktiabr': sovety rabochikh deputatov)*. No. 9 in the twenty-five-poster series "The History of the VKP(b) [All-Russian Communist Party (Bolshevik)] in Posters" (*Istoria VKP(b) v plakatakh*). 1925–26. Lithography. 26 × 20½" (66 × 52.1 cm). Collection Merrill C. Berman.

184. *The Party in the Years of the Imperialist War 1914–1916 (Partiia v gody imperialistich-eskoi voiny 1914–1916)*. No. 14 in the twenty-five-poster series "The History of the VKP(b) [All-Russian Communist Party (Bolshevik)] in Posters" (*Istoria VKP(b) v plakatakh*). 1925–26. Lithography. 26⅞ × 20½" (68.3 × 52.1 cm). Collection Merrill C. Berman.

185. *Rumba*. 1928. Gelatin-silver print. 15 × 9⅝" (38 × 24.4 cm). A. Rodchenko and V. Stepanova Archive, Moscow.

186. *Elephant (Slon)*. Illustration for the unpublished children's book *Auto-Animals (Samozveri)*, by Sergei Tret'iakov. 1926–27. Gelatin-silver print. 9⅛ × 6¹¹⁄₁₆" (23.2 × 17 cm). The J. Paul Getty Museum, Los Angeles.

187. *Roly-Poly (Karakatitsa)*. Illustration for the unpublished children's book *Auto-Animals (Samozveri)*, by Sergei Tret'iakov. 1926–27. Gelatin-silver print. 9⅛ × 6⅞" (23.2 × 17.5 cm). The J. Paul Getty Museum, Los Angeles.

188. Cover of the book *Syphilis (Sifilis)*, by Vladimir Mayakovsky. 1927. Letterpress. 6¼ × 4¾" (15.8 × 12 cm). A. Rodchenko and V. Stepanova Archive, Moscow.

189. Cover of the book *Materialization of the Fantastic (Materializatsia Fantastiki)*, by Ilya Ehrenburg. 1927. Letterpress. 6⅞ × 5¹³⁄₁₆" (17.5 × 13.2 cm). The Museum of Modern Art, New York. Gift of Philip Johnson, Jan Tschichold Collection.

190. *Down with Bureaucracy (Doloi biurokratizm)*. 1927. Gelatin-silver print. 5⁵⁄₁₆ × 7⅛" (13 × 17.2 cm). A. Rodchenko and V. Stepanova Archive, Moscow.

191. *The Vase (Vasa)*. 1928. From the series "Glass and Light" (*Steklo i svet*). Gelatin-silver print, mounted on gray board. 6⅞ × 4¾" (17.5 × 12.2 cm); mount: 14 × 10" (35.5 × 25.5 cm). A. Rodchenko and V. Stepanova Archive, Moscow.

192. *Wall of the Brianskii Railway Station (Stena Brianskogo vokzala)*. 1927. Gelatin-silver print. 8¹⁵⁄₁₆ × 4¾" (22.7 × 12.1 cm). The Museum of Modern Art, New York. Anonymous Purchase Fund.

193. The Brianskii railway station, Moscow. 1927. Gelatin-silver print. 9⁷⁄₁₆ × 13¾" (24 × 35 cm). A. Rodchenko and V. Stepanova Archive, Moscow.

194. Pine trees. c. 1930. Gelatin-silver print. 9 × 11⁷⁄₁₆" (22.9 × 29 cm). The Pushkin State Museum of Fine Arts, Moscow.

195. *Pine Trees, Pushkino (Sosny, Pushkino)*. 1927. Gelatin-silver print, mounted. 6¹⁵⁄₁₆ × 4¹⁵⁄₁₆" (17.6 × 12.6 cm); mount: 13⁹⁄₁₆ × 10" (34.5 × 25.5 cm). A. Rodchenko and V. Stepanova Archive, Moscow.

196. *Pine Trees, Pushkino (Sosny, Pushkino)*. 1927. Gelatin-silver print. 8¹³⁄₁₆ × 6¼" (22.5 × 15.9 cm). Collection Première Heure, Paris.

197. Sergei Tret'iakov. 1928. Gelatin-silver print. 11⁷⁄₁₆ × 9¼" (29 × 23.4 cm). The Museum of Modern Art, New York.

198. Nikolai Aseev. 1927. Gelatin-silver print. 6⁷⁄₁₆ × 8⅞" (16.3 × 22.5 cm). The Museum of Modern Art, New York.

Covers of the magazine *Novyi Lef* (New left, or New left front of the arts), 1927–28

199. *Novyi Lef* no. 1 of 1927. Letterpress. 8¹⁵⁄₁₆ × 5⅞" (22.7 × 15 cm). The Museum of Modern Art, New York. Gift of Philip Johnson, Jan Tschichold Collection.

200. *Novyi Lef* no. 11–12 of 1927. Letterpress. 9¹⁄₁₆ × 6" (23 × 15.2 cm). The Museum of Modern Art, New York. Gift of Philip Johnson, Jan Tschichold Collection.

201. *Novyi Lef* no. 1 of 1928. Letterpress. 9 × 6" (22.8 × 15.2 cm). The Museum of Modern Art, New York. Gift of Philip Johnson, Jan Tschichold Collection.

202. *Novyi Lef* no. 2 of 1927. Letterpress. 8¹⁵⁄₁₆ × 5⅞" (22.7 × 15 cm). The Museum of Modern Art, New York. Gift of Philip Johnson, Jan Tschichold Collection.

203. *Novyi Lef* no. 3 of 1927. Letterpress. 8¹⁵⁄₁₆ × 5⅞" (22.7 × 15 cm). The Museum of Modern Art, New York. Gift of Philip Johnson, Jan Tschichold Collection.

204. *Novyi Lef* no. 4 of 1927. Letterpress. 8¹⁵⁄₁₆ × 5⅞" (22.7 × 15 cm). The Museum of Modern Art, New York. Gift of Philip Johnson, Jan Tschichold Collection.

205. *Novyi Lef* no. 5 of 1927. Letterpress. 8¹⁵⁄₁₆ × 5⅞" (22.7 × 15 cm). The Museum of Modern Art, New York. Gift of Philip Johnson, Jan Tschichold Collection.

206. *Novyi Lef* no. 6 of 1927. Letterpress. 8¹⁵⁄₁₆ × 5⅞" (22.7 × 15 cm). The Museum of Modern Art, New York. Gift of Philip Johnson, Jan Tschichold Collection.

207. *Novyi Lef* no. 7 of 1927. Letterpress. 8¹⁵⁄₁₆ × 5⅞" (22.7 × 15 cm). The Museum of Modern Art, New York. Gift of Philip Johnson, Jan Tschichold Collection.

208. *Novyi Lef* no. 8–9 of 1927. Letterpress. 8¹⁵⁄₁₆ × 5⅞" (22.7 × 15 cm). The Museum of Modern Art, New York. Gift of Philip Johnson, Jan Tschichold Collection.

209. *Novyi Lef* no. 10 of 1927. Letterpress. 8¹⁵⁄₁₆ × 6¹⁄₁₆" (22.7 × 15.4 cm). The Museum of Modern Art, New York. Gift of Philip Johnson, Jan Tschichold Collection.

210. *Novyi Lef* no. 2 of 1928. Letterpress. 9 × 6" (22.8 × 15.2 cm). The Museum of Modern Art, New York. Gift of Philip Johnson, Jan Tschichold Collection.

211. *Novyi Lef* no. 3 of 1928. Letterpress. 9 × 6" (22.8 × 15.2 cm). The Museum of Modern Art, New York. Gift of Philip Johnson, Jan Tschichold Collection.

212. *Novyi Lef* no. 4 of 1928. Letterpress. 9 × 6" (22.8 × 15.2 cm). The Museum of Modern Art, New York. Gift of Philip Johnson, Jan Tschichold Collection.

213. *Novyi Lef* no. 5 of 1928. Letterpress. 9 × 6" (22.8 × 15.2 cm). The Museum of Modern Art, New York. Gift of Philip Johnson, Jan Tschichold Collection.

214. *Novyi Lef* no. 6 of 1928. Letterpress. 9 × 6" (22.8 × 15.2 cm). The Museum of Modern Art, New York. Gift of Philip Johnson, Jan Tschichold Collection.

215. *Novyi Lef* no. 7 of 1928. Letterpress. 9¹⁄₁₆ × 5⅞" (23 × 15 cm). The Museum of Modern Art, New York. Gift of Philip Johnson, Jan Tschichold Collection.

216. *Novyi Lef* no. 10 of 1928. Letterpress. 9¹⁄₁₆ × 5⅞" (23 × 15 cm). The Museum of Modern Art, New York. Gift of Philip Johnson, Jan Tschichold Collection.

217. *Novyi Lef* no. 11 of 1928. Letterpress. 9¹⁄₁₆ × 5⅞" (23 × 15 cm). The Museum of Modern Art, New York. Gift of Philip Johnson, Jan Tschichold Collection.

218. Front and back covers of *Novyi Lef* no. 8 of 1928. Letterpress. Closed: 9¹⁄₁₆ × 5⅞" (23 × 15 cm); open: 9¹⁄₁₆ × 11¾" (23 × 29.8 cm). The Museum of Modern Art, New York. Gift of Philip Johnson, Jan Tschichold Collection.

219. Front and back covers of *Novyi Lef* no. 9 of 1928. Letterpress. Closed: 9¹⁄₁₆ × 5⅞" (23 × 15 cm); open: 9¹⁄₁₆ × 11¾" (23 × 29.8 cm). The Museum of Modern Art, New York. Gift of Philip Johnson, Jan Tschichold Collection.

220. Front and back covers of *Novyi Lef* no. 12 of 1928. Letterpress. Closed: 9¹⁄₁₆ × 5⅞" (23 × 15 cm); open: 9¹⁄₁₆ × 11¾" (23 × 29.8 cm). The Museum of Modern Art, New York. Gift of Philip Johnson, Jan Tschichold Collection.

Book covers, 1928

221. Front and back covers of the book *No. S*, by Vladimir Mayakovsky. 1928. Letterpress. 7⅛ × 10½" (18.1 × 26.7 cm). The Museum of Modern Art, New York. Gift of Philip Johnson, Jan Tschichold Collection.

Photographs, 1926–32

222. *Street Trade* (*Ulichnaia torgovliia*). 1928. Diptych of gelatin-silver prints mounted on cardboard. Each print 4⅝ × 6" (11.8 × 15.2 cm); mount: 13¾ × 10" (35 × 25.5 cm). A. Rodchenko and V. Stepanova Archive, Moscow.

223. *Street Trade* (*Ulichnaia torgovliia*). 1928. Triptych of gelatin-silver prints mounted on cardboard. Each print 3⅜ × 4⅞" (8.2 × 11.3 cm); mount: 13¾ × 10" (35 × 25.5 cm). A. Rodchenko and V. Stepanova Archive, Moscow.

224. *Street Trade* (*Ulichnaia torgovliia*). 1928. Diptych of gelatin-silver prints mounted on cardboard. Top print 4½ × 5¹³⁄₁₆" (11.5 × 14.8 cm), bottom print 4⅝ × 5¹³⁄₁₆" (11.8 × 14.8 cm); mount: 13¾ × 10" (35 × 25.5 cm). A. Rodchenko and V. Stepanova Archive, Moscow.

225. Courtyard. 1928–30. Gelatin-silver print. 12 × 9¼" (30 × 23 cm). A. Rodchenko and V. Stepanova Archive, Moscow.

226. Courtyard. 1928–30. Gelatin-silver print. 5⅜ × 3⅜" (13.6 × 8.6 cm). Collection Prentice and Paul Sack, San Francisco.

227. Courtyards. 1926–28. Four gelatin-silver prints mounted on gray cardboard. Two prints 5½ × 3¾" (8 × 5.3 cm), two prints 3¾ × 5½" (5.3 × 8 cm); mount: 14¹⁄₁₆ × 9¹⁵⁄₁₆" (35.7 × 25.3 cm). A. Rodchenko and V. Stepanova Archive, Moscow.

228. Untitled. 1926–27. From the series "The Building on Miasnitskaia Street" (*Dom na Miasnitskoi*). Gelatin-silver print. 11¹¹⁄₁₆ × 9⅛" (30 × 23.5 cm). A. Rodchenko and V. Stepanova Archive, Moscow.

229. *The Courtyard of Vкhuтeмas* (*Dvor Vкhuтeмasa*). 1926–28. Gelatin-silver print. 9⅛ × 6¹¹⁄₁₆" (23.2 × 17 cm). The Museum of Modern Art, New York. Gift of Mrs. Alfred H. Barr, Jr.

230. *The Courtyard of Vкhuтeмas* (*Dvor Vкhuтeмasa*). 1926–28. Gelatin-silver print. 5⅝ × 2¹⁵⁄₁₆" (14.2 × 7.5 cm). Collection Jack Banning. Courtesy Ubu Gallery, New York.

231. *The Courtyard of Vкhuтeмas* (*Dvor Vкhuтeмasa*). 1928–30. Gelatin-silver print. 7¾ × 11⁹⁄₁₆" (20 × 29 cm). A. Rodchenko and V. Stepanova Archive, Moscow.

232. *The Courtyard of Vкhuтeмas* (*Dvor Vкhuтeмasa*). 1928–30. Gelatin-silver print. 6¾ × 9⅜" (16.8 × 22.8 cm). A. Rodchenko and V. Stepanova Archive, Moscow.

233. *Assembling for a Demonstration* (*Sbor na demonstratsiiu*). 1928–30. Gelatin-silver print. 19½ × 13⅞" (49.5 × 35.3 cm). The Museum of Modern Art, New York. Mr. and Mrs. John Spencer Fund.

234. *Apartment Building by [Moisei] Ginzburg on Nivinskii Boulevard* (*Dom Ginzburga na Nivinskom bul'vare*). 1929. Gelatin-silver print. 9⁷⁄₁₆ × 11¾" (24 × 29.8 cm). A. Rodchenko and V. Stepanova Archive, Moscow.

235. *Planetarium* (*Planetarii* [the Moscow planetarium, designed by Mikhail Barsh and Mikhail Siniavskii]). 1929. Gelatin-silver print. 9⁷⁄₁₆ × 11¹¹⁄₁₆" (24 × 29.7 cm). A. Rodchenko and V. Stepanova Archive, Moscow.

236. *The Mossel'prom Building* (*Dom Mossel'proma*). 1932. Gelatin-silver print. 9⁵⁄₁₆ × 11¾" (23.8 × 30 cm). Edwynn Houk Gallery, New York; PaceWildensteinMacGill, New York; and Galerie Rudolf Kicken, Cologne.

237. *Pravda Stairway* (*Lestnitsa izdatel'stva "Pravda"*). 1930–31. Gelatin-silver print. 8¼ × 11⅝" (21 × 29.5 cm). A. Rodchenko and V. Stepanova Archive, Moscow.

238. Untitled. 1932. Gelatin-silver print. 11⅝ × 9¹⁄₁₆" (29.5 × 23 cm). Museum Ludwig, Photosammlung, Sammlung Ludwig, Cologne.

239. *Square by the Bolshoi Theater* (*Skver u Bol'shogo teatra*). 1932. Gelatin-silver print. 11⅝ × 9¹⁄₁₆" (29.5 × 23 cm). A. Rodchenko and V. Stepanova Archive, Moscow.

240. *Theater Square* (*Teatral'nyi skver*). 1932. Gelatin-silver print. 11½ × 8¾" (29.2 × 22.3 cm). Galerie Alex Lachmann, Cologne.

241. Untitled. From the series "Miasnitskaia Street. Traffic" (*Miasnitskaia ulitsa. Dvizhenie*). 1929–32. Gelatin-silver print. 8⅞ × 11⅝" (22.5 × 29.5 cm). A. Rodchenko and V. Stepanova Archive, Moscow.

242. Untitled. From the series "Miasnitskaia Street. Traffic" (*Miasnitskaia ulitsa. Dvizhenie*). 1929–32. Gelatin-silver print. 9¹/₁₆ × 11¾" (23 × 29.8 cm). A. Rodchenko and V. Stepanova Archive, Moscow.

243. Untitled. From the series "Miasnitskaia Street. Traffic" (*Miasnitskaia ulitsa. Dvizhenie*). 1929–32. Gelatin-silver print. 8¹⁵/₁₆ × 11½" (22.7 × 29.2 cm). The J. Paul Getty Museum, Los Angeles.

244. Untitled. 1929. From a series on the Moscow ambulance service. Gelatin-silver print. 7⁵/₁₆ × 11" (18.5 × 28 cm). A. Rodchenko and V. Stepanova Archive, Moscow.

245. *Walking Figure* (*Idushchaia figura*). 1928. Gelatin-silver print. 14⅜ × 21⁷/₁₆" (36.5 × 54.5 cm). A. Rodchenko and V. Stepanova Archive, Moscow.

246. *Pioneer* (*Pioner*). 1928. Gelatin-silver print. 4⅞ × 5" (12.4 × 12.7 cm). Collection Gary Wolkowitz, New York.

247. *Steps* (*Lestnitsa*). 1930. Gelatin-silver print. 14⅜ × 21⁷/₁₆" (36.5 × 54.5 cm). A. Rodchenko and V. Stepanova Archive, Moscow.

248. *Chauffeur* (*Shofer*). 1929. Gelatin-silver print. 11¾ × 16½" (29.8 × 41.8 cm). The Museum of Modern Art, New York. Mr. and Mrs. John Spencer Fund.

249. *At the Telephone* (*Na telefone*). 1928. From a series on the production of a newspaper. Gelatin-silver print. 15½ × 11½" (39.5 × 29.2 cm). The Museum of Modern Art, New York. Mr. and Mrs. John Spencer Fund.

250. *Monument to Freedom* (*Pamiatnik svobody*). 1930–32. Gelatin-silver print. 11⁹/₁₆ × 12¹¹/₁₆" (29.4 × 32.2 cm). Museum Ludwig, Photosammlung, Sammlung Ludwig, Cologne.

251. Demonstration. 1932. Gelatin-silver print. 11⅝ × 8⅜" (29.5 × 21.3 cm). Museum of Photographic Arts, San Diego. Collection Joyce and Michael Axelrod.

252. Renovation. 1929–30. Gelatin-silver print. 7¹⁵/₁₆ × 11³/₁₆" (20.2 × 28.5 cm). Museum of Photographic Arts, San Diego. Collection Joyce and Michael Axelrod.

253. *The Song* (*Pesnia*). 1931. Gelatin-silver print. 11¹³/₁₆ × 9⁹/₁₆" (30 × 24.4 cm). Museum Ludwig, Photosammlung, Sammlung Ludwig, Cologne.

254. *Asphalt Paving* (*Asfal'tirovanie*). 1929. From a series on the construction of Leningrad Boulevard, Moscow. Gelatin-silver print. 9⅝ × 11¹³/₁₆" (24.4 × 30 cm). Gilman Paper Company Collection, New York.

255. Snow sledge. 1929–32. Gelatin-silver print. 11½ × 8⅛" (29.3 × 20.6 cm). A. Rodchenko and V. Stepanova Archive, Moscow.

256. *Kulaks* (*Kulaki*). 1928. Gelatin-silver print. 11⅜ × 9¹/₁₆" (29 × 23 cm). Collection Bernard Danenberg.

257. *Lunch* (*Obed*). 1929. From the series "Factory Canteen" (*Fabrika-kukhnia*). Gelatin-silver print. 9¼ × 10¼" (23.5 × 26 cm). A. Rodchenko and V. Stepanova Archive, Moscow.

Postcards from a series published by Izogiz in 1932

258. *Theater Avenue* (*Teatral'nyi proezd*). 1932. Gravure. 3¹¹/₁₆ × 5⅛" (9.4 × 13.1 cm). The Museum of Modern Art, New York. Gift of the Rodchenko family.

259. *Park of Culture and Rest* (*Park kul'tury i otdykha*). 1932. Gravure. 3¾ × 4⅞" (9.4 × 12.3 cm). The Museum of Modern Art, New York. Gift of the Rodchenko family.

260. *Radio Listener* (*Radioslushatel'*). 1927. Gravure. 3¾ × 4⅞" (9.4 × 12.4 cm). The Museum of Modern Art, New York. Gift of the Rodchenko family.

261. *Bolshoi Theater* (*Bol'shoi teatr*). 1932. Gravure. 3⅝ × 4¾" (9.2 × 12 cm). The Museum of Modern Art, New York. Gift of the Rodchenko family.

Magazine cover, 1929

262. Cover of the magazine *Daesh'* (Give your all) no. 6 of 1929. Letterpress. 11⅞ × 9⅛" (30.2 × 22.9 cm). The Judith Rothschild Foundation, New York.

Photographs of the AMO automobile factory, Moscow, and related graphic design, 1929

The photographs were made to illustrate an article in the magazine Daesh' *(Give your all) no. 14 of 1929. Cat. no. 269 did not appear in the magazine.*

263. Maquette for *Lunch Break* (*Obedennyi pereryv*), an illustration in the magazine. Pasted gelatin-silver prints and ink on board. 11¹³/₁₆ × 9⁵/₁₆" (30 × 23.7 cm). A. Rodchenko and V. Stepanova Archive, Moscow.

264. Page from Rodchenko's photo-story on AMO in the magazine. Letterpress. 11¹⁵/₁₆ × 9⅛" (30.3 × 23.2 cm). The Museum of Modern Art, New York. Gift of Philip Johnson, Jan Tschichold Collection.

265. The magazine's cover, designed by Rodchenko and Mechislav Dobrokovskii. Letterpress. 11⅞ × 9" (30.2 × 22.9 cm). The Judith Rothschild Foundation, New York.

266. *Details of AMO Car* (*Detali AMO* [camshafts]). Gelatin-silver print. 11⅝ × 15¹¹/₁₆" (29.6 × 39.8 cm). A. Rodchenko and V. Stepanova Archive, Moscow.

267. Maquette for the cover of the book *AMO Factory* (*Zavod AMO*), by A. Sviatenko. Gouache and pasted paper on cardboard. 8¹¹/₁₆ × 5¹³/₁₆" (22 × 14.7 cm). The Pushkin State Museum of Fine Arts, Department of Private Collections, Moscow.

268. *Details of AMO Car* (*Detali AMO* [radiator grill]). Gelatin-silver print. 8⅜ × 11¾" (21.3 × 29.8 cm). A. Rodchenko and V. Stepanova Archive, Moscow.

269. *Details of AMO Car* (*Detali AMO* [cogwheels]). Gelatin-silver print. 6⅜ × 9⅛₆" (16.3 × 23 cm). Edwynn Houk Gallery, New York; PaceWildensteinMacGill, New York; and Galerie Rudolf Kicken, Cologne.

Graphic design and collage, 1929–30

270. Poster for the play *Inga*, by A. Glebov. 1929. Letterpress. 27¹⁵⁄₁₆ × 42¹⁵⁄₁₆" (71 × 109 cm). The Museum of Modern Art, New York. Gift of Jay Leyda.

271. Front and back covers of the book *Speaker* (*Rechevik*), by Sergei Tret'iakov. 1929. Letterpress. Closed: 6¹³⁄₁₆ × 5⅜" (17.3 × 13.6 cm); open: 6¹³⁄₁₆ × 10¾" (17.3 × 27.3 cm). A. Rodchenko and V. Stepanova Archive, Moscow.

272. Front and back covers of the magazine *Zhurnalist* (Journalist) no. 4 of 1930. Letterpress. Closed: 10⅞ × 8⅛" (27.6 × 20.7 cm); open: 10⅞ × 16¼" (27.6 × 41.4 cm). A. Rodchenko and V. Stepanova Archive, Moscow.

273. Maquette for the cover of the magazine *Za Rubezhom* (Abroad) no. 2 of 1930. Cut-and-pasted printed papers, gelatin-silver photograph, and gouache on paper. 9⅞ × 6¹³⁄₁₆" (26 × 18 cm). A. Rodchenko and V. Stepanova Archive, Moscow.

274. Maquette for *Political Football* (*Politicheskii futbol*), illustration for the magazine *Za Rubezhom* (Abroad) no. 5 of 1930. Cut-and-pasted printed papers and gouache on paper. 20³⁄₁₆ × 13¾" (51.3 × 35 cm). A. Rodchenko and V. Stepanova Archive, Moscow.

275. Maquette for "War of the Future" (*Voina budushchego*), illustration for the magazine *Za Rubezhom* (Abroad) no. 2 of 1930. Cut-and-pasted printed papers on paper. 20⅛₆ × 13¾" (51 × 35 cm). Galerie Berinson, Berlin.

Photographs, 1930–31

276. *The Smile* (*Ulybka* [Varvara Stepanova]). 1931. Gelatin-silver print. 11½ × 16¹⁵⁄₁₆" (29.2 × 43 cm). A. Rodchenko and V. Stepanova Archive, Moscow.

277. *Pioneer* (*Pioner*). 1930. Gelatin-silver print. 23⅝ × 19½" (60 × 49.5 cm). Musée national d'art moderne, Centre Georges Pompidou, Paris. Gift of Varvara Rodchenko, 1981.

278. *Pioneer Girl* (*Pionerka*). 1930. Gelatin-silver print. 19½ × 14⁹⁄₁₆" (49.6 × 37 cm). The Museum of Modern Art, New York. Gift of Alex Lachmann and friends of the Rodchenko family.

279. *Pioneer with a Bugle* (*Pioner-trubach*). 1930. Gelatin-silver print. 23¼ × 19⅛₆" (59 × 48.5 cm). A. Rodchenko and V. Stepanova Archive, Moscow.

Photographs from a series on a lumber mill in Vakhtan, 1930

280. Sawmill worker. Gelatin-silver print. 11½ × 9¼" (29.2 × 23.5 cm). The Museum of Modern Art, New York.

281. Sawmill worker. Gelatin-silver print. 11⅜ × 8⅞" (29 × 21.5 cm). Museum Ludwig, Photosammlung, Sammlung Ludwig, Cologne.

282. Sawmill worker. Gelatin-silver print. 11⁹⁄₁₆ × 9⁵⁄₁₆" (29.3 × 23.6 cm). The Museum of Modern Art, New York.

283. Lumber. Gelatin-silver print. 9⅛ × 11½" (23.1 × 29.3 cm). The Museum of Modern Art, New York. Gift of the photographer.

284. Sawmill worker. Gelatin-silver print. 11¹¹⁄₁₆ × 7¹¹⁄₁₆" (29.7 × 19.6 cm). The J. Paul Getty Museum, Los Angeles.

285. Lumber. Gelatin-silver print. 8⁵⁄₁₆ × 12³⁄₁₆" (21.2 × 31 cm). A. Rodchenko and V. Stepanova Archive, Moscow.

From a series on the construction of the White Sea–Baltic Sea Canal for the magazine *SSSR na Stroike* (*USSR in Construction*) no. 12 of 1933, designed and with photographs by Rodchenko

286. Cover of the magazine. Lithography. 16½ × 11¹¹⁄₁₆" (42 × 29.7 cm). The Judith Rothschild Foundation, New York.

287. Spread in the magazine. Gravure. 16½ × 23³⁄₁₆" (42 × 59 cm). The Judith Rothschild Foundation, New York.

288. Guard and prisoners. 1933. Gelatin-silver print. 11⁹⁄₁₆ × 17⁷⁄₁₆" (29.3 × 44.3 cm). The Museum of Modern Art, New York. Purchase.

289. Spread in the magazine. Gravure. 16½ × 23³⁄₁₆" (42 × 59 cm). The Judith Rothschild Foundation, New York.

290. *Working with Orchestra* (*Rabota c orkestrom*). 1933. Gelatin-silver print. 11⁷⁄₁₆ × 17¼" (29 × 43.9 cm). The Museum of Modern Art, New York. Purchase.

291. Spread in the magazine. Gravure. 16½ × 23³⁄₁₆" (42 × 59 cm). The Judith Rothschild Foundation, New York.

292. *The Lock* (*Shliuz*). 1933. Gelatin-silver print. 11⁷⁄₁₆ × 8" (29 × 20.2 cm). Galerie Alex Lachmann, Cologne.

293. *Barges in the Lock* (*Barzhi v shliuze*). 1933. Gelatin-silver print. 17⅛ × 11⅝" (43.5 × 29.5 cm). A. Rodchenko and V. Stepanova Archive, Moscow.

294. Spread in the magazine, with foldouts. Gravure. 16½ × 45¹¹⁄₁₆" (42 × 116 cm). The Judith Rothschild Foundation, New York.

Additional copies of SSSR na Stroike *no. 12 of 1933 shown in the exhibition come from the collections of Howard Schickler Fine Art, New York; Stephen and Jane Garmey; and Jack Banning, courtesy Ubu Gallery, New York.*

SELECTED BIBLIOGRAPHY

The sections on Rodchenko's writings are ordered chronologically. The remaining sections are ordered alphabetically by author or, where necessary, by title.

Writings by Rodchenko (Selected)

Collections

Osman, Colin, ed. "Alexander Michailovitch Rodchenko, 1891–1956: Aesthetic, Autobiographical, and Ideological Writings." In *Creative Camera International Yearbook*, 189–233. London: Coo Press, Ltd., 1978.

A. M. Rodchenko: Stat'i, vospominaniia, avtobiograficheskie zapiski, pis'ma. Ed. V. A. Rodchenko, E. Iu. Dutlova, and A. N. Lavrent'ev. Moscow: Sovetskii khudozhnik, 1982.

Alexandre Rodtchenko. Écrits complets sur l'art, l'architecture et la révolution. Ed. Aleksandr Lavrent'ev. French trans. Bernadette du Crest. Paris: Philippe Sers Éditeur, 1988.

A. M. Rodtschenko: Aufsätze, Autobiographische Notizen, Briefe, Erinnerungen. Trans. Hans-Joachim Lambrecht. Dresden: Verlag der Kunst, 1993.

Opyty dlia budushchego: dnevniki, stati', pis'ma, zapiski. Ed. O. V. Mel'nikov and V. I. Shchennikov. Compiled by V. Rodchenko and A. Lavrent'ev. Moscow: Grant', 1996.

Articles and Essays

"Khudozhnikam-proletariiam." *Anarkhiia* no. 41 (April 11, 1918). Published in English in Peter Noever, ed., *The Future Is Our Only Goal*, 118. See "On Rodchenko, Group Exhibitions."

"Dinamizm ploskosti." *Anarkhiia* no. 49 (April 28, 1918). Published in English in Peter Noever, ed., *The Future Is Our Only Goal*, 119. See "On Rodchenko, Group Exhibitions."

"O pokoinikakh. O muzee Morozova." *Anarkhiia* no. 52 (May 3, 1918).

"Bibliografiia." *Anarkhiia* no. 54 (May 9, 1918).

"Bud'te tvortsami." *Anarkhiia* no. 61 (May 17, 1918).

"Samobytnym' kritikam i gazete 'Ponedel'nik.'" *Anarkhiia* no. 85 (June 15, 1918).

"Doklad Rodchenko na obshchem sobranii Profsoiuza khudozhnikov-zhivopistsev g. Moskvy." *Anarkhiia* no. 99 (July 2, 1918).

"Raskol soiuza khudozhnikov-zhivopistsev v Moskve." *Anarkhiia* no. 99 (July 2, 1918).

"Sistema Rodchenko." *10aia gosudarstvennaia vystavka: Bespredmetnoe tvorchestvo i Suprematizm.* Exh. cat. Moscow, 1919. Published in English in John E. Bowlt, ed. and trans., *Russian Art of the Avant-Garde*, 148–50. See "General, Books."

"Iz manifesta suprematistov i bespredmetnikov." Written with Stepanova for the *10th State Exhibition*, 1919. Published in English in Peter Noever, ed., *The Future Is Our Only Goal*, 122. See "On Rodchenko, Group Exhibitions."

"Vse-opyty." 1920. Published in English in Peter Noever, ed., *The Future Is Our Only Goal*, 130. See "On Rodchenko, Group Exhibitions."

"Distsiplina: graficheskaia konstruktsiia na ploskosti. Initsiativa." 1921. Published in French in Selim O. Khan-Magomedov, ed., *Vkhutemas*, 274. See "General, Books." Published in English in Khan-Magomedov, *Rodchenko: The Complete Work*, 291–92. See "On Rodchenko, Books."

"Liniia." Moscow: Инкнук, 1921. Published in English as "The Line," trans. James West, in Richard Andrews, Milena Kalinovska, et al., *Art into Life*, 71–73; in Anna Kafetsi, ed., *Russian Avant-Garde 1910–1930*, 2:663–65; and in Peter Noever, ed., *The Future Is Our Only Goal*, 133–35. See "On Rodchenko, Group Exhibitions."

"Lozungi." February 22, 1921. Published in English in Peter Noever, ed., *The Future Is Our Only Goal*, 158. See "On Rodchenko, Group Exhibitions."

"Sharlo." *Kino-fot* no. 3 of 1922: 5–6.

"Pervaia programma rabochei gruppy Konstruktivistov." Written with V. Stepanova and A. Gan. *Ermitazh* no. 13 of 1922 (August): 3–4. Published in English as "Programme of the First Working Group of Constructivists," trans. Christina Lodder, in Charles Harrison and Paul Wood, eds., *Art in Theory, 1900–1990: An Anthology of Changing Ideas*, 317–18, Oxford and Cambridge, Mass.: Blackwell, 1992.

"Ob'iasnitel'naia zapiska k programme kursu konstruktsii Metfaka VKhUTEMASa professora Rodchenko." 1922–24. Published in French in Selim O. Khan-Magomedov, ed., *Vkhutemas*, 2:646. See "General, Books."

"Programma po kursu konstruktsii metfaka VKhUTEMASa professora R." 1922–24. Published in French in Selim O. Khan-Magomedov, ed., *Vkhutemas*, 2:645–46. See "General, Books."

"Rodchenko v Parizhe. Iz pisem domoi." *Novyi Lef* no. 2 of 1927: 9–21.

"Khudozhnik i 'material'naia sreda' v igrovnom fil'me." *Sovetskoe Kino* no. 5–6 of 1927: 14–15.

Untitled. In "Zapisnaia knizhka Lefa." *Novyi Lef* no 6 of 1927: 3–7.

"Tekhnicheskoe risovanie." *Novyi Lef* no. 11 of 1927: 27–36.

"K foto v etom nomere." *Novyi Lef* no. 3 of 1928: 28–29.

"Protiv summirovannogo portreta za momental'nyi snimok." *Novyi Lef* no. 4 of 1928: 14–16. Published in English as "Against the Synthetic Portrait, for the Snapshot," trans. John E. Bowlt, in Christopher Phillips, ed., *Photography in the Modern Era*, 238–42; and in John E. Bowlt, ed. and trans., *Russian Art of the Avant-Garde*, 250–54. See "General, Books."

"V redaktsiiu 'Sovetskoe foto.'" *Sovetskoe Foto* no. 4 of 1928.

"Pis'mo v redaktsiiu." *Novyi Lef* no. 5 of 1928: 47.

"Krupnaia bezgramotnost' ili melkaia gadost'?" *Novyi Lef* no. 6 of 1928: 42–44. Published in English as "Downright Ignorance or a Mean Trick?," trans. John E. Bowlt, in Christopher Phillips, ed., *Photography in the Modern Era*, 245–48. See "General, Books."

"Stolitsa i usad'by." In "Zapisnaia knizhka Lefa." *Novyi Lef* no. 7 of 1928: 39–40.

"Tovarishch Svidel'!." In "Kak rabotat' fotolefy." *Novyi Lef* no. 8 of 1928: 44.

"Puti sovremennoi fotografii." *Novyi Lef* no. 9 of 1928: 31–39. Published in English as "The Paths of Modern Photography," trans. John E. Bowlt, in Christopher Phillips, ed., *Photography in the Modern Era*, 256–63. See "General, Books."

"Predosterezhenie." *Novyi Lef* no. 11 of 1928: 36–37. Published in English as "A Caution," trans. John E. Bowlt, in Christopher Phillips, ed., *Photography in the Modern Era*, 264–66. See "General, Books."

"Tekhnicheskoe risovanie." *Novyi Lef* no. 11 of 1928: 27–28.

"Diskussii o novoi odezhde i mebeli—zadacha oformleniia." In A. Glebov, *Inga*, 12–14. Moscow, 1929. Published in English in Peter Noever, ed., *The Future Is Our Only Goal*, 198. See "On Rodchenko, Group Exhibitions."

"Programma fotosektsii ob'edineniia Oktiabr'." Written with Aleksei Gan and Varvara Stepanova. In *Izofront. Klassovaia bor'ba na fronte prostranstvennykh iskusstv*, 149–51. Moscow and Leningrad, 1931. Published in English as "Program of the October Photo Section," trans. John E. Bowlt, in Christopher Phillips, ed., *Photography in the Modern Era*, 283–85. See "General, Books."

"K analizu foto iskusstva." *Sovetskoe Foto* no. 9 of 1935: 31.

"Master i kritika." *Sovetskoe Foto* no. 9 of 1935: 4–5.

"Perestroika khudozhnika." *Sovetskoe Foto* no. 5–6 of 1936: 19–21.

"O. Ia.Khalip." *Sovetskoe Foto* no. 10 of 1936.

"Kakim dolzhno byt'." *Sovetskoe Foto* no. 9 of 1937.

"Uroki pervogo opyta." *Sovetskoe Foto* no. 12 of 1937.

"Kholstoi vystrel." *Sovetskoe Foto* no. 11–12 of 1938.

"Chernoe i beloe." c. 1939. *Sovetskoe Foto* no. 12 of 1971. Extracts published in English in Selim O. Khan-Magomedov, *Rodchenko: The Complete Work*, 286. See "On Rodchenko, Books."

"Rabota s Maiakovskim." *Smena* no. 3 of 1940. Published in English as "Working with Mayakovsky," trans. from a variant publication in *V Mire Knig* no. 6 of 1973, in David Elliott, ed., *Rodchenko and the Arts of Revolutionary Russia*, pp. 102–4. See "On Rodchenko, One-Man Exhibitions."

"Vstrechi s V. V. Maiakovskim. Otryvki is vospominanii." *Sovetskoe Foto* no. 4 of 1940.

"O kompozitsii. Vmesto predisloviia."
1941–42. Published in *Sovetskoe
Foto* no. 8 of 1979.
"O Tatline 1915–1917." 1941–42.
Published in English in David
Elliott, ed., *Rodchenko and the Arts
of Revolutionary Russia*, pp. 132–
33. See "On Rodchenko, One-Man
Exhibitions."
"Otkryvaiutsia nevidannye vosmozh-
nosti (vyderzhi iz statei i lektsii
Rodchenko o fotografii)."
Sovetskoe Foto no. 8 of 1979.

On Rodchenko

Books

*Alexander Rodchenko 1914–1920:
Works on Paper.* With an essay by
David Elliott. London: Sotheby's,
Ltd., 1991.
Dickerman, Leah. "Aleksandr
Rodchenko's Camera-Eye: Lef
Vision and the Production of
Revolutionary Consciousness."
Ph.D. dissertation, Columbia
University, 1997.
Garrubba, Caio, ed. *Alexander
Rodčenko.* I Grandi fotografi.
Milan: Gruppo Editoriale Fabbri,
1983.
Gassner, Hubertus. *Rodčenko
Fotografien.* Munich: Schirmer/
Mosel, 1982.
———. *Alexander Rodschenko:
Konstruktion 1920: oder die Kunst,
das Leben zu organisieren.* Frank-
furt a. M.: Fischer Taschenbuch
Verlag, 1984.
Karginov, German. *Rodcsenko.*
Budapest: Corvina Kiadó, 1975.
Published in English as *Rod-
chenko,* trans. Elisabeth Hoch,
London: Thames and Hudson,
1979.
Khan-Magomedov, Selim. *Opere di
Aleksandr Rodcenko 1891–1956.* Ed.
Vieri Quilici. Idea Books Edizioni,
1986. Published in French as
*Alexandre Rodtchenko: L'Oeuvre
complete,* trans. Sylvie Coyaud,
Paris: P. Sers, 1986, and in English
as *Rodchenko: The Complete Work,*
trans. Huw Evans, Cambridge,
Mass.: The MIT Press, 1987.
Kiaer, Christina. "The Russian
Constructivist 'Object' and the
Revolutionizing of Everyday Life,
1921–29." Ph.D. dissertation,
University of California, Berkeley,
1995.
Lavrent'ev, Aleksandr. *Aleksandr
Rodchenko: Fotografii.* Moscow:
Planeta, 1987.

———. *A. M. Rodchenko, V. F.
Stepanova: Mastera sovetskogo
knizhnogo iskusstva.* Moscow:
Kniga, 1989.
———. *Rakursy Rodchenko.* Moscow:
Iskusstvo, 1992.
——— (transliterated as Alexander
Lavrentjev). *Rodchenko Photog-
raphy.* Trans. John William
Gabriel. New York: Rizzoli
International Publications, Inc.,
1982.
———. *Rodchenko: Photography
1924–1954.* Cologne: Könneman,
1995. Text in English, French, and
German.
Rodchenko: Flying Objects. With
essays by Hubertus Gassner
(in German) and Alexander
Lavrentiev (in English).
Göttingen: Arkana Verlag, 1991,
for Lufthansa German Airlines.
Rodtschenko, Warwara, and
Alexander Lawrentjew. *Alexander
Rodtschenko: Maler Konstrukteur
Fotograf.* Dresden: VEB Verlag der
Kunst, 1983.
Volkov-Lannit, Leonid Filippovich.
*Aleksandr Rodchenko risuet,
fotografiruet, sport.* Moscow:
Iskusstvo, 1968.

Exhibition Catalogues
One-Man Exhibitions
Aleksandr Rodchenko. Moscow, 1968.
*Aleksandr Rodchenko. Vystavka
fotografii.* Moscow: Soiuz
zhurnalistov, 1987.
Alexander Rodchenko—Photographs.
Tokyo: Wildenstein Tokyo, 1995.
*Alexandre Rodtchenko: Possibilités de
la photographie (Possibilities of
Photography).* With texts in French
and English by Aleksandr
Lavrent'ev, Varvara Stepanova
(1927), and Rodchenko (1934).
Cologne: Galerie Gmurzynska,
1982.
Elliott, David, ed. *Rodchenko and the
Arts of Revolutionary Russia.* New
York: Pantheon Books, 1979. The
American edition of Elliott, ed.,
Alexander Rodchenko 1891–1956.
Oxford: Museum of Modern Art,
1979.
*Katalog vystavki rabot Aleksandra
Mikhailovicha Rodchenko.*
Moscow, 1961.
Pottier, Marc, and Nathalie Karg, eds.
*Alexander Rodchenko: A fotografia
como máquina da história.* With
an essay by Annateresa Fabris. São
Paulo: Museu de Arte Moderna,
1997.

Rodčenko: Grafico, designer, fotografo.
With essays by Varvara Rodcenko,
Aleksandr Lavrent'ev, Nicoletta
Misler and John E. Bowlt,
Giuliana Scimé, and Rodchenko.
Milan: Nuove edizioni Gabriele
Mazzotta, 1992, for the Galleria
Credito Valtellinese, Refettorio
delle Stelline, Milan.
Rodtchenko photographe. With an
essay by Andrei B. Nakov. Paris:
Musée d'Art Moderne de la Ville
de Paris, 1977.
Unverfehrt, Gerd, and Tete Böttger,
eds. *Rodtschenko, Fotograf 1891–
1956: Bilder aus dem Moskauer
Familienbesitz.* Göttingen:
Arkana Verlag, 1989, for the
Kunstsammlung der Universität
Göttingen.
Weiss, Evelyn, ed. *Alexander
Rodtschenko: Fotografien, 1920–
1938.* Cologne: Wienand Verlag,
1978, for the Museum Ludwig,
Cologne.

Group Exhibitions
Ades, Dawn. *The 20th-Century Poster:
Design of the Avant-Garde.* New
York: Abbeville Press, 1984, for the
Walker Art Center, Minneapolis.
Ades, Dawn, et al., eds. *Art and
Power: Europe under the Dictators,
1930–45.* London: Thames and
Hudson, in association with the
Hayward Gallery, 1995.
*Alexander Rodtschenko und Warwara
Stepanowa: Werke aus sowjetischen
Museen, der Sammlung der Familie
Rodtschenko und aus anderen
Sammlungen.* Duisburg: Wilheim-
Lehmbruck Museum, and Baden-
Baden: Staatliche Kunsthalle, 1982.
Andrews, Richard, Milena
Kalinovska, et al. *Art into Life:
Russian Constructivism 1914–1932.*
New York: Rizzoli International
Publications, Inc., 1990, for the
Henry Art Gallery, University of
Washington, Seattle.
Antonowa, Irina, and Jörn Merkert,
eds. *Berlin-Moskau 1900–1950.*
Munich and New York: Prestel-
Verlag, 1995.
Barr, Alfred H., Jr. *Cubism and
Abstract Art.* New York: The
Museum of Modern Art, 1936.
Reprint ed. Cambridge, Mass.:
Belknap Press of Harvard
University Press, 1986.
Barron, Stephanie, and Maurice
Tuchman, eds. *The Avant-Garde in
Russia, 1910–1930.* Los Angeles: Los
Angeles County Museum of Art,
1980.

Claverie, Jana, and Jacqueline Costa,
eds. *Utopies et réalités en URSS,
1917–1934: Agit-Prop, Design,
Architecture.* Paris: Centre de
création industrielle, Centre
Georges Pompidou, 1980.
*10aia gosudarstvennaia vystavka:
Bespredmetnoe tvorchestvo i
Suprematizm.* Moscow, 1919.
Dickerman, Leah, ed. *Building the
Collective: Soviet Graphic Design,
1917–1937. Selections from the
Merrill C. Berman Collection.* New
York: Princeton Architectural
Press, 1996, for the Wallach Art
Gallery, Columbia University.
Elliott, David, ed. *Photography in
Russia 1840–1940.* London:
Thames and Hudson, 1992, for the
Museum of Modern Art, Oxford.
Elliott, David, and Ralph Turner, eds.
*Art into Production: Soviet Textiles,
Fashion and Ceramics 1917–1935.*
Oxford: Museum of Modern Art,
in conjunction with the Crafts
Council of England and Wales,
1984.
Erste Russische Kunstausstellung.
Berlin: Galerie van Diemen, 1922.
*The Great Utopia: The Russian and
Soviet Avant-Garde, 1915–1932.*
New York: Solomon R. Guggen-
heim Museum, 1992.
Hambourg, Maria Morris, and
Christopher Phillips. *The New
Vision: Photography between the
World Wars. Ford Motor Company
Collection at The Metropolitan
Museum of Art.* New York: The
Metropolitan Museum of Art,
1989.
*Internationale Ausstellung des
Deutschen Werkbundes: Film und
Foto.* Stuttgart, 1929. Reprint ed.,
with an introduction by Karl
Steinorth, Stuttgart: Deutsche
Verlags-Anstalt, 1979.
Kafetsi, Anna, ed. *Russian Avant-
Garde 1910–1930: The G. Costakis
Collection.* 2 vols. Athens: The
Ministry of Culture, National
Gallery and Alexandros Soutzos
Museum, European Cultural
Centre of Delphi, 1995.
Magazin. Moscow, 1916.
Mrázková, Daniela, and Vladimir
Remes. *Early Soviet Photographers.*
Ed. John Hoole. Oxford: Council
of the Museum of Modern Art,
1982.
Noever, Peter, ed. *The Future Is
Our Only Goal: Aleksandr M.
Rodchenko, Varvara F. Stepanova.*
Munich: Prestel-Verlag, 1991, for

the Österreichisches Museum für angewandte Kunst, Vienna, and the A. S. Pushkin State Museum of Fine Arts, Moscow.

Paris-Moscou, 1900–1930. Paris: Centre Georges Pompidou, 1979.

5x5=25. Moscow: Club V.S.P., 1921. Facsimile reprint ed. Budapest: Helikon, Holland and Belgium: van Gennep, U.K.: Artists' Bookworks, and Germany: König, 1992.

Rodcenko e Stepanova: Alle origini del Costruttivismo. Milan: Electa, 1984, for the Palazzo dei Priori, Perugia.

The Rodchenko Family Workshop. Ed. Chris Carrell. Compiled by V. Rodchenko and A. Lavrent'ev. Glasgow and Strathclyde: New Beginnings, Ltd., and London: The Serpentine Gallery, 1989.

Sowjetische Fotografie der 20er und 30er Jahre. Cologne: Galerie Alex Lachmann, 1991.

Szarkowski, John. *Photography until Now*. New York: The Museum of Modern Art, 1990.

Teitelbaum, Matthew, ed. *Montage and Modern Life 1919–1942*. Cambridge, Mass.: The MIT Press, 1992, for the Institute of Contemporary Art, Boston.

Tendenzen der zwanziger Jahre. Berlin: Dietrich Reimer Verlag, 1977, for the Neue Nationalgalerie, Berlin, et al.

Tupitsyn, Margarita. *Glaube, Hoffnung-Anpassung: Sowjetische Bilder, 1928–45*. In German and English. Essen: Museum Folkwang, 1996.

The Utopian Dream: Photography in Soviet Russia 1918–1939. With an essay by Max Kozloff. New York: Laurence Miller Gallery, 1992.

Von der Fläche zum Raum. From Surface to Space. Russland, Russia, 1916–1924. Cologne: Galerie Gmurzynska, 1974.

Von der Malerei zum Design. From Painting to Design. Cologne: Galerie Gmurzynska, 1981.

Vtoraia vesennaia vystavka OBMOKhU. Moscow, 1921.

Articles and Essays

Barris, Roann. "Inga: a Constructivist Enigma." *Journal of Design History* 6 no. 4 (1993): 263–81.

Bojko, Szymon. "Collages et photomontages oubliés de A. Rodchenko." *Opus International* no. 10–11 (1969): 30–35.

Brik, Osip. "V proizvodstvo!" *Lef* no. 1 of 1923: 105–8. Published in English as "Into Production" in Anna Kafetsi, ed., *Russian Avant-Garde 1910–1930*, 2:707. See "On Rodchenko, Group Exhibitions."

———. "Foto-kadr protiv kartiny." *Sovetskoe Foto* no. 2 of 1926: 40–42. Published in English as "The Photograph versus the Painting," trans. John E. Bowlt, in Christopher Phillips, ed., *Photography in the Modern Era*, 213–18. See "General, Books."

———. "Chevo ne vidit glaz." *Sovetskoe Kino* no. 2 of 1926. Published in English as "What the Eye Does Not See," trans. John E. Bowlt, in Christopher Phillips, ed., *Photography in the Modern Era*, 219–20. See "General, Books."

Dickerman, Leah. "The Radical Oblique: Aleksandr Rodchenko's Camera-Eye." *Documents* no. 12 (Summer 1998).

Gan, Aleksei. "Rodchenko." *Zrelishcha* no. 1 of 1922: 9.

"Illiustrirovannoe pismo v redaktsiiu: nashi i za granitsa." *Sovetskoe Foto* no. 4 of 1928 (April). Published in English, with the byline "A Photographer," as "An Illustrated Letter to the Editor: At Home and Abroad," trans. John E. Bowlt, in Christopher Phillips, ed., *Photography in the Modern Era*, 243–44. See "General, Books."

Khan-Magomedov, Selim. "A. Rodchenko. Put' khudozhnika v proizvodstvennoe iskusstvo." *Tekhnicheskaia Estetika* no. 5–6 of 1978.

Kiaer, Christina. "Rodchenko in Paris." *October* no. 75 (Winter 1996): 3–35.

Kuchner, Boris. "Otkrytoe pis'mo." *Novyi Lef* no. 8 of 1928: 38–40. Published in English in Christopher Phillips, ed., *Photography in the Modern Era*, 249–51. See "General, Books."

Lavrent'ev, Aleksandr. "Rodchenko v SSSR na Stroike." *Sovetskoe Foto* no. 1 of 1981: 38–40.

———. "Vera, nadezhda—prisposoblenie." *Fotografiia* no. 5 of 1996: 36–41.

Nakov, A. B. "Alexandre Rodchenko: Le Dépassement de la problématique picturale." *Art Press* no. 7 (1973): 28–31.

———. "Back to the Material: Rodchenko's Photographic Ideology." *Artforum* 16 no. 2 (October 1977): 38–43.

"Pamiati A. M. Rodchenko." *Sovetskoe Foto* no. 1 of 1957.

Roman, Gail Harrison. "Art After the Last Picture: Rodchenko." *Art in America* 68 no. 6 (June 1980): 120–31.

Shklovsky, Viktor. "Aleksandr Rodchenko: khudozhnik-fotograf." *Prometei* no. 1 of 1966: 387–418.

Stepanova, Varvara. "Rabochii klub: Konstruktivist A. M. Rodchenko." *Sovremmenaia Arkhitektura* no. 1 of 1926: 36.

Summer, Susan Cook, and Gail Harrison Roman. "Cinematic Whimsy: Rodchenko's Photographic Illustrations for *Autoanimals*." *Art Journal* (Fall 1981): 242–47.

General

Books

Anikst, Mikhail, ed. *Soviet Commercial Design of the Twenties*. London: Thames and Hudson, 1987.

Ball, Alan M. *Russia's Last Capitalists: The Nepmen, 1921–1929*. Berkeley: University of California Press, 1987.

Bann, Stephen, ed. *The Tradition of Constructivism*. New York: Viking Press, Inc., 1974.

Barooshian, Vahan D. *Brik and Mayakovsky*. The Hague: Mouton, 1978.

Benjamin, Walter. *Moscow Diary*. Ed. Gary Smith. Trans. Richard Sieburth. Cambridge, Mass.: Harvard University Press, 1986.

Billington, James H. *The Icon and the Axe: An Interpretive History of Russian Culture*. New York: Knopf, and London: Weidenfeld and Nicolson, 1966.

Bojko, Szymon. *New Graphic Design in Revolutionary Russia*. New York: Praeger Publishers, 1972.

Bowlt, John E., ed. and trans. *Russian Art of the Avant-Garde: Theory and Criticism, 1902–1934*. Second ed. New York: Thames and Hudson, 1988.

Bown, Matthew Cullerne, and Brandon Taylor. *Art of the Soviets: Painting, Sculpture and Architecture in a One-Party State, 1917–1992*. Manchester and New York: Manchester University Press, 1993.

Brown, Edward J. *Mayakovsky: A Poet in the Revolution*. Princeton: at the University Press, 1973.

Chudakov, Grigory, Rijke Draaijer, and Ger Fiolet, eds. *Twenty Soviet Photographers 1917–1940*. Amsterdam: Fiolet & Draaijer Interfoto, 1990.

Clark, Katerina. *The Soviet Novel: History as Ritual*. Chicago: at the University Press, 1981.

Compton, Susan. *Russian Avant-Garde Books, 1917–1934*. Cambridge, Mass.: The MIT Press, 1992.

Constantine, Mildred, and Alan Fern. *Revolutionary Soviet Film Posters*. Baltimore: The Johns Hopkins University Press, 1974.

Dabrowski, Magdalena. *The Russian Contribution to Modernism: Construction as Realization of Innovative Aesthetic Concepts of the Russian Avant-Garde*. Ph.D. dissertation, New York University Institute of Fine Arts. Ann Arbor: UMI Press, 1990.

Eisenstein, Sergei. *The Film Sense*. Ed. and trans. Jay Leyda. New York: Harcourt Brace Jovanovich, 1942.

Elliott, David. *New Worlds: Russian Art and Society 1900–1937*. New York: Rizzoli International Publications, Inc., 1986.

Erlich, Victor. *Russian Formalism: History—Doctrine*. Third ed. New Haven and London: Yale University Press, 1981.

Eskildsen, Ute, and Jan-Christopher Horak, eds. *Film und Foto der zwanziger Jahre: Eine Betrachtung der Internationalen Werkbundausstellung "Film und Foto" 1929*. Stuttgart: Hatje, 1979.

Fitzpatrick, Sheila. *The Commissariat of Enlightenment: Soviet Organization of Education and the Arts under Lunacharsky, October 1917–1922*. Cambridge: at the University Press, 1970.

———. *The Cultural Front: Power and Culture in Revolutionary Russia*. Ithaca: Cornell University Press, 1992.

———. *The Russian Revolution*. Second ed. Oxford: at the University Press, 1994.

Fitzpatrick, Sheila, ed. *Cultural Revolution in Russia, 1928–1931*. Bloomington: Indiana University Press, 1978.

Fitzpatrick, Sheila, Alexander Rabinowitch, and Richard Stites, eds. *Russia in the Era of NEP: Explorations in Soviet Society and Culture*. Bloomington: Indiana University Press, 1991.

Gassner, Hubertus, and Eckhart Gillen, eds. *Zwischen Revolution-*

kunst und Sozialistischen
Realismus: Dokumente und
Kommentare Kunstdebatten in der
Sowjetunion von 1917 bis 1934.
Cologne: DuMont, 1979.

Gleason, Abbott, Peter Kenez, and
Richard Stites, eds. *Bolshevik
Culture*. Bloomington: Indiana
University Press, 1985.

Golomstock, Igor. *Totalitarian Art: In
the Soviet Union, the Third Reich,
Fascist Italy and the People's
Republic of China*. Trans. Robert
Chandler. New York: Icon
Editions, 1990.

Gorky, M., et al. *Belomorsko-Baltiiskii
kanal imeni Stalina*. Moscow:
Gosudarstvennoe izdatel'stvo
"Istoriia fabriki i zavodov," 1934.

Gray, Camilla. *The Great Experiment:
Russian Art, 1863–1922*. London:
Thames and Hudson, 1962. Rev.
and enlarged ed., by Marian
Burleigh Motley, under the title
*The Russian Experiment in Art,
1863–1922*, New York: Thames and
Hudson, 1986.

Groys, Boris. *The Total Art of
Stalinism: Avant-Garde, Aesthetic
Dictatorship, and Beyond*. Trans.
Charles Rougle. Princeton: at the
University Press, 1992.

Günther, Hans, ed. *The Culture of
the Stalin Period*. New York: St.
Martin's Press, in association with
the School of Slavonic and East
European Studies, University of
London, 1990.

Jangfeldt, Bengt. *Majakovskij and
Futurism 1917–1921*. Stockholm
Studies in Russian Literature 5.
Stockholm: Almqvist & Wiksell
International, 1976.

Kandinsky, Wassily. *Kandinsky: Complete Writings on Art*. Kenneth C.
Lindsay and Peter Vergo, eds. 2nd
ed. New York: Da Capo Press,
1994.

Kassák, Ludwig, and László Moholy-
Nagy. *Buch neuer Künstler*.
Vienna: Ma, 1922. Reprint ed.,
with an afterword by Éva Körner,
Budapest: Corvina Verlag/Magyar
Helikon, 1977.

Kenez, Peter. *The Birth of the Propaganda State: Soviet Methods of
Mass Mobilization, 1917–1929*.
Cambridge: at the University
Press, 1985.

Khan-Magomedov, Selim O., ed.
Vkhutemas: Moscou 1920–1930.
2 vols. Trans. Joelle Aubert-Young,
Nikita Krivocheine, and Jean-

Claude Marcadé. Paris: Éditions
du regard, 1990.

King, David. *The Commissar
Vanishes: The Falsification of
Photographs and Art in Stalin's
Russia*. New York: Metropolitan
Books/Henry Holt and Company,
1997.

Knödler-Bunte, Eberhard, ed. *Kultur
and Kulturrevolution in der
Sowjetunion*. Berlin: Asthetik und
Kommunikation Verlags-GmbH,
1978.

Lavin, Maud. *Cut with the Kitchen
Knife: The Weimar Photomontages
of Hanna Höch*. New Haven: Yale
University Press, 1993.

Lavrent'ev, Aleksandr. *Varvara
Stepanova: A Constructivist Life*.
Ed. John E. Bowlt. London:
Thames and Hudson, 1988.

Lawton, Anna. *The Red Screen:
Politics, Society, and Art in Soviet
Cinema*. London and New York:
Routledge, 1992.

Lawton, Anna, and Herbert Eagle,
eds. *Russian Futurism through Its
Manifestos, 1912–1928*. Ithaca:
Cornell University Press, 1988.

Leclanche-Boulé, Claude. *Le
Constructivisme russe: Typographes
et photomontages*. Paris:
Flammarion, 1991.

Lef: Zhurnal levogo fronta iskusstv.
Moscow, 1923–25. Reprint ed.,
2 vols., Munich: Wilhelm Fink
Verlag, 1970.

Leyda, Jay. *Kino: A History of the
Russian and Soviet Film*. Third ed.
Princeton: at the University Press,
1983.

Lissitzky-Küppers, Sophie, ed. *El
Lissitzky: Life, Letters, Texts*. Trans.
Helene Aldwinckle and Mary
Whittall. With an introduction by
Lissitzky-Küppers. Greenwich:
New York Graphic Society, 1968.
Rev. ed. London: Thames and
Hudson, 1980.

Livschits, Benedikt. *L'Archer à un
oeil et demi*. Lausanne: L'Age
d'Homme, 1971. Published in
English as *The One and a Half-
Eyed Archer*, trans. and ed. John E.
Bowlt, Newtonville, Mass.:
Oriental Research Partners, 1977.

Lodder, Christina. *Russian Constructivism*. New Haven: Yale
University Press, 1983.

Marcadé, Jean-Claude. *L'Avant-
Garde russe 1907–1927*. Paris:
Flammarion, 1995.

Margolin, Victor. *The Struggle for
Utopia: Rodchenko, Lissitzky,

Moholy-Nagy 1917–1946*. Chicago:
at the University Press, 1997.

Markov, Vladimir. *Printsipy
tvorchestva v plasticheskikh
iskusstvakh, faktura*. Saint
Petersburg: Soiuz molodezhi, 1914.

———. *Russian Futurism: A History*.
Berkeley and Los Angeles:
University of California Press,
1968.

Matsa, I., et al., ed. *Sovetskoe
iskusstvo za 15 let. Materialy i
dokumentatsiia*. Moscow and
Leningrad: Ogiz-Izogiz, 1933.

Mayakovsky, Vladimir. *Pro Eto*. With
photomontages by Aleksandr
Rodchenko. Moscow and
Petrograd: Gosudarstvennoe
Iskusstvo, 1923. Reprint ed., with
an essay by Aleksandr Lavrent'ev
and translations into German and
English, Berlin: Ars Nicolai, 1994.

——— (transliterated as Vladimir
Majakovsky). *Vladimir
Majakovsky: Plays, Articles, Essays*.
Ed. Alexander Ushakov. Raduga
Publishers, 1987.

Mendelsohn, Erich. *Amerika:
Bilderbuch eines Architekten*.
Berlin: Rudolf Mosse Buchverlag,
1926, Rev. and enlarged ed. 1928.
Published in English as *Erich
Mendelsohn's "Amerika": 82
Photographs*, trans. Stanley
Appelbaum, New York: Dover
Publications, Inc., 1993. Published
in French as *Amerika: Livre
d'images d'un architecte*, Paris: Les
Éditions du Demi-Cercle, 1992.

Milner, John. *The Exhibition 5x5=25:
Its Background and Significance*.
Budapest: Helikon, 1992.

Moholy-Nagy, László. *Malerei,
Photographie, Film*. Bauhaus-
bücher 8. Munich: Albert Langen
Verlag, 1925. Rev. ed., under the
title *Malerei, Fotografie, Film*, 1927.
The 1927 ed. published in English
as *Painting, Photography, Film*,
trans. Janet Seligman, Cambridge,
Mass.: The MIT Press, and
London: Lund Humphries, 1969.

Nakov, Andrei B., ed. *Nikolai
Taraboukine: Le Dernier Tableau*.
Paris: Éditions Champ Libre, 1972.

Novyi Lef: Zhurnal levogo fronta.
Moscow, 1927–28. Reprint ed.,
2 vols., Munich: Wilhelm Fink
Verlag, 1970.

O'Connor, Timothy Edward. *The
Politics of Soviet Culture. Anatolii
Lunacharskii*. Ph.D. dissertation,
University of Minnesota. Ann
Arbor: UMI Press, 1983.

Petric, Vlada. *Constructivism in Film:
The Man with the Movie Camera*.
New York: Cambridge University
Press, 1987.

Phillips, Christopher, ed. *Photography
in the Modern Era: European
Documents and Critical Writings,
1913–1940*. New York: The Metro-
politan Museum of Art and
Aperture, 1989.

Pipes, Richard. *Russia under the
Bolshevik Regime*. New York:
Alfred A. Knopf, Inc., 1994.

Robin, Régine. *Socialist Realism: An
Impossible Aesthetic*. Stanford: at
the University Press, 1992.

Roh, Franz, and Jan Tschichold, eds.
*Foto-Auge: 76 Fotos der Zeit; Oeil
et photo: 76 photographies de notre
temps; Photo-Eye: 76 Photos of the
Period*. Stuttgart: Akademischer
Verlag Dr. Fritz Wedekind & Co.,
1929. Reprint eds. New York: Arno
Press, 1973, Tübingen: Wasmuth,
1973, Paris: Éditions du Chêne,
1973, and London: Thames and
Hudson, 1974.

Roman, Gail Harrison, and Virginia
Haelstein Marquart, eds. *The
Avant-Garde Frontier: Russia Meets
the West, 1910–1930*. Gainesville:
University Presses of Florida, 1992.

Rudenstine, Angelica Zander. *Russian
Avant-Garde Art: The George
Costakis Collection*. New York:
Harry N. Abrams, Inc., 1981.

Sartorti, Rosalinde. *Pressefotografie
und Industrialisierung in der
Sowjetunion: Die Pravda 1925–1933*.
Wiesbaden: Harrassowitz, 1981.

Sartorti, Rosalinde, and Henning
Rogge. *Sowjetische Fotografie,
1928–1932*. Munich: Carl Hanser
Verlag, 1975.

Serge, Victor. *From Lenin to Stalin*.
Trans. Ralph Manheim. New York:
Pioneer Publishers, 1937. Reprint
ed. New York: Monad Press, 1973.

Shklovsky, Viktor. *Mayakovsky and
His Circle*. Ed. and trans. Lily
Feiler. New York: Dodd, Mead &
Co., 1972.

Starr, S. Frederick. *Melnikov: Solo
Architect in a Mass Society*.
Princeton: at the University Press,
1978.

Stepanova, Varvara. *Chelovek ne
mozhet zhit' bez chuda*. Ed.
O. V. Mel'nikov. Compiled by
V. Rodchenko and A. Lavrent'ev.
Moscow: Izd. "Sfera," 1994.

Stephan, Halina. *"Lef" and the Lef
Front of the Arts*. Munich: Verlag
Otto Sagner, 1981.

Stites, Richard. *Revolutionary Dreams: Utopian Vision and Experimental Life in the Russian Revolution*. New York: Oxford University Press, 1989.

Taylor, Brandon. *Art and Literature under the Bolsheviks*. Vol. 1, *The Crisis of Renewal, 1917–1924*. London and Concord: Pluto Press, 1991.

———. *Art and Literature under the Bolsheviks*. Vol. 2, *Authority and Revolution, 1924–1932*. London and Boulder: Pluto Press, 1992.

Taylor, Richard, and Ian Christie. *The Film Factory: Russian and Soviet Cinema in Documents*. Trans. Richard Taylor. Cambridge: Harvard University Press, 1988.

Tret'iakov, Sergei. *Selbstgemachte Tiere*. Ed. Werner Fütter and Hubertus Gassner, with photographs by Rodchenko. Cologne: Verlag der Buchhandlung Walther König, 1980.

Tupitsyn, Margarita. *The Soviet Photograph 1924–1937*. New Haven and London: Yale University Press, 1996.

Vartanov, An., O. Suslova, and G. Chudakov, eds. *Antologia sovetskoi fotografi*. Vol. I, *1917–1940*. Moscow: Izdatel'stvo planeta, 1986.

Vertov, Dziga. *Kino-Eye: The Writings of Dziga Vertov*. Ed. Annette Michelson. Trans. Kevin O'Brien. Berkeley: University of California Press, 1984.

Willet, John. *Art and Politics in the Weimar Period: The New Sobriety, 1917–1933*. New York: Pantheon Books, 1978.

Zhadova, Larissa Alekseevna. *Malevich: Suprematism and Revolution in Russian Art, 1910–1930*. Trans. Alexander Lieven. New York: Thames and Hudson, 1982.

Zhadova, Larissa Alekseevna, ed. *Tatlin*. Trans. Paul Filotas et al., rev. Colin Wright. New York: Rizzoli International Publications, Inc., 1988.

Exhibition Catalogues

Baer, Nancy Van Norman. *Theatre in Revolution: Russian Avant-Garde Stage Design 1913–1935*. London: Thames and Hudson, and San Francisco: The Fine Arts Museums of San Francisco, 1991.

El Lissitzky: Architect, Painter, Photographer, Typographer. Eindhoven: Municipal van Abbemuseum, 1990.

Eskildsen, Ute. *Fotografie in deutschen Zeitschriften 1924–1933*. Stuttgart: Institut für Auslandsbeziehungen, 1982.

Fotomontage. Berlin: Staatliche Kunstbibliothek, 1931.

Gassner, Hubertus, and Roland Nachtigäller. *Gustav Klucis: Retrospektive*. Stuttgart: Verlag Gerd Hatje, 1991, for the Museum Fredericianum, Kassel.

Mount, Christopher. *Stenberg Brothers: Constructing a Revolution in Soviet Design*. New York: The Museum of Modern Art, 1997.

Nisbet, Peter, ed. *El Lissitzky 1890–1941*. Cambridge: Harvard University Art Museums, Busch-Reisinger Museum, 1987.

Die Revolution: Die Anfänge des Bildjournalismus in der Sowjetunion. Zurich: Kunsthaus, 1989.

Russische Künstler aus dem 20. Jahrhundert. Cologne: Galerie Gmurzynska, 1968.

Vystavka OBMOKhU. Moscow, 1920.

Articles and Essays

Arvatov, Boris. "Everyday Life and the Culture of the Thing." *October* no. 81 (Summer 1997): 119–28.

Barr, Alfred H., Jr. "The Lef and Soviet Art." *Transition* 14 (Fall 1928): 267–70.

———. "Russian Diary 1927–28." *October* no. 7 (Winter 1978). Reprinted in Barr, *Defining Modern Art: Selected Writings of Alfred H. Barr, Jr.*, eds. Irving Sandler and Amy Newman, New York: Harry N. Abrams, Inc., 1986.

Bois, Yve-Alain. "El Lissitzky: Radical Reversibility." *Art In America* 76 no. 4 (April 1988): 161–81.

———. "Painting the Task of Mourning." *Painting as Model*. Cambridge, Mass.: The MIT Press, 1990.

———. "Material Utopias." *Art in America* 79 no. 6 (June 1991): 98–107, 165.

Bowlt, John E. "Russian Exhibitions 1904–1922." *Form* no. 8 (September 1968): 4–13.

Brik, Osip. "IMO—Art of the Young." Trans. Diane Matias. *Screen* 15 no. 3 (Autumn 1974): 82–94.

———. "IMO—Iskusstvo molodykh." In Vs. Azarov and S. Spasskii, eds. *Maiakovskomu. Sbornik vospominanii i stat'ei*.

Leningrad: Khudozhestvennaia literatura, 1940.

———. "Mayakovsky and the Literary Movements of 1917–1930." Trans. Diane Matias. *Screen* 15 no. 3 (Autumn 1974): 59–81.

Buchloh, Benjamin H. D. "From Faktura to Factography." *October* no. 30 (Fall 1984): 83–118.

———. "The Primary Colors for the Second Time." *October* no. 37 (Summer 1986): 41–52.

———. "Residual Resemblance: Three Notes on the End of Portraiture." In *Face Off: The Portrait in Recent Art*, 58–59. Exh. cat. Philadelphia: Institute of Contemporary Art, 1994.

Burgin, Victor. "Photography, Phantasy, Function." In Burgin, ed. *Thinking Photography*, 177–216. London: Macmillan, 1982.

Clark, Katerina. "Engineers of Human Souls in an Age of Industrialization: Changing Models, 1929–1941." In Lewis Siegelbaum and William Rosenberg, eds. *Social Dimensions of Soviet Industrialization*. Bloomington: Indiana University Press, 1993.

De Duve, Thierry. "Who's Afraid of Red, Yellow, and Blue." *Artforum* 22 no. 1 (September 1983): 30–37.

"Documents from *Novy Lef*." *Screen* 12 no. 4 (Winter 1971–72): 6off.

Frizot, Michel. "Une Autre Photographie: Les Nouveaux Points de vue." In Frizot, ed. *Nouvelle Histoire de la photographie*, 387–97. Paris: Bordas, 1994.

Gassner, Hubertus. "John Heartfield's Moscow Apprenticeship." In Peter Pachnicke and Klaus Honnef, eds. *John Heartfield*, 256–89. New York: Harry N. Abrams, Inc., 1992.

Gough, Maria. "The Moscow Experiment: Karl Ioganson and Russian Constructivism." Ph.D. dissertation, Harvard University, 1997.

———. "In the Laboratory of Constructivism: Karl Ioganson's Cold Structures." *October* no. 84 (Spring 1998).

Haus, Andreas, and Michel Frizot. "Figures de style: Nouvelle Vision, nouvelle photographie." In Frizot, ed. *Nouvelle Histoire de la photographie*, 457–75. Paris: Bordas, 1994.

Jakobson, Roman. "Retrospect." *Selected Writings*. The Hague: Mouton, 1962.

Kaufman, Mikhail. "An Interview with Mikhail Kaufman." *October* no. 11 (Winter 1979): 54–76.

Kemp, Wolfgang. "Das Neue Sehen: Problemgeschictliches zur fotographischen Perspektive." *Foto Essays zur Geschichte und Theorie der Fotografie*. Munich: Schirmer/Mosel, 1978.

Kemp-Welch, A. "'New Economic Policy in Culture' and Its Enemies." *Journal of Contemporary History* 13 (July 1978): 449–65.

Kiaer, Christina. "Boris Arvatov's Socialist Objects." *October* no. 81 (Summer 1997): 105–18.

Lavrent'ev, Aleksandr. "Experimental Furniture Design in the 1920s." *Journal of Decorative and Propaganda Arts* no. 11 (Winter 1989): 142–67.

——— (transliterated as A. Lavrentiev). "Tramway 'F.' Moscou. Années 1920–1930." In *L'Histoire de Moscou à travers le regard des photographes russes et étrangers*, 20–33. Text in French and Russian. Exh. cat. Moscow: Maison de la Photographie de Moscou, 1997.

Nesbit, Molly. "Photography, Art and Modernity." In Jean-Claude Lemagny and André Rouillé, eds. *The History of Photography*, 103–23. New York: Cambridge University Press, 1987.

Phillips, Christopher. "Resurrecting Vision: The New Photography in Europe between the Wars." In Maria Morris Hambourg and Phillips. *The New Vision: Photography between the World Wars*, 65–108. Exh. cat. New York: The Metropolitan Museum of Art, 1989.

———. "Twenties Photography: Mastering Urban Space." In Jean Clair, ed. *The 1920s: Age of the Metropolis*, 209–25. Exh. cat. Montreal: The Montreal Museum of Fine Arts, 1991.

Shklovsky, Viktor. *Literatura i kinematograf*. Berlin: Russkoe universalnoe izdatel'stvo, 1923.

Tarabukin, Nikolai. "Foto reklama i foto-plakat." *Vremiia* no. 10–11 (1924): 43–46.

Wood, Paul. "Art and Politics in a Workers State." *Art History* 8 no. 1 (March 1985): 105–24.

GLOSSARY

AkhR (Assotsiatsiia khudozhnikov revoliutsii) — *Association of Artists of the Revolution*

AKhRR (Assotsiatsiia khudozhnikov revoliutsionnoi Rossii) — *Association of Artists of Revolutionary Russia*

Assotsiatsiia fotoreporterov — *Association of Photo-Reporters*

Daesh' — *Give your all*

Dobrolet — *Good flight*

GAKhN (Gosudarstvennaia akademiia khudozhestvennykh nauk) — *State Academy of Artistic Sciences*

Glavpoligrafizdat (Glavnoe poligraficheskoe izdatel'stvo) — *Central Graphic Design Publisher*

GOELRO (Gosudarstvennaia komissia po elektrifikatsii Rossii) — *State Commission for the Electrification of Russia*

Gosizdat (Gosudarstvennoe izdatel'stvo) — *State Publishing House*

Gosudarstvennaia Tret'iakovskaia galereia — *State Tretyakov Gallery*

GUM (Gosudarstvennyi universalnyi magazin) — *State Universal Store*

INKhUK (Institut khudozhestvennoi kul'tury) — *Institute of Artistic Culture*

Izo (Otdel izobrazitel'nykh iskusstv) — *Section of Visual Arts (of Narkompros)*

Izogiz (Izobrazitel'nnoe gosudarstvennoe izdatel'stvo) — *State Publishing House for Art*

Izvestia — *News*

Khudozhestvenno-promyshlennyi podotdel Izo — *Art and Production Subsection of the Section of Visual Arts (of Narkompros)*

Kino-Fot — *Cine-Photo*

Klub vserossiiskogo soiuza poetov — *Club of the All-Russian Union of Poets*

Komakademia (Kommunisticheskaia akademiia) — *Communist academy*

Krasnaia Niva — *Red field*

Krasnaia Nov' — *Red soil*

Lef (Levyi front iskusstv) — *Left Front of the Arts*

Lef — *Left*

MAPP (Moskovskaia assotsiatsiia proletarskikh pisatelei) — *Moscow Association of Proletarian Writers*

Metfak (Metalloobrabatyvaiushchii fakul'tet) — *Metalworking Faculty (of VkhUTEMAS)*

Molodaia federatsiia — *Young Federation (of Profsoiuz)*

Molodaia Gvardiia — *Young guard*

Moskovskii soiuz sovetskikh khudozhnikov — *Moscow Union of Soviet Artists*

Mospoligraf (Moskovskii poligraficheskii kombinat) — *Moscow Polygraphic Combine*

Mossel'prom (Moskovskaia sel'skokhoziaistvennaia promyshlennost') — *Moscow Agricultural Industry*

MOSSKh (Moskovskoe otdelenie soiuza sovetskikh khudozhnikov) — *Moscow Section of the Union of Soviet Artists*

Muzei zhivopisnoi kul'tury — *Museum of Painterly Culture*

Muzeinoe biuro — *Museum Bureau (of Izo)*

Narkompros (Narodnyi komissariat prosveshcheniia) — *People's Commissariat of Enlightenment*

NEP (Novaia ekonomicheskaia politika) — *New Economic Policy*

NKVD (Narodnyi komissariat vnutrennykh del) — *People's Commissariat for Internal Affairs*

Novyi Lef — *New left*

OBMOKhU (Obshchestvo molodykh khudozhnikov) — *Society of Young Artists*

Obshchaia rabochaia gruppa ob'ektivnogo analiza — *General Working Group of Objective Analysis*

ODSK (Obshchestvo druzei sovetskogo kino) — *Society of the Friends of Soviet Cinema*

Oktiabr' (Ob"edinenie khudozhestvennogo truda) — *October (Association of Artistic Labor)*

OST (Obshchestvo khudozhnikov-stankovistov) — *Society of Easel Painters*

Permskoe obshchestvo liubitelei zhivopisi, vaianiia i zodchestva — *Perm Society of Friends of Painting, Sculpture, and Architecture*

Pervaia rabochaia gruppa konstruktivistov — *First Working Group of Constructivists*

Podotdel po delam muzeev i okhrany stariny — *Department of Museums and Conservation of Antiquities*

Pravda — *Truth*

Profsoiuz (Professional'nyi soiuz khudozhnikov-zhivopistsev) — *Professional Union of Artist-Painters*

Profsoiuz kinofotorabotnikov — *Professional Union of Photo-Cine Workers*

Proletarskoe Foto — *Proletarian photography*

Proletkul't (Proletarskaia kul'tura) — *Proletarian Culture*

RAPP (Rossiiskaia assotsiatsiia proletarskikh pisatelei) — *Russian Association of Proletarian Writers*

REF (Revoliutsionnyi front iskusstv) — *Revolutionary Front of Art*

RGALI (Rossiiskii gosudarstvennyi arkhiv literatury i iskusstva) — *Russian State Archive for Literature and Art*

ROPF (Rossiiskoe ob"edinenie proletarskikh fotoreporterov) — *Russian Association of Proletarian Photoreporters*

RSFSR (Rossiiskaia Sovetskaia Federativnaia Sotsialisticheskaia Respublika) — *Russian Soviet Federal Socialist Republic*

Sovinformbiuro — *Soviet Bureau of Information*

Sovetskoe Foto — *Soviet photography*

Sovetskoe Kino — *Soviet cinema*

Sovremennaia Arkhitektura — *Contemporary architecture*

Starshaia federatsiia — *Senior Federation (of Profsoiuz)*

Stroganovskoe khudozhestvenno-promyshlennoe uchilishche — *Stroganov School of Applied Art*

SVOMAS (Svobodnye gosudarstvennye khudozhestvennye masterskie) — *Free State Art Workshops*

Transpechat' — *Transport Press*

Tridtsat' Dnei — *Thirty days*

Tsentral'naia federatsiia — *Center Federation (of Profsoiuz)*

Tsentral'nyi dom zhurnalista — *Central House of Journalists*

VAPP (Vserossiiskaia assotsiatsiia proletarskikh pisatelei) — *All-Russian Association of Proletarian Writers*

VKhUTEIN (Vysshii gosudarstvennyi khudozhestvenno-tekhnicheskii institut) — *Higher State Artistic and Technical Institute*

VKhUTEMAS (Vysshie gosudarstvennye khudozhestvenno-tekhnicheskie masterskie) — *Higher State Artistic-Technical Workshops*

VKP(b) (Vserossiiskaia kommunisticheskaia partiia (bol'shevikov)) — *All-Russian Communist Party (Bolshevik)*

VOKS (Vsesoiuznoe obshchestvo kul'turnykh sviazei s zagranitsei) — *All-Union Society for Cultural Relations Abroad*

Za Rubezhom — *Abroad*

Zhivskul'ptarkh (Kollektiv zhivopisno-skul'pturno-arkhitekturnogo sinteza) — *Collective of Painterly, Sculptural, Architectural Synthesis*

Zhurnalist — *Journalist*

PHOTOGRAPH CREDITS

Photographs of works of art reproduced in this volume have been provided in most cases by the owners or custodians of the works, identified in the Catalogue of the Exhibition. Individual works of art appearing herein may be protected by copyright in the United States of America or elsewhere, and may thus not be reproduced in any form without the permission of the copyright owners. The following copyright and/or other photo credits appear at the request of the owners of individual works.

© 1998 Artists Rights Society (ARS), New York/ADAGP, Paris: p. 22 fig. 5. Valerii Mikhailovich Evstigneev: p. 75 fig. 4. Plates 1–9, 11–13, 17, 22, 26–31, 33–37, 39–44, 46–48, 50–52, 54, 55, 58–78, 80, 82, 84–90, 95–97, 99, 105, 110, 112, 113, 115, 116, 121, 122, 127–29, 131, 132, 137, 138, 147, 149, 154, 160–71, 174–82, 185, 188, 190, 191, 193–95, 222–25, 227, 228, 231, 232, 234, 235, 237, 239, 241, 242, 244, 245, 247, 255, 257, 263, 266–68, 271–74, 276, 279, 285, 293, 296, 301, 313, 315, 318. Jim Frank: pp. 70, 106. Plates 79,

83, 93, 94, 98, 100, 104, 107, 109, 111, 114, 155–57, 183, 184, © President and Fellows, Harvard College, Harvard University Art Museums: p. 20 fig. 2. Markus Hawlik: p. 116 fig. 18. David Heald: plates 117, 118, 123–25, 130, 158, 159, 262, 265, 286, 287, 289, 291, 294. Jorg Heupel: plates 145, 240, 292. Annely Juda Fine Art, London: plate 38. Francene Keery: p. 113 figs. 11 and 12; p. 124 figs. 28 and 29. The Museum of Modern Art, New York. Digital images: plates

133, 134, 140, 142, 143, 172, 173, 192, 197, 198, 229, 230, 233, 236, 246, 248, 249, 251, 252, 254, 258–61, 269, 278, 280, 282, 283, 288, 290, 295, 297, 298, 300, 302–5, 312, 314. Tom Griesel: plates 10, 56, 81, 91, 92a–j, 119, 120, 126, 135, 139, 150, 153, 189, 199–221, 264, 270, 316, 317. Kate Keller: p. 37 fig. 22; p. 118; plates 21, 45, 53. Soichi Sunami: p. 29 fig. 10; p. 119. John Wronn: p. 85; p. 92; p. 93; p. 109 fig. 7; p. 111; p. 113 fig. 13; p. 115; p. 116 fig. 19; p. 117 fig. 21; p. 121; p. 130 fig. 35. © Photothèque des collections du Musée national d'art mod-

erne, Centre Georges Pompidou, Paris. Adam Rzepka: plate 277. Rheinisches Bildarchiv Köln: plates 238, 250, 253, 281. A. Rodchenko and V. Stepanova Archive, Moscow: pp. 2, 18, 20 fig. 1, 21, 33 figs. 11 and 12, 39, 40, 50, 62, 71, 86, 109 fig. 6, 112 fig. 10, 117 fig. 19, 125, 127, 129, 138, 300, 302–4, 305 bottom left, 306, 307, 308 top left and bottom center, 309–12. William Short: plates 306–11.

LENDERS TO THE EXHIBITION

The B. M. Kustodiev Astrakhan State Picture Gallery
Berlinische Galerie, Landesmuseum für Moderne Kunst,
 Photographie und Architektur
Museum Ludwig, Cologne
The V. and A. Vasnetsov Kirov Regional Art Museum
Getty Research Institute, Research Library, Los Angeles
J. Paul Getty Museum, Los Angeles
The Pushkin State Museum of Fine Arts, Moscow
State Mayakovsky Museum, Moscow
State Tretyakov Gallery, Moscow
The Metropolitan Museum of Art, New York
The Museum of Modern Art, New York
Musée national d'art moderne, Centre Georges Pompidou, Paris
George Eastman House, Rochester, N.Y.
State Russian Museum, Saint Petersburg
Museum of Photographic Arts, San Diego

Svetlana Aronov
Joyce and Michael Axelrod, San Diego
Jack Banning. Courtesy Ubu Gallery, New York
Galerie Berinson, Berlin
Merrill C. Berman
CameraWorks, Inc., New York
Elaine Lustig Cohen
Bernard Danenberg
Barry Friedman, Ltd., New York
Stephen and Jane Garmey
Gilman Paper Company Collection, New York
Galerie Gmurzynska, Cologne
Manfred Heiting, Amsterdam
Edwynn Houk Gallery, New York
Galerie Rudolf Kicken, Cologne
Galerie Alex Lachmann, Cologne
PaceWildensteinMacGill, New York
Première Heure, Paris
Productive Arts, Brooklyn Heights, Ohio
A. Rodchenko and V. Stepanova Archive, Moscow
The Judith Rothschild Foundation, New York
Prentice and Paul Sack
Howard Schickler Fine Art, New York
Thomas Walther, New York
The Wolkowitz Collection, New York

Private collection, New York

In the aftermath of the Russian Revolution of 1917, a group of artists who came to call themselves Constructivists set out to create a new art in the spirit of the new society to come. Aleksandr Rodchenko (1891–1956), the most important and versatile member of the group, made outstanding and original works in virtually every field of the visual arts. In the first part of his career, Rodchenko produced innovative abstract painting, sculpture, prints, and drawings. In 1921, however, he made a bold break, committing himself to applied art in the service of revolutionary ideals, and moving on to lasting achievements in photocollage, photography, and design of all kinds: books, posters, magazines, advertising, furniture.

This book is published to accompany the first major American retrospective of Rodchenko's work, at The Museum of Modern Art, New York, in the summer of 1998. The essays in *Aleksandr Rodchenko* explore both phases of his career, drawing out the formal ideas that he developed as well as the social and artistic context in which he moved. The book's plate section, reproducing over 300 works carefully selected from collections in Russia and throughout the West, for the first time presents a full and coherent overview of his diverse achievement. An illustrated chronology outlines the story of the artist's life.